Carr, O'Keeffe, Kahlo

Yale University Press
New Haven and London

Carr, O'Keeffe, Kahlo

Places of Their Own

Sharyn Rohlfsen Udall

Permission to reproduce all Frida Kahlo images
has been received from the Instituto Nacional de
Bellas Artes and Banco de Mexico, Mexico City.
All other works are reproduced by permission of
their owners.

Designed by Daphne Geismar.
Typeset in Adobe Garamond and Univers type
by Amy Storm.

Printed in China by World Print.

Library of Congress Cataloging-in-Publication Data
Udall, Sharyn Rohlfsen.
 Carr, O'Keeffe, Kahlo : places of their own /
Sharyn Rohlfsen Udall.
 p. cm.
 Includes bibliographical references and index.
 ISBN 0–300–07958–3 (alk. paper)
 1. Women artists—North America—Biography.
 2. Art, Modern—North America—Biography.
 3. Carr, Emily, 1871–1945. 4. O'Keeffe, Georgia,
 1887–1986. 5. Kahlo, Frida. I Title.
N8354.U33 2000
704'.042'0904—dc21

 00—032100

A catalogue record for this book is available from
the British Library.

The paper in this book meets the guidelines for
permanence and durability of the Committee
on Production Guidelines for Book Longevity of
the Council on Library Resources.

10 9 8 7 6 5 4 3 2 1

Contents

Preface

Emily Carr, Georgia O'Keeffe, and Frida Kahlo all worked in the first half of
the twentieth century, yet the three formed neither a professional nor any significant
personal bond. Carr and O'Keeffe met once and shared a number of artistic and
cultural concerns. O'Keeffe and Kahlo were acquaintances; they had a few personal
contacts and occasionally corresponded. There is no record that Kahlo and Carr
ever met or were even aware of each other's work. Such scant contacts hardly seem
the basis for a joint study. Yet these artists shared fundamental commonalities—
a professional stature, an attachment to place and nationality, an intense connection
to nature, and a strong interest in indigenous cultures—that link them both as
artists and as women, and form a starting point for an investigation into the place of
the woman artist in the twentieth century. For each overcame general and indi-
vidual prejudices to achieve a secure reputation as her nation's outstanding woman
painter of the century.

In the 1970s the study of women in the visual arts concentrated on the
rediscovery of forgotten women artists, who were then introduced into the
established canon. Historians sought to define the "female experience," as distinct
from the "male." Such efforts to condense and generalize female experience
resulted first in claims of a feminine "essence," described in terms of—and ulti-
mately reducible to—biology. A later wave of gender studies veered sharply
in the direction of cultural construction: women's experience, historically and indi-
vidually, was said to be shaped more by social conditioning than by innate
tendencies. In this book I question both the old "essentialist" and the more recent
"constructivist" theories, arguing that women's identity is complex and nuanced,
a product of both history and social construction. As new discoveries in ethnology,
psychoanalysis, linguistics, and the history of religions have altered old ways of
thinking, some old questions must be reframed. In the work of Carr and Kahlo par-
ticularly, we see the artists adopting—or being assigned—roles as mediators
between native heritage and modern culture. To explore their individual styles of
modernist primitivism, I have drawn upon postcolonial and feminist critiques
of history, as well as on ethnohistorical material.

In the beginning was the image. Humanistic studies generally argue that
image making is as old as consciousness, or nearly so: people have always recorded
their habitats, histories, beliefs, dreams, and desires in the images they make.
This is visible at many levels, from the tribal to the national; ultimately a history of
images becomes braided into the collective mythos of a people. Deeply imbued

with cultural and national awareness, Carr, O'Keeffe, and Kahlo were intensely conscious of the history, geography, and cultural achievements of their native lands.

My focus will be on the work of these artists, not their lives, although biographical elements will surface throughout the book, for I believe that art must be considered in part within the creative life of its maker. As Lewis Mumford wrote in a *New Yorker* profile on Georgia O'Keeffe, "All art is a sort of hidden autobiography. The problem of the painter is to tell what he knows and feels in such a form that he still, as it were, keeps his secret." But several biographies of each painter remain in print, so in place of a detailed repetition of their life histories I have appended a chronology of important historical and cultural changes, as well as the significant personal and artistic events in each painter's life.

Often in these chapters I focus on episodes in the history of the artists' individual consciousness, seen always against the backdrop of their work and sometimes that of their contemporaries. Viewed as the journeys of stubborn, romantic individuals, their creative lives depended as much on finding a self as on defining a style. Throughout, I look at how the creative process feeds and is fed by the making of a personal mythology. In lives devoted to art, Carr, O'Keeffe, and Kahlo lived out their own invented, unique, and sometimes conflicted mythologies. There is much we can never know about the inner workings of an artist's mind, but there is much we *can* learn in the process of comparing creative lives and achievements. Always, the discussion returns to the paintings themselves, at once revelatory, baffling, and crucial primary "texts."

More broadly, through examining a wide range of works, this study attempts to build associations of ideas. Recognizing the importance of conveying time, place, and social texture, I try to track the relation of the art to its social and political background, while considering as well the influence of the history of ideas and ideology on the way images generate meanings. Besides the paintings themselves, I have drawn on rich source material from the artists' correspondence, journals, and statements. The artists' own words—at times revealing, obfuscating, calculating, inspiring, amusing, and heart-wrenching—are used liberally, but cautiously, to frame important issues in their lives and art. In discussing lives laced with recurring efforts at self-invention, a writer must be careful how she attempts to restore humanity and complexity to identities much manipulated by themselves and by those with a stake in generating icons.

Recent scientific studies suggest there is much to be learned about the gendered human brain and the possible genetic encoding of creativity. Despite significant research, such questions are a long way from being answered. Until they are, we must continue to explore how social attitudes and conditioning affect women in the arts, past and present. Such biological and social differences, I believe, underscore the need to continue studying women artists individually as well as in groups in order to unlock the secrets of female creativity.

Acknowledgments

Many individuals and organizations have supplied valuable help at every stage of this project, beginning with students in my seminars on Carr, O'Keeffe, and Kahlo given in 1995 and 1998 at the University of New Mexico, Santa Fe.

Special thanks go to the McMichael Canadian Art Collection, which undertook to organize a parallel exhibition, and which provided support for the acquisition of all the photographs for the book. Several colleagues at the McMichael provided invaluable help and encouragement: Barbara Tyler, Megan Bice, Catherine Stewart, and Sandy Cooke worked tirelessly on every detail of the exhibition and catalogue. Closer to home, Salomon Grimberg became a frequent informal adviser on the project, providing vital suggestions in many situations. Other colleagues and collectors in Canada and the United States have read or made valuable suggestions about the manuscript. These include David Alexander; Stuart Ashman, Aline Brandauer, Mary Jebsen, and Joan Tafoya of the Museum of Fine Arts, Santa Fe; Sarah Burt, Elizabeth Glassman, Agapita Lopez, and Georgia Smith of the Georgia O'Keeffe Foundation; Flora Clancy; Wanda Corn; William deBuys; Jacqueline Orsini Dunnington; Charles Eldredge; Bitsy Folger; Jill Furst; Bill Garrison; Gretchen Garner; Ellen Landis of the Albuquerque Museum; Sarah Lowe; Barbara Buhler Lynes and Jackie M of the Georgia O'Keeffe Museum; Donna McLarty; Mary-Anne Martin and Sofia Lacayo at Mary-Anne Martin/Fine Art, New York; Lois Rudnick; Jacqueline West; Barbara Mauldin, Curator of Latin American Folk Art at the Museum of International Folk Art, Santa Fe; Jerry Rightman; Edward Sullivan; Gerald Peters and Catherine Whitney of the Gerald Peters Gallery; Elizabeth Hutton Turner of the Phillips Collection; John Wirth of the North American Institute; Pampa Risso-Patron of the Pan-American Cultural Exchange.

In Mexico I received special help from Bertha Cea of the U.S. Embassy; Claudia Walls of the Instituto Nacional de Bellas Artes; Armando Colina; Karen Cordero; Ramis Barquet; and the staff of the Museo Dolores Olmedo Patiño.

Archives and libraries have provided access to indispensable materials: Archives of American Art, Smithsonian Institution, Washington, D.C.; the interlibrary loan services of the Santa Fe Public Library, New Mexico; Special Collections, Green Library, Stanford University, Stanford, Calif.; Center for Creative Photography, University of Arizona, Tucson; Stephanie Gaskins, Ipswich Historical Society, Massachusetts; Harry Ransom Humanities Research Center, University of Texas, Austin; British Columbia Archives and Records Service, Victoria.

Finally, I am grateful to my gifted editors, Judy Metro and Susan Laity, at Yale University Press.

Note to the Reader: In Barbara Buhler Lynes's catalogue raisonné of Georgia O'Keeffe's work, just published by the National Gallery of Art in association with Yale University Press (1999), the titles of several of O'Keeffe's works differ from the titles provided by the owners. In this book the more familiar titles are used throughout the text; however, titles that have changed significantly appear in brackets in the captions to the figures.

Introduction

In an era short on cultural heroes, Emily Carr, Georgia O'Keeffe, and Frida Kahlo testify to the fading belief that painters can convey social and mythic meaning while creating widely memorable images. All were artists of unique perception and mind, whose creative lives show unusual efforts to define themselves culturally as well as individually. The identities (and they are multiple) that each established resulted from a deep engagement with history—cultural, natural, and to some extent political—in search of their authentic selves. And, as T. S. Eliot knew, the authentic, core self is shaped by the work itself, emerging as an artist tells her story or, in this case, as she makes her paintings.

Born at a time when definitions of social, artistic, and sexual roles were changing, O'Keeffe, Kahlo, and Carr were heirs to a late nineteenth-century crisis of cultural authority, and would themselves test the limits of what it meant to be a woman and painter. In a male-dominated art world, men usually decided which people, events, and points of view were deemed important. Each of these painters thus fought simply for recognition, not to mention her own mode of expression— defining struggles for any painter, but especially for women. Indeed, one could argue that each painter's creativity was fueled by the tension between her passion for freedom and her presumed destiny as a woman. It would make a tidy thesis to say unequivocally that each staked out her artistic place and then achieved the necessary freedom in which to reach her creative potential. The truth—as with all significant artists—is more ambiguous. What we can argue is that each carved out spaces of freedom within her own life, often at considerable cost.

In emerging from traditions created by men, the painters learned to manipulate notions of cultural identity and authenticity, defining themselves both inside and outside established norms. By declaring her individuality, identifying herself as an "outsider," each had to resist, at times, the captivity of conditioning: family, religion, artistic expectations.

Georgia O'Keeffe (1887–1986) had less difficulty living out the ideology of the artist than did Kahlo or Carr. A strong-willed second child, she proclaimed herself an artist while still in her teens. When she entered into an artistic and personal relationship with the photographer Alfred Stieglitz, the initial mentor-protégée arrangement soon gave way to an equal partnership and eventually to an association in which she emerged as the more successful of the two. In retrospect, O'Keeffe said that she possessed less of an artistic gift than a kind of "nerve," which enabled her to press forward her artistic explorations. That nerve failed her at several key

moments in her career; yet she always recovered it and put her complex, unstable artistic ideology back on track again and again.

In the relationship between Frida Kahlo (1907–54) and her famous husband Diego Rivera, the imbalance of power was of such long duration that it was difficult for Kahlo ever to find a broad and stable terrain on which to take her artistic stand. During her lifetime her art was classed as minor, always secondary to Rivera's muralistic production. But her place at the margin freed her to break rules: in an era when monumental murals were the prized product of male artists' brushes, her small, highly personal easel paintings signaled a refusal to compete on their terms. In the end, a new generation found in Kahlo's intensely emotional paintings a heroic female voice; she was released in death from artistic dependency on Rivera. This change in relative status forms a compelling contrast to their lived experience: Kahlo's emotional dependence on Rivera was extreme, as we can see in her letters, her diary, and her paintings. Loved, she was a different person from the unloved Frida; and fear of abandonment lodged firmly in her life and art. But she had one strong lifeline that was never severed: the ancient women of Mexico's history and mythology whom she uncovered gave her usable female identifications in an androcentric country. In a sense, Latin America's ubiquitous machismo, which reserved the public sphere for male artists, paradoxically freed women to pursue their own private, personal paths within the arts. The result has been an enlarged role for Mexican women artists—one that often surpasses the relative influence in twentieth-century art of their sisters to the north.

Emily Carr (1871–1945) persisted in her creative journey out of the necessity to overcome circumstances that would have stifled many another artist. We might say that her impetus was fear of the unpainted—the recurring sense that her voice might be stilled, that her creative potential would atrophy if not exercised. She had seen that happen, or nearly so, when she was forced to earn her living as a full-time landlady—dismal years when "all the art [was] smashed out of me flat." Once Carr found a way out of that creative hiatus and glimpsed a future as a full-time professional artist, she seized her chance and never again let it slip away. As her best-loved mentor Lawren Harris recognized, "She eventually planned her life, her studios and abodes and everything around her to assist her work. All the mechanics of living were arranged with this end in view."[1]

As painters sensitive to cultural tradition even while grappling with modernity, O'Keeffe, Kahlo, and Carr sought to reconcile history, political realities, and representation. They observed their surroundings and then reinvented the image in paint. As a result, the United States, Mexico, and Canada we know from their paintings are, in substantial part, the terrain they imagined; we can scarcely envision what their places were like beforehand. As advocates of their native lands, these painters' inscriptions of self upon those places became their ultimate subject and most radiant achievement. Their own movements and their awareness—sometimes

focused, sometimes diffuse—of a kind of hemispheric sensibility invite us to think about the possibility of a revised axial orientation, north-south, to challenge the entrenched east-west cultural consciousness they inherited. In the end, individually and collectively, their work gives form to a mythos of North America, linking region and nationality to larger forces at work in Western consciousness.

Each artist was vitally interested in the native cultures of her area. However romantically tinged, the perceived authenticity of indigenous peoples helped these artists measure their own. Indigenous peoples seemed to hold keys to the primordial spirits of place and nature, and all three artists explored the healing power of native myth as an antidote to personal fragmentation in the modern world. All three also experimented (in a sometimes uneasy awareness of colonialist overlays) with indigenous design and technique in their work. As Carr wrote late in life, "Perhaps I shall never do anything beyond my Indian stuff because it struck into my vitals when I was freshly maturing into young womanhood and my senses were keenly alert. The ever-growing universe called to the fast-developing me. The wild places and primitive people claimed me."[2] Although such borrowings are inherently problematic, there can be no question that these artists tendered homage and respect to indigenous cultures.

Nature also played a primary role in the work of Carr, O'Keeffe, and Kahlo. Identification with nature led each to a lifelong exploration of its forms and symbolism. Such objects as trees, mountains, seas, sun, moon, desert, rock, bone— all were perceived as both physical and symbolic realities. In the larger sense, each artist felt an interrelatedness between herself and all existence; all life fell on a continuum. Not a rational and scientifically framed nature, theirs is a nature of multiform energies. Vitalist theories of growth and energy passed from nineteenth into twentieth-century philosophy and literature and on to all these women. Each read the work of Walt Whitman and D. H. Lawrence. As well, O'Keeffe and Kahlo absorbed aspects of nature in Asian poetry. All three artists independently explored nature as a geography of the unconscious in which human forms and relationships masquerade as natural features and landforms. They renewed the psychological concept of landscape as female, finding and expressing a personal rootedness in that metaphor. In O'Keeffe's sensuous red hills, Kahlo's painted self embraced by the earth mother, and Carr's paintings of totemic female forest spirits, nature's energies are embodied in unforgettable female imagery. But how the artists represented those energies and their natural contexts offers telling distinctions among them.

The study of nature was also part of the artists' struggle to paint something beyond the visible subject itself—to capture what made that subject compelling. Sometimes, this was the suggestion of linkages to mystery and spirituality. Like Georges Braque, these artists would insist that the important thing about a painting was what could not be explained. Carr, Kahlo, and O'Keeffe all questioned

the Christianity they grew up with, and each explored Eastern philosophy and literature, with visible results in her painting. Various mystical practices such as Theosophy and alchemy also engaged the artists.

Even as they contemplated the infinite, the artists had to make a place for themselves and their work in the social world. The homes and studios each artist created for herself reflected her conception of domesticity, shelter, belonging and safety, communion with her surroundings, and questions of control, engagement, and isolation. In the choice of clutter or emptiness reside complex notions of self and identity. Amid the objects collected during a lifetime, as much as in artistic production, resides evidence of a fundamental aesthetic.

Domestic, familial selves were offset in all three cases by public selves. Carr, O'Keeffe, and Kahlo all established public identities, communicated their ideas, and negotiated careers. Unmistakably, each found it difficult to figure out how to live fully as both women and artists. As artists, they wanted to establish and sustain a sense of their own originality, a notion often bound up with the ideology of genius and the cult of personality that almost inevitably attach themselves to successful creative individuals in European American society. Old stereotypes die hard: still lingering was the widespread perception, to quote Stendhal, that "All geniuses born women are lost to the public good." How to prevent that loss, how to bring forth one's gift? Cherishing one's individuality, as Western artists have been conditioned to do since the Renaissance, often presented special problems for the woman artist, who lacked culturally instilled confidence (more common in male artists) in the belief that as an artist she was unique, with special attributes and prerogatives. More, if a female artist did embrace this view, she discovered, like the male, that she was obliged to live it out, attend to its perpetuation.[3] Doing so called for ever higher achievement—often judged by public whim. Success, these artists learned, can be its own kind of trap.

Yet Kahlo, O'Keeffe, and Carr all created and modified identities that allowed them to make their ways as artists in the world. Each negotiated the balance between originality and tradition. In varying degrees, each paid attention to developments in European and American modernism, borrowing what she needed, rejecting what seemed inauthentic, and, in Kahlo's case, settling upon an artistic stance that was ultimately more antimodern than modern. For Carr and O'Keeffe, authenticity came from struggling for a technique that would match the new motifs they had found in nature. These long and deepening explorations made their work modern and vital.

Artistic subjects, intention, and identity formation are linked in the work of these three painters. When identity and creativity mingle, the artist is encouraged to work into and out of the deepest recesses of the self. Embedded there is a degree of intentionality never fully knowable to others but partially discernible through prolonged study of their work. Based on the examples considered here, I believe that

Carr and O'Keeffe painted not in an effort to teach or to tell but because each wanted to *know* things—things she tried to discover in the exercise of asking visual questions. Eventually, from the repeated queries posed by their paintings, Carr and O'Keeffe constructed iconographic patterns congruent with their questioning of the universe. The queries are cumulative and ultimately philosophical: What is the nature of sight? How can I represent in paint the rhythmic patterns of topography, plant growth, weather, changing light, the mind's journeys through space? How do observation and reflection serve each other? What is stasis? Are there finite things that are absolute and unchangeable?

In Kahlo's work it is often difficult—and perhaps fruitless—to separate out specific intentions: her body and its complex relationship to nature keep the two tightly locked in an iconographic embrace. Still, if precedence must be ceded to one or the other, the edge must go to her concrete treatment of the body (including her self-portraits), measured both in numbers and in intensity as her most significant achievement. Alone of the three, she obsessively translated the experience of the physical body into self-portraiture, incorporating her particularly feminine obsessions and dilemmas as subject. The landscape, ultimately, was for Kahlo a way of both being in the world and not being in it. Reconciling that paradox, she retained narrative in her self-portraits, while refusing to be limited by it. Instead she strove to keep alive a conversation among her paintings, her polymorphous cultural heritage, and her own physical reality. Her work became a complex circuitry, in which she built up nodes of meaning through repetition, juxtapositions, and detail.

Of all the artists' work, Kahlo's self-portraits provide the most obvious, assertive, and unrelenting questioning of self and reality. But as I shall argue, all the artists made symbolic self-portraits that extend beyond mere self-representation into self-invention. Whether direct or symbolic, these self-portraits stem from the artists' individuality and their relation to artistic tradition, the natural world, and their own time and place. Deep within such work, most significantly, lie keys to the structure and functioning of their creative minds. Present in those temperaments were many of the commonly accepted characteristics of creative persons: imagination, nonconformity, independence, perseverance, focus, and intensity. Their experiences and careers were very different yet hauntingly analogous at key points. In my comparisons I have tried always to preserve enough distance among the artists to see each, in Ranier Maria Rilke's buoyant phrase, "whole against the sky."

In their achievement of art that bridges sensation and image, Carr, O'Keeffe, and Kahlo perennially renewed connections between the centers and circumferences of their minds. For that, and for their eloquent, unceasing exploration of how place, nationality, nature, and gender intertwine in art, Emily Carr, Frida Kahlo, and Georgia O'Keeffe must be counted among the cardinal painters of the continent. We venture to claim them as our own.

Part One Landscape and Identity

The paintings of Frida Kahlo, Emily Carr, and Georgia O'Keeffe all demonstrate a special connectedness to place. Each artist rooted herself in a region of the Americas and then reinvented the image of that place in her work. This process holds the key to many aspects of each artist's developing social and personal identities.

Nationalism—a sense of belonging to a place and of it belonging to you and to a larger collective of persons with shared experiences and beliefs—can offer a kind of communion with a place. The art critic Peter Schjeldahl has argued that "nationality is one of the most significant and interesting things about anyone, and therefore any art. It affects the content and character of art at least as much as, say, gender does, even or perhaps especially when an artist tries deliberately to transcend it."[1] Although place and nationality are not the same thing, they are intimately connected. And gender complicates the issue: what does it mean to be a woman artist in a particular place? More to the point, how did the experience of being female in Mexico, Canada, and the United States in the 1920s affect the artistic aspirations of Kahlo, Carr, and O'Keeffe?

Competing with nationalism is globalization, which rejects territoriality and nationalism. In the visual arts, an interest in globalization developed around the 1960s, when the possibility of a transnational, even universal art could be imagined. Today, although transnational art is being made, globalization has not led to borderless art. Artistic roots remain, part of the local identity endemic to each human being. Though that identity cannot always be defined, it can be recognized.

But nationality is more than territory; it involves a space which is simultaneously physical, linguistic, symbolic, cultural, and social. None of us can free ourselves completely from place; rather, our challenge is to understand national identity without reducing it to nostalgia or folklore, without perpetuating empty cultural clichés. Carr, O'Keeffe, and Kahlo, as women artists in a transitional period, felt the competing pull of their own place against the different places that became available to them with expanded opportunities for travel. Hardly international jet-setters, each traveled considerably, and the art of all three was enriched by exposure to extraterritorial ideas and forms.

In this chapter I shall consider some of the nationalist issues in the lives and imaginations of these three artists, observing the ways they drew upon, challenged, or, at times, rejected outright the cultural identities they inherited. This will allow us to look more broadly at the connections between nationalism, culture, and the creative process, recognizing that even as cultural constructs confer collective authority in art, they also help to shape the artist's personal mythology.

It is a truism to say that the creative process feeds and is fed by the making of a personal mythology. The discovery of her own myth allows an artist to paint out of the deepest recesses of the self. At the same time, that myth connects to larger spheres of consciousness and to the figures within them. For women artists those figures are likely to be older women artists within their national tradition or other historical, literary, or even mythic women from their cultural past. In my examination of some of those wellsprings of cultural identity, I shall consider the mythic or archetypal women encountered by Carr, O'Keeffe, and Kahlo. A point of entry is Frida Kahlo's understanding of Mexican nationalism.

Frida Kahlo and the Idea of Mexicanidad

The turbulent decade of the Mexican Revolution, especially the years of armed conflict between rival factions, including President Porfirio Díaz, the guerrilla Pancho Villa, and the agrarian reformer Emiliano Zapata, from 1914 to 1917, set the stage for sweeping changes to follow. Mexico's artists and writers were stirred to confront remnants of its colonial past and to imagine a new cultural future within the larger struggles for economic reform, modernity, mechanization, and social justice. New ways of portraying the revolution itself, the rural populations, the landscape, the urban environment, and the pre-Columbian past— all were of concern to Mexico's artists, who were active in shaping the new cultural agenda. Few were more active in these struggles than Diego Rivera and Frida Kahlo, who worked separately and together to advance the development of a specifically Mexican aesthetic.

Fired by social revolutionary passion, Kahlo based her *Mexicanidad* in the desire to recover Mexico's mythic past—a pre-Cortésian era from which sprang modern *indigenismo*, the celebration of native culture. Her interest, like that of Rivera, lay in both ancient mythology and modern politics, and she sought ways to reconcile the two. For Rivera, Kahlo was "the Mexican artist with [a] sophisticated European background who has turned to native plastic tradition for inspiration; she personifies the cultural union of the Americas for the South."[2] Hers was an expansive view of Mexican culture, one which blended many races into contemporary Hispanic culture. Philosopher José Vasconcelos, a friend of Kahlo and Rivera's, termed the hybridized peoples of Latin America "la raza cosmica." And that cosmic race, more than most individual groups, could trace its origins to specific events, especially the arrival of the Europeans. Indeed, modern national histories throughout Latin America begin either in 1492 with Columbus or in 1519 with Cortés.

Mexican nationalism, rooted in atavistic spiritual and material culture, wore a Janus face. Mexicans looked to the present, manifested in the cosmic race, but they had ample reminders of the past. Nahuatl, the language of the Aztecs, was still spoken, and it was to the Aztecs that many modern Mexicans turned when they sought their ancient roots.

Why the Aztecs? In the first place, there is an abundance of information, particularly documents like those assembled by the pioneer Spanish anthropologist Fray Bernardino de Sahagún, which enabled scholars to reconstruct the richness of Aztec society in considerable detail. Diego Rivera relied on that documentation when he painted his mural of Aztec life at Tenochtitlan on the walls of the Palacio Nacional in Mexico City.

In addition, Aztec culture carried political overtones that must have been irresistible to the communist Kahlo and Rivera: the Aztecs themselves practiced a form of communism.[3] Eerily modern too, is the series of deep contradictions that stood side by side in Aztec life. The novelist Carlos Fuentes commented on these paradoxes: "The Aztec world, a sacrificial theocracy, wanted to wed the promises of peace and creativity symbolized by the Feathered Serpent, Quetzalcoatl, with the bellicose necessities demanded by the bloodthirsty god of war, Huitzilopochtli. Therefore the starkly ambiguous character of the Aztec universe: great artistic and moral achievements side by side with execution, blood rites, and terror."[4]

Kahlo, whose broken body (devastated by childhood polio and a terrible streetcar accident) generated its own terror and blood rites, identified early with the cataclysmic wounds of the Aztecs. A mixture of Indian and European races, she understood Mexico's conflicted past through her own ethnicity and education, as well as its bloody attempts to adapt to the twentieth century. Indeed, the country's struggles paralleled her own in search of personal and artistic identity. Her Indian blood and her lifelong leftist political leanings allied her with the largely indigenous masses of Mexico, while her upbringing with an adored German father created sympathies for aspects of European culture.

The Aztecs, whose universe featured dynamic oppositions of paired forces, provided part of the metaphorical basis for Kahlo's art making. Aztec art created symbols and glyphs from different contexts, combining them in a number of ways. As the art historian Esther Pasztory writes, "In a single image the Aztec artist could express so many levels of meaning that whole volumes of texts would be needed to explain them in writing. From the Aztec point of view, the fact that this system was also multivalent and capable of different reinterpretations added to its universal truth and applicability."[5]

Kahlo invented her own system of multivalent images, drawing on the richness of the pre-Columbian past for depth and resonance of meaning. And she found in modern sources ideas that complemented Aztec thought concerning the force and energy of nature. Walt Whitman, whom Kahlo read with enthusiasm and encouraged her students to read, wrote in *Leaves of Grass* of the cosmic creative force underlying the energy of nature, an energy that becomes eternal when recreated in poetry. The poet, as both the Aztecs and Whitman believed, transforms energy from the level of the spirit to that of the present. The same role is avail-

able to the painter, who can likewise transform spirit into matter and can, via quasi-shamanic power, move between the two realms.[6]

Kahlo tapped into a long mythic tradition linking the ancient Mexican past to more recent ideologies. She may well have drawn on Nahuatl cosmology's own paradoxical space-time orientation for a model: despite the Aztecs' development of sophisticated calendars, they made no sharp distinctions between space and time. Like them, Kahlo moved easily back and forth between her own life and a mythic continuum to which she constantly referred.[7]

And by incorporating female imagery from the ancient past into her art, Kahlo developed a way of validating both her personal and her national history. Octavio Paz has written of the centrality of the female, particularly the maternal, influence in Latin America: "The predominance of the maternal image in Latin American society is no accident; it is a confluence of ancient Mediterranean female divinities, Christian virgins, pre-Columbian and African goddesses: Isis and Mary, Coatlicue and Yemanya (who is venerated in Cuba as the Copper Virgin and in Brazil as Saint Barbara). Axis of the world, wheel of time, center of motion, force of reconciliation, the mother is the fountain of life and the storehouse of religious beliefs and traditional values."[8]

Turning to some of those archetypal female figures as they relate to Kahlo's oeuvre, we encounter the many mother and mother-goddess images populating Mexican folklore and pre-Columbian tradition, figures Kahlo knew and incorporated into written and painted explorations of her own identity. La Llorona, the weeping woman of popular myth, is an ubiquitous cultural demon, fearful and tragic, who blends elements from old and new traditions. In an early letter to her first lover, Kahlo signs herself "Frieda Lagrimilla de Gómez Arias or I Virgen Lacrimorum" and writes after the physical therapy that followed her streetcar accident, "every time they pull me I cry a liter of tears."[9] Years later, in her diary, Kahlo recorded her weeping face in a lithograph called *Frida and the Miscarriage* (fig. 1), a highly personal image that is laden at the same time with the mythic associations she often incorporated into her personal experience. In modern myth La Llorona wanders the streets, canals, or dry riverbeds at night, her anguished cries ringing out for her lost children, whom she has drowned. Dressed in white, she accosts unwary travelers in the moonlight, then disappears. Those who see her might go mad; those who dare to speak to her risk death. According to one old version, an officer who persuaded La Llorona to remove her rebozo saw a skeleton, whose icy breath caused him to fall unconscious. Upon reporting the incident he died.[10]

The skeleton woman under the rebozo is also known as La Huesera, the bone woman, or La Pelona, Lady Death, both of whom are familiar in Mexican folklore. Kahlo illustrated her letters with miniatures of La Huesera, and consoled herself after her terrible accident with the notion that "at least *la pelona* did not take me away." Lady Death, though she had not yet captured Kahlo, lingers nearby. She appears in

Kahlo's paintings as the skeletons in *Four Inhabitants of Mexico* (1938; private collection), *The Wounded Table* (1940; now lost), *What the Water Gave Me* (fig. 2), and *The Dream* (1940; private collection) and as the skull in *Self-Portrait on the Border Line Between Mexico and the United States* (fig. 3).[11] In these paintings the bones seem intimately connected to Kahlo, reminders of the proximity of life and death in Mexican culture, as well as in Kahlo's own pain-ridden existence.

Whether bone woman or clothed in flesh, the wailing woman is a formidable presence. As death's companion she instills a kind of mocking fear, but as a living woman she is sometimes more to be pitied than feared. La Llorona has sometimes been identified with La Dolorosa, the sorrowing Madonna, whom Kahlo included in her 1932 painting *My Birth* (private collection). In that work the weeping virgin's portrait hangs on the wall above the head of a woman in childbirth (Kahlo's mother), whose emerging infant is clearly Kahlo herself. Though Kahlo and her mother both survived that birth, a shadow meaning behind Kahlo's painting may be a reference to a recently terminated pregnancy, one of several she had to end for medical reasons during the 1930s. Kahlo grieves, like the Madonna, for the child she has lost.

At other times in Mexican popular tradition, La Llorona merges with Dona Marina (La Malinche, c. 1500–1527), the mistress of Cortés. La Malinche, also known as Malintzin, is the mythic prototype of the merger of the Old and New Worlds.[12] Like Kahlo, La Malinche was a woman of two worlds, though in her case it

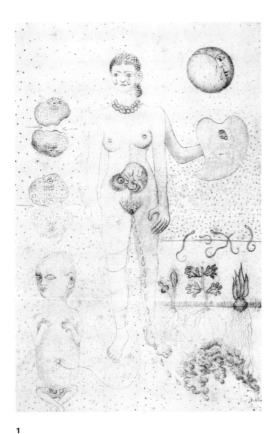

1

Frida Kahlo, *Frida and the Miscarriage*, 1932, lithograph, 31.8 x 23.5 cm. Collection of Museo Dolores Olmedo Patiño, Mexico City. Photo courtesy Mary-Anne Martin/Fine Art, New York.

was not by birth but by circumstance. A noble Nahuatl, La Malinche was sold into slavery by her family, then given (along with twenty other women) to Cortés upon his arrival in Mexico in 1519. She became his mistress, interpreter, and ambassador during his invasion of Mexico. While La Malinche can be seen on one hand as the betrayer of her people, she represents alternatively the mother of modern, culturally diverse Mexico. Her dual roles have given her an important place in the mind and mythology of Mexico. Another weeping woman, La Malinche's endless tears represent her repentance for the betrayal of her people or, more generally, the remembered pain of the Spanish conquest.

From an even older tradition, La Llorona has incorporated the Aztec deity Cihuacóatl, literally "serpent woman," who was also called Tonantzin, "our mother." As Charlotte McGowan writes, "Cihuacóatl, the Serpent Woman, has been absorbed into La Llorona and wails in the streets at night carrying a cradle with an obsidian knife in it; the cradle, the symbol of life and the obsidian knife, the symbol of sacrifice and death." Sometimes Cihuacóatl carries a child in her arms, an act that links this Serpent Woman with the magnificent Coatlicue (fig. 4), the

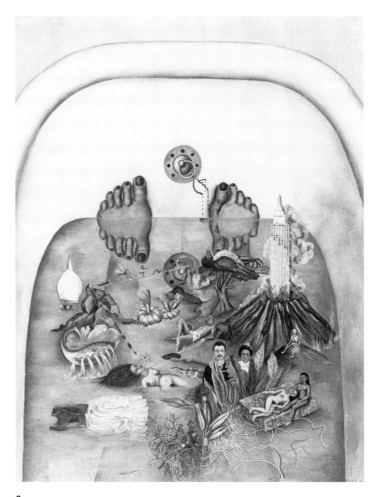

2
Frida Kahlo, *What the Water Gave Me*, 1938,
oil on canvas, 96.5 x 76.2 cm. Private collection. Photo
courtesy Juley Collection, Smithsonian Institution,
Washington, D.C.

Nationality, Region, Cultural Landscape

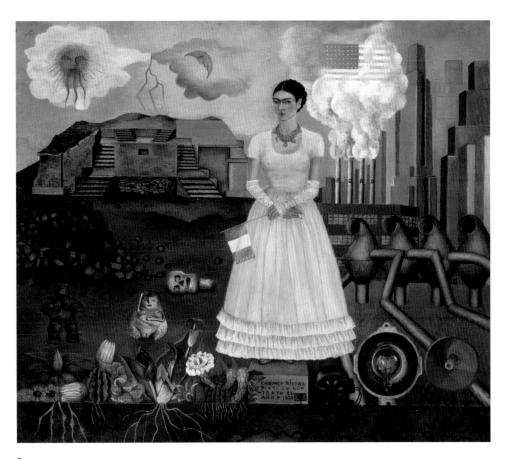

3

Self-Portrait on the Border Line Between Mexico and the United States, 1932, oil on metal, 31.7 x 34.9 cm. Private collection, New York. Photo courtesy Christie's Images.

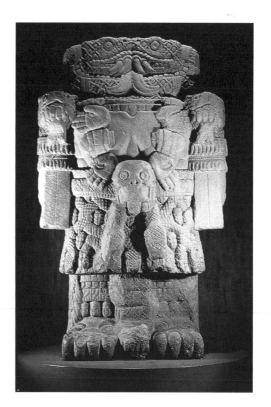

4
Coatlicue, late 15th century, basalt. Height approximately 2.4 m. Mexican National Museum of Anthropology, Mexico City. Reproduction authorized by National Institute of Anthropology and History (INAH).

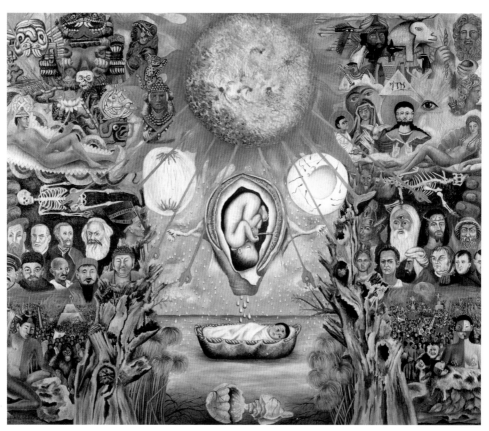

5
Frida Kahlo, *Moses*, 1945, oil on masonite, 50.8 x 93.98 cm. Private collection. Photo courtesy Mary-Anne Martin/Fine Art, New York.

extraordinary Aztec mother figure known as the Lady of the Serpent Skirt. In Kahlo's mind the formidable Coatlicue embodied the most powerful and meaningful aspects of the woman-earth nexus. "Mexico is alive!" she wrote. "Like Coatlicue, it contains life and death; like the magnificent land on which it is built, it hugs the earth with the strength of a live and ever-living plant." Kahlo included Coatlicue among the deities in her encyclopedic painting *Moses* (fig. 5) and described her then as "mother of all the gods."[13]

Of all Mexico's pre-Columbian deities, Coatlicue was probably the richest in associations and the most accessible to Kahlo. Her lure was ancient, chthonic, and majestic. As the historian Miguel Léon-Portilla writes, "Coatlicue emerges powerfully as the concrete embodiment in stone of the ideas of a supreme cosmic being who generates and sustains the universe."[14] Her "tragically beautiful" form was (and is) easily available to modern Mexicans, and Kahlo drew freely on its symbolic identity. In the goddess's best-known image, Coatlicue survives as a basalt statue, more than eight feet high and weighing some twelve tons, that was discovered in the 1790s on the site of ancient Tenochtitlan. It has long been a centerpiece of the National Museum of Anthropology in Mexico City, though it has traveled abroad as well. As early as the nineteenth century, visitors from the United States remarked on the formidable Coatlicue; and in 1940 when the Museum

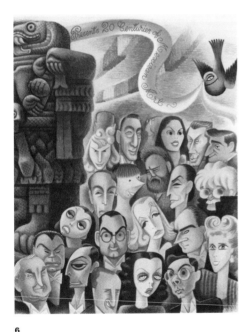

6
Miguel Covarrubias, *The Museum of Modern Art Presents Twenty Centuries of Mexican Art* (detail), illustration from *Vogue*, 15 June 1940, 41. Georgia O'Keeffe and Alfred Stieglitz are at the extreme right, second row from top. Photo courtesy Condé Nast Publications, Inc.

of Modern Art presented "Twenty Centuries of Mexican Art," Coatlicue was shipped in several pieces to New York, then reassembled for a starring role in the exhibition. Miguel Covarrubias, who covered the museum opening for *Vogue*, drew the goddess in the midst of a stellar crowd of politicians, literati, and artists, including Georgia O'Keeffe and Alfred Stieglitz (fig. 6). Frida Kahlo was not in that crowd, but she already knew the forms and details of the magnificent sculpture intimately.

Coatlicue is described as decapitated, though twin serpents emerge from the severed neck to form a new double head. Beneath it hangs a necklace of human hands and hearts over a skull breastplate. Writhing serpents make up her skirt, while her hands and feet are clawed. The

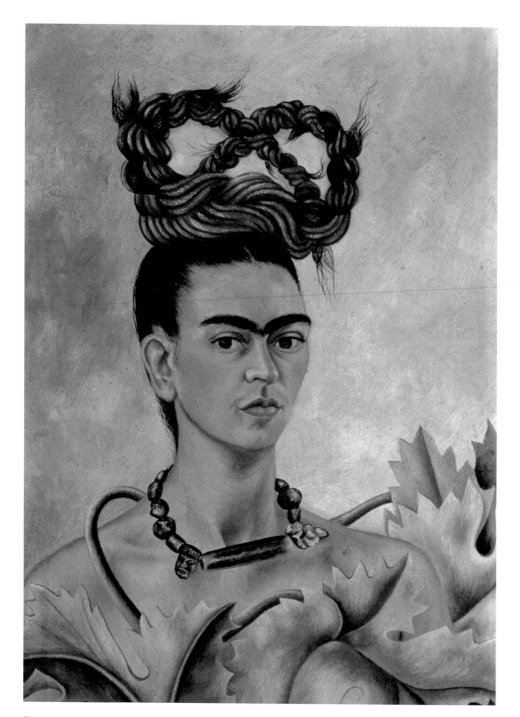

7

Frida Kahlo, *Self-Portrait with Braid*, 1941, oil on canvas, 51 x 38.5 cm. Jacques and Natasha Gelman Collection, Mexico City.

unforgettable image of Coatlicue has been described by George C. Vaillant as "bring[ing] into a dynamic concentrate the manifold horrors of the universe."[15]

Despite, or perhaps because of, her horrific aspect, Coatlicue provided a wealth of symbolic imagery for Kahlo. On at least one occasion Kahlo drew herself as decapitated, and she wore the goddess's skull necklace in self-portraits, notably in her 1941 *Self-Portrait with Braid* (fig. 7). In this, the wildest and most aggressive of Kahlo's painted selves, Coatlicue's necklace is her only accessory, dividing her head from her bared (a rarity) shoulders. Encircling the shoulders are sharply serrated leaves, perhaps an oblique reference to ancient Aztec vegetation rites in which a woman representing Coatlicue was flayed and decapitated as symbol of the rejuvenation of nature.[16] As if to mimic that rejuvenation, Kahlo has replaced the hair she had severed some months earlier in a defiant gesture of self-mutilation upon the break-up of her marriage to Rivera. The headdress of colored yarn entwined in her hair is called a *tlacoyal*—an Aztec legacy; in its agitated, escaping tendrils we are reminded as well of the fury of the classical Medusa, whose uncontrolled snake locks presented a threat to all who approached her. This is Frida at her most defiant— spiritual daughter of the fearsome Coatlicue and embodiment of nature's fierce power.

Still other ancient Mexican goddesses are implicit in the earth-nature iconography Kahlo constructed. Included among the ancient mother-goddess figures Paz and Kahlo knew well are those associated with water. Their attributes, activities, and symbolic value were vital to Kahlo's work. Chalchiutlicue, for example, was the Aztec goddess of terrestrial water, specifically rivers. Like Coatlicue, she is known from both ancient manuscripts and sculpted monuments, one of which stands in the Mexican National Museum of Anthropology (fig. 8). Chalchiutlicue's recumbent form, lying in the flowing river current, bodies forth a *nopal* (prickly pear) cactus, whose symbolic fruits, as we shall see later, were painted by Kahlo with great deliberation.

Chalchiutlicue, she of the jeweled skirt, plays an important role in the birthing and mothering process. From beneath her skirt flows the water that represents the breaking of waters preceding birth; in recognition

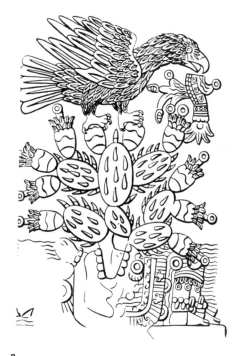

8
Unknown artist, drawing of an Aztec sculpture in the Mexican National Museum. *Below:* the river goddess Chalchiutlicue, from whose body grows a prickly pear laden with fruit (*tunas*) symbolizing the human heart.

of this role and of her concern with newborns, she is patron of the naming ceremony for the infant. The childless Kahlo, always obsessed with the reproductive process, knew water's ancient and modern lore; she spoke of it as the quintessential maternal source, that which gives birth to a baby.[17] At her home she kept human fetuses, provided by her physician and exhibited as her "children" in formaldehyde-filled bottles.

Kahlo's 1945 painting *Moses*, which included Coatlicue in the artist's catalogue of heroic and divine personages, also provides a significant vehicle for Kahlo's common themes of birth, death, and regeneration. At the time she painted it she had been reading Freud's *Moses and Monotheism*, extracting from that text a watery metaphor for birth. "I started painting the image of the infant Moses," she wrote, "Moses means 'he who was taken out of the waters' in Hebrew, and 'boy' in Egyptian. I painted him the way the legends describe him: abandoned inside a basket and floating down a river. From the artistic point of view, I tried to make the animal skin-covered basket look as much as possible like a uterus because, according to Freud, the basket is the exposed uterus and the water is the mother's water when she gives birth to a child."[18]

Finding (or inventing) links between pre-Columbian imagery, world myths, and psychoanalytic theory was becoming a recurrent challenge for Kahlo— a game of connections from which she seemed to derive pleasure and stimulation. She would have laughed to learn that her informal studies fell under the rubrics of structural anthropology. Her interest lay in setting afloat symbols to see where they might touch others, a game in which water proved a particularly fluid medium.

Throughout her career, in ways direct and indirect, Kahlo continued to use water as symbol and metaphor. We find an early example in letters to her young lover Alejandro Gómez Arias; instead of her name, she sometimes used a simple triangular water symbol as a signature.[19] Later, in her complexly layered self-portraits, Kahlo invoked water symbols to explore aspects of her identity. A 1940 painting combines a number of water references (fig. 9). As frequently happened in her self-portraits, Kahlo here fuses a mythologized self with a natural element, in this case the sea. Painted in the year following her brief divorce from Rivera, this work and others from the period hide emotional turmoil beneath the outwardly serene mask of her features. But the greenish-yellow of the background is a color Kahlo identified in her diary with "madness and mystery" and with the clothing worn by phantoms. Wrenched apart from Diego, Kahlo dwelt just then in a watery nether-realm to which the divorce had delivered her. Neither dead nor fully alive, the mythologized Kahlo merges oceanically with nature's hidden domain beneath the waters. She announces that residence most clearly in the embroidered rectangular symbol on her blouse: it is the Aztec glyph for water, associated with the rain god Tlaloc and with Chalchiutlicue. As she once wore Coatlicue's skull necklace, Kahlo now wears the necklace of a sea goddess. It is nearly identical to the pre-

Columbian jade necklace in her portrait with the braid, but in place of the skulls we now see four shells, mysterious, hermetic objects from the sea.

A dark net on Frida's head encloses her hair and falls behind her shoulders, resembling a mantilla but with darker references. Like a sinister black bridal veil, it symbolizes Kahlo's mourning for her dead marriage. But more even than that, the net metaphorically gathers a whole collection of sea symbols and sea meanings. Kahlo must have known, for example, of Matlachiuatl, an Aztec goddess known as "The Woman with the Net." A fearsome vampirelike creature, she carried a large net with which to capture her victims.[20] Was Kahlo angry enough at Rivera's infidelities to associate herself with Matlachiuatl?

But Kahlo's thoughts ran often on the sea and the legendary women associated with it. As early as 1927 she had written of "the sea, a symbol in my portrait,

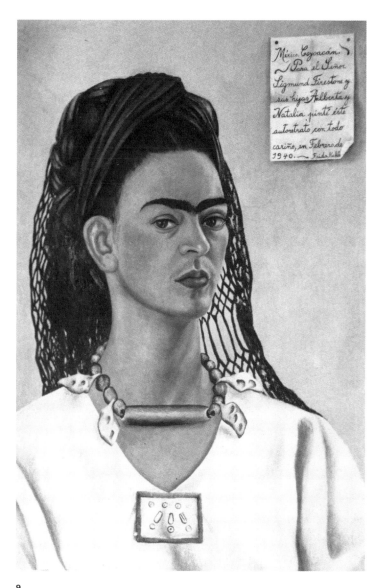

9
Frida Kahlo, *Self-Portrait*, 1940, oil on masonite,
61 x 43 cm. Private collection.

synthesizes my life." Her diary pages contain many references to Isis as well as to Queen Nefertiti, and it is clear that she identified with both. Of Nefertiti she wrote, "I imagine that besides having been extraordinarily beautiful, [Nefertiti] must have been 'a wild one' and a most intelligent collaborator [with] her husband." From the two celebrated Egyptians Kahlo invented a hybridized goddess-woman, "Neferisis," whom she described as "the beautiful" and "the immensely wise."[21]

The Egyptian goddess Isis, whose tears flooded the Nile, was grieving for her dead brother-consort Osiris, whose dismembered body she was searching for. Eventually, she found it and restored it to life; a process associated in Egypt with the annual flooding of the Nile and the renewal of the seasons. Isis's grief must have called up memories of Kahlo's own sorrows, rendered visible as tears on the cheeks in a number of her self-portraits. Historical representations of Isis have often shown

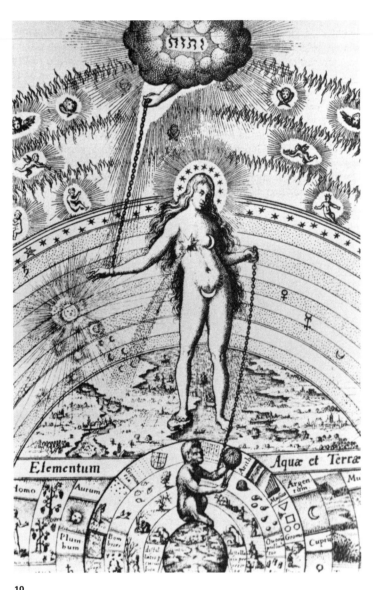

10

Integrae Naturae Speculum Artisque Imago (Mirror of All Nature and Symbol of Art), or *The Soul of the World*, from Robert Fludd, *Utriusque Cosmi Historia* (Oppenheim, 1617).

Nationality, Region, Cultural Landscape

her within or straddling water. Worshiped throughout the ancient Greco-Roman world in a various incarnations, Isis traveled in a stone moon-boat and, as in figure 10, is often shown with her foot on or near a miniature boat. In a highly revealing connection, Kahlo adopted the identical motif in *Memory* (fig. 11), where a small boat supports her own foot. The tears on Kahlo's cheeks in *Memory* are probably, as Hayden Herrera suggests, a legacy of the artist's devastation at her sister Cristina's affair with Rivera.[22]

But the story of Isis, and Kahlo's interest in it, did not end there. Even casual reading would have told her that Isis, whose moon-cult attained great popularity throughout the ancient Mediterranean world, had become linked with other goddesses in various parts of the world: Venus, Minerva, Ceres, and Diana. And when joined with her brother/consort Osiris, their respective correspondences to moon and sun

11
Frida Kahlo, *Memory*, 1937, oil on canvas,
40 x 28 cm. Private collection. Photo courtesy
Mary-Anne Martin/Fine Art, New York.

came to stand for embodiments of the polarities—positive and negative forces—of the universe.[23] Kahlo, already interested in the Aztec dualities derived from nature and legend, would have appreciated these aspects of the story. Isis, the "Oldest of the Old," the "Goddess from whom all becoming arose," blended the attributes of creator and nurturer, of Nature herself.[24] Wheat often adorns her head, a reminder that she was regarded as the discover of grain and its cultivation. In Kahlo's *Self-Portrait with Monkey and Parrot* (1942; private collection), a thick, insistent screen of grain behind the artist's head invites an association with this aspect of Isis. And what about the double snake heads featured in Isis's headdress in Athanasius Kircher's print (fig. 12)? The caption (letters BB) tells us that the snakes represent the moon's generative power and its sinuous path, but they are an uncanny reminder as well of the twin serpent heads atop Coatlicue's severed neck—yet another symbolic link that would have intensified Kahlo's interest in Isis.

Goddess lore records that Isis, who cradled the moon between the horns of her headdress, was the embodiment of the Egyptian throne. On her lap sat her son Horus or one of the pharaohs, protected by her arms or wings. And from her body poured out the divine essence (blood or milk) that kept the gods and all other creatures alive.[25] In Rome early Christianity failed to eradicate Isis worship; instead, veneration for her merged gradually with that of the Virgin Mary. Isis as mother-protector passed indirectly into Christianity as the Madonna, who likewise became the "throne" of medieval Christianity. Attributes of Isis, including her starry crown and crescent moon, survive as well in Mexico's patron Madonna, the Virgin of Guadalupe.

Kahlo, whose rebellion against Christianity and study of ancient mythologies had acquainted her with a broad range of imagery, relished the survival of "pagan" heresies within Christian orthodoxy. And as a knowledgeable enthusiast of Meso-american culture, she saw several levels of meaning in the legend of Isis. She would have recognized striking parallels between Aztec legend and the Isis-Osiris story, parallels which perhaps accounted for her use of Egyptian deities in the first place. The similarities are obvious: Coyolxauhqui, the Aztec moon goddess, daughter

12

Isis, from Athansius Kircher, *Oedipus Aegyptiacus* (Rome, 1652).

of Coatlicue and sister of the war god Huitzilopochtli, fought her brother for control. Brother killed sister, cutting her body into fourteen pieces. In spite of her dismemberment, however, Coyolxauhqui continued to exert great power. Though the victims are reversed, the Egyptian and Aztec goddesses were both associated with the moon, with a close sibling relationship, and with dismemberment. Kahlo could not have missed those similarities. Nor would she have failed to link her own history to theirs in her perpetual self-mythologizing. Bodily fragmentation in particular would have spoken to Kahlo; as a result of lingering effects from injuries, her own body was being dismembered surgically, in stages. Several toes were removed, and eventually her gangrenous right leg was amputated below the knee. She felt that her body was disintegrating over time, as her letters and diary entries show: one of the images is captioned "Yo soy la DESINTEGRACIÓN" (fig. 13).

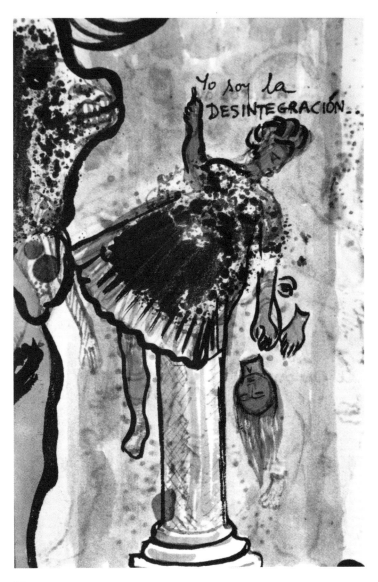

13
Frida Kahlo, "Yo soy la DESINTEGRACIÓN,"
1953, diary page. Collection of the Museo Frida Kahlo,
Mexico City.

Adding to the specter of physical fragmentation that confronted Kahlo, were images painted by her husband of human dismemberment that seem to include portraits of Kahlo herself as the dark moon goddess; in Rivera's mural *Great City of Tenochtitlan* (1945; Palacio Nacional, Mexico City), a tattooed Aztec woman with Kahlo's features stands next to a severed human arm. Her skull necklace reminds us that Coyolxauhqui, like her mother Coatlicue, represents the proximity of life and death in Aztec myth. In a final, circular tribute to the paradoxical Mexican symbols of death and rebirth, Kahlo's ashes were placed after cremation back into a female body—a clay jar, headless like Coatlicue, in the rounded shape of a pre-Columbian goddess.

Kahlo drew upon ancient human archetypes as well as mythic figures for her female models. From de Sahagún's *Historia General de las Cosas de Nueva España* (also known as the *Florentine Codex*), an illustrated, encyclopedic account of Nahuatl culture based on the work of sixteenth-century missionary friars, Kahlo gathered extensive information on the natural history of the Nahuas. But it also included an account of the people: their social class, occupations, virtues, and vices. Particularly fascinating are the descriptions disreputable characters, especially, in chapter 15, the catalogue of dangerous women, including the harlot, the carnal woman, the scandalous woman, and the hermaphrodite. Reading through these pages, we can easily imagine their appeal to the rebellious, hoydenish young Kahlo. The harlot, for example,

makes herself beautiful; she arrays herself; she is haughty. She appears like a flower, looks gaudy, arrays herself gaudily; she views herself in a mirror—carries a mirror in her hand. She bathes . . . she washes herself . . . [she] acts like a sacrificial victim; she

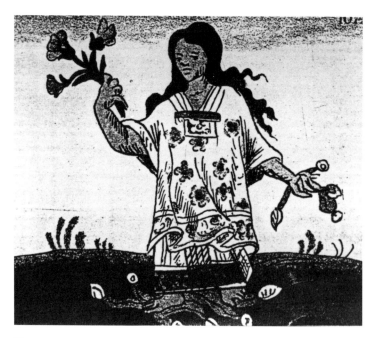

14

The Harlot, from Fray Bernardino de Sahagún, *Codex Florentine*, c. 1575–80. Note the disheveled hair, gaudy clothing, and water symbol underfoot.

Nationality, Region, Cultural Landscape

goes about with her head high—rude, drunk, shameless—eating [hallucinogenic]
mushrooms. . . . She paints her face. . . . Her face is covered with rouge. Half of her hair
falls loose. . . . She goes about constantly merry, ever on the move, wandering here
and there, never coming to repose, unquiet, restless, flighty. . . . She lives on the water.[26]

The scandalous woman, according to the codex, is an "aborter" who commits adultery, while the hermaphrodite "takes female companions" and goes about like a man, "bearded," with "fine body hair."

The Kahlo who reveled in nonconformity and disobedience to societal norms might have taken the catalogue of vices as something of a model for her outrageous behavior. In fact, so much of this description corresponds to the deliberately scandalous aspects of Kahlo's life that one wants to see her in these passages. The three illustrations that accompany the misogynist description in the *Florentine Codex* of the harlot show different aspects of these women (fig. 14). "Gaudily attired," with loose hair, standing on the Nahuatl pictorial symbol for water (not to be confused with the glyph), the harlot contains many features of the type of woman the Kahlo aspired to be: outspoken, radical, sexually liberated. When, much later, Kahlo painted *Self-Portrait with Loose Hair* (fig. 15), she may have been recalling or reconnecting with that formidable prototype.

Kahlo's associations of women with water, as we have seen, range from ancient, specifically Aztec sources to her own life. For Kahlo, women and water, like women and the moon, have intertwined identities. Water is the rich, generative medium in which Kahlo's artistic ideas were often spawned and grew; in a 1937 photograph (fig. 16) she leans over flowing water, dreamily watching the current wash over her hand. A year later she summarized her associations with water in her most surrealist painting, *What the Water Gave Me* (see fig. 2). Grotesquely playful, it encodes, in nightmarish microcosm, elements of Kahlo's life in her mythic-folkloric iconography.[27]

Bathing, we recall, is an activity associated with the harlot in the *Florentine Codex*. It also represented a sensual interlude to Kahlo, who once told a friend that her view of life was "Make love, take a bath, make love again."[28] Bathing invites dreaming and slow, floating juxtapositions of oddly discordant images. The Mediterranean water goddess Melusine, a mermaid, would spend the day reclining in her bath. Though hounded from her castle at the advent of Christianity, legend holds that Melusine returns nightly, like the moon, to suckle her children or (in an alternative death-goddess form) appears wailing over the town ramparts. Modern Mexican mermaid masks and tails, still used in rural areas, testify to the presence of variants of these water goddesses, paralleling modern New Year's offerings to the mermaid goddess Yemanja in Brazil. And Kahlo's inclusions of fish-tailed women in her diary pages and on a letter box labeled "La Sirena" are yet more evidence of her interest in the linkage of mythical women and water.[29]

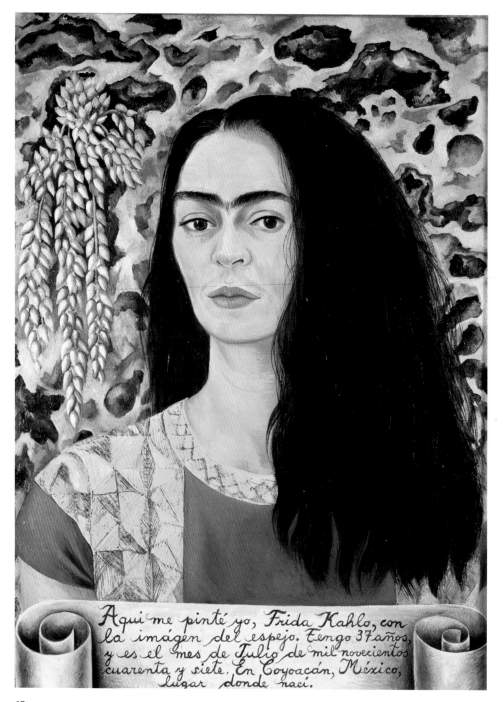

Aqui me pinté yo, Frida Kahlo, con
la imágen del espejo. Tengo 37 años,
y es el mes de Julio de mil novecientos
cuarenta y siete. En Coyoacán, México,
lugar donde nací.

15
Frida Kahlo, *Self-Portrait with Loose Hair*, 1947, oil
on masonite, 61 x 45 cm. Photo courtesy Salomon
Grimberg and Mary-Anne Martin/Fine Art, New York.

In the sea of her imagination—as vast as the world's oceans, as small as her bathtub—Kahlo floated the characters of folklore and legend alongside individuals from her own life. *What the Water Gave Me* contains both. Its human occupants, mythic and real, living and dead, include her parents, a tiny skeleton that probably represents La Huesera, a nude Frida being strangled by a rope (her Tehuana dress floating nearby), a reclining male figure wearing a pre-Columbian mask, and a pair of nude women, one fair-skinned and one dark. Primordial energy, as symbolized in the fiery volcano, erupts from below the land and beneath the waters. As usual, Kahlo is playing with dualities, collapsing differences of time and space, reality and dream. The tiny ship under sail in Kahlo's bathtub, possibly a reference to Isis, probably also recalls Cortés, who burned his ships when he landed in Mexico, thus ending one era and forcing the violent redefinition of all things Mexican.

We have seen in Kahlo's self-portraits a range of female characteristics and types that emerge, as Paz wrote, from the confluence of many sources. Their numbers and their insistent mythic and folkloric references argue that Kahlo employed them to work out aspects of her own complex, changing identity. Distinguishing features of individual deities sometimes emerge clearly, only to recede in other contexts into a generalized spirit world. But that is the telling and, for Kahlo, vital difference between Mexico's ancient gods and those of the Mediterranean world. As the scholar Richard Townsend writes, "There is a rainbow-like quality to these supposed gods of Mesoamerica; the closer one searches for a personal identity so vividly displayed by the anthropomorphic deities of the Mediterranean world, the more evanescent and immaterial they become, dissolved in mists of allusion and allegory with which Mexican poets and sculptors expressed their sense of the miraculous in the world about them."[30]

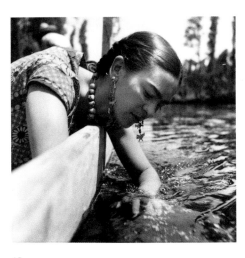

16
Fritz Henle, *Frida Kahlo in Xochimilco*, photograph, 1937. Photo courtesy Fritz Henle Estate.

It is clear that although Kahlo assembled her mythic references with great care and calculation, it was essential that their identities be fluid enough for her to adapt them to her own devices. Their variety, interplay, and allegorical richness enabled Kahlo to explore the depths of a wide range of selves within the context of her Mexican nationality, expressing her own sense of the miraculous in the world around her. Continually looking for past modes of experience from which to make metaphors for her own,

she used the past as vehicle for the present, repeatedly moving forward, turning to reclaim the past, then going forward again. Conflating women and nature, Kahlo engendered the Mexican earth through self-revelatory paintings of great poignancy and truth.

Emily Carr and Canadian Nationalism

If Frida Kahlo identified closely with the Mexican past and the Mexican earth, Emily Carr's nationalism was grounded in Canada's history, geography, and people. At rare but significant moments the two artistic traditions invaded each other's territory. Mexican art, as we have seen, burst upon the New York scene in 1940 with "Twenty Centuries of Mexican Art"; three years later Canadians flocked to an exhibition called "The Latin American Collection of the Museum of Modern Art" (1943; Art Gallery of Toronto), where they could see for themselves how indigenous art had helped define Mexico's national identity. Influential critics urged Canadians to follow the cultural leadership of Mexico in redefining the art of the Americas: "South of the Rio Grande there has always existed what was denied to us: a native tradition of tremendous strength and immemorial antiquity. The key to the astonishing vitality of Mexican art is to be found ultimately in the 'indomitable Aztec seeping through—steady as the beating of a drum, as the throbbing of a heart.'"[31]

Whereas Kahlo's nationalism embraced pre-Cortésian cultures to emphasize the non-European aspects of her divided self, Carr's life and work tested the balance between European and North American—specifically Canadian—culture. The culture of mid-nineteenth-century Victoria, British Columbia, where Carr grew up, was overwhelmingly British. Founded as a trading post in 1842, it became a crown colony, then joined the Dominion in 1871, the year of Carr's birth, although it was still something of a rough outpost. Nonetheless, Victorians fancied themselves an enclave of European civility in a harsh, raw land; the city, as one of Carr's biographers wrote, was "full of the scent of New World possibility . . . but thoroughly steeped in Old World culture and values."[32]

Carr's family was conservative by almost any measure, political, religious, or aesthetical. And Carr absorbed some of that conservatism: though her behavior frequently smacked of personal anarchism, politically she remained a lifelong monarchist; she was, for example, deeply troubled by the abdication of Edward VIII. It was When she first left Canada in 1890 for art school in San Francisco, however, that she realized just how English her upbringing had been: "I was not English but I was nearer English than any of the others. I had English ways, English speech, from my English parents[,] though I was born and bred Canadian."[33] It was probably as early as that San Francisco sojourn that Carr felt the need to differentiate her English childhood from her intended Canadian adulthood.

Canada did not experience the turmoil of Mexico's decades-long revolution, which left a legacy of social and artistic volatility, and led in the early part of the

twentieth century to questions of nationalism and national self-identification that mirrored the speech and thought of the art world. "It was possible," wrote the cultural historians Laura Mulvey and Peter Wollen, "for political and artistic avant-gardes to overlap in Mexico in a way that they never could in Europe."[34] Or in Canada, where culture in most places grew out of a legacy of nineteenth-century Christianity, which placed God, nature, family, and nation on a grand continuum. In Canada stability was the order of the day; change was suspect in almost every avenue of life.

Nonetheless, in Canada as in Mexico and the United States, artists began searching for ways of creating a national experience through the arts. In Mexico the separation from the colonial past had been followed by the attempted recovery of the mythic one. Canadians recognized no such ancient past for recovery; instead, they saw themselves as developing from their slow separation from England and France. Canada's confederation as a nation took place in 1867; the transcontinental rail line joined West and East in 1887. The vast tracts of Canada's uninhabited wilderness had been named but by no means tamed. Possessing the planet's second-largest land mass, Canada had a population in 1920 that was only one-tenth that of the United States.

Still, change came, inevitably and irrevocably. In 1927 the Statute of Westminster was passed, increasing Canadian independence from Britain. Turning their attention away from Europe, Canadians strove to emulate the United States, with its expanding industrial base. But at the same time, they wished to distinguish themselves, to achieve a national idiom apart from those of England and the United States. They therefore called upon their visual artists to express what was new, North American, and, more specifically, Canadian in their art.

Until the second decade of the twentieth century most Canadian painting, centered in Toronto, derived from European styles, especially impressionism and the older Barbizon and Hague schools. Then in 1913—the year the Armory Show brought modernism to New York—two Canadians visited another pivotal exhibition in the United States. Lawren Harris and J. E. H. MacDonald traveled to Buffalo for the "Exhibition of Contemporary Scandinavian Art,"a show that was much less controversial critically but much more explosive personally for artists in search of a national aesthetic. There they saw paintings from regions of northern Europe whose topography corresponded strikingly to the rugged landscape of Canada. It was an art imbued with the symbolist taste for broad, bold patterning, but with pronounced landscape emphasis—enough, in fact, to provide the Canadians with a model for depicting both the spiritual and the physical essence of their own vast lakes, forests, and skies. The two artists were thunderstruck; as MacDonald remarked, "Except in minor points, the pictures might all have been Canadian, and we felt 'This is what we want to do with Canada.'"[35] Through Harris and MacDonald, the effects of the Scandinavian paintings were transmitted to

their colleagues in Toronto. With individual variations, they all began to develop an increasingly monumentalized landscape mode in which wilderness subjects suggested deeper meanings embedded in Canadian nature.

By 1920 these artists had coalesced into the Group of Seven—painters with common ideological goals committed to an art that would express their national identity.[36] In the catalogue of their first exhibition they declared themselves "imbued with the idea that an Art must grow and flower in the land before the country will be a real home for its people." During the next decade the Group held seven more shows and were widely hailed as founders of a new aesthetic based on an authentic Canadian national experience. As a leading Canadian critic wrote in 1926, "The modern European schools have been largely influenced by Cézanne. The modern Canadian so-called school [the Group of Seven] was inspired as the result of a direct contact with Nature herself."[37]

Canadian national identity, defined visually by the Group of Seven, has long been allied to the land, to nature, and especially to ideas about wilderness. The Group's breadth of artistic feeling and militant nationalism impressed Carr deeply, but with the exception of Lawren Harris (whose influence will be considered in another context), their individual styles were of lesser importance to her. Her own painting grew out of her student exposure to postimpressionism in Europe, drawing significantly on her personal sense of nature and on her encounters with native traditions. For Carr a vital part of the Canadian experience was the lore and art of Canada's First Nations peoples.

In Canada, Mexico, and the United States, indigenous populations seemed to offer an authentic attachment to place in contrast to the more tenuous (or at least less definable) connections of immigrant populations. By eliminating what was seen as imported or appropriated from European culture, artists hoped to identify a purer, more authentic national essence. In Mexico, Indian peoples had been rejoined to the national history by the revolution. Zapata's land reforms were seen as part of a rediscovered political history: modern land redistribution was construed as analogous to pre-Cortésian land use.

No such prospect had yet appeared for the Indians of British Columbia in Emily Carr's day. Encroaching European American civilization had eroded the lifeways of the coastal natives: their villages were becoming deserted (at least seasonally), their art disappearing. As a young artist, Carr developed an early interest in British Columbia's native people and their traditions. "These things," she wrote, "should be to us Canadians what the ancient Briton's relics are to the English." As her biographers have pointed out, Carr's affinity for indigenous peoples was apparent even in the early, documentary phase of her work. Beginning in 1899 she took repeated trips to the remote villages north of Victoria and Vancouver, and between 1907 and 1913 she made some two hundred paintings and sketches of native villages and totem poles, culminating in a monumental exhibition at Dominion Hall

staged at her own expense. She was photographed on one of these trips, probably at Tanoo, Queen Charlotte Islands, in 1912 (fig. 17). By that time Carr was well advanced in her plan to, as she said, "picture totem poles in their own village settings, as complete a collection as I could." She feared their irretrievable loss, lamenting in 1913 that in "only a few more years [the poles] will be gone forever into silent nothingness." [38] That year she asked the provincial government to purchase her paintings as a record of the fast-disappearing poles and to finance the remainder of her documentation project. The government declined to do so, a numbing disappointment for her altruistic efforts and her career aspirations as well. This failure was so painful that she never mentioned the Dominion Hall exhibition in her autobiographical writings. The experience led, at least in part, to the subsequent years of bitterness she harbored as a "rejected artist."

Carr scholars note that her interest in native people and subjects is freighted with the lingering romanticism of her day, elegiac attitudes which tended to view indigenous people as exotic "others" who could only be preserved by the intervention of benevolent, paternalistic whites. In her historical consciousness she certainly internalized something of a salvage mentality: she was what James Clifford has described as an ethnographic modernist, searching "for the universal in the local, the whole in the part." [39]

Those are cultural attitudes, held collectively. And they were so pervasive in her time and place that Carr could scarcely escape them. It is against those attitudes, not against those of our own era, that we must judge her efforts, remembering as well that she had no real exposure to contemporary politics. Still, by any stan-

17
Unknown photographer, Emily Carr at Tanoo,
Queen Charlotte Islands, 1912. British Columbia
Archives, Victoria, F07756.

dard, Carr's responses to native cultures were sensitive and complex, often transcending the widespread ethnocentrism of her day. When she went to France for further art study in 1910, Carr took some of her documentary native-subject watercolors with her. There she showed them to her Fauve-circle teacher William "Harry" Phelan Gibb, who praised them: "He was as convinced as I," Carr remembered, "that the 'New Art' was going to help my work out west, show me a bigger way of approach."[40] After that, and especially when she resumed painting in British Columbia, the native subjects became even more intertwined with her own developing stylistic proclivities. We can detect in her work both modernist and antimodernist sympathies, visible when we compare two paintings based on native subjects: one made not long after her 1910–11 stay in France, the second painted in 1928, after she returned to native subjects following a long hiatus. The earlier work, *Kispiox Village* (fig. 18), shows the clear influences of postimpressionism absorbed from her recent French experience. *Kitwangar Pole* (fig. 19) is a much more strongly formalized painting, dense with weight and solidity, enlarged in scale to build upon the plastic power of the Tsimshian carver's art.

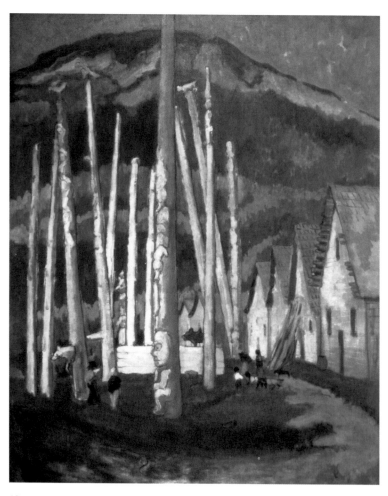

18
Emily Carr, *Kispiox Village*, 1912, oil on canvas,
British Columbia Archives PDP00634.

By 1929 Carr was convinced that similar creative principles underpinned both European Canadian and native art. Rather than relegating native art to the past, she looked for and found in it certain abstract design qualities compatible with the postcubist style she was herself exploring. She insisted in a 1930 address that "the oldest art of our West, the art of the Indians, is in spirit very modern, full of liveliness and vitality."[41] Given the conservative nature of British Columbian art audiences, many people preferred Carr's early, more representational Indian subjects. Among other critics, however, those early works were long seen as illustration, while her later, post-1928 paintings were regarded as more accomplished inquiries into the inner meanings of forms.

An important aspect of Carr's artistic and personal relationship with native peoples relied on her own "outsider" status. For Carr, to be an artist was to be "different"—marginalized from society in ways akin (at least in her mind) to the cultural isolation of indigenous peoples. Out of that similarity, as well as her genuine sympathy and respect for them as individuals, grew several warm friendships in the native communities.[42] The broader implications of Carr's self-defined "difference"

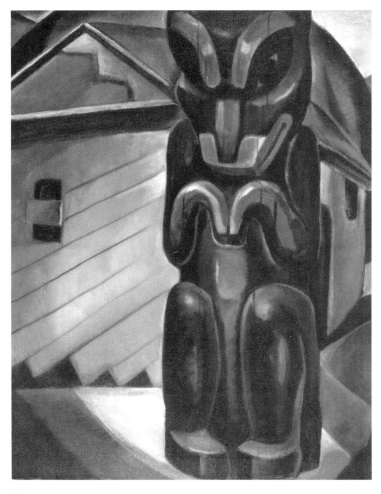

19
Emily Carr, *Kitwangar Pole*, 1928, oil on canvas,
64.8 x 57.2 cm. British Columbia Archives PDP00585.

will be studied in other contexts. For now, I focus on Carr's identification, via gender, to native peoples and to a gendered Canadian nature. Those issues run parallel to the ones discussed above, in Kahlo's work.

On several of her trips to native villages Carr encountered a fearsome supernatural being whose image appeared on totem poles, the ogre goddess D'Sonoqua. Particularly among the Kwakiutl (Kwakwaka'wakw), but in related form among the Tsimshian and Haida, D'Sonoqua (whose name is also recorded as Dzonokwa, Tsonoqua, Dzunukwa) plays a powerful mythic role in First Nations culture.

Structural anthropologist Claude Lévi-Strauss made an extensive study of this wild woman of the woods. In his book *Way of the Masks*, he describes her:

Generally speaking, the term Dzonokwa designates a class of supernatural beings, most often female, but endowed with breasts no matter what their sex. . . . The Dzonokwas dwell far inside the woods; they are savage giantesses, also ogresses, who kidnap the Indians' children to eat them. Yet, the relations they maintain with humans are ambiguous, sometimes hostile, sometimes imbued with a certain complicity. Kwakiutl sculpture favors representations of Dzonokwa; many of its masks are known, being easily recognized by their distinctive traits.[43]

Those traits include hollow eye sockets, pierced in the bottom or half-closed against glare, and concave cheeks and other body parts. Many are decorated with black tufts of hair, beard, and mustache—features which further confuse their sexual identity. For use in potlatch feasts, the Kwakiutl enlarged the masks to become composite serving bowls of up to nine feet long (fig. 20). The wild woman reclines, her body cavity a massive receptacle within which two elongated bowls, each ending in a face, form her breasts. The hair-trimmed face mask, when removed, reveals yet another bowl beneath. In this prone position, her body assuming something of the earth's own scale, D'Sonoqua as earth mother (or earth monster) is even more explicitly—and wittily—spelled out.

20
Kwakiutl wooden bowl representing D'Sonoqua
as composite serving dishes; from British Columbia.
Photo courtesy Department of Library Services,
American Museum of Natural History, Neg. 338015.

When Carr encountered D'Sonoqua on her back-country explorations in 1912, she was awed by the power and the wild untouchability of the forest woman. In her story "D'Sonoqua" (published in her first book, *Klee Wyck*, 1941), Carr described a figure whose details correspond closely to her watercolor rendering of the ogre, as well as to Edward S. Curtis's photograph of what must be the same sculpture (figs. 21 and 22). In her story Carr told of scrambling out of a nettle bed to gaze up at the fearsome female giant:

Her head and trunk were carved out of, or rather into, the bole of a great red cedar. She seemed to be part of the tree itself, as if she had grown there at its heart, and the carver had only chipped away the outer wood so that you could see her. Her arms were spliced and socketed to the trunk, and were flung wide in a circling compelling movement. Her breasts were two eagle-heads, fiercely carved. That much, and the column of her great neck, and her strong chin, I had seen when I slithered to the ground beneath her. Now I saw her face.

The eyes were two rounds of black, set in wider rounds of white, and placed in deep sockets under wide, black eyebrows. Their fixed stare bored into me as if the very life of the old cedar looked out, and it seemed that the voice of the tree itself might

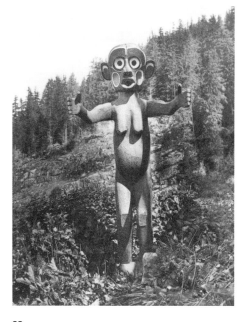

21
Emily Carr, *D'Sonoqua*, 1912, watercolor.
British Columbia Archives, PDP00933.

22
Edward S. Curtis, *Dzonokwa with Outstretched Arms*,
c. 1910–15, from Curtis, *The North American Indian*
(1910–16), vol. 10. Special Collections Division,
University of Washington Libraries, Neg. NA0410.

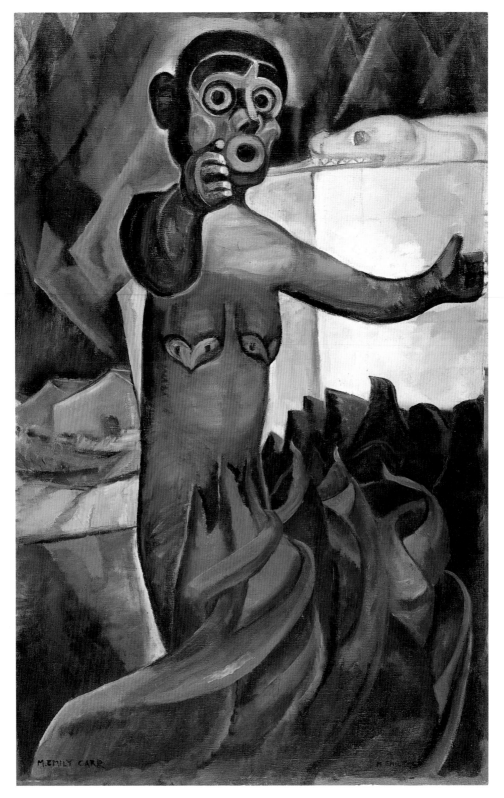

23
Emily Carr, *Guyasdoms d'Sonoqua*, 1928–30,
oil on canvas, 100.3 x 65.4 cm. Art Gallery of Ontario,
Gift of the Albert H. Robson Memorial Subscription
Fund, 1942.

have burst from that great round cavity, with projecting lips, that was her mouth. Her ears were round, and stuck out to catch all sounds. The salt air had not dimmed the heavy red of her trunk and arms and thighs. Her hands were black, with blunt finger-tips painted a dazzling white. I stood looking at her for a long, long time.[44]

Carr never went back to the village, but she painted its D'Sonoqua and several others between 1929 and 1931 (fig. 23). A related figure is her *Zunoqua of the Cat Village* (fig. 24), which Carr scholar Doris Shadbolt believes may actually represent a different mythic forest woman. Carr notes this figure's difference from the *Guyasdoms' D'Sonoqua*: "She appeared to be neither wooden nor stationary, but a singing spirit, young and fresh, passing through the jungle. No violence coarsened her; no power domineered to wither her. She was graciously feminine. Across her forehead

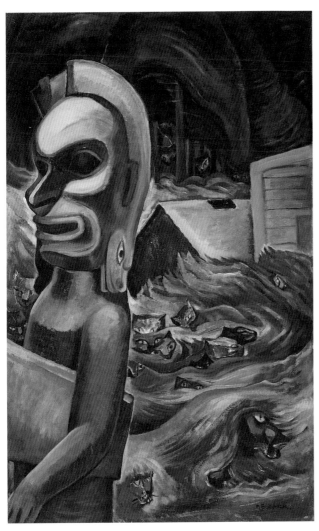

24
Emily Carr, *Zunoqua of the Cat Village*, 1931, oil on canvas, 112.5 x 70.5 cm. Vancouver Art Gallery, Emily Carr Trust, VAG 42.3.21. Photo by Trevor Mills.

her creator had fashioned the Sistheutl, or mythical two-headed sea-serpent. One of its heads fell to either shoulder, hiding the stuck-out ears, and framing her face from a central parting on her forehead which seemed to increase its womanliness." Striking is the Sistheutl—the double serpents on the figure's head—a strange reminder of the double serpent-headed Mexican earth goddess Coatlicue. Like Coatlicue, D'Sonoqua is essentially a terrestrial being, though Lévi-Strauss notes that there is also a D'Sonoqua of the sea; on land she may dwell in a very deep lake at the top of a mountain in company with sea lions and otters.[45] Such associations with water are reminiscent of Kahlo's sea goddesses and multiple water references.

Familiar too (based on similarities to Mexico's female supernaturals) are D'Sonoqua's capture of children, her monumental size, her decapitation in some ver-

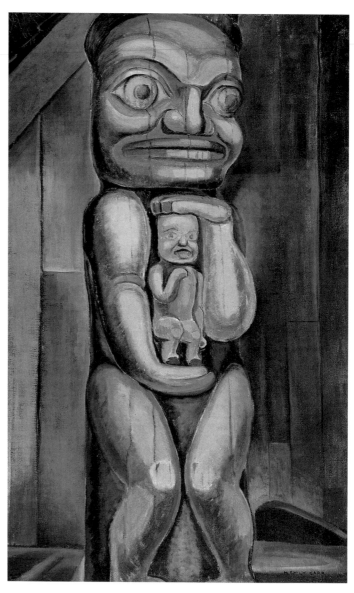

25

Emily Carr, *Totem Mother, Kitwancool*, 1928,
oil on canvas, 109.2 x 69.3 cm. Vancouver Art Gallery,
Emily Carr Trust, VAG 42.3.20. Photo by Trevor Mills.

sions of the myth, and her night wailing (like La Llorona, the weeping woman). In fact, Marius Barbeau, a respected Canadian anthropologist whom Carr came to know, wrote of a "weeping woman" in Tsimshian culture, likely a variant of D'Sonoqua. She was depicted on a totem pole at Tanu on which Weeping Woman clutches her dead child to her breast. And Lévi-Strauss concludes that such myths may be ultimately linked on a North-South axis: "Supernatural beings equipped with a weepy baby or one that must be made to weep, or beings who themselves cry like small children, are very common in the Americas, and it can be assumed that they constitute a quite archaic theme since they have spread throughout the Western Hemisphere." [46]

Carr herself encountered such benign or grieving mother figures in the British Columbian forest, as pictured in her *Totem Mother, Kitwancool* (fig. 25). Of this monumental mother Carr wrote: "The sun enriched the old poles grandly. They were carved elaborately and with great sincerity. Several times the figure of a woman that held a child was represented. The babies had faces like wise little old men. The mothers expressed all womanhood—the big wooden hands holding the child were so full of tenderness they had to be distorted enormously in order to contain it all. Womanhood was strong in Kitwancool." [47]

In what she called "wild places" Carr found mythic females who conveyed both the mysteries of Canadian nature and the connectedness of humanity to it. Native totemic images provided her with usable prototypes for female imagery of great tenderness and great power. More, they enabled her to examine the presence of the feminine in her own spirituality. "Of course I do not believe in supernatural beings," she wrote. "Still—who understands the mysteries behind the forest? Half of me wished that I could meet her [D'Sonoqua], and half of me hoped I would not." [48]

As in Mexico, British Columbia's coastal Indians lived with daily proximity to life and death. To Carr, whose writings as well as paintings were inspired by their lore, the natives lived close to a seam where art, mythic nationalism, and folklore were joined. Canadian poet John Newlove captures the European American's desire to probe these mysterious confluences:

> *These*
> *paranoid peoples, these coastal Salish,*
> *Kwakiutl, Nootka, Tsimshian, Haida,*
> *what do I have to apologize to them for?—*
> *their fears, legends of malicious tricks,*
> *colors and maskings, knowledge of*
> *the wild woman of the woods wearing*
> *a hummingbird in her hair, deaths,*
> *are mine.* [49]

Like Kahlo, Carr discovered that out of the bodies and stories of ancient, mythic women, artists could resurrect meaningful connections to a non-European past. But there is more to Carr's compelling interest in D'Sonoqua. The wild, forbidding earth goddess whose story terrified generations of native children—what was it in her that seized Carr's imagination? Her own written narrative of the ogre reveals an ambivalence, a recognition of D'Sonoqua's chthonic power, her oneness with the massive red cedar, but also the dark side of this fierce, forbidding presence, as monstrous as she was monumental.

There are obvious parallels, as suggested above, between Frida Kahlo's fascination with Coatlicue and Carr's with D'Sonoqua. Though Kahlo seldom painted Coatlicue's image—only in *Moses* does she appear in her complete form—the artist often appropriated her attributes: skulls, necklaces, and associations with life, death, and the earth. Even, or especially, when her image was fragmented, Coatlicue came to represent the tragic multivalence of Mexico to Kahlo. She also symbolized the living paradox of synthesis and fragmentation the artist experienced within her own body. Carr, on the other hand, painted D'Sonoqua whole, rising up from the surging undergrowth of the forest floor; the wild places Carr haunted were made more forbidding by D'Sonoqua's presence.

Part of Carr's lasting fascination with D'Sonoqua is, without doubt, the ogre's role bridging nature and history. By siting her mythic power within nature, brooding in the shadows, Carr unknowingly captured what the critic Roland Barthes would later call the modern function of myth. "Myth today," wrote Barthes, "turns reality inside out, empties it of history and fills it with nature."[50] This is precisely what Carr does; she paints the mythic aspect, negating history (the specifics of which are, in any case, unknowable for each sculpture), and allows nature to flow around and into the void.

Not surprisingly, Mexicans regarded Coatlicue very differently from the way Canadians viewed D'Sonoqua. Coatlicue's historical context was less associated with specific places than with her activity. Modern Mexican identity, based on the recovery of memory, relied on the channeling of Aztec sources, along with more recent Indian ones, into its core. The Aztec goddess became emblematic of that *recovery* of ancient sources: her stone image bodied forth the past into the present. For Kahlo, immersed by training and inclination in Mexico's past, Coatlicue was enshrined in a collective as well as a personal mythology.

To Canadians, on the other hand, D'Sonoqua signified the alien, the monstrous, the exotic within its borders. As D'Sonoqua masks were collected and placed in museums around the world, they represented what was outside modern Canadian (that is, European American) identity. Emily Carr, descendant of British colonials, could claim no ancestral link to D'Sonoqua or her makers; unlike Kahlo, she could make no proximate claim to a tradition that feared *and* revered the forest ogre, who in many ways stands for Canadian nature herself.

Canadian writers and philosophers have long argued that such cultural distancing is implicit in the country's basic ways of relating to nature. Nature and Canadian identity are twisted tightly together, like the strands of a rope, but without the intimacy of the Mexican rootedness to the land. In Canada nature is formidable; the individual has always contended with its power as a determinant of his or her own place in the world. Critic Northrop Frye wrote extensively about nature, identity, and myth in Canada. He suggested that "in Canada, the answer to the question 'Who am I?' is at least partly the same as the answer to another question: 'Where is here?' 'Who am I?' is a question appropriate in countries where the environment, the 'here' is already well-defined, so well-defined in fact that it may threaten to overwhelm the individual."[51]

At other times Canadian nature is more than overwhelming; it is monstrous, terrifying. Added Frye, "I have long been impressed in Canadian poetry by a tone of deep terror in regard to nature." Novelist and critic Margaret Atwood found that characterization throughout Canadian writing: "Nature is a woman, but an old, cold, forbidding and possibly vicious one." She is powerful, ubiquitous, and unrelenting, making the central symbol for Canada, according to Atwood, "Survival, la Survivance."[52]

Emily Carr, as both writer and painter, struggled for her own artistic and emotional survival. In *Klee Wyck*, her collection of prose sketches describing her journeys among the Indians, she reveals her obeisance to this faintly threatening environment. Unlike many Canadians, she wrote not of Canada's frozen north, but of the enveloping greenness, the initial impenetrability of the British Columbian rain forest. Often she feared falling victim to the overwhelming power of the place; she struggled against nature, as well as (on various occasions) the twin dangers of social oppression and deprivation which had victimized the Indians. Carr's own survival, as writer and especially as painter, would come from her eventual ability to penetrate that ecstatic forest surround and to return from it to tell the story in words and paint.

Though her sympathies with native culture were profound, Carr never forgot that she was an outsider. Indians, for Carr, were a source of arcane knowledge of the natural, the magical, and the supernatural worlds. In modern secular society, as she wrote in *Klee Wyck*, whites had lost touch with nature's secret workings and found themselves outside the circle of knowledge. At times Carr herself straddled that blurred divide between appreciation and appropriation. In the period between 1914 and 1927, when she struggled to make a living as a landlady, she seldom had the luxury of concentrated painting. Instead, she supplemented meager rental income by making hooked rugs and pottery with Indian designs (fig. 26). In a crude hand-built backyard kiln she fired "hundreds and hundreds of stupid objects, the kind that tourists pick up." Later, when other white artists followed her lead, she castigated herself for using Indian designs in ways foreign to native artistic production in the

region. Though she loved working with clay, "I hated myself for prostituting Indian Art; our Indians did not 'pot,' their designs were not intended to ornament clay." Even the fact that she "did keep the Indian design pure" did not fully assuage her guilt.[53] It lingered as a bothersome memory, one of the barbs that eventually steered her back to her own expressions. The point is this: Carr never fooled herself about her cultural borrowings. As a North American with deep English roots, she felt distant from European cultural antecedents yet unsure of what was authentically hers as a Canadian, as a woman, and as a westerner. For years she struggled to find out.

If Carr's experiment with appropriated Indian design left a bitter taste, most of the time her attempts to establish an identity as a Canadian artist were more positive. Rather than despair about her own separateness, Carr claimed it and owned it. Indeed, as I shall consider in another context, her insistence on her outsider status was part of a larger, lifelong process of cultural reckoning. Always, she searched for an expressive path that would accommodate the otherness she felt in herself yet still allow her every Canadian's birthright, a deep and abiding identification with nature. "Indian people and their Art touched me deeply," she concluded. "Indian art broadened my seeing, loosened the formal tightness I had learned in England's schools. Its bigness and stark reality baffled my white man's understanding. I was as Canadian-born as the Indian but behind me were Old World heredity and ancestry as well as Canadian environment. . . . I learned a lot from the Indians, but who except Canada herself could help me comprehend her great woods and spaces?"[54]

Decades after her art training in Europe, and long after she had given up her travels to Indian villages, Carr still mused on what it meant to be a Canadian and a woman painter trying to express her native land. She was pleased when a Toronto newspaper in 1937 recognized her nationalistic aims, noting, "Miss Carr is essentially Canadian, not by reason of her subject matter alone, but by her approach to it." What "her approach" meant was not clear from the context, but Carr believed that it was at least in part due to her female feeling for nature. She copied the newspaper comment into her journal, then added her woman's resolve to the cause of Canadian art: "So I have decided to stop squirming, to throw any honour in with Canada and women. It is wonderful to feel the grandness of Canada in the raw, not because she is Canada

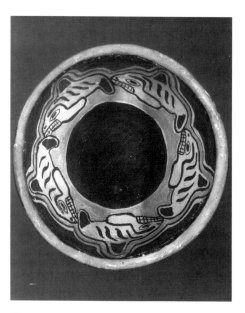

26
Emily Carr, bowl with killer whale design, n.d., clay with polychrome painted design. British Columbia Archives PDP04433.

but because she's something sublime that you were born into, some great rugged power that you are a part of."[55]

It becomes clear that Carr's experience of Canadianness was as strong as Kahlo's Mexicanidad, though very differently manifested. As woman, Canadian, and artist, Carr had to contend with the pleasures and difficulties of a land replete with space but sometimes maddeningly limited by political and cultural institutions that were no match for its geography. If, as Ian Angus wrote, "our primal [Canadian] experience is wilderness . . . origin is wilderness here," then one is forever beginning, starting from nothing to express something of the experience of absence, of space, of possibility. Carr knew this about Canadian space: that it was at once empty and replete; she wrote of "filling space and at the same time leaving space, shouting but silent. Oh, to be still enough to hear and see and know the glory of the sky and earth and sea!"[56]

Like many Canadians, Carr's nationalism incorporated a generous portion of awe at the country's sheer vastness; to express that immensity required feeling and sensitivity. Upon her return from her second sojourn abroad—a year and a half in France—Carr was convinced that she must apply new sensibilities to capturing what Gaston Bachelard has termed "intimate immensity." "More than ever," wrote Carr, "I was convinced that the old way of seeing was inadequate to express this big country of ours, her depth, her height, her unbounded wideness, silences too strong to be broken—nor could ten million cameras, through their mechanical boxes, ever show real Canada. It had to be sensed, passed through live minds, sensed and loved."[57]

"Real Canada," then, was the province of the painter rather than the photographer. In this we discover both a fundamental similarity and a basic difference between Carr and Georgia O'Keeffe. Both artists made their country's vastness a prominent aspect of their nationalism. But O'Keeffe, whose decades-long association with Alfred Stieglitz and American photography had convinced her of the medium's artistic capabilities, believed that the camera was an instrument of sufficient sensitivity to capture—in the hands of a creative, sympathetic photographer—the "real" America. Though it has been shown decisively that Carr herself used photographs as memory aids from her travels, she insisted that the camera played no aesthetic role in her art. As she told an audience in 1930: "The camera cannot comment. The camera cannot select. The camera cannot feel, it is purely mechanical."[58]

When Carr set out to capture the real Canada, she chose her native West over the East, where most of Canada's artists lived; even the Group of Seven was based no farther west than Toronto. The West was not the place where artistic reputations were made, either in Canada or in the United States. For both Carr and O'Keeffe, living in the West was a mark of individuality, a point of identification that placed them, for better or worse, outside the broad directional currents of their country's art. But for Carr and O'Keeffe, lifetimes of creative possibility awaited there.

For Carr the challenge was to tackle the landscape many artists considered "unpaintable." With little precedent to dictate her approach to the British Columbian landscape and its native inhabitants, she felt free to release her own prodigious energies in pursuit of a new pictorial language. In 1927, after a fifteen-year hiatus in her painting, Carr looked back on her earlier work and lamented its factual rigidity: "Next time I paint Indians I'm going off on a tangent tear. There is something bigger than fact: the underlying spirit, all it stands for, the mood, the vastness, the wildness, the Western breath of go-to-the-devil-if-you-don't-like-it, the eternal big spaceness of it. Oh the West! I'm of it and I love it."[59]

The sense of West as home was a powerful stimulus for Carr. It was her place of birth, her native ground, a comfortable and comforting locus of belonging. Although O'Keeffe was a midwesterner by birth, the notion of the West took hold of her early and persistently. As children, Georgia and her siblings listened raptly while their mother read them tales of the Old West—the West of cowboys, Indians, and wide open spaces. That West embedded itself firmly in O'Keeffe's imagination, and she embraced it when she accepted a teaching position at Amarillo, Texas, in 1912. During two years there and a subsequent stint teaching at Canyon, Texas, O'Keeffe fell in love with the expanse, openness, light, and color of the West. There she achieved for the first time a sense of intimacy with the land. A decade later, when she spent her first summer in New Mexico, it felt like a journey of homecoming, to both a place and a self. More than a return to familiar landscape, the West offered O'Keeffe a way of feeling at home in the world. Writing from Taos in the summer of 1929 she told a friend, "You know I never feel at home in the East like I do out here—and finally feeling in the right place again—I feel like myself—and I like it."[60]

For both O'Keeffe and Carr, the West afforded an expansive artistic range to roam. In the Canadian East, Carr would have faced more public scrutiny. Working among Toronto's Group of Seven she would have been measured against their established landscape aesthetic, which had already been acclaimed as the quintessential Canadian vision. Instead, she found a place in a region whose essence had not been permanently fixed in the mind's eye, where nature remained uncontaminated by humanity and accepted landscape conventions broke down: "Misty landscapes and gentle cows do not express Western Canada," she said drily, "even the cows know that." In the West she could stretch Canada's presiding landscape metaphor, painting in a manner complementary to the Group; though different, it showed a similar urge to capture the unique Canadian experience: "I know they are building an art worthy of our great country, and I want to have my share, to put in a little spoke for the West, one woman holding up my end."[61]

What did Carr's West look like? To generations of painters the Pacific Northwest has presented a distinctive gray-blue-green tonality, a wettish climate, and proximity of evergreens, mountains, and bodies of water. Carr noticed a visual

difference from the East, one that at times was highly stimulating but that could be oppressive as well: "The [western] air is denser and moister the growth more dense and lush, the skies heavy and lowering. . . . Beloved West, don't crush me! Keep me high and strong for the struggle."[62]

Carr could never separate her seeing from her feeling. With nature, she was a being in contact with being, painting an intersubjective world. Essentially, she willed herself into a state of ecstatic identification with all nature, partaking of its life force. "There is nothing so strong as growing," she wrote, and she searched for ways to transfer the energy of growth to her canvases: "I want those woods to go whiz-bang and live and whoop it up with a vim."[63] That search obsessed Carr for decades.

Georgia O'Keeffe and the Search for American Imagery

In considering O'Keeffe's sense of her own nationality, we are struck from the outset by the self-conscious way she set out to be an American painter. Like Kahlo and Carr, she took pains to understand and establish a national identity in her life and work. But to a greater extent than they ever did, O'Keeffe learned early to capitalize on her Americanness. In that she was aided by her husband and first promoter, Alfred Stieglitz, whose personal and professional relationship with O'Keeffe is too well known to need recounting here. Both O'Keeffe and Stieglitz prided themselves on a demonstrable Americanness in their thinking, despite their acute awareness of European innovation in twentieth-century art. In 1929 Stieglitz had opened his third New York gallery, An American Place, where his efforts at artistic promotion, once broadly inclusive, now focused on a core group of American painters. O'Keeffe, though embraced by that tight circle, did not share an experience common to most of her colleagues: European training. Because she had not traveled abroad, she was able to downplay her familiarity with European theory and claim to paint in a self-consciously American—and therefore original—way. In 1926 she had emphasized that it was action rather than mere assertion that stamped a person as American: one cannot be an American "by going about saying that one is an American. It is necessary to feel America, live America, love America and then work." She later remarked, "I think that what I have done is something rather unique in my time and that I am one of the few who gives our country any voice of its own." Stieglitz supported her determination to be, above all else, an American painter. Like Rivera, like Whitman, he was struggling to identify an authentically American culture—"America without that damned French flavor." And even more than the European-educated Stieglitz, O'Keeffe stood for undefiled nativism. As early as 1923 he had argued, "That's why I'm really fighting for Georgia . . . she *is* American."[64]

Before long, critics began to say so too. As O'Keeffe took up cityscapes (she produced some twenty New York paintings between 1925 and 1930), she was lauded in the press for finding in her skyscrapers a uniquely American subject.

Following her second exhibition of New York subjects in 1927, critic Frances O'Brien wrote, "O'Keeffe is America's. Its own exclusive product. It is refreshing to realize that she had never been to Europe. More refreshing still that she had no ambition to go there."[65]

True, earlier generations of painters had struggled to realize an American experience, but they had tended to work alone; Stieglitz believed that the efforts of a committed group would carry more weight. With that in mind, he organized an exhibition at the Anderson Galleries in 1925. *Alfred Stieglitz Presents Seven Americans* included the work of Stieglitz regulars O'Keeffe, Arthur Dove, Marsden Hartley, John Marin, Charles Demuth, Paul Strand, and Stieglitz himself. Why seven Americans? Was Stieglitz thinking of the success of the Group of Seven in painting the Canadian experience, and trying to demonstrate a parallel achievement in American art? The number seven was, in fact, a departure for Stieglitz, achieved by adding photography to an exhibition primarily of paintings. And it was the largest show he would ever mount: 159 works in all, of which O'Keeffe's 31 paintings made up the single largest segment.

There is no record that Stieglitz thought of competing with the Canadians, but he surely knew something of their art through his acquaintance with Harold Mortimer Lamb, a well-connected Canadian photographer, writer, and art collector, who visited Stieglitz's gallery 291 in New York several times during the 1910s. Stieglitz published a photograph by Lamb, and their correspondence shows that Stieglitz was made aware of Canadian photography, and probably something of its painting, through Lamb. Striving as he was to define a uniquely American expression, the well-informed Stieglitz could scarcely have avoided the simultaneous efforts of Canadians to set forth their own national identity. In a small way the U.S.-Canadian aesthetic exchange was aided when one of the few works sold from the 1925 Anderson Galleries show, O'Keeffe's painting *The Eggplant* (1924), went to a Canadian collector.[66]

27
Georgia O'Keeffe, *Cross with Red Heart*, 1932, oil on canvas, 213 x 102 cm. Curtis Galleries, Minneapolis.

Nationality, Region, Cultural Landscape

Though O'Keeffe professed to have no desire for travel abroad, she visited the Gaspé Peninsula in 1932, finding paintable subjects in Canadian barns and out-door crosses (fig. 27). Although she seems not to have interacted much with Canadian artists or have known their work (except for a brief encounter with Carr in 1930),[67] we see in certain of O'Keeffe's paintings made in earlier autumn seasons at Lake George (particularly *Maple and Cedar, Lake George*, fig. 28) the same chromatic brilliance of fall foliage that appears in paintings by the Group of Seven. Those paintings and their implications will be discussed in detail in Chapter 2.

O'Keeffe's politics also affected her identity as an American painter. Although O'Keeffe often deferred to Stieglitz in artistic matters because of his reputation and influence, she held her own opinions. Through him she had rubbed shoulders with certain radical-sounding positions, namely, the anarchistic symbolism first generated by Stéphane Mallarmé and others during the French Third Republic that later became part of avant-garde thinking among many Americans as well. Stieglitz, who frequently railed against American philistinism, must be seen in retrospect as

28
Georgia O'Keeffe, *Maple and Cedar, Lake George*
[Trees in Autumn], 1920, oil on canvas, 64 x 51.4 cm.
Georgia O'Keeffe Museum, Santa Fe, New Mexico.

something of a parlor anarchist. O'Keeffe scholar Sarah Whitaker Peters concludes that his most radical act was his "instantly successful public invention of Georgia O'Keeffe: The Woman who embodied sexual freedom, spontaneity, and intuition; the unspoiled, unintellectual artist . . . the American who was an artistic law unto herself." [68]

Still, except for her independent feminist views, O'Keeffe never lived up to her early billing as an anarchic political spirit. An example of her liberal and feminist approach emerges from a politically tinged interview in 1930 with Michael Gold, a leftist writer who had lived in Mexico during and after World War I. Gold saw the Mexican revolution as falling far short of its potential; to him it should have been more than a matter of land reform and the redistribution of wealth. It ought to have gone further, attacking "all that we have named western civilization—its great, nervous cities, the gray commercialism and shallow, eager competitiveness that marks its every feature—even its art and science and so-called culture." [69] Gold's radical views might have pleased Frida Kahlo, but they went too far to suit O'Keeffe. During the interview O'Keeffe disagreed with Gold's assertion that art must serve political aims, insisting that art is and contains its own moral structure. Artists (especially from arguably oppressed groups, like women) must be able to paint independently; but the role of art must ultimately transcend the individual.

In the interview O'Keeffe laid the basis for her later rejection of most art-world politics; she would subsume the artist's personal struggle into a larger integrity of spirit attached only in imprecise ways to her images. But however distasteful activist revolutionary politics may have been to O'Keeffe, she continued quietly to sympathize with certain causes. She remained a member of the National Woman's Party for decades, and she identified—strongly at times—with workers. When visiting Hawaii in 1939, for example, she asked to live near a pineapple field. Informed by her affluent corporate hosts that only workers lived there, O'Keeffe insisted that she too was a worker and stayed among them.

It was perhaps inevitable that O'Keeffe and Kahlo would meet. O'Keeffe's left-leaning liberalism, while far from Kahlo's communism, combined with their mutual interest in finding a national idiom in their art, all but ensured that they would come into some kind of contact. In fact, they met in 1930, the same year O'Keeffe did the interview with Gold, when Rivera and Kahlo came to New York for a retrospective of Rivera's paintings. The exhibition, at the Museum of Modern Art, showed the results of Rivera's own search for a national expression, the search he shared with Kahlo.

In their zeal to explore their own nationality and, more broadly, the arts of the Americas, Kahlo and Rivera had focused on their own Mexicanidad and at the beginnings, decades earlier, of their nation's effort to define itself through landscape painting. They were well acquainted with the work of José Maria Velasco (1840–1912), whose landscapes were painted hymns to Mexican nature, history, and the growing influence of the Mexican nation in the late nineteenth century. Exhibited to considerable acclaim

at the Philadelphia Centennial of 1876 and the Chicago World's Columbian Exposition of 1893, Velasco's paintings gave visibility to Mexican culture north of its borders and engendered a highly patriotic school of Mexican landscape painters.

Kahlo and Rivera were also sensitive to the effects of lingering European influences on the arts of the Americas. After extended sojourns in Europe, Rivera embraced the new spirit of Mexican nationalism, as did Kahlo. They welcomed the excision of the Díaz-era cultural arbiters, who had praised things foreign while denigrating Mexico's own arts. By 1923, as Helen Delpar writes, Mexican tastes had changed: "National songs and dances became fashionable overnight, and every home had examples of popular crafts, a gourd from Olinala or a pot from Oaxaca."[70] In their home decor, their entertainments, their dress, and their collections of native arts, Kahlo and Rivera helped popularize the indigenous in Mexican life.

This is not to say, however, that they ignored foreign influences entirely, nor that they cut themselves off from European influences. Kahlo's appreciation of the exotic jungle landscapes of Henri Rousseau was enhanced by that artist's autobiographical fabrication of a ten-year stay in Mexico. Kahlo also welcomed the attention showered upon her by André Breton, who anointed her the consummate surrealist on what he called the Surrealist Continent. Despite their interest in indigenismo, Kahlo and Rivera always remained in touch with European art, attending the exhibition of French and American art at Mexico's Escuela de Bellas Artes in 1929. By the next year they were encountering it at galleries and museums in the United States. The early 1930s, during which Rivera painted murals in California, Michigan, and New York, allowed them to see the threads of cultural connection joining the countries of North America. Upon their return to Mexico in 1931 Rivera commented, "I was able on my visit to the United States to see the error of the popular belief that there are no great painters in the United States. There is much talent, especially among the young, and there are some real masters[,] but they all must struggle against European schools which dominate the public." Yet in spite of his misgivings about the United States, and despite his avowed suspicion of foreign influences, Rivera too believed in pan-American unity.[71] As World War II approached he advocated a common citizenship for everyone in the Americas and pressed for cultural unity within the hemisphere, fusing the traditions of the South with those of the industrial North.

A few months after his call to U.S. artists to resist European influences, Rivera and Kahlo returned to New York for his retrospective at the Museum of Modern Art, During that visit they met O'Keeffe, the beginning of a cordial relationship based on mutual respect and attraction but also on the shared conviction that the cultural richness of the Americas should not stop at the borders dividing its nations. After their initial encounter at the museum, Kahlo (whose bisexual affairs have been widely recorded) bragged that she had flirted with O'Keeffe at the opening

and intimated on several later occasions that some kind of romantic intrigue underlay her friendship with O'Keeffe. More likely O'Keeffe was fascinated by the colorful, exotic, and unconventional Kahlo, whose salty language, unrestrained laughter, and originality of native Tehuana dress was a model for a new kind of liberated woman for the Americas.

Meeting Kahlo and Rivera opened the door to Mexico for O'Keeffe, but they were by no means her first encounter with Mexican culture. As an early reader of Stieglitz's *Camera Work*, O'Keeffe would have encountered Max Weber's Aztec-inspired poem "To Xochipilli, Lord of Flowers," published in January 1911. Weber, whose musings on cubism, the fourth dimension, and the power of native art placed him at the forefront of the New York avant-garde, signaled a growing interest in the varieties of North American artistic production.

Even more significant in establishing a Mexican connection within the Stieglitz circle was the Mexican caricaturist Marius De Zayas, born in Veracruz but a resident of New York after 1907, when his family escaped the Díaz regime. Stieglitz showed De Zayas's work twice at 291 (in 1910 and 1913), and De Zayas's essays appeared in *Camera Work*. With the approval of Stieglitz, De Zayas and his colleagues established the new, more experimental periodical *291* and set up the Modern Gallery. Upon its opening in 1915, director De Zayas declared that the gallery would sell "paintings of the most advanced character of the Modern Art Movement—Negro Sculptures—Pre-conquest Mexican Art—Photography."[72]

De Zayas did, in fact, exhibit both modern and ancient Mexican art: in 1916 the Modern Gallery showed Rivera (cubist pieces from Paris) side by side with pre-Cortésian work. One critic, placing Rivera firmly in the tradition stemming from Cézanne and Paul Signac, found his painting interesting and progressive. But like several other New York critics who visited the show, he did not pretend much knowledge of the pre-Cortésian work: "The Aztec exhibit is so slight that it gives only the faintest idea of [this] muscular, original and thoroughly interesting art."[73] Nonetheless, De Zayas found buyers for the early Mexican work, among them the celebrated collector Walter Arensberg, who made extensive purchases of pre-Columbian and contemporary works from the Modern Gallery and its successor, the De Zayas Gallery (1919–21).

Another promoter of Mexican-U.S. artistic relations in those years was the well-known critic, painter, and teacher Walter Pach. Co-organizer of the 1913 Armory Show, Pach grew increasingly interested in Mexican art following his first visit to the country in 1922. He befriended the muralists (especially Rivera, whom he championed during the Radio City mural debacle of the 1930s and in a later book), arranged to show their work in New York, and published articles in American periodicals celebrating both ancient and modern Mexican art. For more than two decades the well-connected Pach was a catalyst in cultural matters on both sides of the border, introducing Mexican artists to their American counterparts

and serving as an important link between dealers, institutions, and intellectuals in both countries.[74]

Another highly mobile promoter of pan-American artistic relations was Wolfgang Paalen, the Austrian-born surrealist painter who settled first in France, then (in the early 1940s) in Mexico. In between times he visited the Pacific Northwest where he collected and recorded important examples of Indian art. Paalen believed that a universal art had to arise to complement the universal science in shaping a new global consciousness, and he said so on the pages of *DYN*, the periodical he published and edited in the early 1940s from his home in Coyoacan (the Mexico City suburb where Frida Kahlo lived). In *DYN*, Paalen published the photographs and drawings he had collected in Canada and Alaska, interspersing these with learned studies of the mythology and complexity of pre-Columbian Mexican art. In one instance (fig. 29) he demonstrated formal similarities between a Tlatilco pottery design and a claw motif from a Northwest Coast Chilcat blanket. Paalen used such artifacts to show possible cultural connections resulting from prehistoric migrations of humans from Asia across the Bering Strait and southward through the continent. Paalen argued, "Art can reunite us with our prehistoric past and thus only certain carved and painted images enable us to grasp the memories of unfathomable ages." He believed that Northwest Coast art was unsurpassed in the world and that totem poles, in particular, were "among the greatest sculptural achievements of all times."[75] In the Amerindian number of *DYN* (December 1943) he reproduced a wooden D'Sonoqua mask to illustrate a discussion relating the totemic foundations of indigenous Canadian art with totemic symbols from classical art.

During Paalen's trips to Canada in the late 1930s he visited Emily Carr and was much taken with her work. Their interests in native art and culture overlapped, and he shared with her a belief in the affinity of modern sculpture for the spatial conceptions of Northwest Coast sculpture. Paalen acquired several of Carr's finest drawings from her.

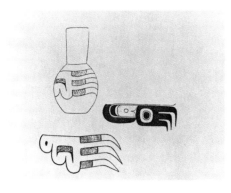

29
Illustrations from *DYN*, nos. 1–3 (1942). *Above*: incised animal claw design on a pot from Tlatilco, reminiscent of (*right*) claw designs from the Northwest Coast. *Below*: claw design from a Chilcat blanket, Northwest Coast.

Another contributor to *DYN* was the Mexican painter, caricaturist, and gifted amateur archaeologist Miguel Covarrubias, who provided an article on the archaic art and culture of Tlatilco, illustrated with his own drawings, for the journal's Amerindian number. Both Paalen and Covarrubias traveled often to New York, whence *DYN* was distributed to art circles that

included O'Keeffe and Stieglitz, as well as to the surrealist painters in wartime exile from Europe and a group of American painters who would become the Abstract Expressionists of the late 1940s.

Both Paalen (whom Kahlo referred to satirically as one of the "big cacas" of surrealism) and Covarrubias were well known to Rivera and Kahlo. Covarrubias in fact, was a close friend and a fellow collector (and sometime competitor) with Rivera of ancient Mexican artifacts. The charming Covarrubias became a close friend of O'Keeffe's as well. In 1929 Covarrubias caricatured O'Keeffe as "Our Lady of the Lilies" for the *New Yorker* (fig. 30). Covarrubias's drawing makes witty references to O'Keeffe's severe, almost ascetic appearance and manner, as well as to her spectacular, much-publicized sale the previous year of six calla lily paintings, reportedly for the record sum of $25,000. The sale was later exposed as a publicity stunt, but in 1929 it was a source of continuing amazement in the American art world.

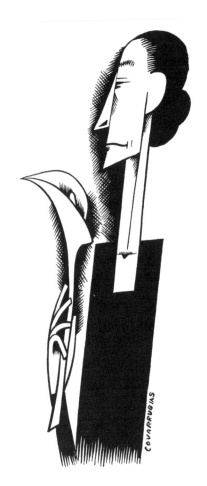

30
Miguel Covarrubias, *Georgia O'Keeffe: Our Lady of the Lilies*, from the *New Yorker*, 6 July 1929, 21. Photo courtesy Condé Nast Publications, Inc.

O'Keeffe's interest in the Americas south of the Rio Grande did not fully ripen until her 1951 (and subsequent) trips to Mexico. She had seen the important shows of Mexican art in New York in 1930 and 1940; by 1951 she was living full-time in New Mexico, a place where Mexican art and crafts were widely collected and appreciated. Motoring through Mexico, the widowed O'Keeffe and her friend Spud Johnson (the poet-editor who had traveled with D. H. Lawrence to Mexico in 1923) spent several weeks seeing such old friends as the Covarrubiases, viewing Mexican art, and shopping avidly in the markets. For her two New Mexico homes O'Keeffe brought back quantities of pottery, fabric, and decorative objects. She also visited Kahlo, who had recently been released after a year in the English Hospital in Mexico, twice during that trip. O'Keeffe's interest in Mexico, its arts, and its history endured for the remainder of her life.

But though she was an admirer of the indigenous culture of Mexico, it was to Native American art that she

turned more readily in her own work. Native culture, as we have seen in the work of Kahlo and Carr, had long provided European Americans with a sense of rootedness to ancient indigenous tradition. Appropriated with varying levels of understanding, it proved a durable point of entry for many in the search for American nationalism. The conduits through which O'Keeffe encountered Native American themes included Max Weber and, in particular, the painter Marsden Hartley. Hartley's symbolic abstractions based on American Indian designs, painted in Europe in the 1910s, signaled his interest in, as he said, "rediscovering America." And because Native Americans, like women, were seen as closer to nature than other groups, some saw connections between women and Native Americans in the United States. Herbert J. Seligmann, Stieglitz's assistant, wrote of O'Keeffe that her "purity and aloofness" were similar to that of Native Americans. Like them, she was "at home in the realm of Manitou, of nature. Something of the aboriginal Indian soul . . . seems to have descended upon O'Keeffe."[76]

Native American art, refusing distinctions between secular and sacred, fascinated American artists who sought to portray the spiritual in art but were trained in an iconography that separated the material and immaterial. Hartley's explorations in metaphysics and Native American culture were self-proclaimed, public, and enduring. If O'Keeffe searched for an "aboriginal Indian soul," however, her quest was quietly insistent, intensely private. When she occasionally used Native American imagery, she painted it with such forthright clarity as to disguise any mystical intent. But in at least one painting, she employed Indian imagery in her examination of nativism, another elusive symbolic state. By 1931, O'Keeffe's third summer of painting in New Mexico, she was considering a range of subjects native to the region. But she was also still concerned with finding a visual language for the experience of being American. In an era when many stalked the "Great American Novel—the Great American Play—the Great American Poetry," she conceived the idea of making an American painting: perhaps not the "Great American Painting" but an identifiably native expression.[77]

O'Keeffe had already tried out the idea a few years earlier. *East River from the Shelton* (fig. 31) has a quintessential American subject, the Manhattan skyline, rendered in the vivid red, white, and blue of the flag. The painting contains an enormous sun, centered overhead like a great eye (or "I"), as Sarah Peters has pointed out.[78] The sun's rays descend in a monumental pyramid shape, recalling (in a manner replete with the iconographic irony O'Keeffe relished in those years) the blazing eye at the summit of another pyramid—that on the Great Seal of the United States, imprinted on every dollar bill. Disguised with considerable subtlety, but signaled by the symbolic play of colors, O'Keeffe's skyline becomes an iconic, perhaps slightly cynical, portrait of America. Money, after all, fuels the engine of American industry, just as the sun's energy permeates the atmosphere.

Three years later O'Keeffe again loaded her palette with red, white, and blue, for another American painting. This time her subject was western, a region that was short on urban icons but long on natural ones. In fact, the surface of the land was littered with them. O'Keeffe picked one up, threw subtlety to the high-desert wind and delivered an image that fairly shouted its national—and regional—origins. *Cow's Skull—Red, White, and Blue* (fig. 32), with its undulating blue center and wide red flag stripes down the sides, received a great deal of attention, as O'Keeffe intended. It was a curious new kind of American icon, and it branded its maker as unmistakably, authentically American in the minds of both critics and viewers.

But she was not yet finished testing the varieties of American subject matter. Still pursuing the "Great American Thing," O'Keeffe wondered if a similar effect might be achieved with Native American imagery. Also in 1931 she painted a kachina doll (fig. 33). Along the vertical edges she once more added red stripes, as if to

31
Georgia O'Keeffe, *East River from the Shelton*
[East River No. 1], 1927–28, oil on canvas, 68 x 56 cm.
New Jersey State Museum Collection, Trenton,
Purchased by Friends of the New Jersey State Museum
with a gift from Mary Lea Johnson, FA1972.229.

Nationality, Region, Cultural Landscape

frame the question again: What does America mean? Which objects best symbolize the real America? Kachinas interested O'Keeffe as forms: stiff, blocky, assertive in color patterning and geometric designs, they are both representational and abstract. O'Keeffe, who played with the human figure more often in surrogate than in straightforward representations (as in her paintings of fruit, flowers, and landforms with body references), would have enjoyed the kachina's attachments to both natural and human contexts. Carved from cottonwood roots and decorated often with feathers, deerskin, or fur, they partake as messengers of the totemic fusion of the human, animal, and spirit worlds. For the Hopi, who with the Zuni are their chief makers, the kachinas (also called *tihu* or *katsintihu*) are likenesses of a whole array of supernaturals, each with specific characteristics.[79] Most are benevolent beings who dwell in the mountains, clouds, springs, and lakes; others, however, are ogres with disciplinary functions that carry social mores from one

32
Georgia O'Keeffe, *Cow's Skull—Red, White, and Blue*,
1931, oil on canvas, 101 x 91 cm.
The Metropolitan Museum of Art, the Alfred Stieglitz
Collection, 1949, 52.203.

generation to the next. Kachinas were sometimes said, like D'Sonoqua and La Llorona, to eat disobedient children.

As the owner of this and other kachinas during her lifetime, O'Keeffe knew of their diverse forms, and something of their multiple meanings. Throughout the 1930s and into the 1940s she painted the kachinas, a half-dozen or more in all. In both watercolor and oil she gave the compact wooden figures a monumentality far outstripping their modest stature as "dolls." Usually she presented them frontally, with attention to identifying detail. *Kachina* employs the same subtle asymmetry as *Cow's Skull—Red, White, and Blue* to create a slight formal tension. Both skull and

33
Georgia O'Keeffe, *Kachina*, 1931, oil on wood panel,
50.8 x 40.1 cm. Collection Gerald and Kathleen Peters,
Santa Fe, New Mexico.

kachina are placed slightly off-center, the latter with strikingly mismatched eyes that suggest a kind of Whitmanesque off-focus vision that (according to the poet as well as to Emily Carr, herself a painter of totemic native sculpture) allowed a clearer vision of the spirit: in Whitman's words, "silent, gazing, pondering the themes thou lovest best / Night, sleep, death and the stars."[80]

O'Keeffe's consideration of such midnight journeys of the soul was reinforced by many visits to native ceremonials. As early as 1929, her first summer in New Mexico, she attended religious observances among the Pueblo and Navajo peoples of New Mexico and Arizona. She made plans several times to visit the celebrated Hopi Snake Dance and ventured 250 miles from Abiquiu to the early-winter Shalako night ceremony at Zuni. Just before Christmas 1950, she wrote to a friend of that house-blessing ceremony and another, an all-night curing ceremonial on the Navajo Reservation. She described the experience vividly: "Some 1200 people gathered out there in the night—built big fires—particularly a big central fire—surrounded by some 15 or more smaller fires within an enclosure of pine boughs—teams of 20 and 30 came in and danced and sang all night—they all bring food and eat around the fires—evening and morning—the singing and dancing amid the green—the smoke—the fires and the stars—It is quite wonderful."[81]

Walt Whitman would have approved. For the Navajo, curing the body's ills involves bringing the patient and the world back into balance. For O'Keeffe, whose own emotional balance had been significantly disrupted in the early 1930s when she suffered a nervous breakdown, the restoration of a disturbed equilibrium would have struck a sympathetic chord. In 1950 she was again recovering her balance, this time following the death of Stieglitz and the prolonged business of settling his complex estate. That fall, having closed An American Place, she was finally free to return to her beloved high desert, to attend to nature's cycles and seasons, and to appreciate the Native Americans' rhythmic lifeways.

After her first kachina paintings, O'Keeffe began to depict the figures with different emphases—sometimes in ways that suggest the totemic role of animals in the Hopi world. As we shall see with Frida Kahlo, some of the most telling symbols of migration between worlds are winged creatures, whose flight readily suggests the allegory of soul flight, or of the artist's own shamanic transmigration into other realms. On occasion, O'Keeffe seemed to use the kachina for similar symbolic travel. Another kachina (fig. 34) renders in exquisite detail the brown bird feathers attached to the kachina's head. Behind those delicate forms rise a pair of stylized black wings, carved from wood and rendered by O'Keeffe with firmness and solidity. Below, the body of the kachina dissolves into patterns of black and white, the latter leaking into (and identical with) the whiteness of the paper itself. The black rectangle, doubtless a feature of the kachina's actual design, is reminiscent of O'Keeffe's black rectangles in other paintings dating back to the 1910s and forward into the 1960s—paintings in which the inky rectangle stands for door-

ways into the unknown, into other states of reality. With exquisite precision
and with calculated imprecision, O'Keeffe in this mysterious *Kachina* hints not only
at her stylistic wanderings between realism and abstraction but at the artist's
shamanic passage between states of being. She seemed to sense its mystery when she
wrote that the kachina in her studio possessed a "curious kind of live stillness." [82]

Eventually, the artist painted the kachina less and less iconically, cropping
and abstracting it to play off the geometries first rendered by the Hopi artist
who made them. As if in homage to that design sensibility, she proceeded to find in
their striking contours and applied geometric patterns stimulus for her own
formal inventions (fig. 35). Though she played freely with kachina forms, with ques-
tions of scale, pattern, and monumentality, O'Keeffe never lost sight of the fact
that—spiritual content aside—they were always already works of art. In painting

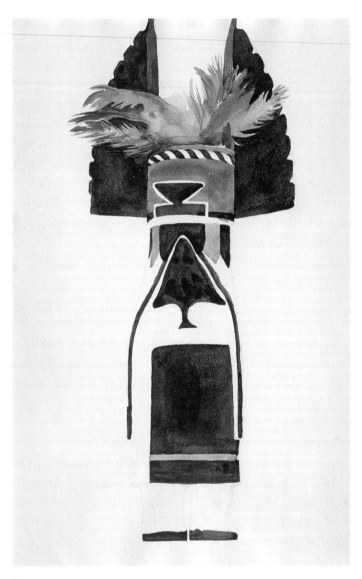

34
Georgia O'Keeffe, *Kachina [Untitled (Kachina)]*, n.d.,
watercolor, 54.6 x 36.2 cm. Private collection. Photo
courtesy Gerald Peters Gallery, Santa Fe, New Mexico.

Nationality, Region, Cultural Landscape

them, she was making art about existing art. It is a practice that has often cropped up in the history of Western art but one with inherent limitations for would-be "original" and "modern" European American artists. Like Emily Carr, O'Keeffe eventually questioned the validity of using native subjects in her work, but as a newcomer to the Southwest she could test the capacities of such subjects for experiments in form and content.

One of the most common soutwestern subjects O'Keeffe took up was the cross, a symbol that had many meanings for her aside from their Christian associations. Many of these crosses had been set up throughout the Southwest by the Penitentes, a lay brotherhood of Hispanic Catholics whose religious rites were performed in small chapels called *moradas* or outdoors, when processions of flagellants would wind out to the crosses in the Lenten season. Crosses, crossroads,

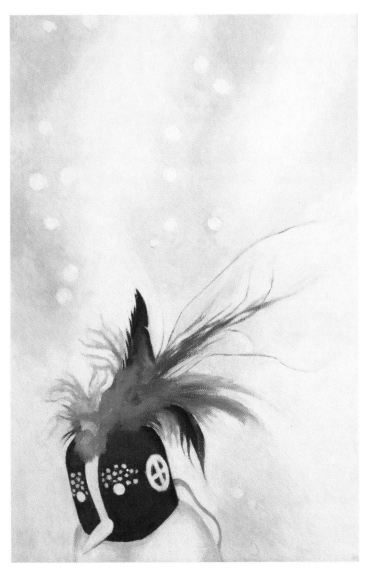

35
Georgia O'Keeffe, *Kokopelli with Snow*, 1942,
oil on board, 38 x 25.4 cm. Georgia O'Keeffe Museum,
Santa Fe, New Mexico.

crossing over—all are metaphors for change and movement; perhaps they reveal O'Keeffe's conviction that her future life, transformed by her experience in New Mexico that summer, was bound to take a decisive change in direction. Behind the dark intersecting arms of several of her New Mexican cross paintings O'Keeffe placed a literal crossroads, a place where paths converge and separate.[83]

O'Keeffe also painted the more conventional New Mexican churches of mainstream Catholics. The most famous was the eighteenth-century Franciscan church at Ranchos de Taos, a structure O'Keeffe called "one of the most beautiful buildings left in the United States by the early Spaniards."[84] Its sculpturesque adobe walls and buttresses, formed of massive sun-dried mud bricks and plastered by hand, gave the building a rounded, organic appearance, as if it belonged to the earth. In *Ranchos Church* (fig. 36), strong shadows emphasize the individual components of the church's apse end, transept, buttress, and surrounding wall, much in the way Romanesque architecture reveals its discrete, blocky modules. At the same time, the building's tone and texture, combined with its simple, unfenestrated walls, silently announce its marriage to the earth below.

O'Keeffe's *Ranchos Church* provides a striking contrast to a church Emily Carr painted the same year and reveals much about the intersections of nature and culture in their respective regions. If O'Keeffe's adobe structure murmurs its acquiescence to the earth, Carr's *Indian Church* (fig. 37) fairly shouts its dissent. Where O'Keeffe's church relaxes into the earth's contours, Carr's rises erect, alert, watchful. Yet the verticality of Carr's church is also born of truth to its materials—wood from the forest that surrounds it. Its crisp, white-painted exterior, a legacy of Euro-

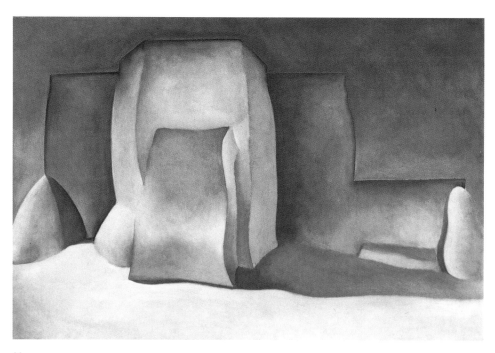

36
Georgia O'Keeffe, *Ranchos Church*, 1929,
oil on canvas, 61 x 91.4 cm. The Phillips Collection,
Washington, D.C.

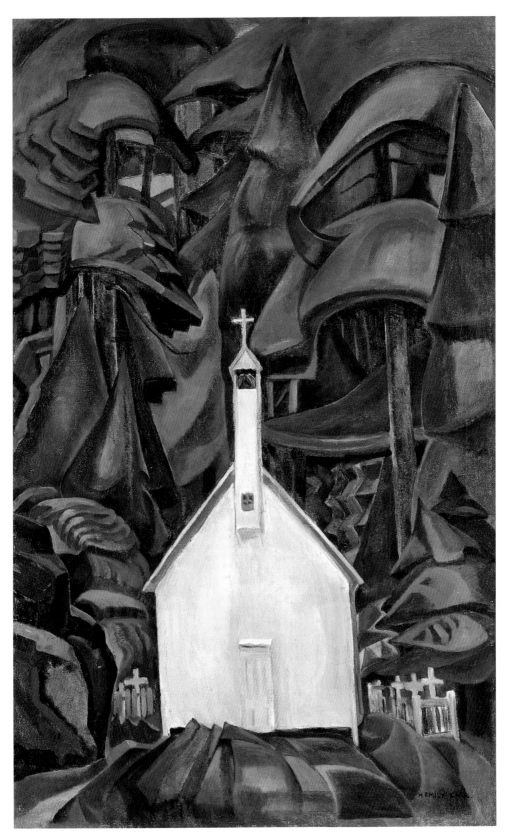

37
Emily Carr, *Indian Church*, 1929, oil on canvas,
108.6 x 68.9 cm. Art Gallery of Ontario, Bequest of
Charles S. Band, 1970.

pean missionary zeal, stands flattened and severely frontal, defying the high forest sur-round. But in its small size and lack of perspectival treatment, it also reads as a flat, vulnerable, cut-out form, nearly engulfed by the surging, angular forest shapes.

Carr painted the same kind of thick green enclosure (though perhaps more aggressively handled by Carr) that had often stifled O'Keeffe during a decade of summers spent painting at Lake George, in New York State. From there, in 1929, O'Keeffe had fled to the high-desert expanses of New Mexico in search of sun and open space; *Ranchos Church* shimmers in that liberating light, "an equiva-lent," she wrote, "for what I felt about what I was looking at."[85] Carr, on the other hand, was seeking another kind of environment: dark, enclosing forest interiors, which became her most distinctive subjects. Carr had come north the summer of 1929, when she painted *Indian Church*, in search of the heavy skies, damp soil, and sepulchral evergreens of Friendly Cove, Nootka Sound, Vancouver Island. Adding to the sense of decay was the rank scent of skunk cabbage (also well known to O'Keeffe, who had painted a whole series of the plants earlier in the 1920s) lingering near the villages.

Carr was following advice given her earlier that spring by Lawren Harris, who urged her to "leav[e] the totems alone for a year or more" since "the totem . . . already in itself is a definite artistic form," upon which she should not become depen-dent.[86] On Vancouver Island, Carr began to paint other subjects from nature, recasting them in her own personal language. In *Indian Church* we see her own forms and feelings creating a formal dialogue between forest and totem. On the right side of the painting, the trunk of the large evergreen seems to rise upward into a series of overlapping forms suggestive of a giant totem head, with cavernous mouth and nose touching the side of the church steeple. A primitivist obeisance to death and power lingers about the scene, a compelling reminder of the role fear and dread, as well as joy and reverence, played in native spirituality of the region. Such feelings became an important element too in Carr's relationship with nature; as her biographer Paula Blanchard writes, "Ever since her early trip to Ucluelet [in 1898], she had worked under a vague sense of being constantly watched from the forest by something indefinably hostile, and she had come to accept and even welcome it. Without it her work, lacking tension and complexity, would have lost its unique power."[87]

In the massive totemic face in *Indian Church* (as in her depictions of D'Sonoqua, discussed above), Carr captured this balance between menace and affir-mation in the forests of her native British Columbia. The painting is both a personal and a cultural statement, a reflection on the sometimes uneasy overlay of European American Christianity on totemic native religion in the Americas.

O'Keeffe's *Ranchos Church* was a North American statement as well, but one in which nature sings an older, gentler song; her building and its surroundings are reconciled to each other. Like generations of American painters before her, O'Keeffe

often began with the raw material of landscape. Reconciling architecture with the land, earth to firmament, she pursued an art that was measured and planar, smoothly executed, timeless, yet charged in many instances with biological energies. Blending America's twin proclivities for the real and the ideal, her paintings realize their expressive potential in contemplation.

Literary Influences and the North American Experience

Nature was a key focus in the way each artist viewed her North American identity. For O'Keeffe, nature gave rise to endless personal sensations. Aztec concepts of nature informed such works of Kahlo's as *My Nurse and I* (fig. 38) and *Love Embrace of the Universe* (fig. 39), and metaphors for nature's ambivalent and powerful presence appear in Carr's encounters with D'Sonoqua and in her totemic *Indian Church*. But there was another source for the way the three artists viewed nature, a concept derived from nineteenth-century Wordsworthian romanticism. A whole range of writers had followed this poetic trail, including Emerson, Thoreau, and especially Walt Whitman. More than any other writer of the Americas, Whitman defined for Anglo-American audiences the experience of self in nature.

For many artists and writers, Whitman wrote the inclusive, all-embracing soul music of the Americas. Celebrating the here and now, the native place, and the divinity of nature, Whitman advocated an art rooted to place yet somehow

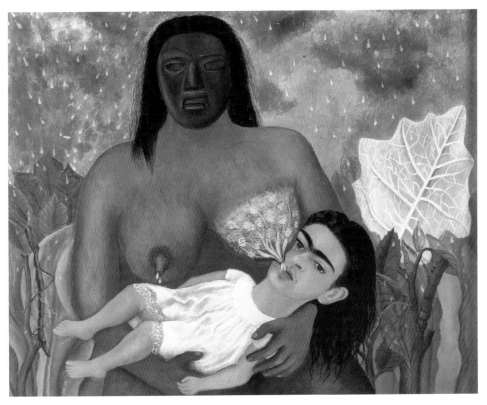

38
Frida Kahlo, *My Nurse and I*, 1937, oil on metal,
30.4 x 34.3 cm. Collection of Museo Dolores Olmedo
Patiño, Mexico City.

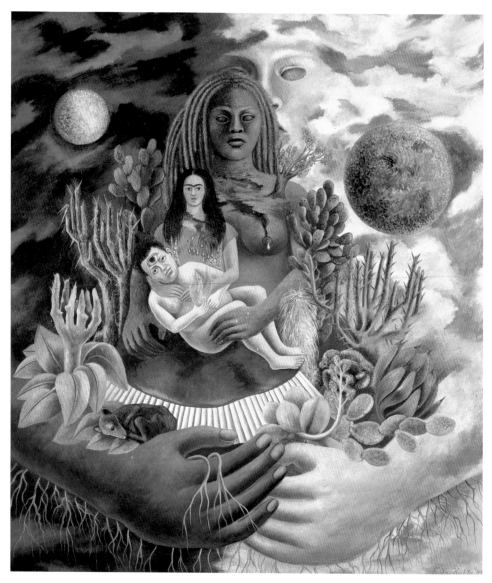

39

Frida Kahlo, *The Love Embrace of the Universe:*
The Earth (Mexico), Diego, Me and Señor Xolótl, 1949,
oil on masonite, 70 x 60.5 cm.
Jacques and Natasha Gelman Collection, Mexico City.

transcending all physical limitations. He of the voyaging ego took his joyous sensibilities on trips, imaginary and real, far beyond the borders of his own native place. He wrote of heading "To the north betaking myself to sing there arctic songs / To Kanada till I absorb Kanada in myself." Ultimately, Whitman understood Canada and the United States as inseparable, the "One Formed out of All."[88]

Canadians, for their part, had embraced Whitman's work since as early as 1872, when critics—sometimes shocked by his sexual openness—praised the largeness of his vision. Painters as well as poets longing for personal liberation within an American identity turned to Whitman for direction. Fred Housser, chief apologist and biographer of the Group of Seven, lectured and wrote on him, and Emily Carr read Housser as well as Whitman. In Housser's *Whitman to America*, she found in the poet's writings renewed courage to continue along the uncertain road of the artist. On a day when she complained of feeling "akin to the worm, the caterpillar and the grub"—a day when "I can't reach anything, even the low middle," she looked to Whitman for a view beyond the tired familiar into unknown realms of possibility: "Whitman knew life from the soul's standpoint. What glorious excursions he made into the unknown! He wrote, 'Darest thou now, O soul, Walk out with me toward the Unknown Region, Where neither ground is for the feet, nor any path to follow'; and he *dared.*"[89]

And she dared. It was summer 1933, and Carr had bought and refurbished an old caravan trailer, which she took into remote areas for long periods of work. Throughout that summer she tapped into Whitman's buoyant enthusiasm, finding in him new validation for the artist's life in nature: "Integrity has a new meaning for me," she wrote in her journal, "Living the creative life seems more grandly desirous (opening up marvellous vistas) when one is searching for higher, more uplifting inspiration, when one is listening intently for what a thing is saying and for the urge of life pouring through all things."[90]

Benevolent nature, freeing the soul for endless wanderings, beckoning the artist and writer to merge with it, was a mainstay of Whitman's poetry. What Carr had called his "ever-lasting on-going" was his eternal dance with natural forces, the great pulsing of the soul-become-universe. The entire cosmos served as mirror and womb for Whitman, the place of longing for ultimate return. As such, nature was female and primal. Whitman visualized her this way:

> As I see myself reflected in Nature,
> As I see through a mist, One with inexpressible completeness,
> sanity, beauty,
> See the bent head, and arms folded over the breast, the
> Female I see.[91]

For Carr, who had decided that nature was female long before she read Whitman, the poet's sense of the female, embodied earth was gratifying. Part of Whitman's appeal to artists has always been his transformation of felt impulses into describable images. For Carr those visual references to the earth added a layer of life, of wholeness, and of "inexpressible completeness." Nature, its creatures, and the cosmos fell on a single continuum, which demanded honoring. In "Starting from Paumanok," Whitman exhorted his readers to that holistic view: "I will not make poems with reference to parts / But I will make poems, songs, thoughts, with reference to ensemble." When Carr's work was going badly that summer, she realized she had temporarily forgotten Whitman's pledge: "Today I see that I am what Whitman would call 'making pictures with reference to parts' not 'with reference to ensemble.' The individual mighty trees stagger me. I become engaged with the figures and not the sum and so I get no further with my reckoning up of the total. Nothing stands alone; each is only a part. A picture must be a portrayal of relationships." [92]

Nothing would prove of more crucial importance to Carr's painting than that last sentence. Her work celebrates relationships, in ways both formal and philosophical. And Whitman was clearly at the heart of Carr's determination to portray connections. She committed great gulps of his writing to memory, and he led her into a deepened identification with nature, confirming her own perception of it as female, and to a way of looking at it whole. She was still thinking of Whitman as she wrote the last lines of "Growing Pains" at age seventy: "Walt Whitman's words come ringing—We but level this lift to pass and continue beyond." [93]

Whitman was a vital force in the arts of Canada, but his influence extended far to the south as well. As the twentieth century unfolded, he became increasingly a poet for all the Americas. He felt it himself, in such lines as "Far breath'd land! Arctic Braced! Mexican breez'd! the diverse! the compact!" Whitman had, in fact, won a sizable Mexican audience before the turn of the century. By the 1920s, when cultural elites introduced modernism to Canada, Mexico, and the United States, Whitman's reputation grew still more; his protean literary imaginings made him a figure who spanned centuries as well as continents. Linked back to the nineteenth century and seen as anticipating the themes of the twentieth, Whitman was celebrated as "an indigenous American rebel and the fountainhead of counterculture art in this country." [94]

Rebelliousness in others fortified Frida Kahlo's own self-styled opposition to convention. Like her, Whitman was an iconoclast, subversive, sexually ambivalent, and an outsider. Politically, Whitman's earthy egalitarianism linked him vaguely to her pantheon of proletarian heroes—Marx, Lenin, Trotsky, and Stalin. He could also be aligned with a number of revolutionary artists, including Picasso and Rivera. In fact, Kahlo likened Rivera to Whitman for their wide-ranging embrace of interests and experience. Rivera, she wrote, "talks and argues about everything, absolutely everything, like Walt Whitman." [95] As time passed she admired Whitman more and more, and she encouraged her students to read him as part of their education in the arts.

Whitman's own relationship to art and artists included the writing of criticism, especially in appreciation of his favorite painter, Jean-François Millet. The French realist's earth-centered canvases were evocative of a populism that appealed as well, at least in theory, to the communitarian values Kahlo and Rivera later professed. Between Millet's *paysan* and the Mexican *campesino* was a discernible link, an identity rooted in the soil. Millet's sowers and gleaners, backs bent to their labors, echoed the heavy, rounded contours of the earth. Whitman, who once described his poems as "really only Millet in another form," based his love of the earth on its intimate connection with humanity. In Mexico that intimacy gave rise to a reconsideration of art as an expression of a national impulse. As Kahlo's friend Anita Brenner wrote, "Nowhere as in Mexico has art been so organically a part of life, at one with the national ends and the national longings, fully the possession of each human unit, always the prime channel for the nation and the unit."[96]

For Whitman the "human unit" was fundamentally the human body itself, abode of the soul. And the soul was endlessly capacious, like nature herself: "Was somebody asking to see the soul? / See, your own shape and countenance, persons, substances, beasts, the trees, the running rivers, the rocks and sands. . . . Behold, the body includes and is the meaning, the main / concern, and includes and is the soul." Whitman's body-centered imagery, its organic connectedness to the smallest and grandest integers of the cosmos, laid a track which Kahlo followed, pursuing her own tragic poetics of the body. Perhaps in search of wholeness, she read and reread Whitman after her miscarriage in Detroit in the summer of 1932. Such later paintings as *Remembrance of an Open Wound* (1938; destroyed) and *Tree of Hope* (1946; private collection) focus on her physical pain, but they connect it to other states of being, other realities. Whitman's words remind us of several frequent themes in Kahlo's paintings, including birth—both her own and her desire to give birth to or merge with Rivera—and its linkage with water and bathing, as in her *What the Water Gave Me* (see fig. 2). Whitman: "This is the nucleus—after the child is born of woman, man is born of woman, / This is the bath of birth, the merge of small and large, and the outlet again."[97]

During their years of travel and work in the United States, Kahlo and Rivera searched for what was intrinsically theirs, as individuals and Mexicans. But like Whitman, they looked as well for transnational themes. Whitman had written in *Leaves of Grass* of nature's "original energy" stemming from a creative cosmic force. In poetry, he believed, that energy is transferred from the realm of spirit into measurable space and time. This transference, as Peter and Roberta Markman have pointed out, is remarkably similar to that of the Aztec artist, who (like Whitman) used images of grass, flower, and song as metaphors for the creative process.[98] Nature and creativity thus are the province not merely of the divine but of the artist as well. And a complex linkage of forces, a vast continuum of life, joins all levels of reality into a magnificent spiritual system.

In the United States, Whitman, the "good gray poet," formulated what it meant to be American; he labored for decades to express what then seemed elusive: a sense of national identity. As Malcolm Cowley wrote, before Whitman, America hardly existed. There was something in Whitman for everybody; he was America's most capacious poet. But he spoke with special clarity of what it was to be an artist in an egalitarian society, and for that he became the patron saint of the American avant-garde. In 1917 William Carlos Williams celebrated Whitman and the idea of place in American poetry, a notion easily transferable to painting. As art historian Matthew Baigell notes, "Probably Whitman was the more potent immediate source for the Stieglitz artists, since his name was invoked repeatedly in the literary and artistic press before and after 1920 both as a model and as the first important American artist." [99]

As a member of the Stieglitz circle, O'Keeffe could scarcely escape the influence of Whitman, even had she wanted to. What we know about her suggests that she didn't. Although she wasn't as drawn to his work as Carr and Kahlo, it did influence the formation of her conceptions of body, land, and nationality. From a rural, agrarian background herself, O'Keeffe shared Whitman's rootedness in the land: "Where I come from, the earth means everything. Life depends on it." [100]

But it was Whitman's broad embrace of the land and the people that made him particularly important for a new movement that began in the early decades of the twentieth century, a movement that fostered hemispheric cultural unity. What might be called the keynote address for this idea was delivered in 1932 by Herbert E. Bolton, a Latin Americanist at the University of California, Berkeley, and president of the American Historical Association. In his speech entitled "The Epic of Greater America," Bolton expanded a thesis he had been developing since 1920, when nearly eight hundred students registered for his course "Greater America": that the nations of the Western Hemisphere share a significant common heritage.

By that time Bolton's vision of pan-Americanism had become widespread: in 1921 President Warren G. Harding dedicated a statue of Simón Bolívar, the South American liberator, in New York's Central Park. In his dedicatory speech, Harding likened Bolívar to another celebrated liberator, George Washington. The recent world war, argued Harding, had enlarged the global role and opportunity for all the Americas. Throughout the 1920s and 1930s a flood of English-speaking writers and visual artists visited Mexico, further enhancing the appeal that country in the American imagination. And Canada was not ignored. In 1901 a Pan-American Exposition in Buffalo had included, in its Fine Arts section, a gathering of works by U.S. and Canadian artists. The lopsided collection (1,667 works by U.S. artists; 92 by Canadian) had become more balanced by 1925, when a show billed as "The First Pan-American Exhibition of Paintings" circulated widely. Its aim was to reinforce cultural relations while at the same time demonstrating individual artistic tendencies.

Writers also embraced the movement. William Carlos Williams published his essay "The Destruction of Tenochtitlán" in 1925; Waldo Frank his *America Hispana* and Archibald MacLeish his long poem "Conquistador" in 1932. Poets Carleton Beals (whose book *Mexican Maze* achieved a wide readership), Idella Purnell, and Elizabeth Cutter Morrow all published on Mexican themes in the 1920s. By 1932 Hart Crane was in Mexico, at the same time as painters Marsden Hartley and Andrew Dasburg and photographer Paul Strand. These visual artists were part of a decades-long pilgrimage from Canada and the United States. Others among the more famous visual artists heading south between the 1910s and the 1940s were Milton Avery, Gustave Baumann, Henrietta Shore, George Biddle, Elizabeth Catlett, Howard Cook, Laura Gilpin, Philip Guston, Dorothea Lange, Yasuo Kuniyoshi, Robert Motherwell, Millard Sheets, Edward Weston, and Tina Modotti.[101]

Musical connections within the Americas were advanced by artists who traveled along the North-South axis in search of inspiration. Mexican composer Carlos Chavez, for example, made repeated visits to the United States during the 1920s in retreat from what many among the Mexican intelligentsia saw as the vestiges of an outdated and stultifying European influence. Searching for a new musical-theater concept, Chavez enlisted the help of Leopold Stokowski in orchestrating his *Caballos de Vapor*, a revolutionary production with sets designed by Rivera. In another North-South musical exchange of the same year, Aaron Copland spent four months in Mexico at the invitation of Chavez. Writing to a friend after his return, Copland extolled the *indigenista* strains he encountered there: "Mexico offers something fresh and pure and wholesome—a quality which is deeply unconventionalized. The source of it is the Indian blood which is so prevalent. I sensed the influence of the Indian background everywhere—even in the landscape."[102]

The indigenous earth Copland praised in Mexico is not unlike that celebrated by Whitman, in Mexico, Canada, or the United States. But it was equally reminiscent of land described in the passionate writing of British novelist D. H. Lawrence, who, on his own retreat from modern industrial society in 1923, headed south from Taos to the warmer climes of Mexico. Accompanied by two other writers, poet-essayists Witter Bynner and Spud Johnson, Lawrence hungrily absorbed the color, history, and mythic possibilities of the land.

Lawrence was also responsible for reinforcing Whitman's influence among more recent American writers and its visual artists, describing Whitman as the "greatest modern poet" and "the greatest of the Americans." Whitman had, in fact, paved the way for Lawrence's grasp of indigeneity in the Americas; he became, Lawrence wrote, "the first white aboriginal." That aboriginal quality (arising even earlier in Emerson), that attempt to locate original essences—what Lawrence called "Spirit of Place"—was of profound concern not only to Lawrence but to Kahlo, Carr, and O'Keeffe as well. For Lawrence it involved separating out the *reality* of the Americas from Europe, whose reality was in eclipse. During his first sojourn in the

Americas (which included, in 1922 and 1923, both Mexico and the United States), Lawrence tried to articulate his vision of a cataclysmic cultural break with the past: "I feel about [the] U.S.A. as I vaguely felt a long time ago; that there is a vast, unreal, intermediary thing intervening between the real thing which was Europe and the next real thing, which will probably be in America, but which isn't yet, at all. Seems to me a vast death-happening must come first. But probably it is here in America (I don't say just U.S.A.) that the quick will keep alive and come through."[103]

Lawrence produced a whole range of literary responses to Mexico, the best known of which remains *The Plumed Serpent*, a novel set in 1920s Mexico. Through the eyes of its chief European American character, the world-weary Englishwoman Kate Leslie, Lawrence explored the imagined return of Quetzalcóatl in the context of neoprimitivism and an obsession with death and power. Inventing modern surrogates for ancient gods and heroes, Lawrence invoked the Aztec legacy then being revived and forming one pole of Mexico's 1920 cultural struggle between *indigenistas* and *hispanistas* in Mexico.

While Frida Kahlo's own mixed blood embodies the imposed ethos of the hispanista, she and Rivera came down forcibly on the side of an indigenous Mexican renaissance. In postrevolutionary 1920s Mexico they, like Lawrence, monitored the nation's shift in political consciousness away from a colonial or dictatorial past to an older, pre-Cortésian era. This shift only accentuated the differences between Mexico and the future-fixated United States. Kahlo's painting of cultural contrast, *Self-Portrait on the Border Line Between Mexico and the United States* (see fig. 3) is her comment on straddling the Mexico–United States cultural divide. Like all her work, it reflects a personal reaction to larger ideas and, often, contemporary events. And it reveals Kahlo's considerable gift for intuiting vernacular metaphors. In this painting she contrasts the crumbling pre-Columbian temple on the left with the belching smokestacks of an American factory (labeled FORD), a pointed reference to Henry Ford's notion that he had invented something like a new secular religion embodied in his oft-cited comment that the man who builds a factory builds a temple.

While visibly an indictment of messianic technology north of the border, this painting demonstrates—paradoxically—not Kahlo's isolation from it but rather her stance on a boundary stone linking both worlds. The border is a permeable one, and Kahlo finds herself a living link between the past and present, between North and South. And although she complained publicly about "gringolandia," she appreciated many aspects of the United States. In 1933 she wrote, "New York is very beautiful and I'm much happier here than in Detroit, but I miss Mexico, nevertheless."[104]

Kahlo's *Border* painting, her summation of the factors that divide North from South, leads us back directly to Lawrence. We know she read and appreciated his writings; one wonders if in painting *Border* she was thinking of a passage from *The Plumed Serpent* describing the resurgence of Mexican men, felled like trees by the Spanish conquest: "But the roots of the trees are deep and alive and forever

sending up new shoots And each new shoot that comes up overthrows a Spanish church or an American factory." In Kahlo's painting, on the Mexican side of the border plants send down vigorous new roots, signifying a life force missing from the sterile, smoke-choked factory on the American side. She would express her love of indigeneity in her own plant metaphor: Indians, she wrote, are "the living flower of the cultural tradition of America."[105] Whether she was thinking specifically of Lawrence as she painted cannot be verified, but it is clear that writers like Lawrence underpinned Kahlo's complex (and sometimes contradictory) attitudes to indigenous Mexican culture.

Indeed, Kahlo's behavior and her words reveal deep ambivalence about cultural divides. And they point to a strong likelihood that she was dissembling in her statement "I never knew I was a Surrealist till André Breton came to Mexico [in 1938] and told me I was." Is it possible that Kahlo was a self-invented surrealist, as Breton suggested? Given the complexity and explicit address of her *Border* painting, her innocence of surrealist theory seems implausible. With its depiction of the artifacts, attitudes, and beliefs making up social reality in Mexico and the United States, Kahlo's *Border* painting is a perfect embodiment of Breton's stated goal of surrealism: "the elaboration of a collective myth appropriate to our time," specifically, one that could resurrect the old balance between society and nature, though at an elevated level of global interconnection and technological achievement. Collective mythology, writ modern and large, is precisely what *Border* addresses— far too closely to Breton's surrealist goal to support Kahlo's pretense of naïveté.

To maintain her fictive distance, Kahlo would quibble with Breton on cultural interpretations; she clearly did not appreciate his attempts to categorize her or to define Mexican culture for the world. She complained in 1939 from Paris that Breton had displayed her paintings in the "Méxique" exhibition next to "lots of popular objects which he bought on the markets of Mexico—*all this junk*, can you beat that?"[106] She did not want her paintings mingled with what Breton prized as Mexican folk art. This revulsion is curious from a woman who considered herself an indigenista, an artist, and a revolutionary. Kahlo's objections to the French were largely that they were effete cultural snobs, whose endless café conversations on "culture, art and revolution" sickened her. When she added that rather than mingle with the café crowd, she would choose to sell tortillas on the floor of the Toluca market, her objections seem, at the least, inconsistent. Especially so considering that a few years later she took her painting students to the Friday market in Mexico City, where they admired everything from hand-made puppets to street food. She also collected folk-art *retablos*, which she displayed along with her own paintings in her Coyoacan house. Apparently she found the mix acceptable in Mexico; she could not extend to the detested French the prerogative of selecting and exhibiting "low" and "high" art in the same gallery. Kahlo's nativism and her egalitarian political ideals wavered, it seemed, when it came to art—specifically her own. Like

Lawrence, she could be deeply in sympathy with native tradition; but like him as well, she sometimes expressed an impatience with and even an elitist rejection of folk culture.

Kahlo's ambivalence about elements of her national heritage make one last Mexican female cultural hero worth mentioning here. She is Sor Juana Iñes de la Cruz, a Mexican writer and intellectual of the late seventeenth century. In 1941 Kahlo was asked by the Mexican government to paint portraits of (as she described them) "the five Mexican women who have had the most relevance in the history of our people."[107] She asked her physician friend Leo Eloesser to help her find information on Sor Juana, the poet-nun whom she thought embodied the duality of Mexican colonial world, a figure who was doubly isolated as a woman intellectual of her era. Sor Juana's poems had been published in the United States by the time of Kahlo's research, and the poet-nun was becoming more widely known as an important writer in Mexican history. Too, Sor Juana must have represented the kind of independent artist Kahlo was trying to become in 1941, the year of her remarriage to Rivera. More than anything else, Kahlo wanted to be a strong female artist whose work could sustain her and would reduce her financial and emotional dependence on men, especially on a marriage that had so far brought as much pain as pleasure. As Octavio Paz wrote, "The surface of [Sor Juana's] work, like that of her life, does not reveal any fissures. All of her being responded to what the times could ask of a woman."[108] What the times asked of Kahlo, what she asked of herself, was to become a strong model of Mexican womanhood, like Sor Juana.

Writers as diverse as Sor Juana and Lawrence helped to shape subsequent views of Mexican culture, both inside and outside its borders. Kahlo, Carr, and O'Keeffe were all attentive to Lawrence's writings, not only concerning Mexico but on larger cultural questions within the Americas. In addition to *The Plumed Serpent*, Lawrence wrote in "The Woman Who Rode Away" of collisions of values—ancient and modern, northern and southern. One of Lawrence's most powerful and disturbing short stories, "The Woman Who Rode Away" recounts the dark tale of a bored American woman married to a mining engineer in remote northern Mexico. Taken by an irresistible impulse, she rides away from her life to seek out a tribe rumored to be the descendants of Moctezuma. "Like a woman who has died and passed beyond," she is found and carried away by the natives to their remote mountain camp, a place where human sacrifice is still practiced. With a sense of fatality and fascination, the woman accepts her ritual preparation for death so that an ancient power, wrested from the Indians' ancestors, can be restored to them through her sacrifice.

It is a tale steeped in primitivism and obsession with power and death. But "The Woman Who Rode Away" also embodies Lawrence's gift for symbolizing visible nature, for translating visual experience from the language of the eye to that of

the ear. This capability has always drawn visual artists to Lawrence's writing. A passage from the story evokes both the visual and symbolic power of color: "[Blue] is the colour of the wind. It is the colour of what goes away and is never coming back, but which is always here, waiting like death among us. It is the colour of the dead. And it is the colour that stands away off, looking at us from the distance, that cannot come near to us. When we go near, it goes farther. It can't be near." [109]

Lawrence evokes in this literary passage what many visual artists have explored with brush and palette. O'Keeffe, for example, came to think of blue as the color of the infinite, the unknown always beyond. At various times in her career, particularly in 1916–17 and again in the 1940s, O'Keeffe made special use of the color. During World War II she wrote of blue in much the way Lawrence had described it: "When I started painting the pelvis bones I was most interested in the holes in the bones—what I saw through them—particularly the blue from holding them up in the sun against the sky as one is apt to do when one seems to have more sky than earth in one's world. . . . They were most wonderful against the Blue—that Blue that will always be there as it is now after all man's destruction is finished." [110]

In still another of his works written in the Americas, Lawrence revisits the conflict found in many of his novels between a woman's passion for freedom and the constrictions placed on her by the power of destiny. *St. Mawr*, a novella first published in 1925 and read by both Carr and O'Keeffe, features women who find in acceptance of wild, primordial nature their true female experience. In his typically primitivist fashion, Lawrence argues that urban existence, particularly in Europe, bankrupts the human spirit. The protagonist Lou complains of England's hypercivilization: "Not a space, not a speck of this country that wasn't humanized, occupied by the human claim. Not even the sky." The answer? As Lawrence laments, "Generally speaking, nothing. . . . The individual can but depart from the mass and try to cleanse himself. . . . Retreat to the desert, and fight." Lawrence's appeal for individual action, for withdrawal from society to uncorrupted places, struck a powerful note in both Carr and O'Keeffe. Carr, who had spent considerable time in Europe, suffered physically from what English doctors told her were the ill effects of the city. Ever afterward, she would leave her home in the Canadian West with trepidation and long to return quickly to the less-populated spaces of British Columbia. At least as powerful was the effect of space on O'Keeffe, who eventually took Lawrence's admonition literally; she retreated to the desert and fought for her solitude. Complaining of ill health at Lake George amid a surfeit of Stieglitzes, she wrote a friend that she "mostly need[ed] a dry open space all by myself." [111]

In *St. Mawr*, Lawrence described that dry open space in words that suggest O'Keeffe's own expansive paintings of the American Southwest: "He was watching the pale deserts . . . shimmer with moving light, long mirage of a shallow lake ripple, the great pallid concave of earth and sky expanding with interchanged light." O'Keeffe's

well-known pastel *Pedernal* (fig. 40) evokes that great, mystical union. Lawrence's character Lou, drawn inexorably to the Southwest, experiences an epiphany before the sky's expanse. Compelled to, O'Keeffe would have described her own American epiphany less effusively, though with equal conviction. Lawrence: "It seemed to [Lou] that the hidden fire was alive and burning in this sky, over the desert, in the mountains. She felt a certain latent holiness in the very atmosphere, a young spring-fire of latent holiness, such as she had never felt in Europe, or in the East. 'For me,' she said, as she looked away at the mountains in shadow and the pale-warm desert beneath, with wings of shadow upon it: 'For me this place is sacred. It is blessed.'"[112]

Lawrence's great pallid concave of earth and sky occurs not only in the desert. It appears as well where sea, shore, and sky come together in Emily Carr's paintings. *Shoreline* (fig. 41) embodies that interchange of light and movement—a connection the artist herself described in 1934: "Now I see there is only one movement. It sways and ripples. It may be slow or fast but it is only one movement sweeping out into space but always keeping going—rocks, sea, sky, one continuous movement."[113]

Emily Carr and Georgia O'Keeffe, whose volumes of Lawrence's works remained in their libraries throughout their lives, found many themes in his writings relevant to their painting. Lawrence's sensitivity to place and to the everlasting tug of nature upon cultures old and new made him a favorite throughout the Western Hemisphere. In the United States, Lawrence's writings parallel those of modernist critics in New York, whose ideas—both directly and filtered through others in the Stieglitz circle—affected O'Keeffe's growing sensitivity to place. Waldo Frank, in his influential *Our America* (1919) had already heard Mexico's clear cultural

40
Georgia O'Keeffe, *Pedernal*, 1945, pastel, 53.3 x 109.2 cm.
Georgia O'Keeffe Museum, Santa Fe, New Mexico.

voice arising out of its own soil: "The lowly Mexican is articulate, the lordly American is not. For the Mexican has really dwelt with his soil, cultivated his spirit in it, not alone his maize." Paul Rosenfeld, echoing Whitman as well as Lawrence, wrote in *The Dial* in 1921 that Albert Pinkham Ryder's work should serve as a model for paintings which "speak to the American of what lies between him and his native soil." And William Carlos Williams, who would soon celebrate Mexican themes in his work, seconded that attention to indigeneity by writing, "If Americans are to be blessed with important work it will be through intelligent, informed contact with the locality which alone can infuse it with reality."[114] Lawrence was thus riding a wave of interest in locale as being vital to native expression when he included his chapter "Spirit of Place" in *Studies in Classic American Literature* (1923).

In Canada, Mexico, and the United States, Lawrence's works continued to be widely read and reviewed—even when, or perhaps especially when—they were confiscated or banned, as *Lady Chatterley's Lover* was in the late 1920s. During those years Lawrence corresponded with Stieglitz and sent a copy of *Lady Chatterley* to him and O'Keeffe. Carr, whose Victorian reserve and sexual prudishness (as Ruth Appelhof argues) make her an unlikely Lawrence fan, nonetheless overcame her customary reserve and read his books with great relish.[115] The uninhibited Kahlo would have had no such compunctions, while O'Keeffe—whose own 1920s work had been overloaded with sexually tinged critical response—would have read him privately. Still, because she and Stieglitz corresponded directly with Lawrence, and because she had friends who knew Lawrence well during his sojourns in the United States, O'Keeffe's connection to the novelist was closer than either Carr's or Kahlo's. In 1929, her breakthrough summer, O'Keeffe stayed for a few weeks

41
Emily Carr, *Shoreline*, 1936, oil on canvas, 68 x 111.5 cm.
The McMichael Canadian Art Collection, Kleinberg,
Ontario, Gift of Mrs. H. P. de Pencier, 1966.2.1.

in the cabin Lawrence had occupied earlier in the twenties. There she saw and painted the famous pine Lawrence had immortalized in *St. Mawr*. In her turn, Carr also responded to O'Keeffe's and Lawrence's treatment of that tree. But that account belongs more properly to Chapter 2.

In a painting like Carr's *Indian Church* are revealed the ways—both formal and symbolic—in which she straddled the gap between Victorianism and modernism in Canada. The prim white church amid the great sweeps of semi-abstracted trees calls up the contrast of styles in a direct, even confrontational way. Modernist encroachments challenge the old realist credo, just as native spirituality challenges the starched certainties of nineteenth-century Christianity. Carr struggles to find a visual language that can accommodate both, acknowledging the staunch moral correctness of colonialist religion but making it seem small and circumscribed within the larger mysteries of wild nature. In the combined generative and destructive power of the Canadian forest there is something to worship that is vaster than any human. Carr, though she sometimes feared the menacing power of Canadian nature, would never seek to diminish its role in either her painting or her writing. She would have agreed, always, with Lawrence's admonition to "acknowledge the wonder."

Through *Indian Church*, her totem paintings, and *Klee Wyck*, Carr also served as a link between native and European American arts. With her paintings, Kahlo did as well: because of their appropriation of the native art of the past, both Carr and Kahlo were seen in their nations as links between indigenous ("primitive" was the more common term during their lifetimes) artistic expressions and the developing modernist aesthetic. The roots of modernism were believed to arise, in part, from tribal art; as such, Carr's and Kahlo's overt and extended references to such art in their painting seemed to validate their connectedness to indigenous artistic expression. O'Keeffe, on the other hand, flirted more briefly with native art and imagery. Nonetheless, by association with her colleagues at 291, she was positioned among the most eager American explorers of such connections. As women, O'Keeffe, Kahlo, and Carr were also subject to—and believers in—the connections of women to nature, which will be discussed more thoroughly in Chapter 2.

The complex social and personal identities forged by Emily Carr, Frida Kahlo, and Georgia O'Keeffe were due in part to the interaction of nationality, region, and cultural practice. It is clear that place, whether outside one's window or represented in a painting, has been a powerful cultural determinant in the arts of the Americas. Evidence of a rising North-South cultural consciousness during the twentieth century is widespread in the hemisphere. Visible too is the paradoxical emergence of national cultural consciousness during the very decades when efforts at pan-hemispheric unity were under way. But in another sense, perhaps each tendency needed the other in order to develop. Lawrence's writings provided that paradoxical appeal for Carr, O'Keeffe, and Kahlo: even while celebrating the regional nativism

of Mexico and the American Southwest, he ultimately invoked a kind of primitivist universalism that transcends boundaries of nationality and race.

Still, it is obvious that the histories of Canada, Mexico, and the United States dictated fundamental differences in the creation of national consciousness. In each country the strength, duration, and character of colonial influences has been a powerful shaper of that consciousness. When artists are sensitive to the historic, mythic, and political circumstances surrounding them, these things can and must find expression in their work.

Although it can be risky to insist too closely on formal comparisons across artistic genres, a few basic observations appear with overwhelming consistency within national frameworks. For example, Latin American (including Mexican) literature and visual art have long shown a predilection for fantasy, dreaming, and mystical experiences. Social as well as aesthetic meanings are highly visible there too, more often than not conveyed through figural subjects. Historically, in the United States and Canada, landscape has served more often than the figure as a vehicle for conveying the artist's (and the nation's) ideologies. In particular, the artists' encounters with nature, with mythology, and with native peoples have been important markers on their cultural horizons. For Carr, Kahlo, and O'Keeffe, those associations with indigenous peoples, informed by the painters' sensitivity to modernism, liken that aspect of their work to what James Clifford has termed ethnographic modernism.

As they searched for individual identities, the artists were simultaneously aware of the kind of questions that have preoccupied nations of immigrants. In Canada and the United States, both of whose populations are descended overwhelmingly from immigrants, this is self-evident. Mexico, whose modern mestizo population is based largely on Indian and Spanish bloodlines, is somewhat more homogeneous, less ethnically diverse. Nonetheless, the issues remain: Kahlo, as a descendant of mixed European and Indian heritage, grappled with her identity as a mestiza—a continuing internal dialogue within her work and her life.

What emerges finally in studying Carr, O'Keeffe, and Kahlo within the North American cultural landscape is the realization that nationality is not a commodity in itself but carries enormous importance as a medium of exchange between the human-constructed and the natural, the other and the self. Being sensitive to the ways nationality operated helped each of the artists to work into and out of the collective mythos of her country—representing, questioning, and sometimes resisting its hold on her.

Looking at landscape, do we see nature or culture? Few people today would deny that landscape carries both cultural and natural meanings. Landscapes are sites on which dramas of myth, power, politics, and identity have been enacted over the centuries. In Chapter 1, I explored ways the cultural landscape of North America influenced the work of Carr, O'Keeffe, and Kahlo, particularly through myth. For these artists, myth provided conduits for human relationships on both personal and universal levels. Although many in their generation still assumed that humanity's discarding of myth and magic were a measure of its progressive evolution, Carr, O'Keeffe, and Kahlo gave silent assent to the views of Friedrich Nietzsche and Carl Jung, who held that mythic archetypes were imprinted deeply in the human mind, from which they could be retrieved and braided into the rich plait of modernity.[1]

A second major theme of this study, and the subject of this chapter, is the primary role of nature in the work of Carr, O'Keeffe, and Kahlo. For them, nature served as a wellspring of ideas and memories from which they drew perennial sustenance. It is a nature of process, of pulsating energies, of mystery and spirituality. And always, because of their intense subjectivity, human life—specifically their own lives—was integrated into the natural world. These stubborn, struggling souls sought to find antidotes in nature's primal sources to an increasingly mechanized society. Often they treated the natural world as an extension of the self; always they worked to synthesize visual fact with their emotional responses to their subjects.

The visual statements about nature contained in the paintings of Carr, O'Keeffe, and Kahlo are complex and revealing. What the artists chose to represent—what they included and what they left out, what they emphasized or downplayed, whether they painted process or product—in these factors reside the beliefs of each about nature. Beyond that, what do their paintings of nature contain or express beyond what they literally picture? To understand why these artists worked the old-new ground of women's nature experiences, we must pay attention to ideas both unique and widespread, looking at the individual ways each revealed her perceptions and experiences in her nature paintings. From the commonalities of their experience emerge broader models for relationships between women of the Americas and their natural environments.

Women and nature have been married and divorced repeatedly in Western consciousness. Their union has been a stormy one, fluctuating with the tides of history, religion, and whatever values can be described as collective within a society. A vast body of literature has explored the historical, metaphorical, and psycho-

logical implications of the women-nature nexus.[2] Such considerations reach to the core of identity, both cultural and individual.

In basic terms, the distant past has provided several models. If, for example, a society saw itself as rooted in nature, attentive to biological survival and agrarian lifeways, the status of women in that society as birthgivers was likely to be high; the goddess-centered cultures of ancient Europe exemplify such historical epochs. If, however, emphasis was placed on abstract values ascribed to male-dominated mastery of nature, then women were accorded a lower value.

The cultures in which Carr, Kahlo, and O'Keeffe lived and worked held more complex attitudes. Nonetheless, the three artists all found in nature a geography of the mythic and the unconscious. Their paintings and their lives reveal that all three identified with nature through form and symbol. This identification is not imposed from without but springs from the core of identity deep within each of them. Seen that way, the living symbiosis between women and nature resists attempts to bury it. Something in the union grips the imagination. If for no other reason, the sheer durability of the metaphor in women's writing and painting demands attention. The Canadian writer Margaret Atwood summarizes the debate, linking its survival to abiding questions about place:

Simone de Beauvoir and others after her have objected to the tendency in literature to make Woman-Nature metaphors or equations. Their objections are based on the kinds of limiting mystiques about women such metaphors foster, and are no doubt legitimate within certain boundaries; but these are the kinds of patterns literature makes—literature created by women as well as men—and in literature itself they cannot be avoided. Let us suppose then that Woman is Nature, or Nature is a woman. Obviously the kinds of female figures that can be imagined will then depend on what kind of place you live in—a desert is not the same as a jungle—and also on what you think of the kind of place you live in. Some find deserts beautiful and mysterious, others find them hot, sterile and arid.[3]

Taking Atwood's statement as a starting point and extending the ubiquity of the metaphor into the visual arts, place emerges as a mediating concept between women and nature in the work of Frida Kahlo, Emily Carr, and Georgia O'Keeffe.

Landscapes in the First Person: The Body as Primary Source

How can the individual sensibility enter into a place where history, landscape, and myth are fused into a seamless context? Many thinkers, ancient and modern, have argued that we make that entry through our bodies. Maurice Merleau-Ponty, for example, insisted that "we are in the world through our body. . . . Our own body is in the world as the heart is in the organism: it keeps the visible spectacle constantly alive, it breathes life into it and sustains it inwardly, and with it forms a system."[4]

One of humanity's oldest ideas linked the surface and structure of landforms to the human form; it is evident in some of the earliest artistic efforts we know. The complex ways the anthropomorphism of the earth has been connected to the self and society form a knot of cultural ideas about materialism and transcendence, illusion and reality, pleasure and denial, life and death. Although we still lack the evidence to unravel that knot, we can nonetheless perceive through examination of various forms of artistic expression that the dichotomy between self and environment, between the ego and the rest of the physical world, was once narrower than it is today.

The idea that landscape is female is both a historical and a psychological concept. Anatomical features have often been inscribed on natural forms, such as rock engravings, which can be securely dated from as long ago as 30,000 B.C. Styles of consciousness have evolved profoundly since then, but there is a surviving tradition—slender, to be sure—that keeps alive this rich store of symbolism. Modern thinkers, some of whom were known to and read by Carr, O'Keeffe, and Kahlo, have restated the cultural phenomenon of the body as a primary landscape. It operates in nearly hidden ways, embodied in forms which seem to connect to the depths of the psyche, like archetypes.

In modern psychology, especially in the psychoanalyst's attempt to decipher dreams, myths, and visions, such imagery often arises. What do these complicated responses to nature reveal? To Freud—whom Kahlo read assiduously, O'Keeffe more casually (we don't know about Carr)—certain natural forms were gendered. He believed that in both psychological and anthropological terms female forms included pits, caves, hollows, houses, water, blossoms, and fruit. Male forms, on the other hand, included rock outcroppings, sticks, the sun, and certain trees. And though O'Keeffe fiercely resisted Freudian critics who subjected great quantities of her 1920s work to sexual interpretations, there is much—deliberate or gratuitous— that springs from some liminal source in the land-body nexus that O'Keeffe, Carr, and Kahlo explored. It survives as an abiding statement combating death, uniformity, and ecological desolation in the landscape of Western civilization.

Many other twentieth-century thinkers have taken up this question. Analytical psychologist Eric Neumann, a student of Jung's, gave extensive evidence of mythic and anthropological aspects in *The Great Mother* (1955) while Vincent Scully presented findings in *The Earth, the Temple and the Gods* (1962) that architecture and the horizon share a common physiognomy. Paul Shepard, who has written synoptically on the aesthetics of nature, concludes: "From a psychiatric standpoint, architecture and land forms are a continuum, an interlocked series entangled with the body image."[5]

Norman O. Brown agrees. In his *Love's Body* (1966), he writes: "To recover the world of silence, of symbolism, is to recover the human body. . . . The true meanings of words are bodily meanings, carnal knowledge; and the bodily meanings are the unspoken meanings. What is always speaking silently is the body."[6] All analogy, therefore, is based on linkages between mind and body. To philoso-

pher Gaston Bachelard, bodily knowledge need not be cloaked in silence or analogy; it can be intensely direct. His term "muscular consciousness" refers to the sensation of physical identification between a work of art and the body of the maker or the viewer.

Most recently, art historian Whitney Chadwick reasserts the belief that the earth is female and renews the centrality of the body in the experience of twentieth-century women artists, particularly surrealists: "However fantastic their imagery, it remains firmly rooted in their experience of their own bodies and their acceptance of their own psychic reality."[7]

In Chapter 1 we saw how Kahlo used female imagery to extend and support longstanding ideas about *Mexicanidad* and the sacredness of the Mexican earth, an earth she imagined as female. As Kahlo worked out her personal symbolic system built upon dualities—or sometimes multiple layers of meaning—she kept her imagination at work constructing a perception from her own body outward. At times, her body and the Mexican landscape merged, not merely in her own mind but in the imagination of others as well. Art historian Luis Cardoza y Aragon identified Kahlo and Rivera with two of Mexico's ageless geographic symbols, the two snow-capped volcanoes in the rim of mountains surrounding the Valley of Mexico: "Diego and Frida were part of the spiritual landscape of Mexico, like Popocatepetl [the Smoking Mountain] and Ixtaccihuatl [the Sleeping Woman] in the valley of Anahuac."[8]

Such woman-land connections were underscored by many poets, painters, and photographers in Rivera and Kahlo's circle. Alice Paalen's poem "L'Ixtaccihuatl" appeared in the pan-hemispheric periodical *DYN* accompanied by a stark photograph of the mountain's Sleeping Woman contours. The poem begins, "Ixtaccihuatl, named by the gods, the sleeping woman whose face turns toward the rising sun . . ."[9] Kahlo's own husband painted the landscape as a mythic female, perhaps as Kahlo herself. In his *Symbolic Landscape* (fig. 42), painted during his year-long divorce from

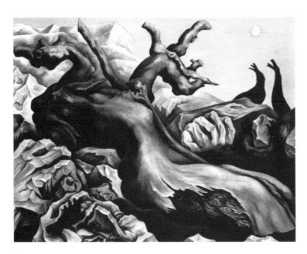

42
Diego Rivera, *Symbolic Landscape*, 1940, oil on canvas, 121 x 152.5 cm. San Francisco Museum of Modern Art, Gift of friends of Diego Rivera.

Kahlo, a tree-woman, decapitated as are several Mexican goddesses, writhes in a rocky landscape under a pale moon. Rivera's faceless woman is a victim of dark earth forces.

If Kahlo identified with the landscape monumentality of Ixtaccihuatl, she also had access through that association to another of Mexico's legendary earth mothers, Malinche, already encountered in Chapter 1. Mexican painter Antonio Ruiz's *Dream of Malinche* (1939; private collection) fuses her with the sleeping woman Ixtaccihuatl. And Kahlo likewise, as a personification of the volcano, belongs to the long tradition of mythic women whose bodies fuse with the land.

Kahlo's paintings of the earth, however, speak less of the victimization Rivera hints at than of her desire to merge her developing personal mythology with the multiple mythologies of the female earth. Her identification—indeed her obsession—with fertility, giving birth, and mothering was often referred to by Kahlo as a prime motivation in her work. In a 1943 article on her work, Rivera summarized the matter thus: "For Frida the mother figure is the tangible, the center of all, the matrix; sea, storm, nebula, woman. And Frida is the only example in the history of art of someone who tears her breast and heart open to tell the biological truth about what she feels in them. She painted her mother and her wetnurse, knowing that she really did not know their faces." [10]

That Kahlo could not remember the face of her wetnurse is not of great importance, for she used that image as a symbol, an archetype for the nurturing earth (see fig. 38). The concept of the earth as nurse occurs in several cultures of Europe, Asia, and the Americas. In the writings attributed to the legendary Hermes Trismegistus, a central figure in the alchemical tradition in which Kahlo became vitally interested, we find preserved an ancient concept of personified nature: "The sun is its father, the moon is its mother. Wind is carried in its belly, the earth is its nurse." [11]

Still another source for Kahlo's personifications of nature must be mentioned here. As a suggestive young woman of seventeen, she read Gustave Flaubert's novel *Salammbô*. [12] There, in the pages of Flaubert's voluptuous and violent tale of the Punic Wars, Kahlo encountered the priestess *Salammbô*, who served in the temple of the goddess Tanit. Flaubert includes various exotic mythologies in his tale, full of bizarre characters and dramatic events. One dark story of the earth's origins contains details that resound in Kahlo's later personifications of body and earth imagery: "Then Matter condensed. It became an egg. It broke. One half formed the earth, the other the firmament. The sun, moon, winds, clouds appeared: and at the crash of thunder animals with intelligence awoke. . . . Rabbetna, like a nurse, leaned over the world, pouring out her light like milk and her might like a mantle." [13]

Kahlo used such images—of eggs dividing, suns with arms, volcanoes, and earth-mother nurses—in such works as *Moses* (see fig. 5), which renders history as claustrophobia. The painting is crowded to the edges with an idiosyncratic pantheon of gods and heroes assembled by Kahlo from many literary sources,

doubtless including *Salammbô*. Arranged in rows (as if shelved that way in Kahlo's brain) the characters in *Moses* compete for space in some half-realized catalogue of the demonic and the divine. That some of Flaubert's symbolic detail overlapped with imagery from the Mesoamerican world would have only increased its appeal for Kahlo. In *Moses*, Kahlo comments in several ways—all transgressive—about Freud's assertions in *Moses and Monotheism*, linking the emergence of monotheism with several simultaneous mythic triumphs: of intellectuality over sensuality, of the father over the mother, and of a single invisible deity over formerly visible gods. As Freud noted,

An advance in intellectuality consists in deciding against direct sense-perception in favour of what are known as the higher intellectual processes—that is, memories, reflections, and inferences. It consists, for instance, in deciding that paternity is more important than maternity, although it cannot, like the latter, be established by the evidence of the senses. . . . Or it declares that our God is the greatest and mightiest, although he is invisible like a gale of wind or like the soul.[14]

In her painting *Moses*, Kahlo challenges Freud, declaring in vehement visual language that the gods and heroes humanity has invented are plural, of both sexes, and insistently visual. Among the many messages Kahlo conveys in *Moses* (some discussed elsewhere in these pages) are the clear claims that sense perceptions are not to be denied, that women occupy central positions as creators, and that the earth itself is female. In the latter assertion, Kahlo found support in Mesoamerican religion, where nature was decidedly female, often represented as a nurturing mother. She was sometimes imagined as a milk-goddess tree (fig. 43). In *My Nurse and I* (see fig. 38), mentioned above, the earth is a nourishing mother with a stone Teotihuacan-style mask that allows no doubt that she is to be identified as Mesoamerican. This painting has been analyzed often; I would prefer to look here at others in which personified nature, and its sources for Kahlo, reveal the complexity of her paintings made with the body in mind.

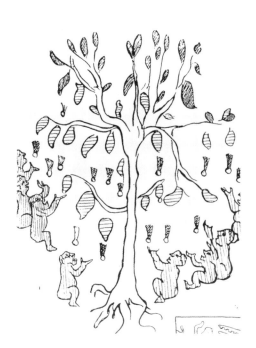

43
Milk Goddess Tree (Breastfruit Tree), from *Codice Vaticano Latino* (Rome, n.d.).

Leonardo and Symbolic Landscape

The year 1519 marked an important beginning and an equally noteworthy ending in Western history: Cortés arrived in Mexico and Leonardo da Vinci died in France, an event that signals the waning of the High Renaissance in European art. At first the two seem to bear no relation to each other, but both had a marked effect on Kahlo's writing and painting.

In the discussion of the Mexican symbols in Kahlo's *What the Water Gave Me* in Chapter 1, we encountered a geography of the obscure land of the unconscious. It is a domain where nature is synthesized as it is in dreams and where natural features often stand for anatomical or social events. This was not a new idea for artists—neither Kahlo nor even the European surrealists. It had a much older basis and had burned with special fervor in the mind and work of Leonardo, who wrote:

So then we may say that the earth has a spirit of growth; that its flesh is the soil, its bones are the successive strata of the rocks which form the mountains, its muscles are the tufa stone, its blood the springs of its waters. The lake of blood that lies about the heart is the ocean; its breathing is by the increase and decrease of the blood and its pulses, and even so in the earth is the flow and ebb of the sea. And the heat of the spirit of the world is the fire which is spread throughout the earth; and the dwelling-place of its creative spirit is in the fires, which in diverse parts of the earth are breathed out in baths and sulphur mines, and in volcanoes.[15]

Kahlo was an admirer of European Renaissance and post-Renaissance painting. Her wide reading and study of art books, as well as her career intentions, would have drawn her early to the protean Leonardo. As a girl, Kahlo dreamed of studying medicine; subsequently, after her bout with polio and her horrific accident of 1925, she considered becoming a medical illustrator. Leonardo pioneered the modern practice of medical illustration, using studies based on anatomical dissection to show, for the first time, such things as embryos in the womb. Kahlo would often use images of the infant in utero in her own drawings and paintings.

In 1926 Kahlo worried that she would never be able to bear a child. Nonetheless, she mused on the possibility of maternity by inventing a fictive son, whom she called Leonardo. On a card written in calligraphy she announced his birth and a ceremonial welcome for him:

LEONARDO

WAS BORN AT THE RED CROSS

IN THE YEAR OF GRACE, 1925, IN THE

MONTH OF SEPTEMBER

AND WAS BAPTIZED IN THE

TOWN OF COYOACAN

THE FOLLOWING YEAR
HIS MOTHER WAS
FRIEDA KAHLO
HIS GODPARENTS
ISABEL CAMPOS
AND ALEJANDRO GÓMEZ ARIAS.[16]

With the Italian Renaissance master, Kahlo shared a taste for land-body metaphors, and several of her works show a strong kinship with Leonardoesque land-body structure. Particularly in her *My Nurse and I* and *Love Embrace of the Universe: The Earth (Mexico), Diego, Me and Señor Xolótl* (see fig. 39), monumental earth mothers take on the mass and coloration of the land itself. In the latter work there are three "mothers": Kahlo herself, holding the infant Diego (to whom she often said she wanted to give birth); the earth goddess Cihuacóatl, here fissured, bleeding from the breast, the unmistakable Mexican counterpart of the female whose flesh, as Leonardo wrote, is the soil itself. The third mother, cosmic and evanescent, is the universe herself, porous, like the *pedregal* (barren volcanic landscape) that Kahlo often painted, with muscles (again borrowing Leonardo's words) like tufa stone. This ultimate mother's body functions as an archetypal primary landscape, whose experiential relationship to humanity conditions subsequent notions about intimacy and space.

Mona Lisa (c. 1503–05; Musée du Louvre), Leonardo's own monumental woman, likewise partakes of the mystery and monumentality of her landscape background—becoming, ultimately, a woman-mountain. Leonardo's groups of women, notably in his *Cartoon for the Virgin and Child with St. Anne and the Infant St. John* (fig. 44), fill the picture space with mass and solidity, like the figures in Kahlo's *Love Embrace*. In fact, Leonardo's multigenerational image of the child on Mary's lap who, in turn, is seated on St. Anne's lap may be a distantly remembered prototype for Kahlo's cosmic generations of earth mothers. A page from her diary that superimposes the features from a Leonardoesque female head above Kahlo's own face reinforces such a likelihood.[17] Still other prototypes—these much closer to home—are found in such Mexican works as a carved seventeenth-century *St. Anne and the Virgin Mary* (fig. 45), an image of powerful monumentality and symmetry.

In Kahlo's *My Nurse* and *Love Embrace* the mothers are intact and multiple, but in a 1944 drawing called *Fantasy I* (fig. 46), the mother has been dismembered, as in Kahlo's own terrible fantasy of her corporeal self. From the earth's crust emerge an anguished face and two breasts which, volcanolike, spurt drops of liquid. Beneath, also embedded in the earth, are two pairs of lips and a jagged fissure that widens into a foreground pool, perhaps again invoking Leonardo's metaphor quoted above or the sea of blood Kahlo herself mentioned painting.[18] This is another reminder of a vision of the earth Kahlo shared with Leonardo—a dynamic vision of the world as a

kind of organism in transformation, where realignments of earth and water surfaces produce oddly discordant landscape elements. Kahlo's painting, however, converts the female landscape into an intensely personal place; in Kahlo's *Fantasy I*, woman as nature is seen at her most violently abused.

At times horrific, Kahlo's imaginings of her body as landscape could also be beatific. In her diary, begun about the same time as *Fantasy I* (1944), more-benign land-body metaphors occur. Even more than *Love Embrace*, they speak of fecundity, of symbiosis, of the cosmic merger of herself with Rivera and, beyond him, with the natural universe. "The green miracle of the landscape of my body," she wrote, "becomes in you [Rivera] the whole of nature." [19]

Kahlo's work contains frequent reminders of the duality of violence and beauty common in Aztec culture, and of the ways they are bound together in legends of women and nature. In the following myth it is a violated earth goddess—here Coatlicue herself—whose dismembered body rejuvenates nature:

44
Leonardo da Vinci, *Cartoon for the Virgin and Child with St. Anne and the Infant St. John*, c. 1498, charcoal heightened with white on brown paper, approx. 137 x 99 cm. National Gallery, London.

The Natural Self: The Body and Nature

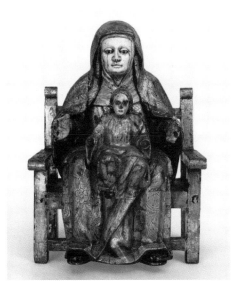

45

St. Anne and the Virgin Mary, seventeenth-century
Mexican, polychromed wood, glass eyes, 68 x 51 x 32 cm.
San Antonio Museum of Art, Museum purchase
with funds provided by the Sarah Campbell Blaffer
Foundation, 76.22.5P.

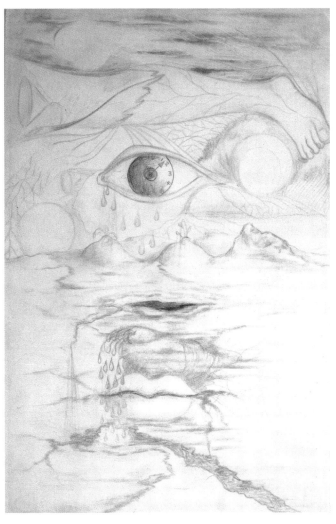

46

Frida Kahlo, *Fantasy I*, 1944, graphite and colored
pencil on paper, 23.9 x 15.7 cm. Collection of Museo
Dolores Olmedo Patiño, Mexico City.

The gods Quetzalcóatl and Tezcatlipoca brought the earth goddess down from on high. . . .
They said to each other, 'We must make the earth.'. . . As they tightened their grip,
she broke at the middle. The half with the shoulders became the earth. The remaining
half they brought to the sky—which greatly displeased the other gods.

Afterward, to compensate the earth goddess for the damage those two had inflicted
upon her, all the gods came down to console her, ordaining that all the produce
required for human life would issue from her. From her hair they made trees, flowers, and
grasses. . . . From her shoulders, mountains.

Sometimes at night this goddess wails, thirsting for human hearts. She will
not be silent until she receives them. Nor will she bear fruit unless she is watered with
human blood.[20]

Many aspects of the woman-goddess-nature triad are united in this story of the
violated Coatlicue, whose body parts configure the earth and its flora; she is monster
as well as mother. Not only is she the prototypical earth mother of Kahlo's
Love Embrace, but she is also La Llorona, Cihuacóatl, and all women who wail in the
night. She is female suffering universalized; she is Kahlo's agony particularized.
And yet she survives, as Kahlo did, to personify the triumph of female will, rebirth,
and creativity over all who seek to destroy her. On a page from Kahlo's diary the
Nahuatl word *icelti* (alone)—appearing in large red letters surrounded by fragmented
heads and eyes—persuasively equates the artist's personal agony with the ritualized
suffering of the Aztec world. And a page from the Aztec *Florentine Codex* pictur-
ing fragments of the human body recalls the pre-Cortésian antecedents of Kahlo's
images of human dismemberment.

The Heart: Power and Vulnerability

No discussion of Kahlo's body imagery would be complete without reference
to her frequent paintings of hearts. Surely they are related to her own corporeality,
to her heart as the core of her body and the seat of romance, longing, and heartbreak.
Some of Kahlo's visual vocabulary of the heart finds its basis in traditional Mexican
Catholicism: the bleeding heart refers to the passion of Christ, a tradition too well
known to need discussion here.[21]

But Kahlo also—and perhaps most significantly—thought of the heart as
generative of artistic creativity. Her diary and her paintings suggest that the source of
this iconography lay in Aztec (Nahuatl) thought. In such texts as the famous *Codice
Matritense* of the early conquest period, artists were said to be born, not made—
destined from birth to create. But to realize that destiny, the artist had to possess a
"face and a heart," understood by the Nahuas to be a well-defined personality.
More, the artist had to learn to converse with that heart:

The Natural Self: The Body and Nature

The true artist, capable, practicing, skillful,
maintains dialogue with his heart, meets things with his mind.
The true artist draws out all from his heart.[22]

In the Nahua language the word for heart, *yollotl*, is derived from *ollin*, movement. As historian Miguel Léon-Portilla notes: "The profound significance of movement to the Nahuas can be deduced from the common Nahuatl root of the words movement, heart and soul."[23] Thus when Kahlo wore stitched on her dress the glyph for movement (discussed in Chapter 1), she was really identifying herself as an active searcher—an artist. It was a badge of identity. In Kahlo's case, the search was through visual art; in the Nahuatl texts it could also be through poetry or song. But always the heart stands for the dynamic quality of the ego which goes wandering after wisdom and art. So to acquire an education in Nahuatl terms was to humanize the heart and give shape and meaning to the human face. The Nahuatl educator, called "teacher of people's faces," assisted in this process:

He makes wise the countenances of others;
he contributes to their assuming a face;
he leads them to develop it
. .
Before their faces, he places a mirror;
prudent and wise he makes them;
he causes a face to appear on them.[24]

A painter of portraits—her own or others—does precisely the same thing. She places a mirror before her face (in the case of a self-portrait) and causes a new face to appear on canvas. As it materializes, the artist gives shape and meaning to that painted face, investing it with dynamic ego—the Nahua "face and heart."

As artist and teacher, Kahlo took this role seriously; she never tired of pursuing "face"—that which most intimately characterized the individual. In modern European American culture, we take for granted that the portrait painter will affix something of the sitter's individuality on canvas. In Nahua terms the creation of a face meant much more: by acquiring a face the individual could be helped to arrive at his or her own truth and to humanize his or her heart. The intensity and persistence of Kahlo's scores of self-portraits reflect that deeper mystery; through them Kahlo "assumed her face" and conversed with her heart. That is, she fulfilled her destiny, establishing her identity as an artist.

Kahlo expanded on heart imagery in a number of her paintings, notably *Self-Portrait with the Portrait of Dr. Farill* (fig. 47), in which she portrayed her palette

as a clearly delineated heart, with its chambers, major arteries, and veins detailed explicitly. From the bundle of brushes she clutches in her right hand fall red drops, obviously blood. In unequivocal visual language, Kahlo tells us that this portrait comes straight from the heart. Reinforcing this Nahua-based interpretation is the tasseled ornament Kahlo places prominently on her smock—a detail borrowed directly from the Aztec codices.[25]

　　Dr. Juan Farill was Kahlo's surgeon during an especially devastating period of her life, in which she underwent at least seven operations on her spine. After a year spent in the English Hospital in Mexico City, she was released in 1951, feeling a tremendous debt of gratitude to the surgeon. "Dr. Farill saved me. He gave me back the joy of life. . . . I already have begun to paint the little painting that I am going to give to Doctor Farill and that I am doing with all my affection for him."[26] Kahlo's biographer Hayden Herrera has likened the resulting painting to a secular *retablo*, an act of faith. But *Dr. Farill* is more than an expression of gratitude, a mere votive painting. It is a complex tapestry of myth: seen through the Nahua lens, Kahlo as an artist draws out all from her palette-heart. And in alchemical terms Dr. Farill, as a physician, also qualifies as an artist whose skills are rooted in the heart. If Farill gave Kahlo back the joy of life, she renders her thanks by "giving him a face." And the face she gives her physician-artist, with its densely joined eyebrows,

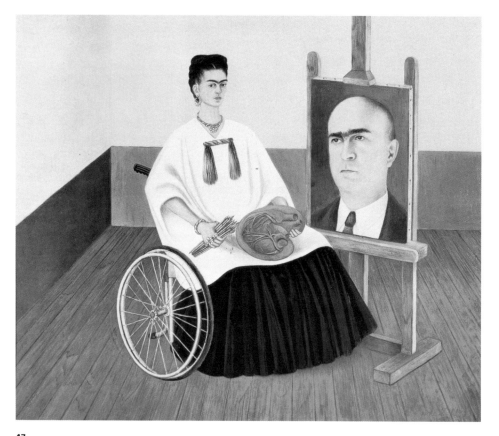

47
Frida Kahlo, *Self-Portrait with the Portrait of Dr. Farill,*
1951, oil on masonite, 41.5 x 50 cm. Private collection.
Photo courtesy Galeria Arvil, Mexico City. Photo by
Javier Hinojosa.

The Natural Self: The Body and Nature

is—unsurprisingly—akin to Kahlo's own face. Both are, after all, artists in their own ways. Comparing this painting with the marriage portrait Kahlo painted twenty years earlier in San Francisco (fig. 48), we see here her final coming of age as an artist. In 1931 Diego Rivera had been the acknowledged artist—holder of the heart-shaped palette; beside him, a deferential Kahlo held only his hand. Now, in her portrait with Dr. Farill, she clutches the heart-shaped palette and brushes firmly in her own hands: she has come into full possession of the heart and skill of the artist.

As she often did, Kahlo layered meaning upon meaning, freely fusing past and present, Christian, alchemical and pre-Cortésian texts, in a kind of romantic ecumenism. The bleeding hearts of Mexican Christianity resonate with older symbolic references from the Aztecs. According to their tradition, when the Aztecs arrived at the Lake of the Moon, they saw the eagle (the Sun) perched on a nopal cactus whose fruits (called tunas) are blood-red and shaped like human hearts. As historian Laurette Séjourné writes, "In Aztec art the prickly pear, fruit of the miraculous stone, is given the shape of a human heart."[27] The old identification of the heart with tunas, the fruit of the prickly pear, lingered into modern times and was incorporated by Kahlo into several of her still lifes. *Tunas* (fig. 49) is one of them. Three irregularly shaped fruits, two of them blood-red, seem to have been cut violently from their plants. Smeared on the plate and the white drapery beneath is their red juice—

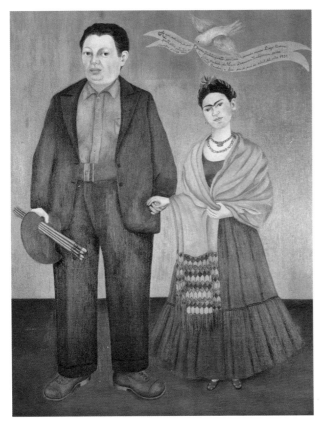

48
Frida Kahlo, *Frieda and Diego Rivera*, 1931,
oil on canvas, 99 x 78.7 cm. San Francisco Museum
of Modern Art, Albert M. Bender Collection,
Gift of Albert M. Bender.

"blood" from fruits that symbolize the human heart. In describing the associations and uses of such colors in her diary, Kahlo called deep red *tlapali*, an Aztec word for that color, and likened it to the "Old blood of prickly pear." Kahlo's friend Anita Brenner put it more simply: in Mexico, she wrote, "fruits and flesh are of the same blood-filled texture."[28] In *Tunas*, Kahlo uses the vegetal world to represent human suffering—most likely her own.

Other of Kahlo's heart images move back and forth between indigenous and European American contexts, extending the artist's highly personal references. In *Memory* (see fig. 11), a ghastly, oversized heart has been excised from her chest and lies bleeding profusely on land and sea. Bodily wounds here seem to refer to the mental pain Kahlo had suffered as a result of Rivera's affair with her sister Cristina. When her marriage deteriorated, Kahlo again called upon the heart to convey her desperate unhappiness. *The Two Fridas* (fig. 50) includes a dual self-portrait, with double exposed hearts. The Frida on the right, clad in indigenous Tehuana costume, represents the woman loved by Diego. The other, in stiff Victorian white, is Frida scorned; her heart has been cut open and drips blood on the white dress.

49
Frida Kahlo, *Tunas (Still Life with Prickly Pear Fruit)*,
1938, oil on tin, 19.7 x 24.8 cm. Private collection.
Photo courtesy Mary-Anne Martin/Fine Art, New York.

The Natural Self: The Body and Nature

No longer is she connected to Diego, to whom she had once addressed a fragment of poetry copied into her diary: "My blood is the miracle that travels in the veins of the air from my heart to yours."[29]

In November 1938 two of these heart-imagery paintings were included in a show of Kahlo's work at the Julien Levy Gallery in New York. *Memory* (alternatively titled *The Heart*) and *Tunas* were among the twenty-five subjects exhibited. The whole group was rich in body, heart, and blood imagery and included most of Kahlo's major works up to that time. Georgia O'Keeffe came to the opening, along with many important figures from the New York art world. The two women had met, we recall, seven years earlier and had since corresponded a bit. Now O'Keeffe was seeing Kahlo's work, presumably for the first time outside of reproductions. Kahlo was just beginning her public career; O'Keeffe, at fifty, had already achieved much critical success and public acclaim. What would she have taken note of in Kahlo's exhibition? The penetrating self-portraits? The many references to the Mexican past? The frequency with which Kahlo alluded to the body, to themes of life and death, to the human heart?

50

Frida Kahlo, *The Two Fridas*, 1939, oil on canvas,
173.5 x 173 cm. Museo de Arte Moderno, Mexico City.
Photo by Rafael Doniz.

Lewis Mumford had already written of O'Keeffe that "every painting is a chapter in her autobiography."[30] O'Keeffe surely saw that searingly personal autobiographical quality in Kahlo's work, revelatory of the Mexican's most intimate secrets. By contrast, her own work was serenely veiled.

But O'Keeffe would have her own affairs with heart imagery. A few years later she made a pastel she sometimes called *My Heart* (fig. 51) but sometimes depersonalized into *Untitled*—changes that leave viewers wondering about O'Keeffe's original intent. The subject is unmistakably two smooth black rocks, of the kind O'Keeffe collected and prized. As in other paintings of small natural objects, like shells and flowers, O'Keeffe has magnified the objects to full-frame proportions. Turned 90 degrees counterclockwise, the combined shapes do indeed resemble a rough heart—of the Valentine variety, not like Kahlo's bleeding organs. Is this O'Keeffe's little joke, that in rotating the image (as she sometimes liked to do) two overlapping rock shapes become a heart? Or is she, as Mumford would have it, slyly suggesting something about her inner life? On several occasions O'Keeffe had referred to herself as heartless, for example, in 1930, when she left Stieglitz for a respite in Maine. Feeling some guilt about her departure, she wrote to Dorothy Brett, calling herself "a heartless wretch."[31]

In 1944, the year she painted *My Heart*, O'Keeffe again left the perpetually ailing Stieglitz for what had become her annual ritual of painting in New Mexi-

51
Georgia O'Keeffe, *My Heart* (formerly *Untitled 3*),
1944, pastel, 69.9 x 54.6 cm. Museum of Texas
Tech University, Lubbock, Collection of the Museum
of Texas Tech University Association.

The Natural Self: The Body and Nature

co. Gone for more than half the year, O'Keeffe struggled to balance her need for independence with regrets about abandoning Stieglitz. To fortify herself, she had learned to assume a certain steely determination, a hard heart. Shortly after arriving in Abiquiu that April, she wrote to a friend about her relationship with Stieglitz: "I know Ive had to be both strong and tough to survive." She told other friends that summer that the harsh New Mexican outdoors also demanded toughness: "I certainly take a beating from the country and the weather."[32] Like the polished black rocks she called her heart, O'Keeffe felt herself hardened and weathered by necessity, by the effort of living her chosen life. Explaining why she had called her pastel of rocks *My Heart*, she said, smiling slightly, "I thought they looked hard."[33] That her heart is comprised of two parts perhaps indicates the divided nature of O'Keeffe's affections. But the two halves are unconnected to anything outside themselves: their smooth surfaces, glinting a dull gray, are completely self-contained.

By contrast, Kahlo's pulpy, blood-saturated hearts always seem laden with violence and immediacy; severed veins and arteries drip with her lifeblood. For both artists, their bodies, especially their hearts, were their ways of being in the world. These artists manifested their presence in paintings that speak corporeality—Kahlo's in shouts, O'Keeffe's in whispers. But both summoned nature back to the rhythms of their own pulses. They perceived the world through their bodies, a phenomenon which, as Maurice Merleau-Ponty, Norman O. Brown, Eric Neumann, and others have argued, is no less true for being self-evident.

Emily Carr: The Body Speaks

Emily Carr made no heart paintings. Her vision of the body found itself rather in the female earth, with which she identified deeply, bringing all her senses to focus on the land: "Dear Mother Earth! I think I have always especially belonged to you. I have loved from babyhood to roll upon you, to lie with my face pressed right down on to you in my sorrows. I love the look of you and the smell of you and the feel of you."[34] As early as 1893, when she returned home from art school in San Francisco, Carr was offended by her brother-in-law's remark that she had lost the smell and flavor of mother earth; she determined that in the future she would never be without it.

As she worked on a difficult painting, *The Mountain*, in 1933 (fig. 52), Carr struggled to subdue the unruly form, which she had come to think of as female: "My mountain is dead. But I haven't done with the old lady; far from it. She's sprawling over a new clean canvas, her germ lives and is sprouting vigorously." The intransigent mountain, the "old lady," is part of an artistic landscape Carr made from her own body—the body that for her became one with the environment and with her artistic aspirations: "If I could only make her throb into life, a living, moving mass of splendid power and volume!"[35]

A few years later Carr painted a magnificent oil-on-paper self-portrait (fig. 53), alive with the splendid power and volume she had tried to coax out of her mountain.

52
Emily Carr, *The Mountain*, 1933, oil on canvas,
111.4 x 68 cm. McMichael Canadian Art Collection,
Kleinberg, Ontario, Gift of Dr. and Mrs. Max Stern,
Dominion Gallery, Montreal, 1978.16.

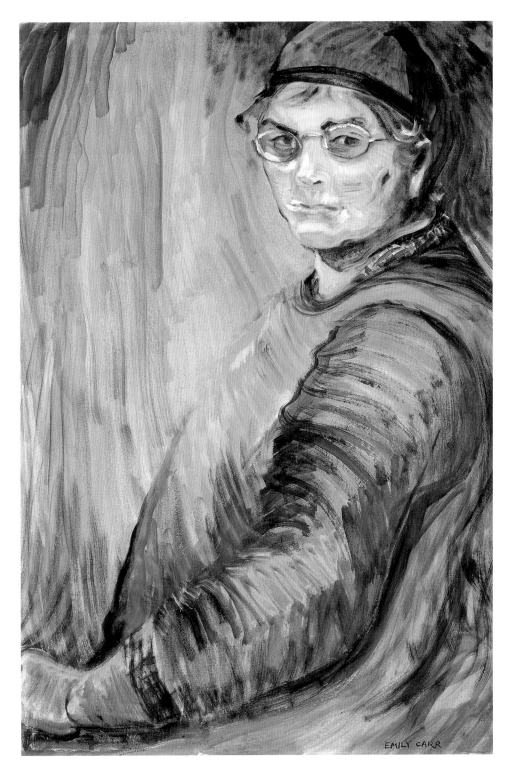

53

Emily Carr, *Self-Portrait*, 1938, oil on wove paper,
mounted on plywood, 85.5 x 57.7 cm. National Gallery
of Canada, Ottawa, Gift of Peter Bronfman, 1990.

Gazing steadily out at us beneath the little net cap she frequently smoothed over her head, Carr has become, symbolically, her own mountain—massive, rounded, striated with moving contour lines like those that describe the ribbed and lumpy face of her mountain. In color and texture she is one with her background, rising and vibrating with it.

Though she sketched a few friends and acquaintances in the late thirties, painting portraits was not to Carr's liking. She struggled with the issue of privacy, reluctant to reveal too much of the sitter's inner self: "I hate painting portraits. I am embarrassed at what seems to me to be an impertinence and presumption, pulling into visibility what every soul has as much right to keep private as his liver and kidneys and lungs and things. . . . The better a portrait, the more indecent and naked the sitter must feel." [36]

Is it possible Carr did not realize how revealing her own self-portrait was? Had she known, or admitted, her own achievement, Carr might have shrunk from what her self-portrait disclosed. Perhaps she thought she had given only a surface treatment: "An artist who portrays flesh and clothes but nothing else . . . is quite harmless," she insisted. Perhaps she thought the painting's simplicity and sternness concealed what every soul has the right to keep private. Indeed, compared to the few other existing portraits Carr made, her own is radically simple, undetailed. Still, it speaks volumes about her and her relationship to nature.

What she shows of herself at age sixty-seven is nothing less than her core identity. Beneath the mountain-monumentality and simplicity of her self-in-nature, Carr is just what she had once wanted her mountain to be: solid, securely grounded on the earth, alive. Carr had dreamed of her mountain as a "living, moving mass of splendid power and volume." Power and volume are there aplenty in the corporeality of her self-portrait, a summation of the iconic power she had learned to summon. We see revealed there, finally, nothing less than the artist's ultimate and complete union with nature, perhaps her most intimate secret of all.

Another aspect of Carr's relationship to the land was her celebration of continuous creation, unceasing change. Meaning was situated in the instability of things, their latency and kineticism; nature was a repository of possibility, not of stasis. She wanted to express that flux in ways both small and large. First in the details of nature: "The *liveness* in me just loves to feel the *liveness* in growing things, in grass and rain and leaves and flowers and sun and feathers and fur and earth and sand and moss." The artist and the world of nature surge through her words and her paintings. In her more expansive moments she wanted her own limited being to merge and swell into a larger wholeness with her work: "Direction, that's what I'm after, everything moving together, relative movement, sympathetic movement, connected movement, flowing, liquid, universal movement, all directions summing up in one grand direction, leading the eye forward, and satisfying." [37]

The Natural Self: The Body and Nature

Carr and O'Keeffe both sought equilibrium between the great forces at work in nature, and both used the fluidity of the sea to suggest an unbroken sweep of land or vegetation. Their remarks are notably similar: Carr, working in impossibly thick forest growth, warned herself in her journal, "Should you sit down, the great, dry, green sea would sweep over and engulf you."[38] Characteristically, Carr exaggerated the overwhelming aspect of nature, in part to enhance her self-appointed role as intrepid forest explorer, alone and braving the aggressive outdoors, which might at any moment swallow her. Carr's forests, as in her *A Rushing Sea of Undergrowth* (fig. 54) are all kinetic energy, given oceanic proportions. The impression is immediate, full-tilt, every sensation working at top speed. Here Carr sees nature through a romantic lens, a consciously subjective filter. It is both sublime and terrible.

Like Carr, O'Keeffe sensed the primordial sea in the vastness of landscape, but her sea metaphors were less fearsome than Carr's. O'Keeffe saw her first sea plains in West Texas, then others in New Mexico. At Taos in 1929 she found fossilized mussel shells out in the sage-covered hills. "The plain was covered with the grey sage that in a few places crept up a bit against the base of the mountains, looking like waves lapping against the shore. . . . I haven't seen any more shells like them and haven't seen a sea of sage like that either."[39] O'Keeffe's prose elegy to ancient seas and uninterrupted waves of sage is likewise romantic, but with the Wordsworthian constraint of emotion recollected in tranquility. Though she loved nature's *sturm-und-drang* in fierce lightning storms, in such works as her pastel *Pedernal* (see fig. 40), O'Keeffe celebrates the serenity of nature embedded in a millennial sweep of time.

For both Carr and O'Keeffe, nature was capacious enough to hold all their moods, its forms and forces sufficiently varied to mirror every nuance of emotion. In her 1933 journal Carr recorded that she was painting a "flat landscape, low-lying hills with an expanding sky." In such places, as Norman O. Brown writes, "Meaning is in the play, or interplay, of light." Carr's concern was to picture on canvas that kind of interplay and balance. She had learned it from life: "What one borrows one must pay back in some form or another. . . . A picture, like life, must also have perfect balance." What she shared with O'Keeffe (who knew a thing or two about solids and voids) was a sense that form and space were vital and interdependent. To O'Keeffe's perennial concern with "filling space in a beautiful way," Carr answered her own need for "filling space and at the same time leaving space, shouting but silent. . . . Space is more real than objects."[40]

A space that could shout while remaining silent, trees that breathed audibly while rooted to the earth, a mountain at once remote and capable of wrestling like a "great corsetless woman"—these are the contradictions within Carr's anthropomorphized nature. The woman, we must inevitably conclude, is Carr herself, another version of the monumental form she had taken on in the 1938 self-portrait

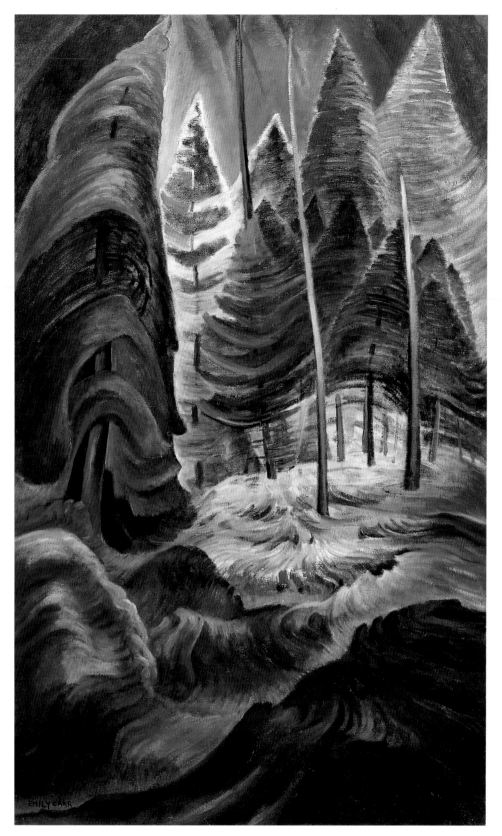

54
Emily Carr, *A Rushing Sea of Undergrowth*, 1932–35,
oil on canvas, 112.8 x 69 cm. Vancouver Art Gallery,
Emily Carr Trust, VAG 42.3.17. Photo by Trevor Mills.

discussed above. The artist embraced both nature's analogous forms and its contradictions, unwilling to force nature into fixed definitions that would squeeze the life from it, and from her paintings as well.

Nature and the Artist's Eye

One of Carr's contradictions is worth looking at a little closer, in part because of its relationship to O'Keeffe's work. Since both artists were interested in scale and magnitude of space, we can reasonably compare their feelings about it. In her later years, Carr came to think of her interest in vast Canadian spaces as present in her work from the start, or nearly. But it is clear that her meeting in 1927 with the Group of Seven painters (augmented, undoubtedly, by her reading of the capacious Whitman) revealed to her the possibilities of painting Canadian wilderness and Canadian space. Thereafter she opened up her spaces, admitting more air, sky, and clouds and struggling for "bigness, simplicity, spirit." Camping in her van during a rainy spell in the summer of 1936, Carr fretted over the necessity to tackle "those big emptinesses. They must work together with the sky—that I know. They must express emptiness but not vacancy. They must be deep." And a few days later she reminded herself, "The stuff about is big. Its beauty consists of its wide sweeps and is difficult, for space is more difficult than objects. Objects are all well enough for studies, but what this place has to say is out in the open. It is like a vast sound that must be produced with very few notes and they must be very true or else it will be nothing but noise."[41]

Carr's struggles with space produced some moments of exultation, others of bitter defeat. If the luminous, expanding dome of heaven was the apex of nature's sublimity, it was also, at times, terrifying. Traveling east to her first meeting with the Group of Seven in 1927, she mused on a merger with the infinite: "I should like, when I am through with this body and my spirit released, to float up those wonderful mountain passes and ravines and feed on the silence and wonder—no fear, no bodily discomfort, just space and silence."[42]

Eleven years later, at age sixty-six, Carr had learned volumes more about space and sky. But she was in failing health and no longer dreamed of vast, unlimited spaces. To her journal she confided, "I have no desire to fly. I love the earth and am afraid of the infinity of the sky. It is over-vast for my comprehension."[43] Carr, whose brush had once attacked the famously unpaintable expanses of Canadian forest and sky, retreated from them in the end. The impersonal vastness of heaven's dome came to hold more dread than exultation. Perhaps it always had: space, she confirmed again, was more difficult than objects.

Perhaps as a way to contain that limitless space, Carr gave it animistic features. She let the land see and breathe, feel and respond in ways that would have made Ruskin shudder. She endowed landscape with human features, often animating it: "The world is wide and white today," she wrote, "with sky low and frowning

blackly over it."[44] Into that visage of sky, Carr regularly inserted shapes that insist on ocular readings. An untitled charcoal from around 1930 (fig. 55) features a distinct, monumental eye-form in the sky, a shape that would reappear in many later drawings and paintings. The ovoid light-shape in *Shoreline* has a loose ocular form, and the sun in an untitled oil on paper (Clover Point from Dallas Road Beach, c. 1934–36; private collection) has an eyelike aspect, similar to the eye or "I" suns in some of O'Keeffe's 1920s paintings of the New York skyline.[45]

Within the private, living realm of the rain forest, Carr also placed eye-shapes as emblems of the sensate environment. Sometimes they are embodied in animal faces, as in *Zunoqua of the Cat Village* (see fig. 24), where the eyes of a dozen or more feral cats peer out from the turbulent forest undergrowth. More sober and stylized is an untitled charcoal (fig. 56) in which Carr inserts only one, or perhaps two, totemic eye-shapes within foliate forms. At a time when she was abandoning Indian themes, this drawing explores in abstract form the deep connections Carr still saw between the environment and native carvings. Like the carvings, her drawing partakes of native spirituality and the totemic projection of human essence onto the forest. This is highly conscious symbol formation.

55
Emily Carr, *Untitled*, 1929–30, charcoal on paper.
Vancouver Art Gallery, Emily Carr Trust, VAG
42.3.136. Photo by Trevor Mills.

The Natural Self: The Body and Nature

56

Emily Carr, *Untitled [Eye in the Forest]*,
1929–30, charcoal on paper, 62.8 x 47.7 cm.
Vancouver Art Gallery, Emily Carr Trust,
VAG 42.3.123. Photo by Trevor Mills.

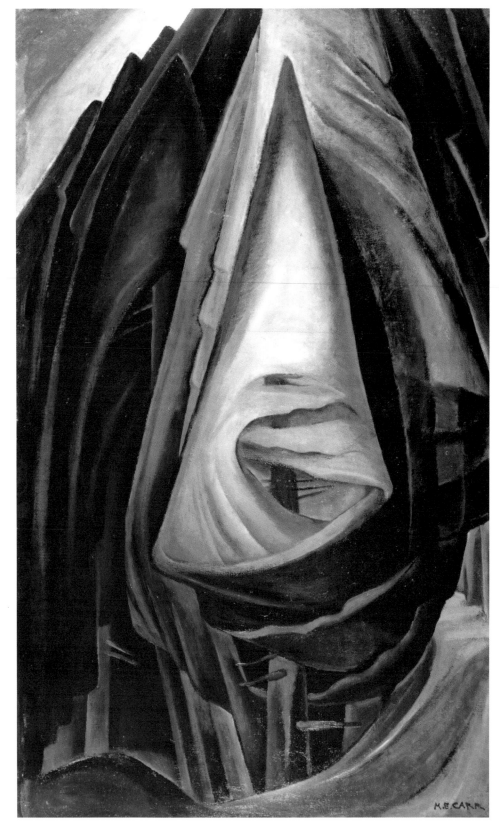

57
Emily Carr, *Grey*, n.d. [c. 1931–32], oil on canvas,
111.1 x 69.2 cm. Private collection. Photo courtesy Art
Gallery of Ontario.

A year or so later Carr's *Grey* (fig. 57) encloses an eye-form within a pale tri-
angle of tree. In form and coloration *Grey* is one of Carr's most abstract paintings,
with its light central triangle-tree reduced to an essential geometric shape, much like
the white triangles in Lawren Harris's or Wassily Kandinsky's paintings. But Carr's
tree moves and folds in upon itself, forming the eye-shape that allows us visual access
to the heart of the tree. During these years, when Carr's titles confirm her efforts
at getting *inside* the forest, she often probed, as in *Grey*, the life and sensory capacity
within the forest's own tree-beings.

Time and impulse relate the huge mask shape within trees in Carr's *Indian
Church* (see fig. 37) to her inscription of eye-forms in *Untitled* [*Eye in the Forest*]
(fig. 56). Together with two of Carr's other works, all represent her repeated
introduction of body imagery into forest interiors. In her charcoal *Port Renfrew* (fig.
58), Carr drew a monumental, foreshortened face—seemingly a mask—at ground
level, lying among the trees. A related oil, *Western Forest* (fig. 59), from the same
time period, retains the mass and placement of the mask but renders it without facial
features, as simplified mounds within the forest. As if buried, or rotting—like a
downed totem pole—in the earth, Carr's vestigial forest faces remind us of her belief
that the forest was inhabited by life and spiritual energies.

Carr's eyes in the British Columbian forests—breaks in the dense surround
of trees—are places where information is gathered, where ideas and sensory
impressions collect. Like ponds, the forest eyes suggest focal points for streams of
materials and energy and affirm that all life belongs within vast, interrelated

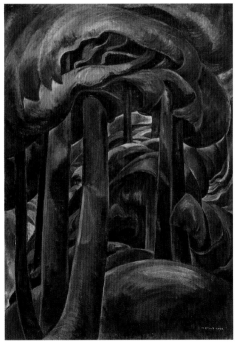

58

Emily Carr, *Port Renfrew*, 1929, charcoal on paper,
64.6 x 50.8 cm. Vancouver Art Gallery, Emily Carr
Trust, VAG 42.3.120. Photo by Trevor Mills.

59

Emily Carr, *Western Forest*, c. 1931, oil on canvas,
128.3 x 91.8 cm. Art Gallery of Ontario, Purchase, 1937.

ecosystems. At once biological and totemic, the forest eye/pool is congruent with Carr's belief in the web of natural existence.

And with O'Keeffe's. The American painted pools and ponds in the forest that read like eyes or totemic mirrors of nature. Two O'Keeffe pastels from 1922 are mysterious and iconic, dense with the colors of water and woods, and static, like a bubble preserved in amber. *Lake George and Woods* (c. 1922; private collection) and *Pool in the Woods, Lake George* (fig. 60) each contain a watery blue disc, shaded like a convex eye or lens. *Pool in the Woods, Lake George*, with its horizontal orientation, is especially eyelike. Turned vertically, the same shapes transmogrify into compositions of cosmic or chthonic divergence: *Green-Grey Abstraction* (fig. 61) or *Corn II* (1924; Georgia O'Keeffe Museum, Santa Fe, New Mexico); in the latter work, broad lengthwise leaves frame a circular eye view down the stalk into the heart of the plant. As these examples show, O'Keeffe's paintings find consonance in varied natural forms, overlapping and merging them in a body of work that has about it, collectively, an organic wholeness.

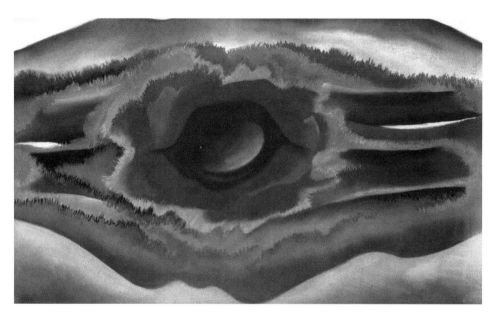

60
Georgia O'Keeffe, *Pool in the Woods, Lake George*,
1922, pastel, 44.45 x 71.1 cm. Reynolda House, Museum of American Art, Winston-Salem, North Carolina.
Photo by Jackson Smith.

The Natural Self: The Body and Nature

How, finally, can we account for the frequency and insistence of eye-forms within the paintings of Carr, O'Keeffe, and, as we shall see, Kahlo? Do they share any metaphorical or symbolic significance? To enter the complex web of eye symbolism is to risk entanglement in a fabric that was millennia in the weaving. Whole volumes have assayed its encyclopedic lore, much of which has slipped into obscurity. Some, however, survives through evolving cultures—testimony, perhaps to the eye's centrality as chief external supplier of sensation to the body. Without opening the entire subject, we can still look at some basic eye lore as it proceeded from ancient to modern consciousness.

At many sites in the ancient world, from paleolithic through neolithic cultures, the eye served as a primary emblem of the Great Goddess, whose cult originated in the Middle East and diffused across the Mediterranean to western Europe.[46] The eye was a prominent feature, often engraved on the clay or bone or stone body of the goddess. Sometimes the eye was incised upon the pelvic triangle of the goddess's body, which led to a fusion of eye and womb symbolism. From that synthesis appar-

61
Georgia O'Keeffe, *Green-Grey Abstraction*, 1931, oil on
canvas, 91.4 x 61 cm. Curtis Galleries, Minneapolis.

ently descended the belief among ancient Greeks (in Plato and Hippocrates, for example) that the womb was capable of migrating to the head, causing hysteria, among other disorders. As late as the nineteenth century, physicians (including Jean-Martin Charcot, one-time mentor of Freud) situated the origin of hysteria in the womb.

One can make almost anything of this knot of symbolic threads, but it would be irresponsible to overlook the possibility of its inclusion, however veiled, in the work of Carr, O'Keeffe, and Kahlo. Doris Shadbolt, the leading scholar of Carr's work, suggests that the opening in Carr's *Grey*, discussed above, represents "an eye or a mouth or a womb." Whitman likened ponds to the earth's eyes, while— in an interesting variation on the Freudian view of things—O'Keeffe scholar Sarah Whitaker Peters insists that Stieglitz and many of his 291 colleagues knew of Freud's "famous link of the eye to the phallus" (this in Peters' discussion of O'Keeffe's ovoid shapes penetrated by a vertical stalk).[47]

By contrast, the eyes in Kahlo's paintings are often unmistakably eyes, such as the third eye in the middle of Rivera's forehead or her own, which she called "the invisible eye of Oriental wisdom."[48] Likewise, in her late painting *Marxism Will Give Health to the Sick* (c. 1954; Museo Frida Kahlo, Mexico City) an eye of wisdom is embedded in the palm of a hand that offers support to Frida as she casts aside her crutches. Less directly, Kahlo paints knots, which are also eyes, in a forest of tortured trees; *The Little Deer* (fig. 62) is Frida, watched by arboreal eyes on both sides of her. Like the many other body references in her work, Kahlo's eyes are

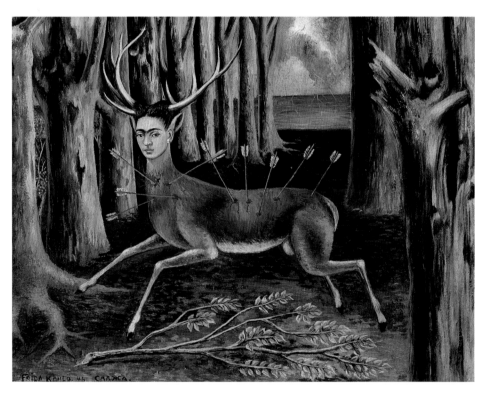

62
Frida Kahlo, *The Little Deer*, 1946, oil on canvas,
22.5 x 30 cm. Collection of Carolyn Farb, Houston.
Photo courtesy Mary-Anne Martin/Fine Art, New York.

The Natural Self: The Body and Nature

more firmly grounded than either Carr's or O'Keeffe's in the materiality of actual bodies and social sites.

Out of the welter of eye symbolism—sexual, philosophical, mythological—there is one more possibility: that the eye in painted nature is really another way of signifying the presence of the artist herself, of her critical inner eye, which supervises and directs all her energies. Self-reflexive and penetrating, the eye is both mirror and window. Its power brings into focus more than surface appearances. As Wordsworth imagined it,

> With an eye made quiet by the power
> Of harmony, and the deep power of joy,
> We see into the life of things.[49]

An eye that can accomplish such seeing is worth painting again and again. It situates the artist firmly within the picture, looking simultaneously at it and outward, at the viewer. The gaze of this limned eye, seeing into the life of things, reconciles the metaphorical and the real in paintings concerned with the poetry and praxis of painting.

O'Keeffe's Self-Portraits in Landscape

Beyond the eye, when O'Keeffe paints varieties of sentience in the nonhuman world, it is usually with more subtlety than Carr or Kahlo. However quietly, the body speaks in O'Keeffe's paintings, just as Norman O. Brown described. It is a body that takes many forms, fragmented like pool eye-shapes or suggestive of a whole, like the contours of landscape.[50] In the same year she made the pool pastels at Lake George, O'Keeffe painted the shoreline as a reductivist silhouette reflected in the blueness of the lake's surface. *Lake George* (fig. 63) is a painting in which nearly symmetrical swelling shapes press against a horizontal waterline which reads like a spinal column. Or a Rorschach inkblot. Whether or not she was thinking in such terms, viewers can hardly miss the interchangeability of smoothly contoured hills with the reclining human form.

As artistic practice, such interchange was much more widespread than has been previously acknowledged. Gustave Courbet's devotion to anthropomorphic landscape in the nineteenth century has inspired much recent scholarship. Just before O'Keeffe's era, Edgar Degas had inserted monumental bodies—both female and male—into the earth forms of his late pastel landscapes. And the massive contours of Henri Matisse's monumental reclining *Blue Nude* (1907; Baltimore Museum of Art) and, especially, his later *Pink Nude* (1935; Baltimore Museum of Art) fairly insist on a landscape interpretation. Meanwhile, artists and writers well known to O'Keeffe were thinking along the same lines. Whitman's body-centered imagery lingered in the Stieglitz circle; think of the lines in his capacious poem "Kosmos": "Who, out of the theory of the earth and of his or her body / understands by subtle analogies all other theories."[51]

Even more directly, the sculptor Gaston Lachaise, who once made a portrait bust of O'Keeffe, was casting monumental female nudes—bodies which undeniably include and acquire meaning—as landscape forms. One, called *La Montagne* (The Mountain, 1919; location unknown), was exhibited by Stieglitz at the Intimate Gallery. The sculpture began, Lachaise recalled, as a monumental standing female figure, who soon "came to forceful repose, serene, massive as earth, soul turned towards heaven. La Montagne!"[52] In a parallel manner, the photographer Brassaï transformed the female body into a landscape by manipulating a camera image; in an extraordinary photograph published in the surrealist periodical *Minotaure* (fig. 64) two fragments of a female torso frame what appears to be a mountain with water below. Brassaï relates the body with the land, making each a sensuous reflection of the other. Like O'Keeffe, Lachaise, and the others, he made the landscape coextensive with the body.

Bifurcated swelling forms along an axis reappear in many later O'Keeffe works, some realistic, some abstract. She revisited axial symmetry in works like *Abstraction,*

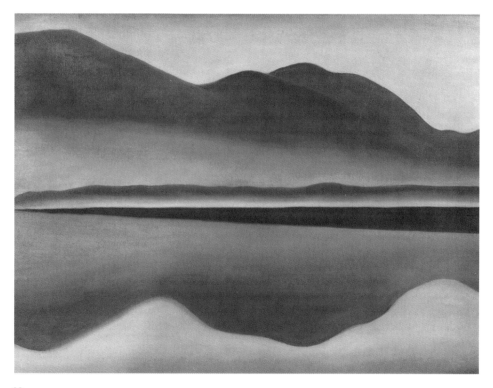

63
Georgia O'Keeffe, *Lake George*, 1922, oil on canvas,
41.3 x 55.9 cm. San Francisco Museum of Modern Art,
Gift of Charlotte Mack.

The Natural Self: The Body and Nature

Blue (1927; Museum of Modern Art), then moving (as Matisse did with his nudes) from blue to *Pink Abstraction* (1929; Phoenix Art Museum). Different in their iconographical reach, none of these paintings strays far from the body; collectively, they hover, like the concentric arcs they contain, around O'Keeffe's axial/spinal references.

Having seen some of the ways in which O'Keeffe referred to the body—sometimes through loose allusion, sometimes through pointed suggestion—in the 1920s, we must now inquire where she received the initial impetus and periodic reinforcement for those connections.[53] If O'Keeffe outwardly objected to Freud's sexualization of the natural world, can we look backward from the 1920s to any other direct sources from which she could have begun to think about her physical self in relation to her environment? Why did she so persistently coax the body to speak through landscape?

An important and nearly overlooked influence for O'Keeffe's thinking was Willard Huntington Wright, critic and author of *The Creative Will*, a book she read with enthusiasm during the 1910s. In the early weeks of her 1916 teaching term at West Texas State Normal College, O'Keeffe reported to her friend Anita Pollitzer that "I've been reading Wright's Creative Will. . . . Have been reading Clive Bell again too. He seems so stupid beside Wright." The regard in which she held Wright's work is further evidenced by the fact that O'Keeffe used *The Creative Will* as a text for her students at West Texas State Normal College that year. In his book, Wright discussed many aspects of aesthetics, none more important to O'Keeffe at that moment than his argument that nature should be seen as an extension of the human body. The first page of *The Creative Will* is an argument for the inextricable connection of all art and truth to the self, specifically to the body. The passage is so strongly worded that it is worth quoting in its entirety:

Art and the Human Body.—*The symbol (in the sense of philosophic analogy) of aesthetic truth, like the symbol of all knowledge, is the human body. The deeper facts of art and the deeper facts of life (the two being synonymous) can be tested by the forces, construction, poise, plasticity, needs, laws, reactions, harmonies, growth, forms and mechanism of the body. The body is the microcosmos of all life; and art, in all of its manifestations, is, in its final analysis, an interpretation of the laws of bodily rhythm and movement. The perception of art is an activity of our own consciousness. Art cannot exist as an isolated absolute; in order to be perceived it must be relative to*

64
Brassaï, photograph from *Minotaure*, no. 6
(December 1934).

ourselves. Our bodies are our only basis of reaction. Therefore art must accord with that basis. Furthermore, the sources and the end of nature are in the body. Only the aspects of nature are without. Nature is not discovered by way of the aspect to *the symbol, but by way of the symbol* to *the aspect. Representation in art reveals only the aspect of life. The truth must emanate from, and be verified by, the body.*[54]

At virtually the same time she was reading Wright, O'Keeffe began to make regular visits to Palo Duro Canyon near the town of Canyon, Texas. There she found shapes of enormous strength and muscularity in the land. *Special No. 21* (fig. 65) pulses with organic life and heat. A number of other Texas landscapes render the redness of the Palo Duro area in watercolor; all simultaneously suggest flesh revealed beneath or behind vegetation. O'Keeffe may have encountered the ancient Comanche belief about Palo Duro, that it was a womb for the birth of the buffalo, ensuring an inexhaustible supply from the body of mother earth.

In 1917, after her first introduction to the landforms around Canyon, O'Keeffe painted a few watercolor nudes, which, though based on the human figure, are less figure paintings than studies of the interaction of the self with the environment. Again, keeping Wright in mind ("the sources and the end of nature are in the body"), it is not surprising that O'Keeffe moved on from her observed surroundings to explore the land-as-body. From the body proceeds all sensation; to it return all external stimuli for verification.

65
Georgia O'Keeffe, *Special No. 21 (Palo Duro Canyon)*
[No. 21—Special], 1916, oil on board, 34 x 40.9 cm.
Museum of Fine Arts, Museum of New Mexico, Gift
of the Estate of Georgia O'Keeffe, 1993.

As a student O'Keeffe had taken top honors in drawing the human figure at the Art Institute of Chicago; but she jettisoned that mastery in Texas, letting the watercolor medium override the strictures of precise drawing. Charles Eldredge maintains that "the Texas nudes are . . . independent of any tradition of figuration which O'Keeffe may have gained in her academic training."[55] They are, in fact, paintings in which O'Keeffe's loose watercolor technique does not so much suggest discrete form as it tests Wright's assertions that "art cannot exist as an isolated absolute: in order to be perceived it must be relative to ourselves."

Where did O'Keeffe find the impetus to discard her academic training with the figure? She had seen innovative nudes before, when Stieglitz exhibited Auguste Rodin's controversial watercolors in 1908. Now the memory of Rodin's example, combined with Wright's words, spurred O'Keeffe to free the body from academic constraints. The monumentality of her Texas nudes—for the most part page-filling massive shapes—encourages us to consider them alongside the other monumental forms she encountered in the Texas landscape. Her nudes become, in fact, figural equivalents for the monumental forms of the landscape around Canyon. Moreover the nudes also embody color and shape in ways that subtly link them to the larger environment. The redness in *Nude Series, Seated Red* (fig. 66) and its overall triangulation of form relate closely, for example, to the liquidity of red mesas in several of her Texas watercolors.

When O'Keeffe overpaints shadows she suggests both volume and abstract shapes within the figure. In *Nude Series, Seated Red* her hand's sureness reduces con-

66
Georgia O'Keeffe, *Nude Series, Seated Red [Nude Series]*,
c. 1917, watercolor, 30 x 22.5 cm. Georgia O'Keeffe
Museum, Santa Fe, New Mexico.

tour to the most elliptical of statements, describing simultaneously the way body parts and pigment melt into one another. With their vivid coloration and soft, fleshy substance, these Texas nudes allow light and air into their liquid shapes, just as O'Keeffe allowed light and air into the landscape watercolors. Yet both are weighty: in their convincingly relaxed postures, the sagging heaviness of the nudes yields, like landforms, to the natural force of gravity.

A number of O'Keeffe's abstractions—works she called portraits—executed in the months surrounding the nude series show us that she was still testing Wright's insistence on body-based forms. *Portrait-W-No. III* (fig. 67) demonstrates its closeness to her seated nudes. Several subsequent charcoals and oils body forth the swelling curves of human anatomy within the concrete representations of form Wright championed.[56] They read initially as tree forms, then exchange signs with other subjects in O'Keeffe's loose and permeable symbolic system of 1917. Both her nudes and her tree-figure hybrids draw attention to interactive systems in the natural world. Like the human body, a tree draws and expends energy and air in a dance linked, as Wright argued all art is, to the rhythms and movement of the body. It is not necessary to be too literal here. What we are considering are dynamic patterns within natural systems, seen through an artistic consciousness attuned both to the possibilities of abstraction and to the centrality of the human body. As Wright argued, "The modern tendency in painting to make objects abstract and to divest subject matter of all its mimetic qualities has led some critics and painters to the false conclusion that form itself is unrelated to recognisable phenomena. But even in the most abstract of the great painters the form is concrete. . . . There are no moving forms which do not have their prototypes in the human body in action."[57]

Suggested everywhere in O'Keeffe's nudes are visual equivalents for natural systems, like the pools she later painted in the woods: energies and materials flow, as through permeable membranes, into and out of their suggested (but by no means absolute) contours. Though she would never again return overtly to the nude after her Texas series, I would argue that she never abandoned them entirely.

67
Georgia O'Keeffe, *Portrait-W-No. III*, 1917, watercolor, 30 x 22.5 cm. Georgia O'Keeffe Museum, Santa Fe, New Mexico.

The body lingers persistently in O'Keeffe's landscapes from the 1910s on, reappearing in every decade. To her many examples from the 1920s, I add one more, a pivotal painting related subtly to her contemporary work yet alluding much more strongly to the fiery redness of her Texas landforms: her 1927 *Red Hills, Lake George* (fig. 68). This is a painting of great simplification and power. Gently contoured hills, caressed by a low-glowing sun, emit both heat and symbolic light from a horizon seam that here joins rather than separates realms.

Red Hills, Lake George also anticipates the red hills O'Keeffe would rediscover in New Mexico, from which she would make dozens of body-landscape paintings. Some are well known, like her wrinkled red hills and the ribbed contours of the Black Place. *Red Hills with the Pedernal* (fig. 69) is one of the most graphic of these: raw red shapes—unmistakably fleshy—extend across the foreground before the cool distant mesa. Others, such as *Grey Hill Forms, New Mexico* (fig. 70) and *Soft Gray, Alcalde Hill (Near Alcalde, New Mexico)* (fig. 71), are more gently constructed hillocks of pale earth, smoothed by the artist into shapes that insist on bodily referents.

O'Keeffe did not forget Wright's chain of sensory-response mechanisms leading into and out of the body. In the early 1940s she wrote to her friend Cady Wells of the outdoor pleasures of cold and wind, color and sound, all present in her experience of the New Mexican landscape. Just outside her door, "It is so bare—with a sort of ages old feeling of death on it—still it is warm and soft and I love it

68
Georgia O'Keeffe, *Red Hills, Lake George [The Red Hills with Sun]*, 1927, oil on canvas, 68.5 x 81.2 cm. The Phillips Collection, Washington, D.C.

with my skin."[58] What seemed bare and dead to others evoked sensory pleasure in O'Keeffe.

Eventually the warm earthiness of the hills came to suggest life itself. It was the surviving germ of an idea she had held since childhood. Her stated dependence on the land, formed in Wisconsin, reemerged in the dry expanses of Texas and later, New Mexico. O'Keeffe preferred when she could to speak in general terms. But at times she admitted that no matter how disguised her symbolism, she was attempting to make paintings that were expressive of all of herself.

If asked outright, O'Keeffe would have denied that some of her Southwest landscapes were self-portraits. That said, we can combine her words and her work with a great deal of circumstantial evidence and draw some convincing conclusions to the contrary. For one thing, O'Keeffe decided late in life that Stieglitz's photographs were frequently self-portraits: "His eye was in him, and he used it on anything that was nearby. Maybe that way he was always photographing himself." About her own work, there were dozens of hints—comments about making paintings that were all of herself and all of a woman; about wanting people to understand and being afraid they'd understand too much; about refusing to sign many of her paintings. Would you sign your face? she asked. If O'Keeffe's landscapes at first do not seem highly personal, it is in part because their surfaces lack signature brushstrokes. With their visual clarity and precise focus, they seem utterly without spontaneity or impulse. Still, if they deny the grand gesture made in paint, O'Keeffe's landscapes acknowledge that the land itself is the grand gesture. She admitted this when she wrote of the genesis of her painting *Red Hills and Sky* (1945;

69
Georgia O'Keeffe, *Red Hills with the Pedernal*
[Pedernal with Red Hills], 1936, oil on linen,
50 x 75.5 cm. Museum of Fine Arts, Museum of New
Mexico, Bequest of Helen Miller Jones, 1986.

The Natural Self: The Body and Nature

70
Georgia O'Keeffe, *Grey Hill Forms*, 1936, oil on canvas,
51 x 76 cm. Museum of Fine Arts, Museum of New
Mexico, Gift of the Estate of Georgia O'Keeffe, 1987.

71
Georgia O'Keeffe, *Soft Gray, Alcalde Hill (Near Alcalde,
New Mexico) [Soft Gray Alcalde Hill]*, 1929–30,
oil on canvas, 25.7 x 61.3 cm. Hirshhorn Museum and
Sculpture Garden, Smithsonian Institution,
Washington, D.C., Gift of Joseph H. Hirshhorn, 1972.

private collection): "A little way out beyond my kitchen window at the Ranch is a V shape in the red hills. I passed the V many times—sometimes stopping to look as it spoke to me quietly. I one day carried my canvas out and made a drawing of it. The shapes of the drawing were so simple that it scarcely seemed worth while to bother with it any further. But I did a painting—just the arms of two red hills reaching out to the sky and holding it."[59]

So when O'Keeffe talks of the land's embrace of sky, her words bespeak personal experience. She is painting landscapes in the first person singular, voicing her intimacy with landforms that became symbolic extensions of her own body. Like Whitman, she felt a sensuous intimacy with the land. The spare desert of the Southwest yielded rare pleasures, evoking simultaneously the vastness of past time and the nearness of a caress. Whitmanic observations—bodily sensations of temperature, sound, color, and touch—were all present, all appreciated in the same moment.

Sarah Whitaker Peters has made a convincing case that many of O'Keeffe's still lifes are in fact self-portraits. My contention here is that many of her landscapes are as well. Even images as seemingly impersonal as her late aerial views of rivers read alternatively as a kind of arterial bloodstream flowing through the body of the land. What O'Keeffe declined to disclose in words, she came very close to revealing in paint: that natural forms veil—without entirely obscuring—the presence of the body, where sensation resides. O'Keeffe's land-body experiences were grand, inclusive, and intuitive. Her landscapes are painted testimony to a conviction she shared with William Butler Yeats that "Art . . . shrinks from all that is of the brain only, from all that is not a fountain jetting from the entire hopes, memories and sensations of the body."[60]

The wide V-shapes manifested by outstretched arms or adjacent hills appear repeatedly in her work. The V or its variants appear in vertical rents zig-zagging downward through 1920s flowers or abstractions, in jagged leaf tears, and in many other landscape clefts and joinings. Some of the most prominent of O'Keeffe's "bodyscapes" are those preserved in her paintings of the White Place, an otherworldly passage of rock and sand near her Abiquiu home. It is a place that occurs unexpectedly, startlingly, like the surprise of Palo Duro Canyon on the Texas *llano estacado*. On her pilgrimages to desert landscapes, O'Keeffe was drawn repeatedly to the White Place.

The White Place is a reminder of the long-held attitude O'Keeffe and Stieglitz shared on the concept of whiteness, that it represented a kind of lucidity and purity of artistic spirit he attributed to her more than to anyone else.[61] O'Keeffe's paintings are studies of that whiteness, both as a symbolic and a formal element. When she found it in the landscape, how could she resist its multiple possibilities?

Her several paintings of the White Place track its eerie silence from various distances and in varied light. Its spare, simple shapes, like the modular architectural forms of the church at Ranchos de Taos, lend themselves to paintings of details as well as to longer views. But the White Place is nature's, not humanity's, stamp

on the landscape. For O'Keeffe, it was more than a geological curiosity or a set of forms she could compose according to *Notan*, the Japanese rules of patterning in light and dark. And in addition to her long ideological identification with whiteness, there are formal consonances that reveal O'Keeffe's personal engagement with the White Place. In their verticality and in the loose foldings of pale gray across undulating surfaces, something weirdly anthropomorphic resides in these paintings. *From the White Place* (fig. 73) bears a striking similarity to Stieglitz's 1921 portrait of O'Keeffe (fig. 72), in which the landscape of tendons in her neck anticipates the deeply shadowed V of O'Keeffe's painting.

This painting of the White Place strikes (fortuitous) chords of familiarity with the work of both Frida Kahlo and Emily Carr. One occurs between Kahlo's 1926 *Self-Portrait with Velvet Dress* (fig. 74), in which the artist has painted an extended V-shape within her own neck, reminiscent of that captured in the Stieglitz photograph of O'Keeffe. In Carr's case, the formal similarity occurs between her painting *Grey* (see fig. 57) and O'Keeffe's *From the White Place*. Carr's tree-triangle is an inversion, both in value and shape, of that of O'Keeffe, whose painting follows it by a decade. Carr's light central form is based on the mass of a tree; O'Keeffe's is the dark void between two paler masses. It is unlikely, though not impossible, that O'Keeffe knew Carr's painting. What is striking about the pair of paintings is that both rely on

72
Alfred Stieglitz, *Georgia O'Keeffe: A Portrait-Neck*, 1921, palladium photograph. National Gallery of Art, Washington, D.C., Alfred Stieglitz Collection, OK25A.

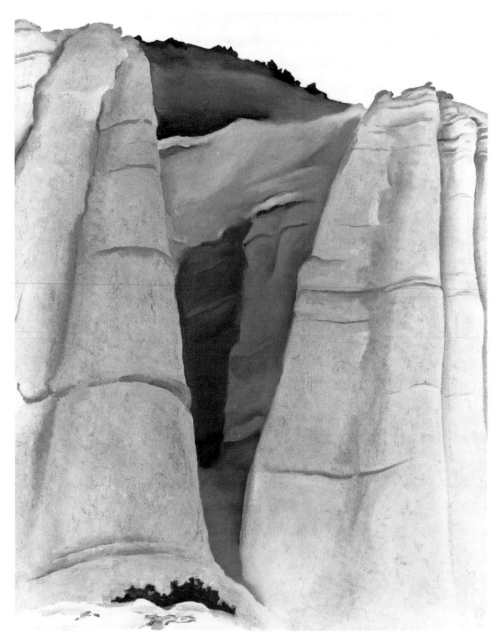

73
Georgia O'Keeffe, *From the White Place*, 1940,
oil on canvas, 76 x 61 cm. The Phillips Collection,
Washington, D.C.

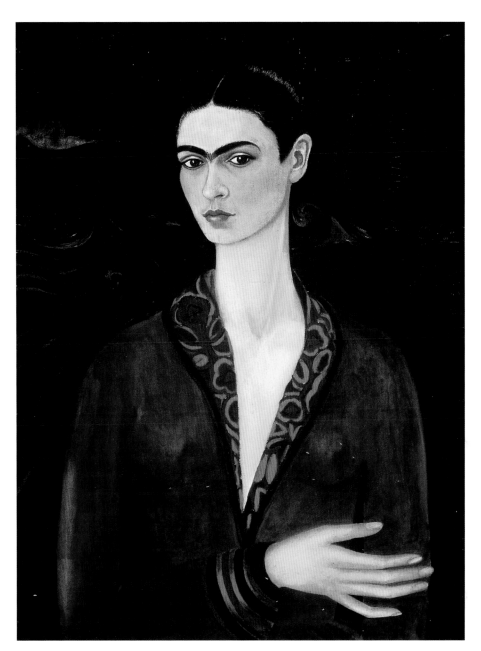

74
Frida Kahlo, *Self-Portrait with Velvet Dress*, 1926,
oil on canvas, 78.7 x 58.4 cm. Private collection. Photo
by Rafael Doniz.

natural form as a starting point for highly personal, perhaps even metaphysical, musings that owe much to the investment of the embodied self in nature.

Trees, the Axis Mundi, and the Physical Self

Carr's formidable tree painting *Grey* also invites a larger discussion of the ways all three painters used tree imagery as a vehicle of artistic exploration. Trees attract myth and tradition, providing some of the most richly layered symbolic material available to artists; they represent an ancient, widespread link between humanity and nature. The tree has often served as an imago mundi. As a single great living presence whose trunk holds together branches, leaves, fruit, and flowers, the tree functioned as worthy model of the greater world. In Nordic cosmology the world tree, the mythic Yggdrasil, was an indestructible ash, destined to extend life beyond the apocalypse. In a slightly different variation the great tree functions as an axis mundi, joining lower, middle, and upper realms to one another and granting access to earth origins as well as to cosmic states. To some in the ancient past, the world tree supported the vault of heaven, with stars lodged in its branches.

The tree has also symbolized the feminine principle: nourishing, supporting, sheltering. A whole range of ancient mythic or magico-religious associations attends the tree as woman.[62] The universal mother goddess of many names was often represented in or as a tree: as early as 2000 B.C. a goddess of the tree was worshiped in the Indus Valley. In Babylon the goddess Ishtar was the cosmic tree whose roots reached to the abyss, her branches to heaven. And in ancient Egypt, Mut (or, alternatively, Isis-Hathor) dwelled in the sacred sycamore, where she poured out water from a vase. Classical mythology abounds with tales of women becoming trees: Daphne, Myrrha, Dione, and the dryads. The ancient Greeks associated Demeter with the tree of life. Sacred groves served as shrines for the goddess Diana throughout the Roman empire, and in the Middle East the goddess of the grove was Asherah, whose power and rites were feared and attacked by the authors of the Old Testament (1 Kings 14:23). But the sacredness of trees, and the practice of phyllomancy—divination from rustling leaves—was not easily eradicated. It lingered, ironically, in the figure of Deborah, a prophet and judge of Israel, who dispensed wisdom under a palm tree (Judges 4:5). And in the Western Hemisphere, the Aztec goddess of vegetation was portrayed as a female tree.

In many traditions, including the Judeo-Christian, the Tree of Life and the Tree of Knowledge of Good and Evil grow in the Garden of Eden. The former, at the center, is the cosmic axis, signifying transcendence and regeneration. The Tree of Knowledge of Good and Evil is essentially dualistic, associated with the loss of innocence, the fall from grace, and impending death. In the alchemical tradition, to be investigated in Chapter 3, the tree is the *prima materia*, the symbol of Hermetic philosophy. One of the most famous trees in the worldwide forest of religious symbols is the bo tree (*Ficus religiosa*), under which Buddha attained enlightenment.

Many ancient narratives tell of a dying god killed on a tree: Odin, Krishna, and Attis were killed outright, while in one version of the myth Osiris was enclosed within a tree before he was brought back to life. In ancient Maya tradition the First Tree was represented in the form of a cross, and the savior-god crucified upon it. The tradition survived into Christianity, whose scholars at times identified the cross of Jesus with the Tree of Life. In Acts 5:30 and 1 Peter 2:24 the New Testament writers declare that Jesus hung on a tree, not a cross. Thus in Western art, we often find imagery of the tree as cross; not surprisingly, it occurs with special vigor in Mexican art, with its proximity to Maya tradition. Otto Rank, who extended psychoanalytic theory to the study of myth and art, concluded that Christ is "man-become-tree, who dies on the stake indeed, but yet lives by it forever."[63] Finally the tree in biblical tradition reappears in the Revelation of John as the Tree of Life in the center of the New Jerusalem—a tree whose leaves are "for the healing of the nations." (Rev. 22:2).

The magico-religious sacredness of trees has been evident in traditions of animism, shamanism, and pantheism reaching back beyond recorded time. For centuries, human beings have taken the configuration, longevity, and cyclical changes of trees as evidence of their homology to the human form. With a centering axis and branches that correspond roughly to a human trunk and limbs, the tree has been a surrogate for the body, sometimes even to the extent of equating leaves with hair, bark with skin, wood with flesh. An ancient Nahua text from the Aztec era in Mexico confirms such correspondences: the term "tree trunk"

> has come from people; it
> resembles people;
> it derives from people;
> it proceeds from people;
> it is a continuation.[64]

Sometimes artists have represented the human figure and the tree in one image: Piero di Cosimo's *The Misfortunes of Silenus* (c. 1500; Fogg Art Museum, Harvard University) and *The Discovery of Honey by Bacchus* (fig. 75) exhibit human attitudes and forms within the pollarded branches and trunks of trees.

As recently as the nineteenth century, authors looked for expressive potential in the forms of trees. The naturalist Humbert de Superville, for example, argued that humanity's upright stance constituted a norm within nature, so that whatever degree of deviation there might be from the vertical in both animals and plants created expressive potential. Trees, noted Superville, vary widely in their emotional expression: the oak is strong and calm, often sacred in past tradition; the pine is generally expansive; but the willow, Norwegian pine, and fir suggest melancholy because of their downward-drooping branches.[65]

In more metaphysical terms, though arising out of similarly romantic impulses, the British painter J. M. W. Turner and the visionary architect John Soane also animated matter in their work; theirs was an allegory of art that saw transcendent death in both nature and the creative imagination. Romantic poets like Wordsworth and Coleridge wrote of the sentience of the nonhuman world, as when Coleridge immortalized "the one red leaf, the last of its clan, / That dances as often as dance it can."[66]

The English critic John Ruskin loudly denounced the romantic insistence that nature reflected the human mood, labeling it the pathetic fallacy.[67] Today Ruskin may seem old-fashioned and excessively moralistic, and Superville's ideas might appear highly eccentric; as literary critique the pathetic fallacy has gone the way of the dodo. Beyond the mere passage of time, other pressures at work in the late nineteenth century denied the presence of spiritual energies in nature: chiefly, a climate of skepticism combined with an increasingly scientific-mechanistic worldview. Anthropologists, psychologists, and scientists in general attacked literary and artistic attempts to personify the world. By the twentieth century, European American critics had largely succeeded in dismissing sensate nature as a relic of a quaint and sentimental past.

Still, for European American artists, there were surviving strains of thought that worked against this positivism. Even in a scientific age, it was possible to think of the natural world as composed of a myriad of living patterns. In his early notebooks Darwin represents the whole of nature, drawn and described verbally, as an irregularly branching tree. Evolution in the natural world was Darwin's concern. Change in nature and society were inevitable, argued the French philosopher Henri Bergson, who insisted that perpetual flux could best be grasped through a flexible, intuitive approach to art and life. Then too, there survived in the United States at the

75
Piero di Cosimo, *The Discovery of Honey by Bacchus*,
c. 1499, oil on panel, 79.2 x 128.5 cm. Worcester Art
Museum, Massachusetts, Museum purchase.

The Natural Self: The Body and Nature

turn of the twentieth century vestiges of New England transcendentalism, with its own version of artistic idealism. But also present, and still underrecognized, was a whole range of thought from Asian traditions that helped catalyze for American artists a dynamic, evolutionary concept of art within which nature was again viewed in animistic terms.

Thus, validated by diverse and fragmentary sources, the notion that natural objects like trees have expressive power has survived in the work of such twentieth-century artists as Wassily Kandinsky, Marc Chagall, Charles Burchfield, and—I will argue—O'Keeffe, Carr, and Kahlo.

Georgia O'Keeffe's Trees

Georgia O'Keeffe's paintings based on tree imagery are among the most diverse and compelling of her nature-derived subjects. They are milestones on an artistic journey that took her repeatedly from realism to abstraction and back again.

Years afterward O'Keeffe recalled one of the first times she focused closely on tree forms. She told of a memorable night in 1908 during her days at the Art Students League in New York. Walking up Riverside Drive one moonlit evening, she was struck by the sight and sound of poplar trees, "breathing—rustling, in the light spring air." Lights from the other side of the river twinkled distantly. Closer to her, O'Keeffe "studied the outlines of the trees," noting especially "the openings where the sky came through—the unevenness of the edges—the mass of the trees, dark, solid, very alive."[68] The next day her efforts to record the night scene began promisingly, until she entrusted her canvas to a fellow student for criticism. Failing to understand her somber night trees, he insisted that she could not have seen them that way; he proceeded to "correct" them by overpainting with impressionist color. Baffled, O'Keeffe temporarily dismissed her work as a failure but kept it nearby. From that flawed canvas she eventually gleaned two important lessons: that she had something to say about the night and trees, and that she should trust her own sensibilities.

Listening to the artist's own recollection, it is clear that by 1908 trees were already more than formal vehicles for O'Keeffe; she had begun her lifelong habit of cloaking emotional experience in natural forms. By 1913 she was studying trees seriously, as a book remaining in her Abiquiu library (W. A. Lambeth, *Trees and How to Know Them*, 1913) testifies.[69] Living or dead, whole or fragmented, O'Keeffe's subsequent trees, like a forest of signs, invite us to move among them—to understand how this artist's rich and profound sensibilities developed.

But caution is called for: there is risk attached to using trees as metaphors for human experience. As we saw, trees are freighted with a lineage of ancient and powerful stereotypes, which, though they frequently present positive and powerful associations, also have negative aspects. Modern scholars have found some of the connections of woman and tree, particularly from the late nineteenth century, trou-

bling. Barbara Buhler Lynes, for example, has written that "themes relating women to forms in nature, such as woman-as-flower and woman-as-tree, are among the most significantly misogynous of the art of the late nineteenth and early twentieth centuries, because they define women as powerless, rooted, passive, and non-thinking beings." Stieglitz thought of women and trees almost in the same breath (fig. 76). He wrote in 1919 of photographing O'Keeffe's body, "head—torso—feet—hands," and added, "even some trees too.—just human trees." So when O'Keeffe complained famously, "I felt like a little plant that [Stieglitz] has watered and weeded and dug around," she spoke from experience, expressing in that complaint the debilitating side of the woman-tree equation.[70]

Nonetheless, when we look at her persistent use of tree imagery, we can see that trees gave O'Keeffe a positive, powerful vehicle for studying the integration of self and nature. In trees she learned to exercise every shade of expressive potential, from nascent growth to stolid rootedness. The latter quality she would explore as a symbol of connection to place and to the nourishing energies of locale. In this O'Keeffe shared the vitalistic beliefs held by the Stieglitz circle, among whom,

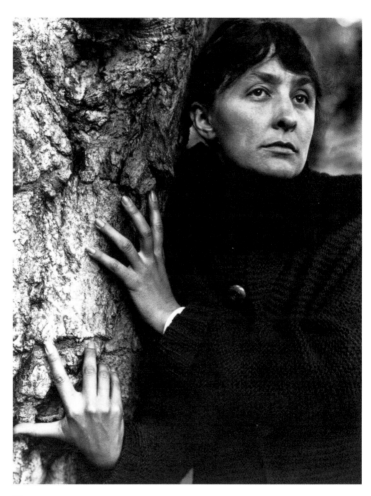

76
Alfred Stieglitz, *Georgia O'Keeffe: A Portrait*, 1918, gelatin silver photograph. National Gallery of Art, Washington, D.C., Alfred Stieglitz Collection, 1980.70.85.

The Natural Self: The Body and Nature

Lynes concedes, metaphors of plant growth (and nature's other forces) were used primarily to represent creativity, dynamism, and productivity in human behavior.

To artists as well as within the ancient spiritual traditions discussed above, the human form and the tree have often shared formal and symbolic interpretations. In the life cycles of trees, in their sturdy or graceful or menacing forms, dynamic energies reveal themselves. And because tree life, like human life, is measured in years, it corresponds usefully to the human life cycle. Painter Andrew Dasburg, for example, remarked on such parallels: "Trees always do seem a great deal like people to me, some have the characters of children, young men and maidens, old men strong and healthy, others battered by the storm look like Rembrandt's head of a Jew who has stood many storms."[71]

Through a convincing series of examples, Sarah Whitaker Peters has argued that the artist began using trees as personal symbols early on. I shall review these images briefly and later extend the investigation to some of O'Keeffe's subsequent tree paintings. Particularly in the 1920s trees offered O'Keeffe a way of portraying individuals and her relationships with them. Their quietude, solidity, and strength appealed to her; they lacked the unpredictability of most people she knew: "I wish people were all trees," she told Marsden Hartley, "and I think I could enjoy them then."[72]

For O'Keeffe certain individuals took on the character of trees, and vice versa. *The Old Maple, Lake George* (fig. 77) is a grizzled, excitable icon, whose arms (branches) twist and writhe, like Stieglitz's in animated oratory. As early as 1905, O'Keeffe's training in figure drawing had taught her to see forms and energy in the headless male torso that would later reappear in trees and in the land itself. The lumpy muscularity of *The Old Maple* is not that of an idealized cast-plaster body but rather of a tough, wizened specimen, now in decline but struggling to hold on to its virility. Even the leaves have a shaggy quality, like Stieglitz's frenzied hair and mustache. If there was ever a portrait of a person as a tree, this is it.

In their absence of such distinctly humanizing qualities, O'Keeffe's other Lake George trees from the 1920s reinforce portrait interpretations for *The Old Maple* and for her 1924 *The Chestnut Red* (private collection). While suggestive of life and energy, O'Keeffe's several variations on the theme of maples and cedars emphasize formal concerns over personification. In such sculpturesque works as *Maple and Cedar, Lake George* (see fig. 28), the cedar forms a crisp cone while veils of red foliage drape the maple. Fiery foliage undulates rhythmically—one wants to say dances— in the full incumbency of autumn.[73] Above, tubular cloud shapes (similar to those in some of O'Keeffe's skunk cabbage paintings from the same years) hold their own against the strong forms below.

At least two other Lake George canvases rework the shapes in these maple and cedar canvases. In *Autumn Trees—The Maple* (1924; Georgia O'Keeffe Museum) convex and concave shapes lead the eye on an undulating path through the tree's muscular branching system. Space is flattened, ambiguous, as if O'Keeffe is borrow-

ing lessons from cubist patterning, overlaid with sinuous symbolist line and diffused color. A year later she painted *Grey Tree, Lake George* (1925; Metropolitan Museum of Art), perhaps her nearest approach to cubism. O'Keeffe's was not the angular analytic cubism of Picasso or Braque but rather a personal modification of that idiom in her continuing dialogue with modernism. Through her positioning within the American avant-garde, and through the variety of teachers she had, O'Keeffe found herself within overlapping circles of influence.

O'Keeffe's most influential teacher, Arthur Wesley Dow, was a conduit for ideas synthesized from both Western and Eastern thought. In his own painting, while grappling with the difficulties of rendering profound meaning in nature he more than once revisited the tendency in older American art to link morality with natural beauty and science. He was equally ambiguous about Ruskin's dogma, unwilling to excise human emotion entirely from natural forms. "It is not the province of the landscape painter," wrote Dow, "to represent so much topography, but to express an emotion; and this he must do by art."[74] There is a difference, certainly, between imputing fanciful emotion to nature and using landscape to express an emotion, but it is a distinction drawn exceedingly finely. To those looking back on such aesthetic niceties, the differences lose meaning in light of the overarching congruency: that natural forms often serve as vehicles for the artist's expression of emotion. O'Keeffe, intuitive by nature, took Dow's more flexible attitude as lifelong permission to use natural forms as vehicles for the expression of emotion. Following Dow's antirealist lead, she saw in trees the possibility for both formal invention and personal expression.

Today Dow is best remembered as an art educator, whose ideas were communicated to generations of American students via his classic text *Composition: A Series of Exercises in Art Structure for the Use of Students and Teachers*, first published in 1899. In it he outlined certain principles of composition as a means of producing harmony in design. An especially important creative principle for Dow was subordination, which he likened to the axial structure of trees: "A tree trunk with its branches is a good type of this kind of harmony; unity secured through the relation of principal and subordinate, even down to the veinings of leaves—a multitude of parts organized into a simple whole."[75]

Knowing this, we can better understand O'Keeffe's axial studies of trees at Lake George, so intent on unity secured through the relation of principal and subordinate. Dow distinguished subordination, as well as his other principles—opposition, transition, repetition, and symmetry—in the art of the present as well as the past. As a student of Asian art, he investigated in considerable depth the great artistic and mythic traditions of the world. Dow's artistic ecumenism was fostered by his own mentor Ernest Fenollosa (1853–1908), a scholar of Chinese and Japanese art and Noh drama.

Fenollosa's lengthy residence in Japan and extensive European travel prepared him to think in comparative terms of East and West. At the Boston Muse-

The Natural Self: The Body and Nature

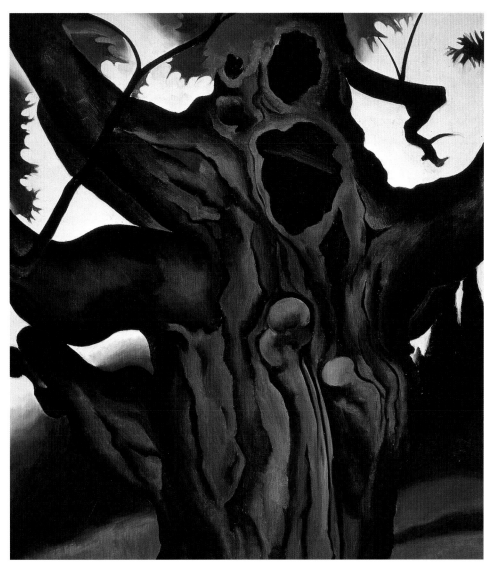

77
Georgia O'Keeffe, *The Old Maple, Lake George*,
1926, oil on canvas, 91.4 x 81.3 cm. Collection of the
Mississippi Museum of Art, Jackson, Purchase,
with funds from the Mississippi Arts Commission
and Operation Snowball, 1972.009.

um of Fine Arts, Fenollosa worked with a collection of Oriental art he had helped assemble in Japan. In 1893 Fenollosa made Dow his assistant, passing along the elements of Chinese and Japanese aesthetics, such as *Notan*, the method of light-and-dark patterning seen in the prints and paintings of Ukiyo-e masters.

In the effort to elevate "pure pictorial synthesis" above subject matter, Fenollosa, like others of his symbolist generation, likened poetry to painting, both of which contain the following vital elements: "thought, sentiment, analogy, symbolism, the interpenetration of meaning, plane behind plane, sphere within sphere; the organic union of parts . . . even the spiritual significance of trees and rocks, and mountains, and water." He argued that form is relational and that "nature" (broadly construed) provided the living example for such relations: "The forces which produce the branch-angles of an oak lay potent in the acorn. Similar lines of resistance, half curbing the out-pressing vitalities, govern the branching of rivers and nations."[76] Such ideas would be tested repeatedly in O'Keeffe's work. Even when her painting enters its most abstract moments, still discernible in it are the metaphors of branching, planar overlap, congruent spheres or spirals, and signature angles.

Fenollosa's study *Epochs of Chinese and Japanese Art* sets forth many overarching principles of Asian aesthetics. Dow discussed Fenollosa's work in his classes, and included *Epochs* and Louis Gonse's *L'Art japonais* on the reading list for students during O'Keeffe's term at Columbia. In Fenollosa's book, and perhaps also in class discussions, O'Keeffe would have encountered the author's reverence for Sung landscape painters, whom Fenollosa regarded as supreme in their integration of landscape and symbol in the Chinese imagination. The Sung master's renderings of landscape, especially trees, mountains, and cliffs, often followed the artist-philosopher's pilgrimage into wilderness, where he meditated, seeking to penetrate nature's inner harmonies. One of the Sung painters Fenollosa discussed was Risei (active c. A.D. 980–1020), whose subjects were chiefly tree effects and forests. According to tradition, the trunks of his trees are drawn with thin ink accented with large spots.

But it is Risei's younger contemporary Kuo Hsi (Kakki) whom Fenollosa celebrates at length in his *Epochs* (where O'Keeffe may well have encountered him). This eleventh-century master carried the painting of trees to new heights, working with ink that somehow continued to look wet even after it dried. Most famous for his forests in winter, Kuo Hsi's deciduous trees "stretch gaunt fingers toward wide plains of snow," while his enormous pines shoot up "against broadsheets of mist, and [hang] over deep crevasses, while through the branches shine glimpses of mountain peaks shrouded in clouds."[77]

It was in words rather than images that Kuo Hsi made his most lasting artistic contribution. His *Essay on Landscape*, according to Fenollosa, is "one of the greatest essays of the world," demonstrating "how every characteristic form of things may be held to correspond to phases of the human soul." Kuo Hsi advised the artist, "The comparing of a tree with man begins with its leaves, and the comparing of man

to a large tree begins with the head." In painting a landscape, he suggested, "One big pine is to be painted first, called the master patriarch, and then miscellaneous trees, grass, creepers, pebbles and rocks, as subjects under his supervision, as a wise man over petty men." Fenollosa picked up the tree metaphor for the forms and life processes of the human body, lauding in Kuo Hsi's essay

the wonderful twisted trees, mighty mountain pines and cedars, loved by these early Chinese and later Japanese, which our Western superficial view first ascribed to some barbarian taste for monstrosities, [but which] really exhibit the deep Zen thinker in their great knots and scaly limbs that have wrestled with storms and frosts and earthquakes—an almost identical process through which a man's life-struggles with enemies, misfortunes, and pain have stamped themselves into the wrinkles and the strong muscular planes of his fine old face.[78]

In the pages of Fenollosa's *Epochs*, O'Keeffe would have seen examples of the spare arboreal images which became prototypes for some of her own tree compositions. One of them is a Chinese-influenced work by the sixteenth-century Japanese painter Kano Soshu (fig. 78). O'Keeffe's austere watercolor *Black Lines* (fig. 79) clearly

78
Kano Soshu (Japanese, Kano School), from Ernest Fenollosa, *Epochs of Chinese and Japanese Art* (London: Heinemann, 1912).

79
Georgia O'Keeffe, *Black Lines*, 1916, watercolor, 62.2 x 47 cm. Extended loan to Georgia O'Keeffe Museum, Santa Fe, New Mexico.

demonstrates the impact of Asian painting on her artistic development. Drawn with a Japanese brush, in the manner recommended by Dow, *Black Lines* is one of a series of works made in the year in which she completed her third session of study with Dow. Stieglitz hung one of these paintings in his gallery 291 that the fall, concluding that the paired lines—which he likened to saplings—symbolized the female and male aesthetic components; eventually he came to think of the composition as a dual portrait of O'Keeffe and himself.[79] For her part, with the influence of Dow close at hand, O'Keeffe may have been thinking more generally of the Sung ideals of yin and yang, the male and female principles symbolizing the duality and rhythm of nature.

We have glimpsed the centrality of natural objects, particularly trees, as vehicles through which Chinese painters conceptualized nature in both formal and mythic terms. As time passed, O'Keeffe would often incorporate Chinese or Japanese design motifs, received via Dow or Fenollosa, into her own work. Still later, in her reading, study, and travel she encountered in many other traditions the tree as mythic subject, though those sources cannot be documented with the directness and specificity of the Sino-Japanese influence.

O'Keeffe often tested the results of her hard-won aesthetic convictions in a variety of situations, occasionally revisiting the visual and aural challenges of nighttime trees. The apogee of that group is her 1929 *The Lawrence Tree* (fig. 80), with its majestic canopy of stars seen through branches. It recalls two precepts of Asian art: the glimmer of forms that appear through Kuo Hsi's branches and the flexibility of vertical-horizontal orientation. It is as if O'Keeffe recalled Fenollosa's assertion that "the Japanese . . . would just as lief at first see a picture upside down; that is, they admire beauty of line and color in art rather than . . . merely depicting nature."[80] O'Keeffe herself exhibited and reproduced *The Lawrence Tree* in both horizontal and vertical formats during her lifetime.

In *The Lawrence Tree* we see O'Keeffe's own artistic coming of age and her growing independence from Stieglitz. More than an unforgettable pattern of branches and stars, *The Lawrence Tree* is the testament to O'Keeffe's own branching out on a journey away from Stieglitz's sometimes stultifying nurture. As authors like Joseph Conrad have always known, and as painters like Paul Gauguin have shown us, journeys *out* are always journeys *in* as well. O'Keeffe's great world tree—displaying an axial formal unity similar to what Dow championed—draws nature to her and stands as a new centering symbol for O'Keeffe's world.

The Lawrence Tree was painted during O'Keeffe's first visit to the Southwest in 1929. Even before she arrived, O'Keeffe knew that D. H. Lawrence had preceded her to Taos and had lived in a cabin beneath the same great pine. Lawrence described the tree several times in his own writing, particularly in his 1925 novella *St. Mawr*:

The . . . long, low cabin crouch[ed] under the great pine tree that threw up its trunk
sheer in front of the house, in the yard. That pine tree was the guardian of the place. But
a bristling, almost demonish guardian, from the far-off crude ages of the world. Its
great pillar of pale, flaky-robed copper rose in strange callous indifference, and the grim
permanence, which is in pine-trees. . . . A passionless, non-phallic column, rising
in the shadows of the pre-sexual world. . . . Strange, those pine-trees! Never sympathetic . . .
they hedged one in with the aroma and the power and the slight horror of the pre-
sexual primal world.

O'Keeffe knew Lawrence's work well by this time and must have had the novelist's
thoughts in mind as she studied the tree for herself. Her description of how she came
to paint the tree from below is worth comparing to Lawrence's. Hers is simple,
understated; his, much more animistically written. As she wrote: "There was a long,
weathered carpenter's bench under the tall tree in front of the little old house that
Lawrence had lived in there. I often lay on that bench looking up into the tree—past
the trunk and up into the branches. It was particularly fine at night with the stars
above the tree."[81]

 Her majestic *Lawrence Tree* demonstrates the painter's awe in the face of
nature, but another tree painting O'Keeffe made that summer is even closer in spirit
to Lawrence's description of the "demonish," "grim" pine in *St. Mawr*. O'Keeffe's

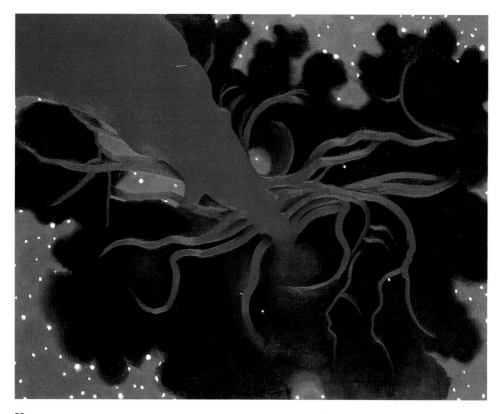

80
Georgia O'Keeffe, *The Lawrence Tree [D. H. Lawrence*
Tree], 1929, oil on canvas, 78.9 x 99.5 cm. Wadsworth
Atheneum, Hartford, Connecticut, the Ella Gallup
Sumner and Mary Catlin Sumner Collection.

Dead Tree, Bear Lake (fig. 81) invokes aspects of both the natural and the supernatural. When O'Keeffe visited the lake that summer, it was probably in the company of Antonio Luhan, a member of Taos Pueblo and the husband of the writer Mabel Dodge Luhan. During his wife's absence that summer, Tony often acted as a guide for O'Keeffe and her companion Rebecca (Beck) Strand. O'Keeffe's letters describe the friendship they established. From Tony Luhan she would have learned of the sacredness of the high-country lakes above Taos Pueblo. Perhaps he deliberately steered her to Bear Lake instead of nearby Blue Lake, the latter a site of such sacredness that its power can be dangerous to the uninitiated.

In any case, the somber stillness and penumbral coloration of all O'Keeffe's Bear Lake subjects suggest her sensitivity to the region's sanctity. Though not strictly off-limits to visitors (Blue Lake and the surrounding area were under Forest Service jurisdiction from 1906 to 1970), the relative inaccessibility of the region probably required approach on foot or horseback. We do not know how many visits O'Keeffe made, but she produced at least three paintings from the vicinity.

Dead Tree, Bear Lake is a dark, eerily lit painting in which the silvery morbidity of the tree gleams forth dead center. Dramatic tapering from base to tip enhances the spiraling monumentality of the trunk, whose height we cannot begin to measure. O'Keeffe's presentation here is once again strongly reminiscent of her affinities with Asian art; Fenollosa had described a large pine tree in a Chinese painting by saying it "rises from the foreground . . . with the spirally resisting and tapering force of a rocket."[82] O'Keeffe's *Dead Tree, Bear Lake* has some of that tapering force, which she enhances by minimizing contextual referents. Surrounding the trunk is a claustrophobic screen of other trunks, presumably living, whose black foliage chokes off the night sky. Unlike *The Lawrence Tree*, no stars suggest escape or transcendence from this deathly midnight. *Dead Tree, Bear Lake* is arguably the polar twin of *The Lawrence Tree*: dead, decontextualized, desolate.

Dead Tree, Bear Lake belongs to the lineage of O'Keeffe's Lake George trees painted earlier in the 1920s; it is, in fact, O'Keeffe's most anthropomorphic tree, imbued with an elegiac poetic content that revives in a stroke all the overempathizing of the pathetic fallacy. She paints it as if it were a gothic fantasy looming in an arboreal nightmare, one the viewer can scarcely fail to interpret as the artist's emotional experience cloaked in natural form. And one source for this image may be Lawrence's. In *St. Mawr* he had written: "The trees hold their bodies hard and still, but they watch and listen."[83]

Why pair a dead tree with the life-affirming *Lawrence Tree*? Perhaps it served O'Keeffe metaphorically to study death and loss in tree portraits that summer. There are several clues available to us from O'Keeffe's personal life. In 1928 her painting had reached something of an impasse; her show that year had seemed, she

81
Georgia O'Keeffe, *Dead Tree, Bear Lake*, 1929, oil on canvas, 81.3 x 43.2 cm. Private collection, Dallas, Texas.

The Natural Self: The Body and Nature

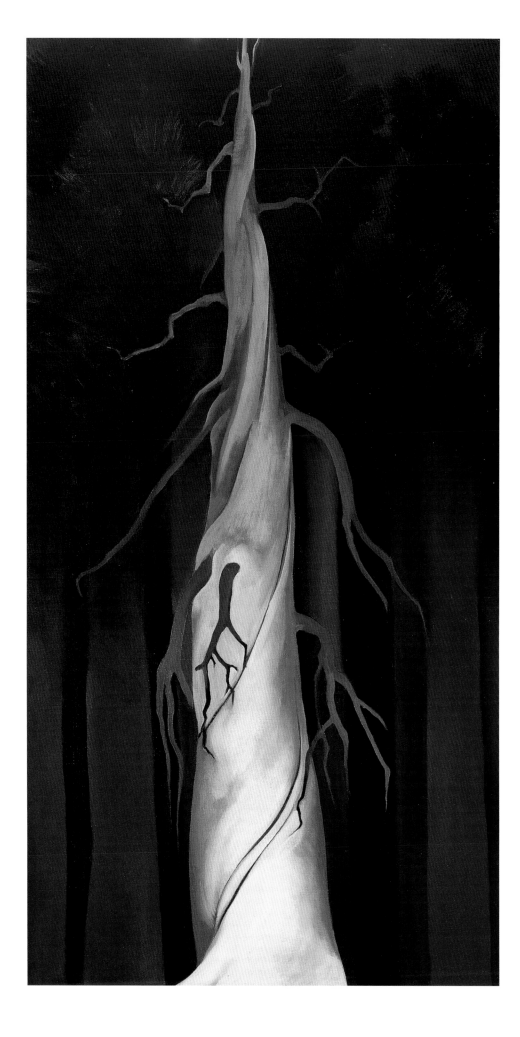

wrote, "mostly all dead for me."[84] Her emotions had also been deadened by tensions in her relationship with Stieglitz, whose infidelities, especially with the younger Dorothy Norman, weighed heavily on O'Keeffe in 1929. O'Keeffe knew too much; she had tasted of the Tree of the Knowledge of Good and Evil, and that taste was Eden soured. As if reflecting her loss of innocence, the lower branches of *Dead Tree, Bear Lake* droop mordantly. And the twisted trunk evokes a wistful memory of her 1916 *Black Lines*; the once-brave saplings standing side by side—symbolic to Stieglitz of O'Keeffe and himself—have here been twisted together, ropelike; in the end they have strangled each other. The axial organization of the Lawrence tree remains firmly in place, but the tree in *Dead Tree, Bear Lake* embraces nothing, gathers in nothing. Even the structure through which the tree is nourished, its root system, has been severed, while the tree's top has been similarly cropped at the upper edge of the canvas. While *The Lawrence Tree* presents the spectacle of élan vital, *Dead Tree, Bear Lake* lingers as an alien forest cadaver.

O'Keeffe's attention was focused on death in other ways during that first New Mexico summer. In empty fields and along roadsides she saw the dark crosses of the austere Penitente sect, whose Holy Week mock crucifixions were secretly reenacted each year. These crosses were also dead trees, handhewn and pegged in the cruciform shape that reminded O'Keeffe of "a thin dark veil of the Catholic Church spread over the New Mexico landscape."[85] As a carefully educated, though lapsed Catholic, O'Keeffe would have felt the symbolic power of the trees-become-crosses.

82
Arthur Wesley Dow, examples of rectangular design, from *Composition* (New York: Doubleday, 1938).

Undoubtedly she also appreciated them as vehicles for formal investigation. She painted them up close, so that the cross's arms or head were often truncated. By extending them to the painting's edge, she also created a series of interior and exterior rectangles, whose edges formed the proportionally varied shapes Dow had suggested as key to understanding harmonious linear compositions (fig. 82).

In several of her 1929 cross paintings, O'Keeffe introduced another element rich in interpretive possibility. At the base of the cross, lines converge, suggesting a crossroads, an intersection of ideas. The tree-cross itself forms such an intersection— literally in its vertical and horizontal members, symbolically in the meet-

ing of religion and nature in northern New Mexico. O'Keeffe herself had reached a crossroads in her life in 1929. Coming west, she reached a defining intersection in her personal and professional life—a place from which she could look backward and ahead, change directions and proceed, if she wished, along a new road. What she chose to leave behind was a period of drift, of metaphysical homelessness; the path she set upon was one of intentionality, self-nurture, and openness to the dark as well as the joyous sides of herself.

It was also a path of healing. That summer Beck Strand wrote Stieglitz that O'Keeffe seemed to have acquired a new vigor, a new toughness—like a hickory root—in New Mexico, "and it's not the false toughness of excitement and newness, but a strength that has come from finding what she knew she needed." The next summer Dorothy Brett, a British painter who had settled in Taos, also wrote to Stieglitz of her friend O'Keeffe's tree-strength, a factor in her occasional isolation from others: "O'Keeffe hasn't altogether realized herself in relation to the world. She has lived so much for her painting—lived so deeply with you—that she is like a tree walking among people, she looks for other trees, without seeing—most of them have but twigs." [86]

During the increasingly long periods she spent away from Stieglitz, O'Keeffe painted many other trees in various places. All reveal her immediate environment, some her interior states as well. O'Keeffe's fragile inner life, drawn taut by emotional conflict and professional frustrations in the late 1920s and early 1930s, snapped on several occasions, forcing her to be hospitalized for nervous conditions. The circumstances and broader implications of those illnesses belong in Chapter 3, but here I shall note some highly suggestive tree imagery that came out of those dark periods.

While recuperating in Bermuda during the spring months of 1933 and 1934, O'Keeffe produced very little art. She gave up painting for more than a year but made a few drawings from Bermuda. Significantly, what she chose to draw were plant fragments, very factual and sometimes with unusual detail. One of those is *Bermuda Tree* (fig. 83), a large, delicate graphite rendering of a heavily anthropomorphized tree. O'Keeffe gives enough leaf and branch detail to assure that it will be recognized as a tree image but then undercuts its treeness by velvety surfaces and swelling curves that insist on being read as female form. Unmistakable allusions to breasts and abdomen convey a distinct sense of vitality and fecundity—qualities conspicuously absent in that dark passage in O'Keeffe's life. In a period when she was emotionally fragile, recovering from deep depression, trees in Bermuda restored a nonthreatening intimacy with nature; more, they opened a way for O'Keeffe back into an art of personal expressiveness disguised as natural form.

More than a decade later she took up naked tree trunks again, this time in a wintry setting. *Bare Tree Trunks with Snow* (1946; Dallas Museum of Art) with its bleak, subtly canted shapes, was painted the year of Stieglitz's death. In winter, deciduous trees enact a mock death; dead trees, like the ones O'Keeffe had personified at

Lake George in the 1920s, draw on even more austere associations with nature. During her years in New Mexico, O'Keeffe continued to paint dead trees in oddly personal ways yet seldom as anthropomorphically as *Dead Tree, Bear Lake.* Instead, she studied the tree, living or dead, as a repository of nature's forces. It was an idea she also held about bones, perhaps confirmed by her increased reading in Eastern philosophy: according to Taoist belief there is no dead or lifeless matter, since the divine energy of Tao permeates all.

For O'Keeffe, trees—familiar, laden with meaning—remained a favorite beginning point from which to discover or rediscover landscape. In her annual transplantations from New York to New Mexico, she might find a well-chosen tree to root her thoughts quickly in the southwestern soil. In the fall of 1948 her first painting was *Grey Tree, Fall* (private collection), which she described as "a dead tree surrounded by the autumn . . . very gentle and pleasant and high in key but it holds its place on the wall alone more than forty feet away."[87] Dead but alive as a composition, the tree offered what O'Keeffe always wanted from a subject: it worked both as a painting and as her personal interpretation of nature.

Her 1943 painting *Dead Cottonwood Tree, Abiquiu* (fig. 84) likewise explores the dualities of life-in-death. The tree is a peculiar shape, bulbous at the base, like her

83
Georgia O'Keeffe, *Bermuda Tree [Untitled (Banyan Tree)]*, 1934, pencil on paper, 54.9 x 37.5 cm. Gerald Peters Gallery, Santa Fe, New Mexico.

The Natural Self: The Body and Nature

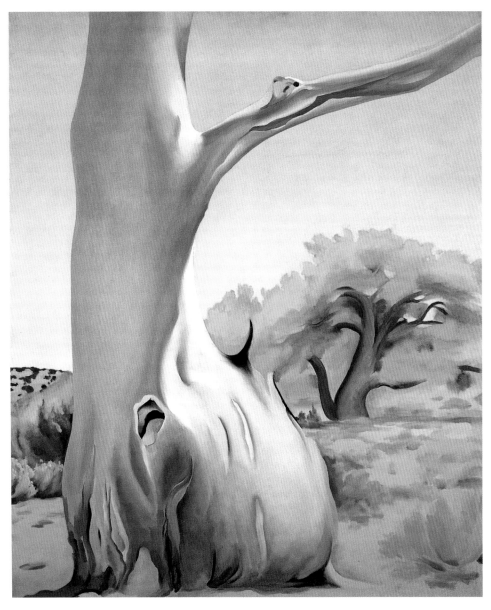

84

Georgia O'Keeffe, *Dead Cottonwood Tree, Abiquiu,*
New Mexico, 1943, oil on canvas, 91.4 x 76.2 cm. Santa
Barbara Museum of Art, Gift of Mrs. Gary Cooper.

1934 Bermuda tree. But this tree is clearly dead; a hole through the swelling reveals that it encloses only air. Above, the tree's smooth trunk and single arm rise palely, with the grace of a frozen marble Aphrodite. Or should we think rather of the nymph Daphne, who escaped pursuit by becoming a tree? Aside from these ancient antecedents, there were clear precedents in recent art for such imaginings. O'Keeffe, who had studied the early issues of Stieglitz's *Camera Work* carefully, would have seen there many photographs by Anne W. Brigman of the conflation of woman and tree, including her *Soul of the Blasted Pine* (fig. 85), an image very much in the spirit of O'Keeffe's *Dead Cottonwood Tree, Abiquiu.*

When O'Keeffe moved permanently to the Southwest after Stieglitz's death, it was as if she had finally ended one chapter and begun another, the penultimate one in her life. The change of seasons in New Mexico, seen most vividly in the rich polyphony of trees, allowed her to write her own chromatic melodies connecting her life with nature's forms and passages. Now she felt the trees welcoming her home in a warm and intimate way: "I cannot tell you," she wrote to a friend, "how pleased I am to be back in this world again—what a feeling of relief it is to me. The brightest yellow is gone from the long line of cottonwood trees along the river valley—With the dawn my first morning here I had to laugh to myself—it seemed as if all the trees and wide flat stretch in front of them—all warm with the autumn

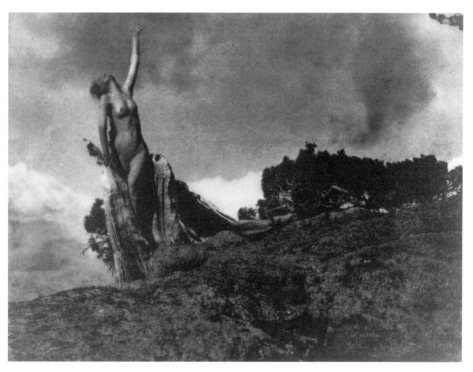

85
Anne W. Brigman, *Soul of the Blasted Pine*,
photogravure, 15.3 x 20.1 cm, from *Camera Work* 25
(January 1909). Minneapolis Institute of Arts.

grass—and the unchanging mountain behind the valley all moved into my room with me—I was very amused."[88]

Cottonwoods, those thirsty, fast-growing denizens of New Mexico's river-banks and *acequias*, put on a season-by-season show below O'Keeffe's Abiquiu home. Delicately green in spring, blazing gold in fall, softly gray in winter, cotton-woods are so heavily foliated that their structure is often hidden. In a painting such as O'Keeffe's *Spring Tree No. 1* (fig. 86) the traceries of branches curl in lively patterns, creating an all-over composition. Except for a few glimpses of blue sky, O'Keeffe gives us little indication of up-and-down orientation. Her once-careful attention to axial organization in trees has softened. She invites us instead to enjoy, with the Japanese, the massing of color and line, seen from any direction and overriding subject matter. True, cottonwoods do not configure themselves neatly along a single axis. Their diffuse structure instead reads like a permeable screen, invit-ing the viewer to enter their treeness. O'Keeffe herself seems already there: she has removed the painter-spectator who stands back from the canvas viewing the subject as she paints it. Instead, we all move together inside the picture space; painting and perceiving are one.

In the 1950s O'Keeffe's travels afforded her new, and sometimes surprising, juxtapositions of art and nature. Those realms seemed to converge at Chartres,

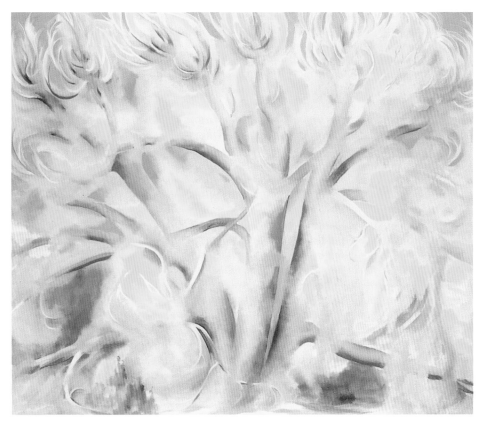

86
Georgia O'Keeffe, *Spring Tree No. 1*, 1945,
oil on canvas, 76.2 x 91.4 cm. Museum of Fine Arts,
Museum of New Mexico, Gift of the Estate
of Georgia O'Keeffe, 88.312.3.

one of France's most magnificent cathedrals. Visiting in 1953, O'Keeffe spent hours studying the cathedral's light and structure. To her friend Anita Pollitzer she concluded that the cathedral "seemed about as beautiful as anything made by the hand of man could be. It was like being under great trees." The next year she spent three months in Spain, savoring the art galleries (particularly the Prado) and experiencing some of the great festivals. In spite of her intense pleasure in the art and pageantry of Spain, she wrote Pollitzer, "Others can have the festivals, I will take the olive trees." [89] Wherever she traveled, O'Keeffe looked for the trees characteristic of the region, deriving delight from their forms, color, and relation to the land.

Meanwhile, O'Keeffe's plane trips inspired drawings and paintings of rivers seen from the air. These works are really linear meanderings, freely colored. Coyly silent about their inspiration, the artist was pleased that people sometimes misinterpreted them as tree forms. She deliberately conflated the two subjects, as is evident from a photograph Todd Webb made in her studio (fig. 87) In this playful obfuscation, O'Keeffe's painting at the right—ostensibly one of her "river" subjects—has no fluvial origin at all but is clearly based on the tree branch propped against the wall at the left. Trees remained for O'Keeffe an important vehicle for abstracting from nature. Understanding her flexible vocabulary of tree forms, we are not surprised to see some of her earliest tree sources reprised in late work. *From the River—Light Blue* (1964; Museum of Fine Arts, Museum of New Mexico), ostensibly

87
Todd Webb, *Georgia O'Keeffe's Studio, New Mexico,*
1963, gelatin silver photograph. Museum of Fine Arts,
Museum of New Mexico, Todd Webb Study
Collection, Gift of the Artist.

The Natural Self: The Body and Nature

based on a aerial river form, is also a sharp reprise of the paired saplings of *Black Lines* and thus of the hybrid tree figure.

After a long, incisive study of the particularity of trees, O'Keeffe learned, paradoxically, to paint their universal treeness. In O'Keeffe's long exploration of tree imagery there are points at which she raised trees to mythic proportions and others where she struggled to extract fresh sensations from the familiar. No matter what her intention of the moment, O'Keeffe painted trees persistently and inventively. Direct, disguised, embodied, or transfigured, O'Keeffe's trees grounded her in the natural world but allowed her at the same time to reach beyond the physical. We have seen how a half-century of intimacy with trees informed her enduring identification with them. To Doris Bry, her agent, she confessed, "When I paint I *am* trees."[90] O'Keeffe, who had struggled as a young woman to balance relational intimacy with the development of an autonomous self, allowed herself to yield personal identity in the presence of natural forms. And in those moments of holding and yielding she discovered the joy of merging with something she needed for her own wholeness.

Though her eyesight failed in her last decade, O'Keeffe retained her feeling for nature, her visual memory, her formal inventiveness, and a technique so sure it sustained her well after the light faded. In painting natural forms such as trees, she framed an allegory about art in which birth, growth, and death served as metaphor for her own lifelong journey of the artistic imagination.

Emily Carr's Trees

Emily Carr experienced an ecstatic identification with the spirit of nature, particularly as she found it in British Columbia. There the cool, gray climate, the proximity of water and—most particularly—the presence of trees offered her endless opportunity for artistic reflection and growth.

To speak of Emily Carr's trees is to seize on the central subject of her work, both as metaphor and form. Like a great axis mundi, the tree centers and grounds most of her paintings. And as a mythico-ritual subject in Carr's work, the tree corresponds in importance to the centerpost often present in her paintings of the homes of native peoples in the Pacific Northwest (fig. 88).

In 1935 Carr spoke before a literary society in Victoria about her art, a talk later published as "The Something Plus in a Work of Art." That "something," Carr explained, was what characterized great works of art—a kind of spiritual connection between the artist and an ideal. It was a connection that echoed Plato as well as the transcendentalists, whom she quoted. But it was more. Carr also brought the Japanese concept of *Sei Do* into her definition: "the transfusion into the work of the *felt nature* of the thing to be painted."[91] Like O'Keeffe, Carr was receptive to principles and practices of Asian art. Carr's influences were received via other artists, particularly Mark Tobey, whose advice and teaching she had sought a few years earlier.

The *felt nature* of the thing—its essence, its distinguishing core. For a painter whose chief subject was trees, Sei Do was treeness, and the expression of it her life's work.[92] Carr had begun to discover its power very early in her career, when she animated trees in a 1905 political cartoon for a Victoria weekly periodical (fig. 89). Captioned "The Inartistic Alderman and the Realistic Nightmare," the cartoon was accompanied by the following poem:

> *Ye ghosts of all the dear old trees,*
> *The oak, the elm, the ash,*
> *Nightly those gentlemen go tease,*
> *Who hew you down like trash.*

Carr, it seems, had already seen the dangers posed by unrestrained tree cutting, a cause she would champion all her life. Trees, she suggests, possess a life of their own and should not be wantonly felled. It was an idea that was rarely popular in British Columbia, where the logging industry yearly consumed ever more of the virgin forests.

Cartooning could not hold Carr's interest for long; she was after something more deeply expressive in the forest. In 1934 she chastised herself for flagging in her work: "I am *hedging*, not facing the problem before me—how to express the forest—pretending I must do this and that first . . . but the other should come *first*; it's my job." By that time Carr had spent years investigating the forest, absorbing all she could of tree existence. Her journals are full of her communion with trees, her

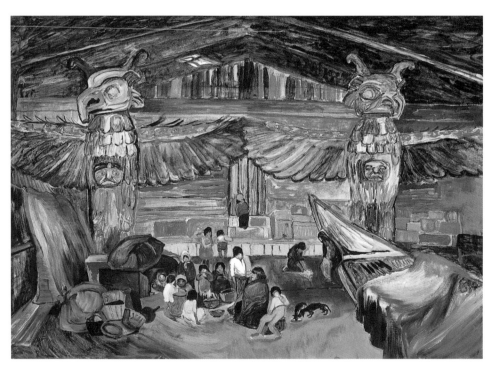

88
Emily Carr, *Indian House Interior with Totems*, 1912, oil on canvas, 89.6 x 130.6 cm. Vancouver Art Gallery, Emily Carr Trust, VAG 42.3.8. Photo by Trevor Mills.

admiration of them, and, ultimately, her close identification with them. Because Carr wrote so much about her life and her artistic struggle—unlike O'Keeffe—we can more readily see how she projected her feelings onto trees. Typical are her remarks "Trees are so much more sensible than people, steadier and more enduring" and "I ought to stick to nature because I love trees better than people."[93] The latter statement echoes that of O'Keeffe to her friend Hartley.

In their paintings of trees both Carr and O'Keeffe made transcriptions from visual experience, and each artist searched out rhythmic patterning and movement within arboreal structure, although there is no evidence that either painter knew the other's work before 1930. Both often cropped trees, and both made much of the negative spaces between branches. Carr's work in the 1920s usually stayed closer to gritty, palpable realism, while O'Keeffe's toyed with space and pressed toward decorative abstraction. The differences are significant.

In 1930 Carr's and O'Keeffe's interest in trees intersected. That spring Carr visited New York, where, in the company of Arthur Lismer, an acquaintance who was a member of the Group of Seven, she sought out new painting. At An American Place a number of O'Keeffe's paintings were still on exhibit from her annual show. Most were based on her previous summer's visit to Taos, including *The Lawrence Tree* (see fig. 80). Carr and O'Keeffe apparently discussed the painting at some length, during which O'Keeffe related the work's connection both to her experience at the Lawrence cabin and to Lawrence's passage about the great pine in *St. Mawr*. Apparently these ideas lingered in Carr's mind, for later that year she copied Lawrence's description into her journal, though with a qualifying comment: "It's clever, but it's not my sentiments nor my idea of pines, not our north ones anyhow. I wish I could express what I feel about ours, but so far it's only a feel and I have not put it into words."[94]

She continued, adding her intent to try to find words for the great pines, because "trying to find equivalents for things in words helps me find equivalents in painting." It is an interesting inversion of Lawrence's great skill, translating from the language of the eye to that of the ear. The search for equivalents also touches on O'Keeffe, who with Stieglitz thought deeply about the issue; unlike Lawrence or Carr, however, O'Keeffe found them most often in photography or music, not words.

To find a visual vocabulary for what she felt about Canadian trees, Carr launched into a series of large studio drawings in charcoal on paper, based on trees but exploring form in a

THE INARTISTIC ALDERMAN AND THE REALISTIC NIGHTMARE.
"Ye ghosts of all the dear old trees,
The oak, the elm, the ash,
Nightly those gentlemen go tease,
Who hew you down like trash."

89
Emily Carr, "The Inartistic Alderman and the Realistic Nightmare," 1905, cartoon for the *Week*. British Columbia Archives, B08163.

conceptual manner. Though Carr had long practiced drawing as a record of what she saw and thought, this 1930–31 series constitutes what Doris Shadbolt has called "the refined product of a period of study, which she seems not to have repeated at any other time in her life." That this extraordinarily free body of work followed directly upon Carr's visit to New York invites speculation that it was undertaken in response to her conversation with O'Keeffe, who had also used drawings—particularly large, expressive studio charcoals—during her own break-through period in 1915. Had O'Keeffe recommended such liberating exercises? Carr's journal entries indicate a readiness for new ideas: in January 1931 she is weary of past directions, writing, "My old things seem dead. I want fresh contacts, more vital searching."[95] Her words are curiously reminiscent of O'Keeffe's two years earlier when, about to make a fresh beginning in the Southwest, the artist complained of her recent work, "It was mostly all dead for me." Carr seldom stretched for abstraction as much as O'Keeffe, but the 1930–31 charcoals seem to have furthered her movement away from preoccupation with native imagery and toward a search for nature's formal equivalents.

At least one of these drawings may be directly responsive to Lawrence and O'Keeffe. *Untitled [Formalized Cedar]* (fig. 90) and two closely related oils, *Red Cedar* (1931; Vancouver Art Gallery) and *Tree Trunk* (fig. 91), are particularly striking as answering motifs. With their central, upward-thrusting trunks, these paintings suggest that O'Keeffe's *The Lawrence Tree* and her jack-in-the-pulpit series, which Carr had also seen during the New York trip, had shown Carr the power of a symbol embedded in a reductivist image. Carr's responses, particularly her *Tree Trunk* and the formalized cedar drawing, demonstrate a new simplicity in her work, as well as the strong possibility of sublimated eros—a suggestion that would have horrified the prim Emily, simultaneously repelled by and drawn to Lawrence's nature-based sexuality.

Perhaps it was Lawrence's characterization of the pine as a "passionless, non-phallic column, rising in the shadows of the pre-sexual world" that made Carr feel she was on safe ground. In any case, she was fascinated (like O'Keeffe) by Lawrence's attention to the darker side of nature, a symbolism of death as well as life. If O'Keeffe had acknowledged that shadowy zone in *Dead Tree, Bear Lake*, Carr painted it in *Old Tree at Dusk* (fig. 92). The tree's spiraling trunk and down-ward-drooping branches are strongly reminiscent of O'Keeffe's dead tree, a painting Carr might also have seen during her New York visit.

What Carr definitely saw in New York was an exhibit of Arthur Dove's work at An American Place. On display were twenty-seven recent paintings by the romantically inclined Dove, whose explorations of abstractions derived from nature parallel those of O'Keeffe. A work such as Dove's charcoal *Thunderstorm* (fig. 93) uses angular geometries to suggest the crackling energy of lightning. O'Keeffe had used similar zig-zag or sawtooth shapes in works from the same period. Early

The Natural Self: The Body and Nature

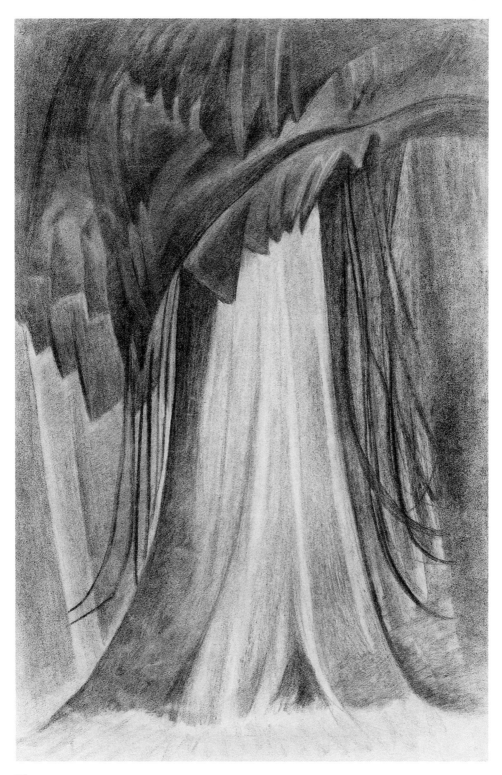

90

Emily Carr, *Untitled [Formalized Cedar]*, c. 1931, charcoal on paper, 91.8 x 61.2 cm. Vancouver Art Gallery, Emily Carr Trust, VAG 42.3.114. Photo by Trevor Mills.

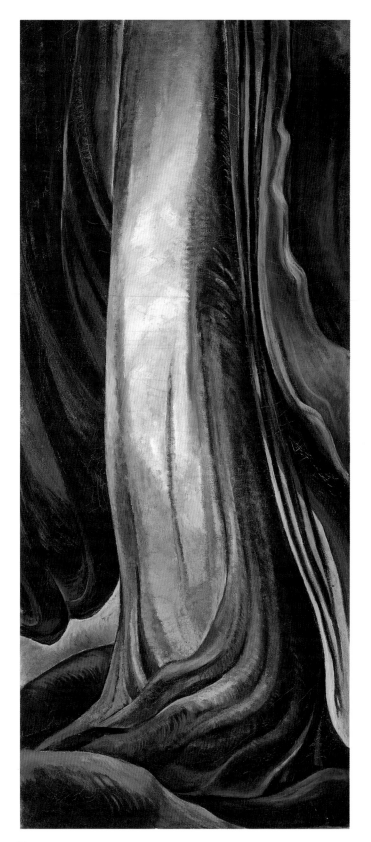

91
Emily Carr, *Tree Trunk*, c. 1931, oil on canvas,
129.1 x 56.3 cm. Vancouver Art Gallery, Emily Carr
Trust, VAG 42.3.2. Photo by Trevor Mills.

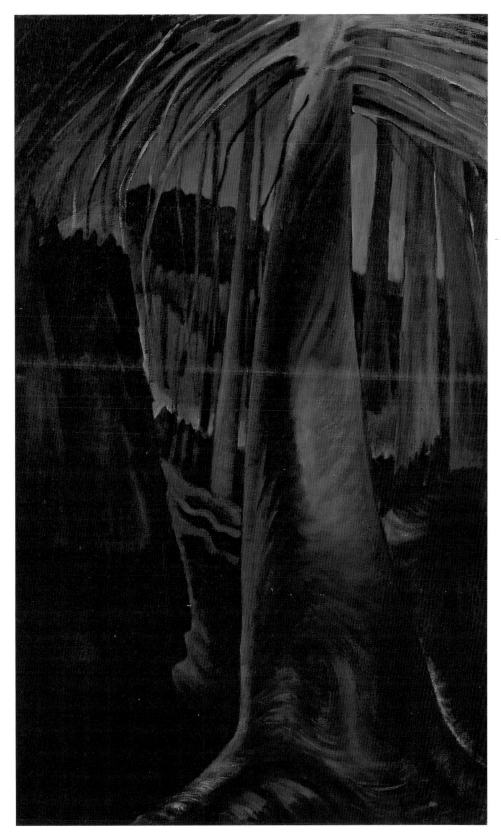

92

Emily Carr, *Old Tree at Dusk*, c. 1936, oil on canvas,
112 x 68.5 cm. McMichael Canadian Art Collection,
Kleinberg, Ontario, Gift of Col. R. S. McLaughlin,
1968.7.13.

in the 1930s, whether in response to the increasing abstraction in Lawren Harris's work (as suggested by Carr scholars) or—as I would argue—with Dove's or O'Keeffe's angularities in mind, Carr introduced stronger geometric forms into her painting. *Grey*, discussed above, and an untitled black-and-gray forest interior from 1931–32 (fig. 94) show Carr moving into the most abstract phase of her forest paintings. Zig-zagging shafts of light, a reductivist palette, and strong geometric patterning reveal Carr's interest in cubist-derived form.

Equally abstract, but far less angular, is Carr's sweeping *Abstract Tree Forms* (fig. 95). Great ribbons of color undulate across the surface of the painting; the red in the foreground encloses a deep tunnel form, like the sinuous wrapped shapes in O'Keeffe's paintings of music. Inside this space, however, is a dark bulbous form—perhaps a tree stump, a fragment of a downed totem pole, or even the form of the artist herself.

The freedom of the work owes as much to materials—thinned oil on paper—as to formal conception. It began as a practical effort: Carr needed to cut her expenses for materials, and she wanted to be able to work large and rapidly. She bought big sheets of inexpensive manila paper, which yielded paintings of consistent size that were simpler to frame and exhibit. To transport the paper and paintings, she made a folding drawingboard. And for paint she chose good-quality white housepaint thinned with gasoline, which could be supplemented with oils, if necessary, on her return to the studio. Most days Carr could produce three of these paintings, which she tacked on the walls of her caravan or cabin overnight. A friend who often painted with her remembered that Carr liked to study her previous day's work in the bright morning light.[96]

Working large, she thinned the oil to admit light and air into the composition. Its quick-drying capabilities gave her some of the fluidity of water-color yet provided more opacity and solidity. Not least, the materials were so cheap that she could afford to be profligate in her experiments. Carr made many of these oil-on-paper works between 1933 and 1936. About them she wrote: "I've learned heaps in the paper oils—freedom and direction. You are so unafraid to slash away because material scarcely counts. You use just can paint and there's no loss with failures. I try to do one almost every day."[97]

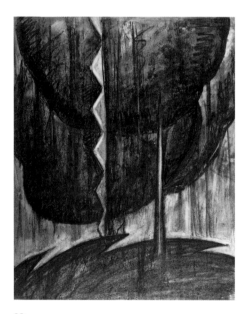

93

Arthur G. Dove, *Thunderstorm*, 1917–20, charcoal, 53.3 x 45.1 cm. University of Iowa Museum of Art, Iowa City, Mark Ranney Memorial Fund.

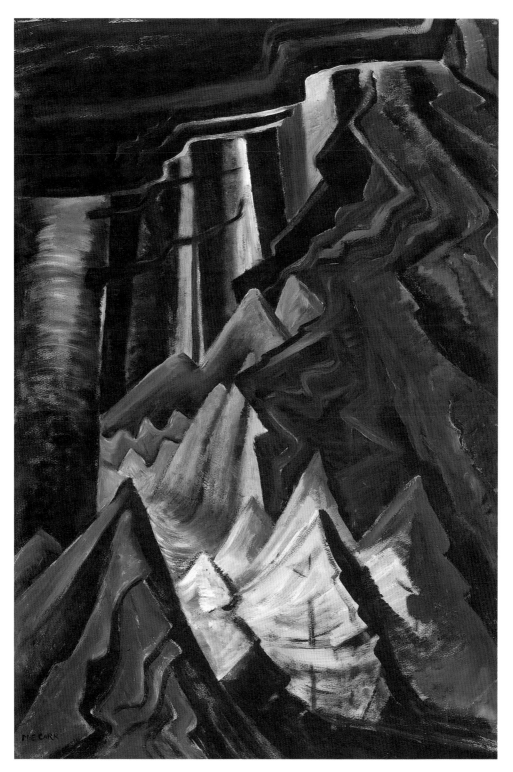

94

Emily Carr, *Untitled [Forest Interior Black and Grey]*,
c. 1930, oil on paper on board, 89.4 x 60.7 cm. Van-
couver Art Gallery, Emily Carr Trust, VAG 42.3.56.
Photo by Trevor Mills.

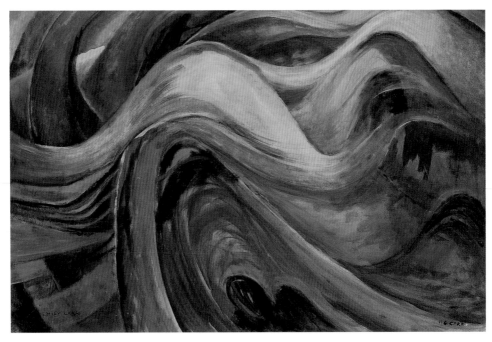

95

Emily Carr, *Abstract Tree Forms*, 1931–32, oil on paper,
61 x 93.5 cm. Vancouver Art Gallery, Emily Carr Trust,
VAG 42.3.54. Photo by Trevor Mills.

Carr sometimes relied on dreaming to press her tree paintings into greater simplification and abstraction. As she wrote, "Last night I dreamed that I came face to face with a picture I had done and forgotten, a forest done in simple movement, just forms of trees moving in space. That is the third time I have seen pictures in my dreams, a glint of what I am striving to attain." O'Keeffe had also developed the capacity to incorporate dreaming into her landscapes, a practice that seems to have facilitated her own impulse to abstraction. In a letter to Dorothy Brett she referred to "that memory or dream thing I do that for me comes nearer reality than my objective kind of work." One thinks here of Gauguin's admonition to the artist to dream before nature.[98] For both Carr and O'Keeffe, letting go of direct, detailed observation was a key to finding other truths in the landscape.

Carr returned in the 1930s to tree subjects she had painted early in her career, and we can see in the comparison how far her conception of Sei Do had evolved. Her early sedate rows of trees give way to later ones, like *Sombreness Sunlit* (fig. 96), in which light, and perhaps wind, take visible form and become the real subjects of the painting. All is movement, all light, perhaps accompanied by sound. Carr wrote about these sensory overlaps, a concept known to modernists as synesthesia: "If the air is jam-full of sounds which we can tune in with, why should it not also be full of feels and smells and things seen through the spirit, drawing particles from us to them

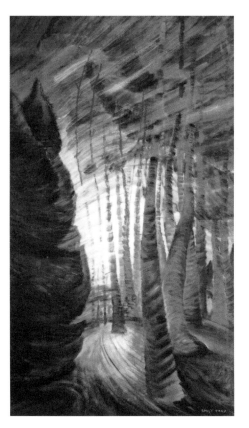

96
Emily Carr, *Sombreness Sunlit*, c. 1937–40, oil on canvas, 111.9 x 68.6 cm. British Columbia Archives PDP00633.

and them to us like magnets?" Such sensory transfers had been made especially visible to Carr during her 1930 New York visit, when she saw the work of Kandinsky and Charles Burchfield; the latter artist was having an exhibit of his early watercolors at the Museum of Modern Art at the time. His brooding works like *Church Bells Ringing, Rainy Winter Night* (fig. 97) exaggerate the expressionistic qualities in plants, buildings, and natural surroundings to make them seem alive with menace. As Ruth Appelhof points out, after seeing Burchfield's work Carr began "to employ rhythmic lines to denote atmospheric movement and as a formal means of unifying the compositions."[99]

Trees figure importantly in the moody spatial evocations of both artists. A work like Carr's oil-on-paper sketch *Chill Day in June* (fig. 98) employs those

devices to great expressionist effect. By now the medium we saw introduced in *Abstract Tree Forms* about six years earlier had taken Carr's work in decidedly new directions. Although Carr herself referred to her more than two hundred of these oils on paper as "sketches," the term is somewhat misleading; they are finished works in their own right. It is true that she borrowed elements from them for later canvases; but what Carr discovered through the new medium was itself pivotal: in oil on paper she learned to join her means and ideas seamlessly. Great sweeps and washes of color, punctuated with seemingly careless dashes, flicks, and strokes, explore surface and depth simultaneously. Filled with light and air, these works break down the impenetrable wall of green seen in her early forest canvases. Moving beyond the Group of Seven, who had taught her something about vastness, she now opened up space even more in beach scenes like *Strait of Juan de Fuca* (fig. 99). And in an oil-on-paper work called *Forest* (fig. 100), color, air, and light chase one another with abandon. In paintings such as this one, Carr's exuberant paint application best expresses her belief in the unquenchable vitality of trees. Of the breadth and spontaneity her oil-on-paper technique afforded her, Carr concluded, "I feel I have gained a lot by its use. It is inexpensive, light to carry and allows great freedom of thought and action." Criticized by some for their large size, she justified the scale by saying, "Woods and skies out west are *big* you *can't* squeeze them down." [100]

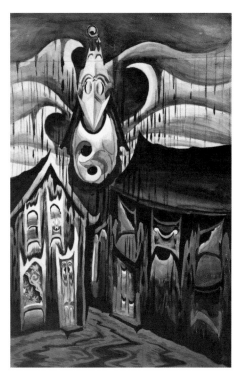

97
Charles Burchfield, *Church Bells Ringing, Rainy Winter Night*, 1917, watercolor over graphite, 77 x 49.8 cm. © The Cleveland Museum of Art, 1999, Gift of Louise Dunn in memory of Henry G. Keller, 1949.544.

Carr's trees developed in many moods and moments. She never seemed to exhaust their expressive possibilities, probably because she identified so closely with them. Trees were the botanical counterpart of her own imagined existence in nature: varied, changing, joyous, despondent. In the latter mood, feeling alienated from people, she wrote of herself as "exposed to all the 'winds' like a lone old tree with no others round to strengthen it against the buffets with no waving branches to help keep time." When the persistent efforts of loggers decimated the old-growth forests in certain areas, Carr returned to the idea she had first used in her 1905 cartoon: she anthropomorphized trees. Loggers were "executioners," she now declared; the stumps mute mourners or tombstones. These things she described, both in paint and in

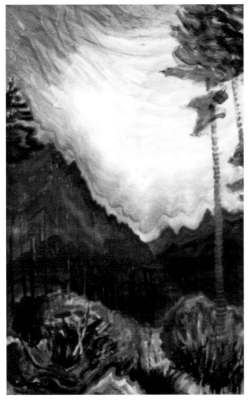

98
Emily Carr, *Chill Day in June*, c. 1938–39,
oil on paper, 106 x 75 cm. Maltwood Art Museum and
Gallery, University of Victoria, British Columbia.

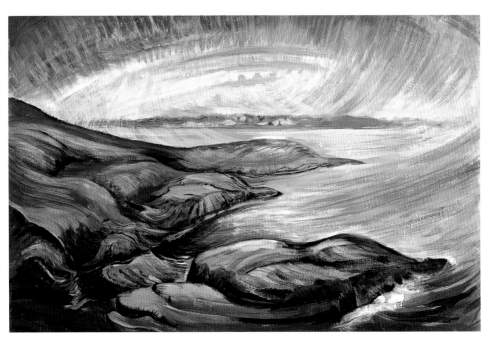

99
Emily Carr, *Strait of Juan de Fuca*, c. 1936,
oil on paper, 60.7 x 91.3 cm. McMichael Canadian
Art Collection, Kleinberg, Ontario,
Gift of Dr. and Mrs. Max Stern, 1974.18.2.

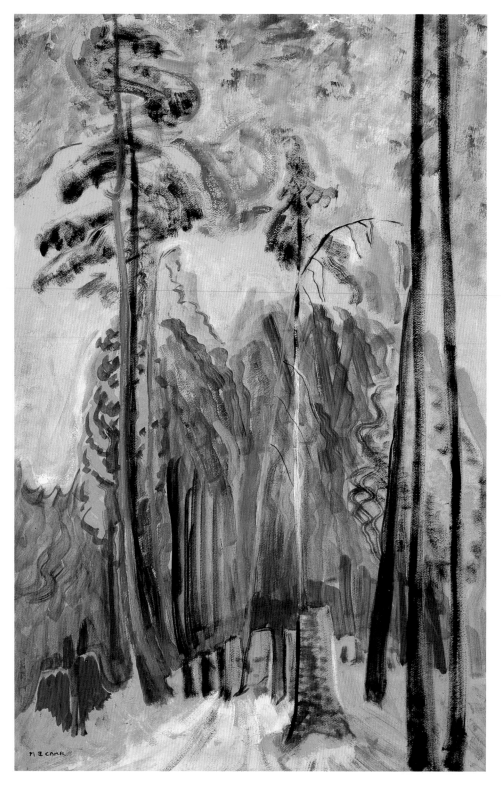

100

Emily Carr, *Forest*, c. 1940, oil on paper, 91 x 59.5 cm.
McMichael Canadian Art Collection, Kleinberg,
Ontario, Gift of Dr. and Mrs. Max Stern, Dominion
Gallery, Montreal, 1974.17.

The Natural Self: The Body and Nature

words: "There's a torn and splintered ridge across the stumps I call the 'screamers.' These are the unsawn last bits, the cry of the tree's heart, wrenching and tearing apart just before she gives that sway and the dreadful groan of falling, that dreadful pause while her executioners step back with the saws and axes resting and watch." [101]

Significantly, the trees have a sex—female, in Carr's thinking; their pain is hers. Her paintings of stumps often continue the theme of scarred flesh; they read like amputations. *Loggers Culls* (1935; Vancouver Art Gallery), *Stumps and Sky* (c. 1934; Vancouver Art Gallery), and *Swaying* (fig. 101) are three examples of such imagery. In the latter painting surviving trees stand like sentinels in a graveyard of stumps.

On the other hand, when Carr entitles a painting *Laughing Forest* or *Happiness* (both c. 1939; private collections), we can be sure that she is projecting her own positive emotions onto the forest. The trees seem, at times, to be singing, a concept known to O'Keeffe as well. Georgia O'Keeffe wrote in 1915 of "the woods turning bright . . . and the pines singing," but the words could as easily have been Carr's. [102]

In their seasonal and annual cycles, trees offered Carr the constant prospect of renewal. She tapped their energy for her own work. Musing on reawakening her strength at age sixty-nine, she wrote: "I think I shall start new growth, not the furious forcing of young growth but a more leisurely expansion, fed from maturity, like topmost boughs reflecting the blue of the sky." [103] A painting such as *Scorned as Timber, Beloved of the Sky* (fig. 102) expresses that vision of high waving foliage, reaching upward for release and renewal in nature.

Often release took the form of spiritual redemption for Carr, whose religious wanderings brought her eventually to a highly personal form of Christianity. The forest as religious refuge is expressed in such paintings as *Cedar Sanctuary* (fig. 103)

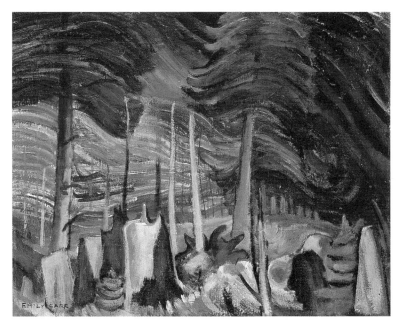

101
Emily Carr, *Swaying*, c. 1936, oil on canvas, 35.5 x 45.5 cm.
The McMichael Canadian Art Collection, Kleinberg,
Ontario, Gift of Mrs. F. B. Housser, 1966.5.2.

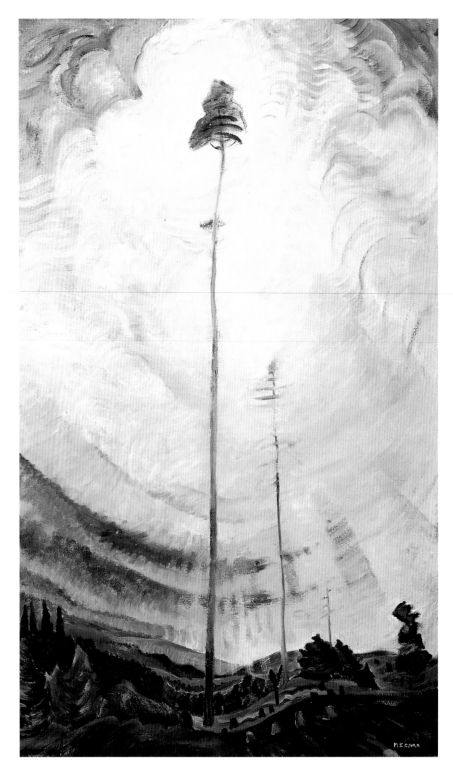

102
Emily Carr, *Scorned as Timber, Beloved of the Sky*, 1935,
oil on canvas, 111.8 x 68.4 cm. Vancouver Art Gallery,
Emily Carr Trust, VAG 42.3.15. Photo by Trevor Mills.

The Natural Self: The Body and Nature

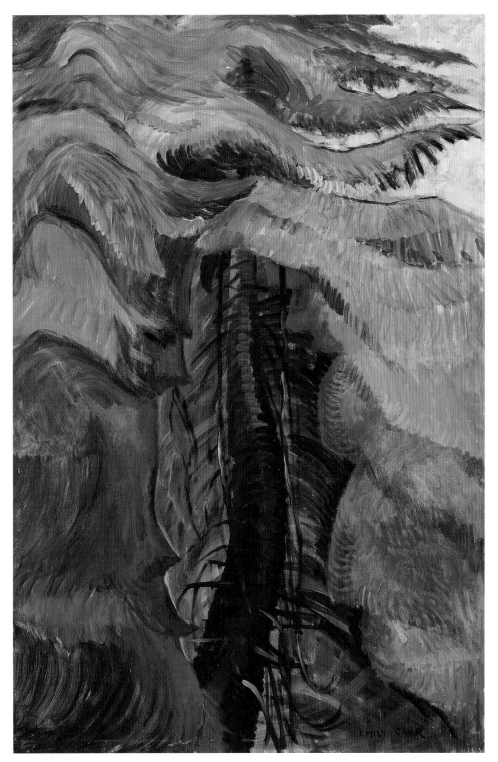

103

Emily Carr, *Cedar Sanctuary*, c. 1942, oil on paper,
91.5 x 61 cm. Vancouver Art Gallery, Emily Carr Trust,
VAG 42.3.71. Photo by Trevor Mills.

and *Wood Interior* (c. 1929–30; private collection), which frame space as if it were within sacred precincts. The interiority there is the visual correlative of her own internal questioning: "Why do you go back and back to the woods unsatisfied, longing to express something that is there and not able to find it? This I know, I shall not find it until it comes out of my inner self, until the God quality in me is in tune with the God in it."[104]

Carr's trees form the axis around which her work rotates. Whether she studied them as native totem poles, as foliage curtains in living walls of jungle, as whirling, spiraling young evergreens against the sky, as murdered stumps, or as pillars within her intimate forest sanctuaries, Carr's trees form the thematic and formal scaffolding upon which her whole oeuvre was constructed.

Frida Kahlo's Trees

Perhaps no Western painter knew trees better than Emily Carr; they were her intimates, her ur-forms. Profoundly different are the tree forms of Kahlo, a confirmed urbanite, who knew trees in contained areas: her own garden, tropical parks, along roadsides, or observed from a passing automobile. To her old friend Alejandro Gómez Arias, she wondered as she thought about painting trees in 1934, "Do you know I've never seen any forests? How is it that I'll be able to paint a forest background?"[105]

Because she knew little about trees in nature, Kahlo felt little obligation to paint them naturalistically. Instead, she often rendered them in a highly stylized manner that points to their mythic rather than their landscape context. As in other aspects of her work, we see in Kahlo's trees her sympathy with the ancient Mesoamerican religious attitude that views the universe as essentially magical. It is not bound by mechanistic laws of cause and effect, and its structure extends through multiple levels of existence. Planes of spirit and matter are joined along a central axis, often represented by a world tree. Kahlo allowed her imagination to move freely along that axis, shamanlike, between levels of reality.

But Kahlo's trees are mythical on more than one level: they are reminders of the ancient milk-tree goddess of Mesoamerica, or the Nahuatl wet-nurse tree or the Aztec cosmic trees (fig. 104). Her extensive use of root

104
Aztec Cosmic Trees (View of the World), paint on animal hide, from *Codex Fejervary-Mayer* (Aztec or Mixtec, c. 1400–1521). National Museums and Galleries on Merseyside, Liverpool.

imagery surely relates to ancient Mexico as well, where the Nahuatl word *neltiliztli* (truth) derives from the same radical as *root*. As Miguel Léon-Portilla points out, *nelhuayotl*, "base" or "foundation," stems from same source. Thus rootedness, truth, and foundation are all related. The question "Does man possess any truth?" could as well be phrased "Does he have firm roots" or "Is anything stable and lasting?" The images spill over into modern Mexican folk culture: Kahlo's bedroom in the Blue House contained a candelabrum shaped like the Tree of Life, and a popular folk song admonishes the Tree of Hope to hold firm. When Kahlo painted such imagery, she no doubt knew both the old and the new references; she drew on both as personal emblems in her own developing mythology. When she was permitted to begin painting again after major back surgery in New York, she wrote to a Venezuelan patron: "I have almost finished your first painting [*Tree of Hope*] which is of course nothing but the result of the damned operation!"[106] Kahlo used such trees to symbolize her own struggle for life in the face of overwhelming difficulties. As long as they remained rooted in the earth, she clung to the hope of life, of truth revealed in her work.

Often Kahlo's body, like these tenacious trees, is rooted in and nourished by the earth. In works such as *Roots* (fig. 105), plant tendrils weave into and out of her body cavity, themselves sprouting red vein-roots attaching her to the earth. It is a botanical dream of rootedness and fertility. Kahlo lies quietly, a living, watchful participant in her own allegorical union with the earth. *Roots* is the obverse of her tragic *Henry Ford Hospital* (1932; Museo Dolores Olmedo Patiño, Mexico City), in which veinlike red ribbons, also extending outward from her midsection, tell of failed human reproductivity. In plant life Kahlo finds a more benign substitute

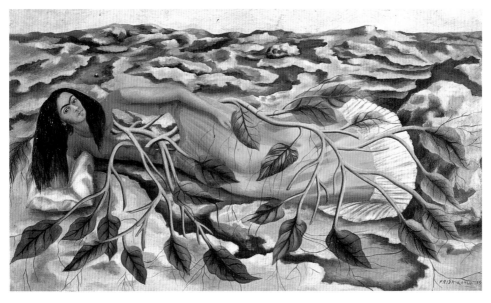

105
Frida Kahlo, *Roots*, 1943, oil on tin, 29.8 x 36.8 cm.
Private collection. Photo courtesy
Mary-Anne Martin/Fine Art, New York.

for the painful reality of her own attempts to generate new life. She uses the metaphor of rootedness to plunge downward to the subsurface world of her imagination, and to suggest that she both fertilizes and is nourished by the earth. Finally, the subject generates yet another reference to Paracelsus. *Roots* corresponds perfectly to his notion of the tree as woman: "Woman is like the earth and all the elements, and in this sense she must be considered a matrix; she is the tree which grows from the earth, and the child is like the fruit that is born of the tree. . . . Woman is the image of the tree."[107]

Whether from Paracelsus or other sources, Kahlo had been studying plant-human crossovers for some time. Because they occur so frequently in her work, they become a vital aspect of her great theme of integration between human life and the natural world. In 1931 in San Francisco, she painted *Luther Burbank* (fig. 106). The American horticulturalist, who had died five years earlier, would have been known to Kahlo only through photographs; nonetheless, she captured a remarkable likeness of the white-haired plant breeder. Best known for his hybridization of fruits, flowers, and a wide variety of other cultivable plants, Burbank becomes in Kahlo's painting a hybrid human-tree himself, holding a plant whose leaves become the tree's own. On either side of the tree-being, Kahlo paints fruit trees, Burbank's most famous successes; the tree on the right, in one of Kahlo's small jokes, touches a fissure in the earth's surface shaped like a human mouth. Below the earth, the botanist's roots are nourished by a corpse Kahlo said was Burbank's own. It is an image highly reminiscent of Edvard Munch's symbolist painting *Metabolism* (1898; Munch Museum, Oslo), which also features a horizontal skeleton below ground from which tree roots feed new life above. And again Kahlo's *Burbank* draws on Mexican mythology and folklore, replete with images of death and reincarnation.[108]

As different as Kahlo's trees are from Carr's, they suggest a few areas of comparison. The concept of rootedness appealed to Kahlo both in the sense of reaching down for connections to the past and in the idea of death and regeneration, two of her favorite themes. At her death a friend of Kahlo's underscored that tree connectedness: "With her death comes the end of the spectacle of a woman who was like a tree, small and weak, but so deeply rooted in the earth of life that death struggled for years to pull her out."[109]

Similarly, Carr considered herself rooted to the earth, admonishing herself to find there the genesis for her own art: "So, artist, you too from the deeps of your soul, down among dark and silence, let your roots creep forth, gaining strength. Drive them in deep, take firm hold of the beloved Earth Mother." At other times, Carr's sense of rootedness was less a metaphor of connection than one of sheer power: "How terrific the forces of nature are! To see roots split stone appalls one. I think that has impressed me more than anything else about the power of growth. An upheaval is good, this digging about and loosening of the earth about one's roots."[110]

The Natural Self: The Body and Nature

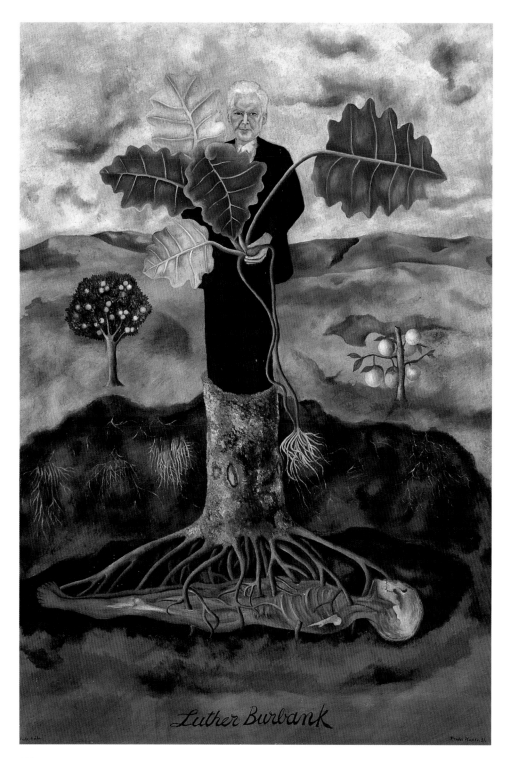

106
Frida Kahlo, *Luther Burbank*, 1931, oil on masonite,
87.6 x 62.2 cm. Collection of Museo Dolores Olmedo
Patiño, Mexico City. Photo by Rafael Doniz.

Both Carr and Kahlo painted jungle environments, Carr's related to the lush rain forest of British Columbia, Kahlo's to the exotic tropicality of Mexico. Carr's jungle was the site of terrific struggle—her own, to capture the exuberant life and to fend off the hidden dangers of the forest. She wrote of jungles in words calculated to reinforce her own feelings of eccentricity:

Working on jungle. . . . What most attracts me in those wild, lawless, deep, solitary places? First, nobody goes there. Why? Few have anything to go for. The loneliness repels them, the density, the unsafe hidden footing, the dank smells, the great quiet, the mystery, the general mix-up (tangle, growth, what may be hidden there), the insect life. They are repelled by the awful solemnity of the age-old trees . . . the rot and decay of the old ones—the toadstools and slugs among the upturned, rotting roots. . . . No, to the average [person]. . . the forest jungle is a closed book. In the abstract people may say they love it but they do not prove it by entering it and breathing its life.[111]

In *Roots* (fig. 107) Carr positions the viewer deep within the murky tangle of the rainforest, where writhing roots stir the dense, claustrophobic atmosphere she had conveyed in words. One can almost smell the dank growth and decay.

Kahlo, on the other hand, painted the jungle as exotic hothouse, where all manner of animal and plant life flourished. She painted the plants with ostensible specificity, as in the screens of leaves behind her head in various self-portraits. They range from bird-of-paradise plants to grain to the burro-tail succulents that spilled over the walls in her Blue House garden. In 1944 Lola Alvarez Bravo photographed her against a dead tree, whose stumpy branches may reappear in one of Kahlo's self-portraits from the next year. Dead trees appear yet again, with powerful iconicity, in her compendium of heroes painted in 1945, *Moses* (see fig. 5). This complex work, claimed Kahlo, shows how humanity invented heroes and gods as an antidote to fear—"fear of life and fear of death." As symbols of hope, Kahlo placed two dead tree trunks prominently in the foreground, explaining, "The two trees forming an arch of triumph are the new life that always springs from the trunk of old age."[112]

When she painted live plants and flowers, Kahlo often rendered their leaves with heavy emphasis on veinings, as if they were botanical counterparts to the human circulatory system she illustrated so insistently. But such leaf-veinings also owe much to Kahlo's desire to find texture and pattern in nature. When she paints hairy plants near her head in *Self-Portrait with Monkey* (fig. 108), she emphasizes other hair textures as well: with great detail she records her own heavy eyebrows, faint mustache, and wisps of hair against her neck. To these she adds the furry outline of her pet monkey.

Unlike Carr's forest paintings, Kahlo's are static, undisturbed by any movement. In truth, they are not paintings about trees or plants as they exist *in nature*; they are

The Natural Self: The Body and Nature

fragments of natural form sharpened, stylized, and frozen. They are the flora of Henri Rousseau, whom Kahlo admired and whose invented ten-year residence in Mexico supposedly taught him to paint the jungle. Close behind her head, Kahlo's lush fabrications present a clotted ersatz jungle, no more real than the fabric backdrops her photographer father once set up behind his portrait sitters. Though she invites us to compare textures and shapes, everything in Kahlo's self-portraits remains discrete, unblended, unmerged. It is as if selfhood and identity depend on separation, an impulse diametrically opposite Carr's wish to create unity out of nature's chaos.

Ultimately, we come to realize that Kahlo's tree paintings are less about nature per se than about the nature of her imagination. In her erotic love notes to Rivera she writes of the "vegetal miracle of the landscape of your body," which she experiences in part as "odor of essence of oak, of the memory of walnut, of the green breath of ash." Had she ever smelled these plants? Probably only in memory or imagination, but

107
Emily Carr, *Roots*, c. 1937–39, oil on canvas,
111.8 x 68.6 cm. British Columbia Archives PDP00635.

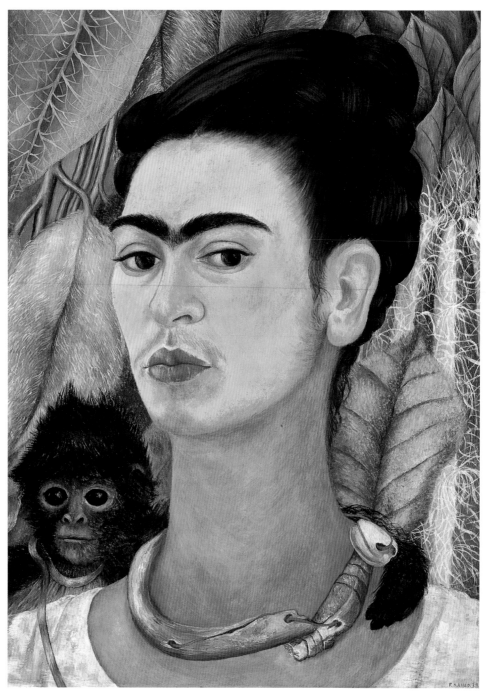

108
Frida Kahlo, *Self-Portrait with Monkey*, 1938,
oil on masonite, 40.1 x 30.5 cm. Albright-Knox Art
Gallery, Buffalo, New York,
Bequest of A. Conger Goodyear, 1966.

The Natural Self: The Body and Nature

that was sufficient. Her aim in thinking about trees was metaphorical. In her writings and in her paintings she sometimes emphasized that self-as-tree. To Rivera she pleaded, "Don't let the tree that loved you so much, that treasured your seed and crystallized your life at six in the morning, be thirsty."[113] Less than a year later they divorced.

Their remarriage in 1940 was on slightly altered terms, with periodic friction and separations. *Diego and Frida, 1929–1944* (fig. 109) was Kahlo's fifteenth-anniversary gift to her husband—painted, oddly, during a year when they mostly lived apart. In this fused double portrait, she painted their heads halved but united in a close, imperfect fit. Around their necks twines a circle of roots or branches holding the halves tightly together. Though there are no thorns here, the image of spiky branches or roots recalls the thorn necklaces—clearly a reference to Christ's martyrdom—with which Kahlo adorned herself in two self-portraits from 1940, while they were divorced.[114] In the double anniversary portrait martyrdom gives way to cautious hope for their renegotiated union. The shells attached to the frame, as she emphasized in her "Moses" speech, represent love, "the two sexes wrapped up by eternally new and living roots." She and Rivera would remain in that ambivalent embrace until her death: the ties that bind are also the ties that wound.

A final, fascinating area in which Kahlo's use of plant imagery makes assertive statements in her work is through still life. The multilayered meanings within

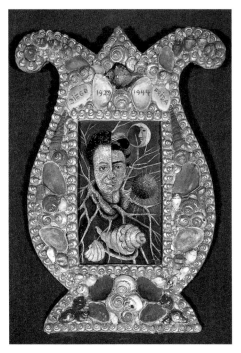

109

Frida Kahlo, *Diego and Frida, 1929–1944 (I)*, 1944, oil on wood, image: 7.4 x 2.29 cm, frame: 25.9 x 18.3 cm. Private collection. Photo by Rafael Doniz.

her *Tunas* have already been discussed. Other Kahlo still life subjects are similarly redolent of human linkages. Unlike O'Keeffe's smooth, closed, pristine fruits and vegetables, which take symbolic meanings from their spacing and important classic references to, for example, the apple,[115] Kahlo's speak much more openly of bodily processes: they burst with ripeness; they are sliced open to reveal fleshy interiors and reproductive mechanisms. As in the still lifes of the Spanish master Cotan, or Kahlo's contemporary Marsden Hartley, cut-open fruit is nearly always present. Such fruits stand in unmistakably for parts of the body; they are bearers of the body's signs. As Hayden Herrera writes, "Frida made her fruits look like her. Her melons and pomegranates are cut open, revealing juicy, pulpy centers with seeds, mak-

ing us remember her wounded self-portraits and her association of sex with pain." Kahlo's exotic fruits and vegetables portend death, not from vegetal decay but from the menaces of violent fragmentation and dismemberment. She does not show us the predatory knives, merely the results of their slashings. In Kahlo's hands, suffering reaches beyond the human, sublimated into a peculiarly vegetal ontogeny.[116]

Animals

In their constant explorations of how human life is integrated into the natural world, Carr, Kahlo, and O'Keeffe did not ignore the importance of animals. All three artists owned pets: Carr and O'Keeffe kept dogs, and Carr also had a pet monkey, as did Kahlo—often several at once. Although these domesticated animals sometimes appeared in their work (especially Kahlo's), it was animals of the farm or the forest that the artists more frequently painted. O'Keeffe, in fact, usually pictured the bleached bones and skulls of animals rather than the living creatures; the bones, she remarked "are strangely more living than the animals walking around."[117]

Perhaps it is a cliché to say that animals compensated for the children none of these artists had; still, that conclusion is difficult to ignore in light of the evidence—overt in the case of Kahlo and Carr, latent in O'Keeffe—that animals enabled the painters to act maternally, without fear of rejection. More, animals opened to the artists avenues of affection, patience, compassion, and protection that were not always available in their human relationships. And, as seen in the artists' painting, animals bridged the world between nature and humankind.

Emily Carr: Animals and the Forest

For Emily Carr, animals meant many things. As a child, she formed an attachment to the family cow, spending much time in the cowyard, where she felt more at home than in the constrained cleanliness of the Victorian parlor. In her story "The Cow Yard," published with her other childhood recollections in *The Book of Small*, Carr revealed how much the earthiness of the barnyard creatures meant to a child who felt herself something of a misfit indoors: "But it was in the Cow Yard that you felt most strongly the warm life-giving existence of the great red-and-white loose-knit cow." This joy in living things was born in Carr through her early animal companions, who were succeeded by a lifetime of pets. They directed her focus both inward, in contact with her maternal self, and outward, toward the wilder world beyond the city's edge. The artist described a former circus pony named Johnny who carried her as a child into "the deep lovely places that were the very foundation on which my work as a painter was to be built."[118]

Carr wrote many stories about animals, often based on her own experiences adopting, buying, and breeding them. Though she claimed to detest the idea of people anthropomorphizing animals, she often treated her own pets like children. Birds, dogs, cats, rats, a monkey—they lived and traveled with her throughout

her life. She raised bob-tailed sheepdogs and, later, Belgian griffons to supplement her income as a landlady (fig. 110). In her apartment house, when truculent tenants collided with her own irascibility, she relied on her dogs to offer an innocence and nobility she felt the world had lost. A few months before her death in 1945 Carr tried to explain her attitude about the "bobbies" she had nurtured: "I am glad you liked my 'Bobbies' in that miserable Tormenting House of All Sorts they were what kept me up They were too good to keep to myself. I think I spent more love on that M.S. than almost any other. I tried to meet the Bobbies halfway not expect them to come to my human level but to go to theirs. I did not give them human traits but their own natural loveliness[?] of character to some they will only be *dogs* to others they will be more."[119]

With the birth of each new litter, Carr reconnected with the processes of life. In a sense, her experience raising animals paralleled what the forest gave her: refuge from flawed humanity and another way of extending her being in the world. Writing about her dogs, she quoted Walt Whitman: "I think I could turn and live with animals, / they're so placid and self-contain'd, / I stand and look at them long and long."[120] For Carr, the noblest part of humanity was revealed in its treatment of "lesser" creatures.

In addition, when the artist could not openly express her exasperation with the world, Carr's animals frequently acted out her feelings. Woo, the Capuchin monkey she acquired in the early 1920s, exorcised the mischief Carr had to suppress in herself. Broken mirrors, scattered food, and spilled ink were left in the monkey's wake, for Carr insisted that Woo have the run of most of the house. Outdoors, the monkey scampered alongside Carr on their walks, kept from escape by a chain

110
Unknown photographer, Emily Carr with her animals at 646 Simcoe Street, Victoria, 1918. British Columbia Archives C5229, 51747.

attached to the painter's belt. Ostensibly to keep the tropical animal warm in chill weather, Carr sewed her pinafores. In fact, Carr admitted that her menagerie allowed her to exercise her "motherliness, most nearly divine of all loves."[121]

But though she was often photographed with them, Carr seldom painted her animals, except for an early portrait of her dog Billie (1909; private location) and a late painting of Woo (fig. 111) completed only a few months before the artist's death.

When Carr painted other animals, she usually rendered them as totemic— stylized, powerful, removed from everyday life. These were the creatures she found on totem poles: beavers, bears, eagles, ravens. They appeared in her stories as well as in her paintings, and Carr strove to portray them with the same respect the native carver did, endowing them with "superstition, fear, reverence, a desire to propitiate the supernatural powers of which the totem creature was possessed." Prominent among the native totem carvings were figures of birds: in addition to eagles and ravens, a straight-beaked bird the Indians called the "how-how" bird, probably mythical. She

111
Emily Carr, *Woo*, 1940s, oil on canvas, British Columbia Archives PDP00603.

The Natural Self: The Body and Nature

was sensitive to the power of the great birds, both from personal experience and from their totemic portrayals. On her 1907 visit to Alaska she had observed them at first hand; as she wrote: "Sitka would not be Sitka without ravens—noisy, weighty, powerful, swooping, uttering sepulchral wisdoms, winging, wheeling blackly into the deep woods behind the village, male and female calling over and over his or her own cry. . . . Indians have fabulous tales of Raven; he figures conspicuously on their totem poles." [122]

Carr painted totem poles from various villages repeatedly over the next two decades. With stylistic debts to fauvism and cubism, and her own expressionist impulses, she tried to match her paintings to the expressive skill of the native carver. She described the relation between the dominant natural environment and native religion in her story "Indian Bird Carving": "The great wooden birds were carved with dignity and intensity. Crude, regal, they surmounted tall poles, wings spread or wings folded. In primitive simplicity their calm seemed to pervade the village." Carr captured that grave simplicity and power in her totemic birds, such as the great eagle in *Skidegate* (1912; Vancouver Art Gallery) and *Big Raven* (fig. 112). Of the latter painting she wrote, "Got the Cumshewa big bird well disposed on canvas. The great bird is on a post in tangled growth, a distant mountain below and a lowering, heavy sky and one pine tree. I want to bring great loneliness to this canvas and a haunting broodiness, quiet and powerful." [123]

112

Emily Carr, *Big Raven*, 1931, oil on canvas, 87.3 x 114.4 cm. Vancouver Art Gallery, Emily Carr Trust, VAG 42.3.11. Photo by Trevor Mills.

Carr scholar Doris Shadbolt believes that both animals and native peoples served as metaphors for aspects of Carr's own personality.[124] Some animals stood for innocence and simplicity, qualities Carr imagined as intrinsic to herself as well. In her earnest but limited exposure to native cultures, she found similar characteristics; she described Indians as she wished herself to be: "plain, straight, simple, Indian." That romantic portrayal of native cultures was more complimentary in Carr's era, and Carr regarded native culture through the screen of her own culture, allying herself with the native "other" as a way of reinforcing her own apartness. Likewise, her close identification with animals reinforced the perception that she was odd, unique, and therefore buffered from high-culture critique.

After she stopped painting totemic animals, around 1930–31, she concentrated more on living creatures. Birds, whether the menagerie that inhabited her homes, her stories, and her travels, or the great wild birds of the forests, seemed to speak to Carr's needs for release and for spiritual symbols in her life. On the ceiling of her attic retreat, she painted two eagles. She would often lie beneath their outspread wings, which stretched from wall to wall, absorbing their strength. And in the last journal entry she wrote before her death, Carr celebrated the return of spring through the release of her own domestic birds: "I gave the birds their mates and nests today. They are bursting their throats. Instinct bids them carry on. They fulfil their moment; carry on, carry on, carry on."[125]

Frida Kahlo's Alter Egos

Like Carr's, Frida Kahlo's animals were also tied to her self-identity. Most striking and interesting in her many representations of animals, especially in her self-portraits, are the monkeys, who look over her shoulder, entwine their fingers in her hair, wrap their arms or tails about her neck, touch her breast, or point to the embroidered emblems she wears on her Tehuana clothes. The monkeys are Kahlo's pets, her companions, and, at times, her alter egos. Best known was her bold spider monkey Fulang-Chang (Any Old Monkey), who, like Carr's Woo, leapt onto tables, grabbed bits of food, and occasionally expressed displeasure or jealousy by biting rivals. At times, the Kahlo-Rivera household contained several monkeys at once, and Frida tried to get them to mate. Her sense of humor, often earthy and ribald, was tickled by the antics of the monkeys, whose uninhibited behavior exceeded what humans were permitted. They became a kind of surrogate family, substituting for the children Kahlo could not have.

But the role played by monkeys in Kahlo's life and work was much more complex than that of pets. As I noted in Chapter 1, throughout Mesoamerica the belief pertained that each person's soul and fate were shared by a companion animal. This concept links humanity to nature, especially in shamanic movement between human and animal selves. Kahlo seems to have selected the monkey for her *nagual*, her companion animal (fig. 113). The choice was appropriate for several

reasons. For one, Kahlo knew that in both Mayan and European American tradition apes symbolized lust and promiscuity. As with humans, the sexual activity of apes is not restricted to a particular breeding season; thus when apes were kept in captivity, from classical antiquity to the Middle Ages, their sexuality was observed and embellished upon. In literature and art, simian imagery has often been encoded with human foibles, usually stressing bodily appetites in ascendance over human rationality. In a woodcut from Nuremberg (fig. 114), a mirror-gazing ape in the upper left acts as an accessory to love and trickery. According to the inscription, the young woman, whose hand reaches into her lover's purse, "makes a monkey" of him. Variations of this theme, in which the ape represents both the sensuality of women and the lust-induced foolishness of men, thrived for centuries. They thus represent the darker side of primate energy, an aspect that was vital to Kahlo's conception of self and the image she wanted to convey.

Also of interest in the Nuremberg woodcut is its inclusion, on the right, of a parrot or similar bird, also an erotic symbol and also a favorite of Kahlo's. Even earlier than the Nuremberg illustration, the two animals appeared together in an initial page in Jacobus de Voragine's thirteenth-century *Golden Legend*, whose miraculous tales were translated into every western European language. Whether or not Kahlo ever encountered these sources directly, she certainly used parrots and monkeys to convey some of the same venerable symbolism. This we can trace in several of her paintings, including *Self-Portrait with Monkey and Parrot* (1942; private collection). Alluding on one hand to the power of eros (perhaps taken from Hindu tradition), the parrot would have appealed additionally to Kahlo for its Mesoamerican roots. Because of its ability to speak, the parrot was regarded there as a supernatural being

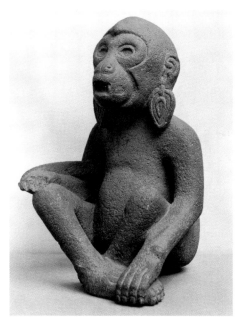

THE SEXUALITY OF APES

113

Mexican (Aztec), *Monkey*, n.d., volcanic rock, 35.6 x 26.7 x 24.8 cm. Museum of Art, Rhode Island School of Design, Providence, Mary B. Jackson Fund.

114

Amorous Couple with Ape and Parrot, woodcut from Nuremberg, c. 1480.

related—then and later—to sorcery and the occult. Kahlo, who called herself "la gran occultadora," relished the parrot as shamanic character.

But there are at least two other germane symbolic associations between women and parrots. The birds are one of many attributes of the Virgin Mary and may be a reference, either straightforward or ironical, for Kahlo's occasional invocations of the Virgin in her art. Finally, in Mexican popular culture a childless woman, perceived as neurotic for failing to fulfill her biological destiny, was sometimes labeled a *cotorra*, or "parrot." Street argot was a favorite vocabulary of Kahlo's, and she used this epithet freely—once when referring to the neurotic behavior of Rivera's former wife Lupe Marin.[126] Such multiple meanings, painted and written, fit in perfectly with the kind of games Kahlo liked to play with symbols.

On another level Kahlo, whose knowledge of art history was broad, may also have remembered some nineteenth-century European examples. Gustave Courbet and Edouard Manet each made celebrated paintings of women with parrots in 1866. Manet's *The Woman with a Parrot* (Metropolitan Museum of Art) is a complex formal study of chromatic values. Courbet's *The Woman with a Parrot*, something of a *succès de scandale* when first exhibited at the Paris Salon, entered the collection of the Metropolitan Museum in New York in 1929, where Kahlo could easily have seen it on one of her trips. A painting of startling sensuality, Courbet's bold intentions (in this as well as other works), though couched in academic guise, were very much in accord with Kahlo's recurrent attempts to represent female sexual desire.[127]

As sentient creatures, animals provide access for humanity to both the natural world and the art world's complex vocabulary of symbol and allegory. Beyond its well-known associations with sexuality, the ape, for example, with its imitative habits, has historically embodied an allegory of art: "ars simia naturae"—art is the ape of nature. Although the metaphor may have originated with ancient Greek philosophy, it evolved in the High Middle Ages to cast painting as "the ape of truth" and in the Renaissance to the implication that the artist imitates nature. Such luminaries as Dante, Bocaccio, Vasari, and Michelangelo carried the metaphor forward; Michelangelo sketched a rough image of an ape (perhaps containing neoplatonist references to the ape as the "lower soul" that humanity has in common with other animals) on a section of marble block behind the legs of his celebrated *Dying Slave* (1513–16; Musée du Louvre).[128] Within a few years Albrecht Dürer had produced his *Madonna with the Monkey* (before 1506) and, more to the point, his *Affentanz* (Ape dance, 1523), a parody of the inconstancy of earthly pleasures. Used widely thereafter, the "ape of nature" idea appeared in Shakespeare and the work of the Carracci family, though by then its references were often pejorative, to slavish, excessive copying of nature by artists. Antoine Watteau, Jean-Baptiste Chardin, and William Hogarth later popularized the subject in various *singeries* (ape pictures); Goya, whose work Kahlo knew well, included a monkey-artist parody in his *Los Caprichos*.

In addition to art history, Kahlo was intensely interested in the occult, especially alchemy, a subject that would have brought her into contact with simian images. Kahlo's familiarity, evident in her writings and paintings, with such alchemical images as *Integrae Naturae Speculum Artisque Imago* (see fig. 10) from Robert Fludd's seventeenth-century volumes *Utriusque Cosmi Historia*, was discussed previously. The large print, with its arrangement of concentric circles, represents the triple realms of humankind, nature, and heaven. I return to it here to note the ape attached by a chain to the central figure of Nature (Isis), whose pose Kahlo borrowed in *Memory*. Fludd's accompanying text explains that the ape is Nature's "servant or attendant who . . . marvellously follows and imitates Nature's vestiges and delineations."[129] The "ape of Nature" is, in other words, once again the artist and is notably identified as female.

If, as argued, Kahlo knew the Nature (Isis) image, she would also have been reminded of the ape's identification with the artist. And she adapts the metaphor to her own pets: just as the alchemist-artist's monkey is linked to nature by a chain, Kahlo links her monkeys to her with colored ribbons. In her self-portraits the ribbons represent the monkey's symbolic connection, winding through history, to art and artist.

What all this demonstrates is that in her self-portraits Kahlo paints her monkeys as much more than pets. She has endowed them with a wealth of allusive meaning. In a modern twist on Dürer's *Madonna with the Monkey*, Kahlo's monkeys function as her *attributes* in the idiosyncratic litany of her self-portraits. Seen this way, they read as quasi-ritualistic symbols (along with necklaces of thorns, knotted cords, bleeding wounds, sun-moon oppositions, hair, skulls, vines, hands, dogs, and birds) borrowed from Christian imagery.[130] Layered with Mesoamerican and alchemical symbology, they form a rich banquet of imagery that fed the narcissism that is widely acknowledged in Kahlo's art.

But even while arguing for an esoteric interpretation of Kahlo's monkeys, we must not forget their more obvious role: they were her intimate companions in solitude. If they summon Kahlo's own powerful sexuality, her relationship with nature, and her role as artist, her monkeys suggest one more important aspect. Beneath benign or impassive facial expressions—both hers and the monkeys'—lies Kahlo's irrepressible humor, which she always said was an important ingredient in her work. Glimpses of that humor appear in the monkey watching the female lovers in *Two Nudes in a Forest* (1939; Collection of Mary-Ann Martin). More poignant is the appearance in *Moses* (see fig. 5) of a monkey with its own baby behind the mask-faced woman whom Kahlo calls the "Mother, creator, her child in her arms."[131] Here the monkey stands for the creative impulse, for mothering and, once again, for art itself.

Kahlo used other animals, often from Aztec sources, to allude to other aspects of nature, culture, and self. Esther Pasztory's assertion, quoted in Chapter 1, is worth repeating here: "In a single image the Aztec artist could express so many levels

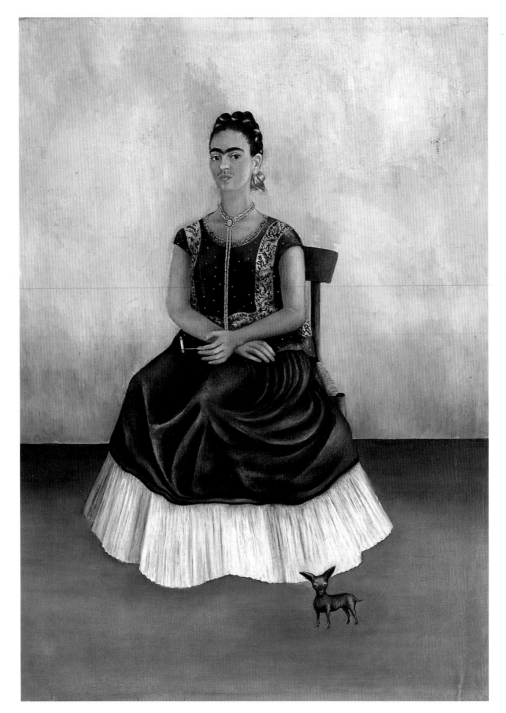

115
Frida Kahlo, *Itzcuintli Dog with Me*, 1938,
oil on canvas, 28 x 20.3 cm. Private collection.

of meaning that whole volumes of texts would be needed to explain them in writing."[132]
Kahlo's beloved *escuincle* (Itzcuintli) dogs, an ancient Mexican breed, provide still
another important example. Often they appear with her in photographs and paintings
(fig. 115). Her favorite escuincle, Señor Xolótl, is pictured curled up on the arm
of the earth goddess Cihuacóatl in *Love Embrace of the Universe* (see fig. 39). His pres-
ence is coded in the work's layered meanings: Xolótl, Aztec god of duality, carries
the dead on his back into the underworld so that they can be reborn. This favorite
theme in Kahlo's work—death and resurrection—invokes the continual recycling of
life. At the same time, Xolótl refers to the painting's dual levels of existence, dream
and reality.

One more animal must be mentioned here as part of Kahlo's menagerie of
the self: her pet deer Granizo, who served as model for Kahlo's *The Little Deer*
(see fig. 62), a self-portrait of suffering. Kahlo places her own head, crowned with
antlers, on the body of a young stag. Dead and decaying trees, seen earlier as
emblems of her suffering, combine here with the injuries inflicted by the nine arrows
piercing the deer's body. Pre-Columbian references are present as well: the deer, as
Hayden Herrera and Salomon Grimberg have pointed out, is the Aztec sign for the
right foot. Kahlo's own right foot was damaged by childhood polio and was a
source of continuing difficulties until it was eventually amputated in 1953. *The Little
Deer* also related to more recent art, which Kahlo could well have encountered
in her research on Sor Juana Iñes de la Cruz, who wrote,

> *If thou seest the wounded stag*
> *that hastens down the mountainside,*
> *seeking, stricken, in icy stream*
> *ease for its hurt,*
> *and thirsting plunges in the crystal waters,*
> *not in ease, in pain it mirrors me.*[133]

O'Keeffe's Animals and the Self in Nature

Georgia O'Keeffe rarely painted animals, but when she did so they had con-
siderable poignancy. Based on observed nature, she painted the crows she saw
rising and drifting on air currents above Palo Duro Canyon in Texas. At Lake George,
New York, a few years later O'Keeffe revisited the soaring birds in *Lake George
with Crows* (fig. 116). By that time her life and Stieglitz's had become intimately
joined, both personally and professionally. From a vantage point high above—per-
haps her own imagined "bird's eye view"—she looks down upon the lake. Its
ovoid blue shape, with a narrow opening to the top left, is strongly reminiscent of
her two versions of *Music—Pink and Blue* (1918; private collection and Whitney
Museum of American Art, New York) from two years earlier, in which an ovoid blue
shape opens as if to allow passage through or out. That form, frequently seen as

alluding to the body, reappears in *Lake George with Crows*. Here the blue ovoid, embraced by dark arms of shoreline, must also be seen as a body referent. Shaped like the figs, pears, and avocados O'Keeffe painted in the years immediately following, the blue ovoid with narrow opening—similarly womblike in shape—speaks of female fecundity. Release, which wild birds have always represented, may allude here to birth as well. O'Keeffe, who longed (like Kahlo) for children, was characteristically more oblique in her references to that desire. But, also characteristically, natural forms mask emotional statements in her work.

A dark bird reappears once more in O'Keeffe's painting in 1946, when circumstances had dramatically changed. This was the year of Stieglitz's death, and the great dark avian form in *Blackbird with Snow-Covered Red Hills* (private collection) heralds another kind of release, this time sorrowful. In many cultures birds have symbolized the departed soul, while the crow in particular shares many points of identification with the death-giving crone in goddess lore. Probably O'Keeffe's black bird was not so consciously invoked as a mythic creature but rather as the spirit of something transcendent, perhaps one of Whitman's universal birds of passage:

116
Georgia O'Keeffe, *Lake George with Crows*, 1921, oil
on canvas, 72 x 63.2 cm. National Gallery of Canada,
Ottawa, Gift of the Georgia O'Keeffe Foundation, 1995.

The Natural Self: The Body and Nature

Over the mountain-growths disease and sorrow
An uncaught bird is ever hovering, hovering
High in the purer, happier air.[134]

After nearly three decades, the O'Keeffe-Stieglitz relationship—by turns passionate, stormy, productive, strained—was ending.

When O'Keeffe was photographed in 1953 wearing a curious birdlike hood and holding a bird's wings (fig. 117), the feathers seem to belong to her and she to them. From beneath the fabric hood, with its points like an owl's erect ear tufts, O'Keeffe gazes out with a knowing expression, as if recognizing her solidarity with owls and other silent-flying creatures, who perfectly symbolize the numinous realities of an art borne always on the wings of nature.

117
George Daniell, Georgia O'Keeffe with hood and
bird's wing, 1953, New Mexico,
photograph. Photo courtesy George Daniell.

O'Keeffe's bird images linger eloquently as metaphors of the artist's self in nature. When she painted other animals, she approached them differently— from the inside out, so to speak. The bones of vertebrates, their internal structures, fascinated the artist, who had begun noticing them as she walked the plains of West Texas in the 1910s. She recalled, "In my Amarillo days cows had been so much a part of the country I couldn't think of it without them." She once painted a quirky, amusing piece, *Cow Licking* (1921; Denver Art Museum), a composition at once representational and oddly abstract in its awkward stylization of bovine form. Usually O'Keeffe was more interested in what lay beneath hide and muscle. When she encountered cattle bones, and those of other animals, in New Mexico, she felt as if she were coming across familiar, well-loved forms. She picked them up, admired their bleached whiteness, and held them up to the cerulean expanse of sky. Instead of death, they suggested life to her: as we have seen, she considered them more living than the live animals. Her attitude is curiously congruent with a remark made by Diego Rivera about Kahlo's painted bones, that they were "like an unfleshed being where life is expressed more intensely." [135]

O'Keeffe began gathering bones during her first summer in New Mexico and at the end of the season took a barrel of them along to New York, a way of taking something of the country with her "to keep me working on it." [136] The iconic horse and cow skulls that materialized from that first effort have been the subject of many studies. Other paintings of skulls have gone unrecognized or have stood as mere cultural icons when there is evidence that they represented something much more personal to O'Keeffe. Several deserve a closer look.

After her return from New Mexico in August 1929, O'Keeffe lingered with Stieglitz late into the fall at Lake George, where she reworked several New Mexico subjects and began "a new painting that raised the roof off the house about ten feet—Red and Orange—I was three days painting it and ill for three days afterward from my excitement." [137] Probably that painting was *My Autumn* (fig. 118), a brilliant symphony of flaming fall color. It lies within her extended series of leaf-motif paintings begun earlier in the 1920s that continued well into the next decade. But *My Autumn* is much more than a painting of leaves; it tracks the shift of O'Keeffe's consciousness from New Mexico to New York, joining the new to the old.

There was much on her mind from that pathbreaking New Mexico experience. When she painted *The Lawrence Tree*, she had done so under the spell of the British novelist's description in *St. Mawr*. And when she came across animal bones and skulls on the land, she would have been reminded of another passage from the same novella. Lawrence wrote of the effect of the bones as clues to the harshness and dread latent in the Southwest's severity: "Bones of horses struck by lightning, bones of dead cattle, skulls of goats with little horns: bleached, unburied bones" [138]

118
Georgia O'Keeffe, *My Autumn*, 1929, oil on canvas,
101.6 x 76.2 cm. Collection of Sheila and Hughes Potiker.

Lawrence laid out a whole program for O'Keeffe. Some—the bold, symmetrical skulls—came out with severe directness. But one is so subtle it goes almost unnoticed at first. Just above the center of *My Autumn*, masquerading as a truncated leaf form, is a flattened cow's skull, with horns, eye sockets, and downward tapering nose ending just above center. Chromatically, O'Keeffe has painted it so much like the surrounding leaf fragments that, except for its telling complexity of outline, it could pass as just another leaf. But once seen as a cow's skull it retains its identity, persistently and unmistakably. The skull is O'Keeffe's private and witty joke—the element that turns autumn into *My Autumn*. In another O'Keeffe leaf painting from that autumn, *Oak Leaves, Pink and Gray* (1929; Frederick R. Weisman Art Museum, University of Minnesota), there appears a form that also reads, though a bit less insistently, as a tiny cow's skull nestled within pink leaves at the painting's left edge.

Critic Lewis Mumford wrote of O'Keeffe that "every painting is a chapter in her autobiography, and yet the revelation is so cunningly made that it probably eludes her own conscious appraisal."[139] Consciously or not, the cow's skull, like her sturdy madonna and her ethereal crossroads from the same year, is a stand-in for aspects of O'Keeffe herself. Part of her mind lingered in the Southwest; her autumn was a blending of remembered sensations with the realities of the season at Lake George. No painting testifies to the rightness of Mumford's words better than *My Autumn*.

Other O'Keeffe paintings reveal that autobiographical element as well, one of which belongs in this discussion of her symbolic self-portraits in natural forms. It is a painting so well known that, ironically, it has not been well observed: *Ram's Head—White Hollyhock—Little Hills, New Mexico* (fig. 119). Although O'Keeffe had painted animal skulls many times before, *Ram's Head* was the first in which the skull floats freely, and the first to combine skeletal imagery with both flower and landscape forms. It is a painting about reconnections and reintegrations—ostensibly of the objects, but equally importantly within the artist herself.

The years immediately preceding this work had been difficult for O'Keeffe. Illness, both physical and mental, impaired her creativity significantly between 1932 and 1935. Here I am concerned with the stunning appearance of *Ram's Head*— no accident—at the end of that difficult period, an occurrence that informs my discussion of animals, bones, and O'Keeffe redivivus.

It is clear in *Ram's Head* that O'Keeffe felt her powers returning; she was reinventing herself as a woman and as an artist. She lets us glimpse her restored self in this summary canvas. The wide sweep of animal horns, as many writers have noted, has been a symbol for millennia of the power of the Great Goddess and the animals sacred to her. Cow-headed Hathor, and later cow forms of Neith, Isis, and Nut were worshiped in Egypt. In many images, the redoubtable Isis (as Kahlo knew) cradled the sun disk—symbol of divinity—between her horns. Elsewhere in the ancient world the cow figured as a divine epiphany of the goddess herself, associated

119

Georgia O'Keeffe, *Ram's Head—White Hollyhock—
Little Hills, New Mexico [Ram's Head, White
Hollyhock—Hills]*, 1935, oil on canvas, 76.2 x 101.6 cm.
Brooklyn Museum of Art, New York.

with Ishtar-Astarte in Mesopotamia and with the Cretan goddess. In Çatal Hüyük, the horned skull, with its resemblance to female reproductive organs, came to be a metaphor for the womb and birth.[140]

O'Keeffe's animal horns, as is clear from photographs, are faithful to optical truth, and these ram's horns undoubtedly conform to observed reality. Nonetheless, O'Keeffe, as a woman for whom childbearing was long a vital issue, may well have noticed the horns' uncanny resemblance to fallopian tubes. Through Stieglitz, who was intensely interested in astrology, she may also have known that Aries, under the sign of the ram, symbolizes spring, which defeats winter and the power of darkness. It is an apt confluence of symbols representing her recovery from a dark, wintry passage in her life.

Most telling of all, however, is the hollow shape at the mouth end of the skull in *Ram's Head* (fig. 120). Its form is startlingly like that of a woman's body—armless and headless but curving and swelling in female configuration. Seen within O'Keeffe's long series of animal skulls, which tend to contain unremarkable orificial openings, this skull stands out. Like the skull O'Keeffe painted as a leaf form in *My Autumn*, its shape moves insistently from negative space to assertive form. Within the dead animal skull, it springs to life—a metaphor for the artist's own resurrection and for the creative capacity of artists in general. Looking more closely at the female form, we see descending through it a column (curiously reminiscent of both O'Keeffe's late 1920s axial bodyscapes, discussed above, and Kahlo's paintings of her broken spinal column) that opens into the air below. It is as if art—the act of painting—allows the woman artist to give birth to herself.

Not all critics knew what to make of O'Keeffe's *Ram's Head*, but they felt its iconic power. Some thought it an apotheosis of death, others a detour into surrealism.

120
Georgia O'Keeffe, *Ram's Head—White Hollyhock— Little Hills, New Mexico* (detail).

The Natural Self: The Body and Nature

Marsden Hartley did not mention the birthing symbolism, but he spoke (in his customary mythopoeic prose) of the mysterious skull as "the journey of [O'Keeffe's] own inner states of being," an esoteric "transmigration of bone," hovering over "hills that are ready to receive." And the insightful Mumford called it the "epitome of the whole show," a painting that "possesses that mysterious force, that hold upon the hidden soul, which distinguishes important communication from the casual reports of the eye."[141]

Ram's Head, like O'Keeffe's other paintings of bones, was anything but casual. In later years, she kept animal skulls and horns at Ghost Ranch, adorning walls and parapets and even, as photographed by Arnold Newman, presiding over her easel like a great talisman (fig. 121). On vertical surfaces they had to be fastened in place, but in paintings they could float freely. The paradox inherent in skulls is their palpable solidity, offset by their disembodied presentation, especially when floating above the earth. O'Keeffe's friend Russell Vernon Hunter wrote of this mysterious

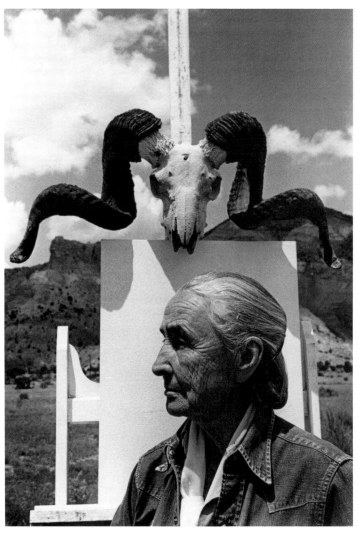

121
Arnold Newman, *Portrait of Georgia O'Keeffe at Ghost Ranch*, 1968, gelatin silver photograph, 47.6 x 31.8 cm. Museum of Fine Arts, Museum of New Mexico, Gift of Arnold Newman.

remove from the physical plane: "The skull is fixed in space, it is suspended by nothing, resting upon nothing. . . . It is as though it were moving mysteriously away from this sagging plane into an eternal dimension where time is not."[142]

O'Keeffe replied to Hunter, perhaps disingenuously, that she did not understand what time and painting had to do with each other. But she must have thought about vanished time—or history—when she painted *Head with Broken Pot* (fig. 122). Here the skull, clearly human, and especially the broken pot within which it shelters, are reminders of a politically charged era in the American past when Native Americans were dislocated or murdered. One thinks of the nineteenth-century romantic elegies of William Cullen Bryant, who lamented the disturbance of ancient burial grounds. The modern plow, he wrote, "Strikes the bare bone, [which] is all that tells their story now." Or George Catlin, who decried empire builders living in luxury "over the bones" of the decimated Native American population.[143] Whether O'Keeffe was aware of these specific sources, she had grown up amid such sentiments. In *Head with Broken Pot*, the skull reads like a microcosm of human experience within a fractured globular pot, a representation of the familiar Spanish expression "Cada cabeza es un mundo," literally, "each head is a world." In O'Keeffe's painting both pot and skull rest on an earth-colored surface, curved like the contour of a globe. Painted near the end of World War II,

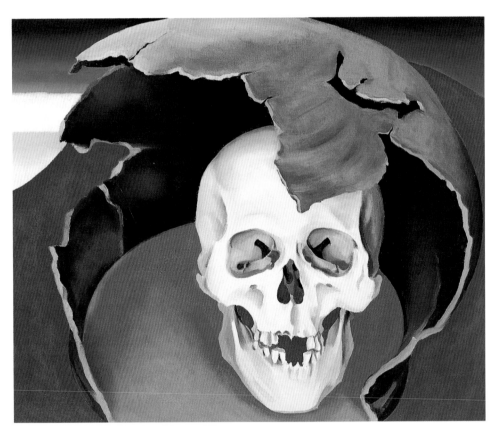

122
Georgia O'Keeffe, *Head with Broken Pot*, 1943, oil on canvas, 40.6 x 48.3 cm. Georgia O'Keeffe Museum, Santa Fe, New Mexico, Gift of the Stéphane Janssen Trust.

The Natural Self: The Body and Nature

O'Keeffe's work reads as a double romantic elegy: for lost cultures and for a shattered world. Despite her protestations to Hunter a decade earlier, real time has entered her timeless, pristine world.

O'Keeffe's approach to animals—elliptical, painted mostly from the inside out—provides an instructive comparison with the wealth of animal imagery furnished by Carr and Kahlo. Fixed on canvas, and considered alongside theirs, O'Keeffe's animals reside at the most ethereal point on a spectrum of animal representations. Curiously, the tension within O'Keeffe's skulls and bones, released from living flesh yet alluding stubbornly to vanished bodies, makes them at once more and less interesting than the animals they were.

In painting skulls, O'Keeffe had given a great deal of attention to their openings. In the pelvis paintings she began in 1944, she made holes even more prominent. They were often ovoid, one of her favorite shapes, and stood out against the cloudless blue sky. As O'Keeffe remarked, "I like empty spaces. Holes can be very expressive."[144] This attitude is reflected in her pelvis series paintings (fig. 123).

In using bones to represent animals from the inside out, O'Keeffe was inverting an earlier approach. In the 1920s she had painted from the outside in—sea creatures hidden within their shells. Her series of clamshells from 1926 are sometimes closed, hermetic, while at other times she opens the shell to give the viewer a

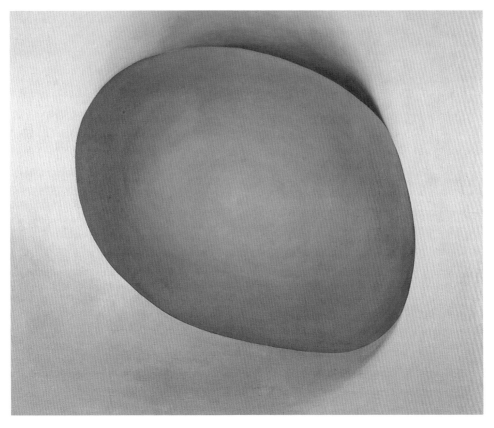

123
Georgia O'Keeffe, *Pelvis Series*, 1947, oil on canvas,
101.6 x 121.9 cm. Collection of Lee E. Dirks,
Santa Fe, New Mexico.

glimpse of the soft flesh within (fig. 124). Besides continuing a symmetrical-design motif she was concurrently exploring in abstract terms, the clamshells—open or closed—are apt metaphors for O'Keeffe's well-known tendency to simultaneously reveal and conceal aspects of herself. As Paul Valéry pointed out in his *Les Coquillages*, shells, like flowers, manifest a paradox of perception: they are "more intelligible for the eye, even though more mysterious for the mind," than other objects in nature. O'Keeffe's shells, appearing at a time when critics sought access through her paintings to every corner of her psyche, might well express a need for privacy. As her longtime associate Doris Bry recalled, "The sensational publicity [the paintings] received in the 1920s, focusing often on an erotic interpretation of the large flower paintings, offended O'Keeffe and led her to efforts to maintain her privacy. Sometimes this took the form of emphatic denials of such theories, other times in feigned indifference. I believe she was well aware of their personal sources, however much she may have denied them." [145]

A hard, closed shell carries a message of defiant self-preservation, a silent notice to critics that O'Keeffe would not submit willingly to their endless speculation on her sexuality. But beyond the strictly personal, shells allowed O'Keeffe to present a whole series of other contrasts: outside and inside, hard and soft, fact and imagination. Shells embody, quite literally, the integration of those opposites. Especially in the spiraling shapes of snails and nautiluses, the shell is a house with a history, formed in widening arcs as the animal grows within and remaining after its demise. Inside, pearly beauty hides under the mollusk's chambered shell. When O'Keeffe magnified the shells and painted them in close-up, as she did her delicate flower blooms, O'Keeffe must have considered the opposed temporality of shells and flowers. The flower's brief life, gaudily paraded, must be painted within a short time. The flower is an emblem of time's fragility, of the intensity of the present moment, while the empty shell, vestige of a creature once alive, has all the time in the world.

O'Keeffe picked up shells on beaches throughout the world and brought them to her studio. She painted them both in and out of context: she tried them out with seaweed, old shingles, spiky coral. She painted them in isolation and in groups. "I find, she wrote, "that I have painted my life—things happening in my life—without knowing. After painting the shell and shingle many times, I did a misty landscape of the mountain across the lake, and the mountain became the shape of the shingle—the mountain I saw out my window, the shingle on the table on my room. I did not notice that they were alike for a long time after they were painted." [146]

The simple act of noticing that things were alike provided O'Keeffe with countless unexpected pairings in her art. Out of the melding of observed fact and slow-simmering association came paintings based on surprising visual consonance. One can forgive O'Keeffe's occasional misremembered sequences,

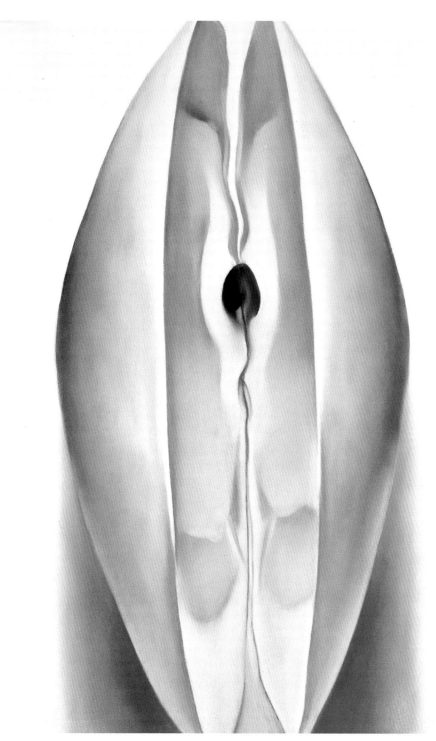

124
Georgia O'Keeffe, *Slightly Open Clam Shell*,
1926, pastel on paperboard, 47 x 33 cm.
Curtis Galleries, Minneapolis.

especially when she tried to reconstruct events years later; despite her remark, she had in fact been painting the mountain outside her Lake George window for at least three years before the 1926 shell and shingle paintings. In 1922, for example, she had produced *Lake George* (fig. 125), a painting which reduces the translake mountain silhouette to something akin to the rough shingle contours. In *Lake George* great sweeps of water echo the wavelike forms of the sky. This painting is another of O'Keeffe's studies in loose axial symmetry, with paired wedges of blue and brown slicing horizontally through its center.

O'Keeffe solidified that metaphor in *Shell and Feather* (fig. 126), a painting from the 1940s. Working again with animals—or at least their remains—rendered in severe ellipsis, O'Keeffe presented in this silver-toned painting a pale clamshell (probably the same painted in the shingle series) bisected by the great swooping rib of a feather. Like the horizon line in *Lake George*, the feather's rib divides the canvas horizontally, extending beyond the edges. Viewed together, each of the paintings—one of natural objects, the other an abstract landscape composition—interrogates the physical reality of the other. Both embody tensions between the specific and the generalized; in their studied simplicity, muted color, and spareness, they are simultaneously mysterious and banal. If O'Keeffe lapses here into a blandness that approaches sedation, it is with ulterior purpose. "Nothing is less real," she wrote, "than realism." And the proof of her conviction lies in these two paintings, where the barrier between still life and landscape blurs in delicious, deliberate contradiction. By undermining the reality of each, she drags us with her to the inexorable conclusion that visual consonances can generate a new pictorial reality, one more alive to her than any positivist index of weight, density, or distance. She traverses that reconstituted reality along the slender rib of a feather, bridge between realism and abstraction.

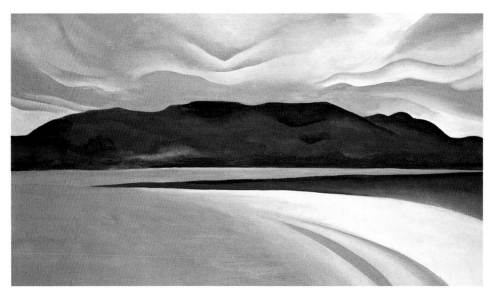

125
Georgia O'Keeffe, *Lake George*, 1922, oil on canvas,
45.7 x 81.9 cm. Curtis Galleries, Minneapolis.

Like O'Keeffe, Frida Kahlo gathered shells about her; she had large conch and abalone shells embedded into her patio walls at Casa Azul. Similar shells and sculptured shell forms are prominent on pre-Cortésian walls at Teotihuacan, a site well known to Kahlo. Kahlo's use of shells in her paintings, some of which have been discussed already, need only a brief glance in this context to contrast them with O'Keeffe's shells. Kahlo's shells, in fact, seem to strive in the opposite direction from O'Keeffe's; they do not signal the need for privacy but rather point directly to private states and feelings she wanted to reveal in her work. When she introduced a snail into her painting *Henry Ford Hospital* (1932), she said that it represented the agonizing slowness of her miscarriage. Yet on an even deeper level, she probably knew that the ancient Aztecs placed layers of human bones beneath a layer of seashells in pyramid burials at Teotihuacan, still another of their multivocal references to death, to fertility, and to gods who demanded appeasement through the sacrifice of human blood.[147]

Kahlo's interest in bones, and particularly in skeletons, frequently prompts her to place them in her paintings. Perhaps she held the Aztec attitude that the skeleton is a reference to life as well as death—a notion that is also similar to O'Keeffe's. I have already considered the embodiment of that notion in Kahlo's *Luther Burbank*. In a more mocking vein, images of skeletons and bones are everywhere in Mexico, especially in connection with Day of the Dead observances. The many skeletal images by Mexico's beloved printmaker Jose Guadalupe Posada (1852–1913) were a fruitful source for Rivera and Kahlo. His *La Calavera Catrina* (The fashionable Calavera; fig. 127) adopts a prevalent Mexican attitude toward death—one which Kahlo described as "death: very gay, a joke." [148] In her *The Dream* (1940; private collection) a skeleton, wired with fireworks like a Holy Saturday Judas figure, stretches out above Kahlo's bed. Rivera jokingly referred to such skele-

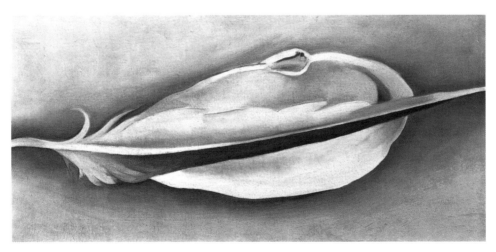

126
Georgia O'Keeffe, *Shell and Feather*, c. 1940, oil on
canvas, 15.2 x 30.48 cm. Colby College Museum of Art,
Waterville, Maine, Bequest of Roland Burdon-Muller.

tons as Kahlo's lovers. In moods that are still mocking, but with subtly different intent, a similar skeleton appeared in another painting from the same year: *The Wounded Table* (now lost). Such expressive use of bone imagery shows once again how the living system formed by the body, its folklore, and the visible spectacle of Mexico pulsates in Kahlo's paintings.

The complex relationships to nature evident in the work of Carr, Kahlo, and O'Keeffe are significant on one level as historical narratives which reconstruct the artists' lives and intentions. On another, these relationships open the door to theoretical readings of their work. Addressing both approaches reveals the insistent ways the artists named their own complex experience by means of landscape metaphors.

First, a word about the way their perceptions of elemental nature intersected with the artistic process: Carr and O'Keeffe were especially attuned to think of nature as process, an arena in which transformation was not only expected, it was inevitable. To capture those changes, they drew upon many formal elements, including the counterbalancing of weight and movement in their compositions. Kahlo's paintings are dense, weighty with material pigment and equally grave intent. Carr's early forests, also laden with dense gravities, gave way in her oils on paper to a state approaching weightlessness. Lying in between, O'Keeffe's carefully brushed canvases embody a kind of formal amplitude, balanced in weight and design.

In nature's continuous change and flux Carr saw proof that all of the visible world was connected; she stated often and vehemently that a picture must be a

127
Jose Guadalupe Posada, *La Calavera Catrina*
(The Fashionable Calavera).

The Natural Self: The Body and Nature

portrayal of relationships. Her belief in the interrelatedness of nature, people, and animals looks backward to such ideas as the great chain of being and ahead to the scientific and philosophical thinking embedded in systems theory. Within that realm, the science of ecology, which studies relationships between organisms and their environment, seeks to keep systems in balance. Carr would neither have known nor cared about such terminology; but she cared deeply about the environment and the balance between survival and dominance in the Canadians' approach to nature. From her earliest days visiting native villages with their neglected and rotting totem poles, Carr probed a human past in the process of being reabsorbed into the lush, impenetrable forest that had produced it. Nearly vanished, it was a past she came to prefer to the depredations of modern humanity. Early Canadian literature often portrayed human beings as victims of a harsh and unforgiving nature; in the work of Emily Carr we see an opposite and accelerating danger: nature becoming the victim of human beings. Most of Carr's career was spent trying to understand the forest and her own connection to it. So intimate did that connection become that ultimately her paintings of forest interiors seemed to be paintings of the inside of her own mind.

In Carr's journal entries we see constant references to nature as a repository of feelings and a mirror of her physical self. "My whole life is spread out like a map with all the rivers and hills showing." And on the map of her life, topographical features gave shape and meaning to her self-in-nature. They *embodied*, as it were, reality, sensation, and the artist's presence in the world. In both writing and painting, Carr documented her body's journey of return to the body of Mother Nature: "It is funny. . . how I sought my companionship out in woods and trees rather than persons. It was as if they had hit and hurt me and made me mad, and cut me off, so that I went howling back like a smacked child to Mother Nature." [149] Nature, once painted by Carr as a formidable other, became increasingly synonymous with her own selfhood.

Fluidity and freedom mark both Carr's and O'Keeffe's landscapes; they are places of release and adventure. Their open spaces suggest wilderness, but they are not usually that far away from human habitation. Carr seldom traveled alone to her remote painting sites; and often her seemingly primeval forest interiors were painted near settlements. After 1930 she stopped making long trips to far-off village sites, instead concentrating her efforts on the area closer to Victoria. She could walk to the cliffs and beaches along Dallas Road. And though her forest interiors felt like sanctuaries in the wilderness, they might be based on the trees in Beacon Hill Park. She found her personal geography in the ecstatic surround of the forest enclosure, a place where spirituality reached her through forms at once intimate and monumental. Most people feared the forest's loneliness, but for Carr it became a sanctuary, a place she described as "good for the few who do enter because the holiness and quiet is unbroken." [150] Reaching to the sky for experiential metaphors, Carr came to terms with nature by finding a pictorial language for its mysteries.

O'Keeffe, on the other hand, came to terms with the high desert by inventing a pictorial language for its sweep, scale, and ethereality. O'Keeffe's Southwest landscapes, empty of cultural proscriptions, replete with sensory possibilities, seem distant and remote; yet they were usually found only a short walk or drive from her northern New Mexico homes. Under vast open skies that invited the eye and mind to venture beyond the known, O'Keeffe set herself on a course of exploration that led to discoveries of a self in nature. Her geography was one of expansiveness and release, a place she came to think of as the "faraway nearby." Where other artists might have risked the loss of self in this territory beyond mapping, she embraced the distance as a means of nurturing and sustaining the self. Unlike the intimate forest enclosures Carr painted and wrote about in such revealing terms, O'Keeffe took steps to disguise, or at least to limit, her identification with the landscape. Many of her landscapes seem to have no intimacy or emotion, only sensuousness. Polished, refined into smooth contours and pale, fleshy colorations, her work was criticized for excessive "prettiness." But if, as I have argued, body and land coexist in her paintings, neither she nor we should be surprised if prettiness occasionally creeps in. As her Stieglitz circle colleague, the painter Oscar Bluemner, described her work, "the human form and face as motifs avoided yet presented in every flower, tree, pebble, cloud, wall, hill, wave, thing . . ."[151]

In addition to the land itself, other subjects from nature provided starting points for formal experimentation. For Carr the raw material of nature yielded a few great themes, which she learned to isolate and render in new ways, although she constantly circled back to her primary responses. Carr's was the slowly realized proof of Albert Camus's insight that the artist journeys through the "detours of art to find again the two or three great and simple images in whose presence the heart first opened."[152] In these she found everything she needed to test and extend her inherited traditions. By personalizing the Canadian landscape, she stirred a settled artistic tradition in a way that startled even her colleagues in the Group of Seven. Breaking the rules, steadily challenging the limits of what was paintable in nature, she rescued Canadian landscape painting from an atmosphere so rarefied that it could barely sustain life. Carr showed that her nation's landscape could be reconciled with modernist ideas, and in doing that she raised the stakes for all Canadian landscape painting to come. Through immersion in nature, especially by working and spending time outdoors, Carr remained connected to the land, widening definitions of the female in her broad, often subtle, explorations of the earth's body.

Kahlo's female earth was more sharply drawn, unmistakable in her weaving of myth, biology, and metaphors of creative regeneration. To Kahlo, landscape carried meanings about human presence, history, and emotion. Body and earth were fused in ritualistic ways, with frequent suggestions of female tenancy. She often portrayed her disguised sexuality in plant or landscape form, and she painted her creativity as stemming from her own heart. As we have seen, her bodyscapes concentrate on a metaphor of rootedness, reaching downward for their meanings. This is in direct

The Natural Self: The Body and Nature

opposition to Carr, whose work suggests another kind of outreach—up toward the vastness of the forests and the Canadian sky.

Kahlo did not live in our geography; she invented a geography of despair and dislocation, as in her landscapes of the volcanic *pedregal*—places that are unmapped, unrelenting in their harshness, and without visible points of entrance or escape. Nature, the outer world, relied less on observed reality than on (as she said) her own reality. She disavowed surrealism, but it is to that realm of dream, unexpected juxtapositions, and Freudian nature that she repeatedly delivers us. In Kahlo's images lies ample evidence of formal structures and cognitive functions at work within her brain—processes that are reminiscent of the universal grammar of forms posited later by the linguistic community, and resident as well in Jung's theory of archetypes and Lévi-Strauss's structuralist analysis of myth. In Kahlo's work, deep nature surfaces.

Part Two The Private Self

In the creation of their art, Kahlo, Carr, and O'Keeffe were as concerned with discovering a self as they were with defining a style. These artists were not just painting pictures, they were creating a personal mythology, out of their individual imaginations, visual experience, and life events. Each grew up in a particular environment and a particular family, from which she received—or rejected—a number of cultural or inherited dispositions. For all these artists, therefore, the creation of her identity, like the creation of her art, was ongoing. To state it succinctly, identity is complex: multiple, fluid, and subject to reinterpretation.

Prodigals and Prodigies

Carr, O'Keeffe, and Kahlo led complex, varied, and unique lives—lives that had more differences than similarities. To study only the commonalities would be to reduce those lives to misleading formulas. Nonetheless, we can learn a great deal about an artist's identity by studying the various sources of her creativity. One such source is the artist's childhood experiences within her family. From the important question, Out of what events or circumstances in her early life did each painter decide to become an artist? we may find affinities that tell us something about the creation and development of women artists in the late nineteenth and early twentieth centuries.

The psychoanalyst Otto Rank, whose extensive research and writing extended into art, myth, and the creative impulse, offered a convincing argument that artists are self-appointed: "Always the starting point is the individual's ideologizing of himself to be an artist. From then on, he will live out that ideology, as far as the realities of life allow him to do so. Insofar as they do not, the artist will fabricate those experiences for himself, search them out and give them form."[1] In other words, people invent the reality they need for self-discovery.

Seen this way, becoming an artist is an act of will that directs whatever actions or choices are necessary to achieve this end. Before the late nineteenth century, most women who took up the profession came from families of artists, or families in which art training was permitted or encouraged. Often, this meant families of considerable means.

The families into which Carr, O'Keeffe, and Kahlo were born were similar in several important ways, beginning with their initial economic circumstances: each was sufficiently well off to ensure certain comforts and the leisure to pursue some degree of cultural attainment. Yet each family later suffered reverses that left their aspiring artist-daughters facing obstacles to an artistic career.

Carr's parents were immigrants who began their family in England and completed it in British Columbia. Two daughters, Edith and Clara, were followed by three sons who died in infancy. Then came a succession of three healthy daughters: Elizabeth, Alice, and Emily. Finally, four years after Emily's birth, a frail son was born, who developed tuberculosis and died as a teenager. Emily Carr was thus the youngest daughter (and later the youngest living child)—much younger than her two oldest sisters, who were more like parents than siblings to her (fig. 128).

Richard Carr, once an adventurous itinerant commercial photographer, became a staid and successful wholesale merchant in Victoria. There he built his family an imposing Italianate house and oversaw the strict religious and social upbringing of his children (fig. 129). The quintessential Victorian patriarch, Carr was alternately kind and harsh to his children. To Emily he came to stand for the range of authoritarian forces—especially family, school, and entrenched Canadian artistic expectations—against which she would define and toughen herself. But although he was a powerful physical presence in the family, Richard Carr seems to have been emotionally distant from his wife and children. Looking back

128
Unknown photographer, the Carr sisters, about 1888.
Clockwise from left: Lizzie, Edith, Clara, Emily, Alice.
British Columbia Archives A02037.

Portrait of the Artist

at age sixty-six, Emily tried to imagine the snowy night she was born: "I wonder what Father felt. I can't imagine him being half as interested as Mother. More to Father's taste was a nice juicy steak served piping on the great pewter hotwater dish. That made his eyes twinkle. I wonder if he ever succored Mother up with a tender word or two after she'd been through a birth or whether he was as rigid as ever, waiting for her to buck up and wait on him."[2]

But as a child, Emily did not recognize her father's indifference; she strove constantly for his attention and approval. The robust Emily became her father's companion, following him about the garden and holding his hand as they walked to church on Sunday. She remembered, "Father kept sturdy me as his pet for a long time. . . . 'Ah,' he would say, 'this one should have been the boy.'" A daughter who is treated as the son her father wanted carries a heavy burden of ambivalence into adulthood. The identity suggested by the father conflicts with messages from other sources. Carr's acting out of this ambivalence seems to have underscored her conclusion that she was "contrary from the start."[3] Unlike her prim sisters, Emily muddied her clothes at play, let her mind entertain rebellious thoughts, rode a horse astride rather than sidesaddle, and took up smoking. It is clear that she was given some of the freedom usually reserved for boys.

The family was extremely puritanical in its attitudes about the human body and sexuality. (Carr, who called herself "a prim prude" and "Early Victorian," was so inhibited that as an art student in San Francisco she refused to draw from live models.)[4] Part of Richard Carr's exercise of paternal control included screening his daughters from what he considered pernicious outside influences. In the "protection" of his children, he could be harsh in the extreme. Emily never forgot an incident from her early adolescence—revealed in her writings only late in life—in which her father "brutally" introduced her to sex. Biographers disagree about what happened—some suggest abuse—but it seems likely from Carr's references that he was shockingly blunt verbally rather than abusive physically. Ever afterward she nursed a loathing of her father.[5]

129
Unknown photographer, the Richard Carr House, Victoria. British Columbia Archives A09186.

Perhaps as a result of their father's simultaneously harsh and overprotective attitudes, only one of the Carr sisters, Clara, married. The other four were cast as variants of the Victorian "spinster"—all except Emily took up altruistic female occupations in teaching, nursing, or missionary work. Against those socially useful pursuits, Emily's artistic inclinations stood out as noticeably eccentric, even self-indulgent.

Carr adored her mother Emily, a small quiet woman, who was devoted to home and children, a Victorian angel in the house. "My mother," remembered Carr, "stood for human motherliness; she was like a beautiful open, sheltering alpaca umbrella." She was also a silent mirror of her husband's will. Her children knew all too well where the power lay; in her autobiographical "Growing Pains," Emily painted a vivid word-portrait of her gentle mother: "To show Mother I must picture Father, because Mother was Father's reflection—smooth, liquid reflecting of definite, steel-cold reality."[6] Frail like her young son, Emily's mother fought tuberculosis for years; she died when Emily was just fourteen. Richard Carr's "overbearing omnipotence" was cut short at his death two years later.

Yet despite the difficult relationship with her father and the early loss of her mother, Emily Carr looked back on her childhood as being, for the most part, happy. Drawn to flowers, fields, and especially animals ("creatures," she called them), she enjoyed the outdoors, where she had the space to wander, dream, and sing aloud. Favorite places were the wild lily field and the cowyard, where she spent a great deal of time befriending the barnyard animals. They were more loving than toys, particularly the dolls her sisters favored.

Carr's writing, begun with poetry composed secretly late in childhood, reveals her private experiences of nature and begins the verbal record of her lifelong identification with the natural world. And in her early attempts at drawing and painting (encouraged by her parents, who provided Emily and her sisters with lessons, materials, and a place to work), she began to develop a sense of her artistic gift. This training she pursued avidly, though other aspects of her schooling, geared more toward "finishing" than educating her, she generally disdained.

Carr's life inside the house was more difficult. While her sisters managed to remain clean, handkerchiefs at the ready, quiet and polite even at children's parties, Emily, to hear her tell it, was the frequent source of dark looks and frowning attention. Often she would escape to untenanted, wilder places. When she finally returned to the house, pinafore dirty and hair awry, her sisters would scold her, teasing that she belonged to a gypsy strain in the family. Even her saintly mother, in Emily's memory, found her youngest daughter an anomaly: "Where the duce I ever came from, goodness knows!" mused Emily, years later. "Indeed I've heard my own Mother wonder that same thing[;] except for my father's bad temper, I inherited nothing famil[ial:] all *unCarrlike* traits. I was the only *fat* thing in the family too."[7]

In her reminiscence of her childhood, *The Book of Small* (a name she called herself), Emily set forth her growing sense of difference from the other Carr children. Later she would weave such stories into a generalized lament, frequently exaggerated, about the pain of isolation: "I don't fit anywhere, so I'm out of everything and I ache and ache. I don't fit in the family and I don't fit in the church and I don't fit in my own house as a landlady. It's dreadful—like a game of Musical Chairs. I'm always out, never get a seat in time; the music always stops first."[8]

But despite her chafing under family criticism, Carr early learned to take pride in her difference, her outsider status. Standing outside family and societal norms prepared her to recognize artistic boundaries and the pleasures and costs of crossing them. The world outside the norm is a place of new possibilities, new definitions; with practice, a person can find her own place to stand, even feel a secret superiority in her status as a loner. Within her structured Victorian household, Emily broke the strict rules of decorum with growing deliberation and creativity, inventing a unique position for herself and a persona—stubborn, curious, and adventurous—that distinguished her from her sisters (fig. 130). In her memoir Emily painted a verbal picture of her sisters as more hesitant, less imaginative, intelligent, and spirited than she.

This setting apart of oneself as unique, rebellious, and therefore superior is typical of women seeking to create a mythology of the self. Eleanor Munro, who interviewed dozens of women artists for her study *Originals: American Women Artists*, found it a frequent, and perhaps necessary, step to artistic independence: "To come to the recognition that one is a 'different' creature, maverick as that bearded fellow down the block."[9] And Carr, O'Keeffe, and Kahlo all demonstrated an early, acute consciousness of self and position.

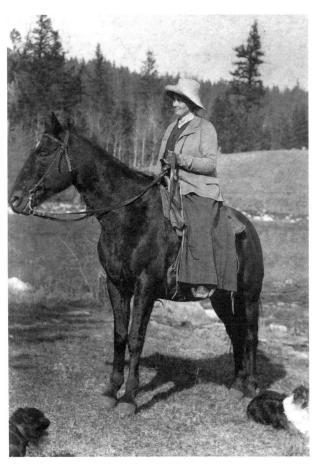

130
Unknown photographer, Emily Carr on horseback
in the Cariboo, 1904. British Columbia Archives PABC
99269, I-51569.

In Georgia O'Keeffe's family there were also five daughters, but unlike Carr and Kahlo, who was the fifth of six girls, Georgia was the oldest girl. As such, she always wielded unusual power among her siblings. And she knew it, then and later: "I had a sense of power," O'Keeffe recalled. "I always had it."[10] While her four younger sisters squeezed into two rooms, no one questioned the fact that Georgia was given a bedroom of her own in the prime tower corner of the farmhouse. Very early, O'Keeffe developed a self-assurance and self-centeredness that enabled her to focus on her own needs and goals, sometimes at the expense of those close to her. Later in life she acknowledged that she had decided early what kind of person she would become and then had "taken hold of anything that came along that I wanted."[11]

But although O'Keeffe did not feel the same need to rebel that Carr did, she did consider herself set apart. Having decided to become an artist, young Georgia O'Keeffe announced to her high school friends, "I am going to live a different life from the rest of you girls. I am going to give up everything for my art." In this decision, it appears, renunciation and sacrifice played a role as well, as they did for many women artists. A few years later, writing to the photographer Paul Strand, with whom she seemed to be forming an uncomfortably close relationship, O'Keeffe stated it even more brutally: "As I see it—[being] a woman . . . means willingness to give life . . . to give up life—or give other life—Nobody I know means that to me— for more than a minute at a time."[12]

For Carr the crisis of renunciation came later, after years of art-school training. Several unsuccessful relationships with men—a lost love in Victoria, others whose affection Emily could not return during her study abroad—precipitated an agonizing realization that marriage would require too much from her. Distrustful of her emotions, of men's motives, and of sex in general, Carr withdrew from the fearful prospect of permanent relationship. She knew no women who had managed both a career in art and a satisfying family life, and her own experience had discouraged her from trying. She resolved on a life of celibacy, devoted to her art. Years later Carr wrote in her journal of receiving a letter from one of those old suitors and mused again on her reasons for rejecting his proposal: "He demanded more than I could have given; he demanded *worship*. He thought I made a great mistake in not marrying him. He ought to be glad I did not; he'd have found me a bitter mouthful and very indigestible, and he would have bored me till my spirit died."[13]

Though late in life Carr would recall her early disappointments in love as "three dreadful hurts," it is clear that her "sacrifice" of marriage for art was based on her larger inability to imagine a life that could accommodate both. She opted to earn her own living—a choice Virginia Woolf later concluded was a woman's only real guarantee of independence. Carr's decision was different from O'Keeffe's, who struggled to reconcile marriage and career, and from Kahlo's, whose career remained embedded in a marriage of perennial interdependence.

For O'Keeffe, notions of sacrifice were tied to a growing self-discipline, especially where her artistic future was concerned. While still at the Art Students League she found full social participation at odds with her concentration on art, and she decided to give up dancing. "I first learned to say no when I stopped dancing," she recalled. "I liked to dance very much. But if I danced all night, I couldn't paint for three days." That ability to focus on art, to say no to herself, served her well. O'Keeffe later recognized a certain steely resolve in herself: "I've been tough. I've made my living selling my paintings since 1927, something I had no idea I would be doing."[14] This remark seems disingenuous; she may not have expected to earn a living by selling paintings, but she would have relied on her own work, perhaps teaching art, to support herself. With Stieglitz's help, she was able to give up teaching and paint full time. But her artistic production depended on focus and self-discipline as well as talent.

Besides saying no to herself, O'Keeffe learned to say no others. Many associates over the years noticed her self-containment, her withholding of self from others. Sometimes she admitted it freely; to Paul Strand she wrote, "I seem to like many people enough to make them miserable—no one enough to make them happy." The writer Jean Toomer saw this as an "unconsciousness stinginess" in O'Keeffe's life: if the painter asked little of others, believed Toomer, she would not be obliged to give much of herself in return.[15] This is not to say that O'Keeffe lacked friends of forsook intimacy, rather that she did not allow people to distract her from concentrating on her work. She sustained few close friendships, summarily discarded others. In most situations, O'Keeffe's rich inner resources conferred self-sufficiency. She was determined not to live out her own myth through anyone else, even Stieglitz.

Unlike O'Keeffe, Carr never learned to make career capital of isolation, to market a public persona based on the illusion of inaccessibility. Instead, she brooded on what she perceived as failures and threw up a protective screen to guard against hurt. Behind it, she could continue to play the part of an artistic rebel who struggled alone to realize her vision. Like Stieglitz, Carr bristled piously at the thought of her paintings being exchanged for "filthy money," even as she pined secretly for commercial success. When it crept up on her, she feigned surprise and cha-grin: "Praise embarrassed me so that I wanted to hide. You've got to meet success half-way. I wanted it to come all the way, so we never shook hands."[16] That she often undermined that meeting is clear in Carr's writings. But through struggle she acquired toughness and a belief in the ultimate solitude of the artist; in her paintings, like those of O'Keeffe and Kahlo, we see the most powerful expression of her unstoppable will to art.

In their struggle to live fully as artists and as women, Kahlo, Carr, and O'Keeffe were perpetuating older histories. Conflict, contradiction, and sublimation abound in the stories of women artists. Mary Cassatt (1844–1926), America's most

successful woman painter before O'Keeffe, opted for a professional career as an artist, foregoing the experience of marriage and motherhood. Yet it was motherhood—specifically the subjects of mothers and children—that provided her most enduring painted motifs. Cassatt, and many artists since, have embraced this contradiction in their own lives and art. Said Cassatt in paradoxical statements: "There's only one thing in life for a woman; it's to be a mother," and "A woman artist must be capable of making the primary sacrifices."[17]

One of those primary sacrifices—not having a child—was made by Carr and O'Keeffe and imposed upon Kahlo. Kahlo, who had not made the choice to give up motherhood for art, was unable through health and circumstances to bear children. Most of her biographers agree that Kahlo saw the lack of children as a great gap in her life.[18] On the other hand, miscarried and aborted pregnancies caused her pain—which she made the subject of a number of paintings. Motherhood, missing from her own life, took on a mythic stature in her art, in renderings of earth mothers whose fecundity transcended human failings and assumed cosmic proportions. Over time, art became her consolation and her catharsis. "Painting completed my life," said Kahlo. "I lost three children that could have filled my horrible life. Painting took the place of all that."[19] When she painted mythic mothers, such as the three figures in *Love Embrace of the Universe* (see fig. 39), Kahlo was reaching out to the dark mothers who preceded and nurtured her: implicit, but not shown, is Kahlo's own dark-skinned mother, a link with Mexico's indigenous peoples and ultimately to the earth and the universe. *Love Embrace* allowed Kahlo to reclaim all her mothers, including the dark mother deep within herself.

Carr and O'Keeffe would not have called their lives horrible, but each wished for the singular connection children provide. In somewhat the same manner as Kahlo, Carr viewed her artistic creativity as consolation for missing motherhood. Expressing a relationship that becomes almost biological, Carr once said, "I feel about my paintings exactly as if they were my children. They are my children, of my body, my mind, my innermost being. When people call them horrible and hideous I resent it deeply—I can't help it. I know people don't have to like my pictures, but when they condemn them I feel like a mother protecting her young."[20]

Like Kahlo, Emily Carr painted mythic mothers, as in her *Totem Mother, Kitwancool* (see fig. 25) and her versions of the ogre-mother D'Sonoqua, discussed in Chapter 1. She also cultivated maternal relationships with living beings, such as the pets she treated as her children. "Until people have been fathers and mothers," she wrote, "they can hardly understand the full of life."[21] In the early 1920s Emily befriended Carol Pearson, a twelve-year-old who attended the school of Carr's sister Alice. Around 1923 Carr approached the girl's parents with a proposal that she adopt Carol; the idea came, in part, from Carr's encounters with the transfer of Indian children from a family with several children to a childless one. Pearson's parents refused a formal adoption, but they allowed Carol to

spend several summers with Carr after the family moved East. The girl called Emily "Mom," received paintings from her, and was given the wedding dress of Carr's mother. After Carr's death, Pearson buried a box of the artist's cherished possessions for her in the forest.[22] With Carol and a few other children, Emily shared a love of animals, games, and storytelling, outlets for a seldom-exercised sense of play in her adult life.

It requires little imagination to extend Carr's remark about animals in her journal, "Everything is absorbed in reproducing its kind. . . . Unmated things are never quite complete," to Carr herself. We have seen that she treated her animals as children, an analogy that becomes even more clear in Carr's wistful journal comment, following a description of a young family picnicking near her campsite, that her monkey Woo "trust[ed] in her 'ole Mom'"—Carr herself.[23]

O'Keeffe, though more circumspect in her comments, has been said by nearly every biographer to have wanted a child. She and Kahlo shared the common experience of being married to older men, who had already fathered children and didn't want any more.

Decisions about becoming artists were further complicated for Carr and O'Keeffe by the early loss of parents, accompanied by downturns in family finances. When Richard Carr followed his wife in death by just two years, he left his children some $50,000 in trust, a substantial sum in 1888. But he willed the family home to the oldest daughter, Edith (Dede), whom Emily resented for her heavy-handed efforts to control and discipline the younger children. Emily's rebellion increased; within a year she had dropped out of high school and petitioned the family lawyer to allow her to attend art school in San Francisco. No doubt her departure was a relief for strained family relationships. For Carr, it was an escape as well. In the years ahead, further funds were advanced to Emily for art study abroad; eventually finances became strained. As her resources began to dwindle Emily felt enormous pressure to earn a living, and the profession she had chosen was risky.

The O'Keeffe family had prospered during their years on their Sun Prairie farm, where Georgia grew up, gradually acquiring land and position. But tuberculosis, which had taken Carr's mother and brother, threatened the O'Keeffe family as well. Father Frank's brothers had all succumbed, and in an effort to avoid the disease, the surviving O'Keeffes moved to Virginia, where the climate was supposed to be healthier, in 1902. But their financial situation suffered from the move, as a succession of businesses failed, leading to the ultimate breakdown of the family. There too, a few years later, O'Keeffe's mother began a lengthy, fatal battle with tuberculosis.

At age twenty-one, while she was still a student, O'Keeffe suspended her art training to take a job as a commercial artist in Chicago. It was clear that the deteriorating family finances had influenced her choice, but years later she cast the events in a different light—perhaps the first time she altered the facts of her life to accord with the outlines of her own myth. She told an interviewer in 1962 that

her decision had been based on a growing conviction that the European-inspired instruction she was receiving was stale and repetitive: "It had been done, and I didn't think I could do it any better."[24]

Poor health also led to a downturn in the Kahlo family fortunes. Not long before he emigrated to Mexico, Kahlo's father Guillermo suffered a fall in which he sustained brain injuries resulting in occasional epileptic seizures. He had never been good at managing money; now his condition made him even less able to maintain the family's former affluence. The Kahlos were forced to mortgage the house, sell their European furniture, even take in boarders. But it was Frida's own horrific accident in the fall of 1925 and her many subsequent relapses, surgeries, and treatments that caused the biggest financial drain. Aware of her responsibility, Frida approached the famous Diego Rivera during a period of relative recovery to ask whether she should continue with her art: "If you are interested in [my painting], tell me so, if not, likewise, so that I will go to work at something else to help my parents."[25] Rivera's enthusiasm for her painting was the beginning of their personal relationship. It may have been her father's inability to pay her medical expenses or support the family comfortably that persuaded him to allow Frida to marry the much older Rivera.

Kahlo's health, and particularly the physical agonies she suffered, became part of her developing self-mythology. So did the stories she told later of her early infatuation with Rivera. Among them was the tale that as soon as she saw Rivera painting a mural in the auditorium of her preparatoria (high school), she determined to have a child by him some day. Despite protestations from her friends that Rivera was a "pot-bellied, filthy, terrible looking" old man, Frida claimed that her lifelong affection for him began at that unlikely point (and, given her rebellious proclivity, probably was enhanced by the disapproval of her friends).[26] On many other occasions Kahlo—like Carr and O'Keeffe, but much more dramatically—changed facts of her life to accord with her desired persona. Most strikingly, she altered her birth date in many references, claiming to have been born in 1910 instead of 1907, apparently in an effort to ally her own history with that of Mexico, whose decade of revolution began then.

In addition to finances and a sense of rebellion, each of the three artists was influenced by various childhood role models. All three belonged to large families, where there were a number of women who served as role models for the future artists. Most important were their mothers, who as biographies attest, provided very different varieties of nurture and diverse models of female behavior.

Of the three, O'Keeffe's mother seems to have been the most compelling figure. Descended from a Hungarian family of some distinction, Ida Totto O'Keeffe was determined to expose her children to the arts. Herself a member of a reading circle, she read to her children and brought in teachers for her daughters' music and drawing lessons. "Our mother had a very good opinion of herself, and she wanted

all of us to be the same way," O'Keeffe said later.[27] Both of O'Keeffe's grandmothers had been amateur painters, as was expected of girls of good family. They were both strong women who had become heads of their families. And Georgia's maternal aunts were important presences in her life, both models of female independence: one was a schoolteacher, the other a newspaperwoman.

Other women taught O'Keeffe to value her intellect and develop her independence. In school she benefited from several gifted teachers, especially Elizabeth Mae Willis, her high school art teacher at Chatham Episcopal Institute in Virginia, who was struck by O'Keeffe's talent and independence. Never a docile, compliant student, O'Keeffe excelled only in art and music, disdaining most academic work. Among the other students (all girls), O'Keeffe soon learned to extend the authority she had assumed at home. Chastised for fomenting mischief, O'Keeffe remarked ingenuously, "When so few people ever think at all, isn't it all right for me to think for them, and get them to do what I want?"[28] She had an early and abiding sense that persons of exceptional talent were entitled to break the rules.

Frida Kahlo's mother was the opposite of O'Keeffe's. Of mixed Spanish and Indian descent, Matilde Calderón y Gonzalez was a very traditional, intensely religious woman who taught her daughters domestic skills and prided herself on the cleanliness of her home. To the young and rebellious Frida, her mother seemed alternately kind and cruel, as well as impossibly old-fashioned—someone she loved but never wanted to emulate. "My mother was hysterical about religion," recalled the iconoclastic daughter. And, "[My mother] did not know how to read or write. She only knew how to count money."[29] The harshness of Kahlo's words cloaks an underlying resentment of a mother who, like Emily Carr's, experienced little freedom: a victim, even a martyr.

Kahlo's undoubtedly overstated complaints about her mother left the girl with few women to whom she could look for role models. Before Frida's birth, her two older stepsisters had been sent away for a convent education; of the younger four, one eloped at age fifteen and was for years disowned by the family. Frida remained closest (despite significant disruptions in their adult years) to her sister Cristina. The two sisters became their father's favorites, particularly Frida. Guillermo Kahlo, like Richard Carr, was an immigrant and a photographer. Of Hungarian descent (like O'Keeffe's Totto forbears), Kahlo was a cultured man, an amateur painter, an avid reader, and a musician. All these enthusiasms he conveyed to Frida, who returned his devotion and sometimes accompanied him on his painting and photographing outings. He also introduced her to Mexican archaeology, encouraged her interest in the natural history of plants and animals, and taught her the fundamentals of photography. Kahlo's *Self-Portrait with Bonito* (1941; private collection) in which the artist arrays herself in mourning, surrounded by a cocoon, caterpillar, and butterfly—collective symbols of Christ's resurrection—is a likely elegy for her father.[30]

More than a decade after Guillermo Kahlo's death Frida painted his portrait from a photograph; he stands next to his large-format camera, posed stiffly like the sitters in his own studio portraits. Something of his attention to exacting photographic detail seems to have survived in Frida's paintings, yet what she remembered most about him was his character, which she described as "generous, intelligent and fine, valiant because he suffered for sixty years with epilepsy, but never gave up working."[31] Frida would graft something of the myth she created about her father—the valiant, suffering artist—onto her own.

Families are complex units, far too diverse to be categorized or stereotyped. Nonetheless, certain characteristics seem to cling to family types in different cultures. The Canadian critic and writer Margaret Atwood has tried to distinguish among images of Canadian, British, and American families in literature: "In American literature the family is something the hero must repudiate and leave; it is the structure he rebels against, thereby defining his own freedom, his own Frontier. . . . Once out you're out, you must forge your own life, your own private America, out of whatever new materials you can find. . . . If in England the family is a mansion you live in, and if in America it's a skin you shed, then in Canada it's a trap in which you're caught."[32] The O'Keeffe and Carr families seem to correspond to Atwood's description of those literary families.

As for Kahlo's, as Octavio Paz has written, the family is central in Mexican society: "Hispanic-Catholic society is communal, and its nucleus is the family, that small solar system that revolves around a fixed star: the mother." But Paz notes that, as a fixed star within the primal unit of the family, women can be distorted, objectified, and imprisoned: "Woman is an object, sometimes precious, sometimes harmful, but always different. . . . Her being is divided between what she really is and what she imagines she is, and this image has been dictated to her by her family, class, school, friends, religion and lover. . . . Women are imprisoned in the image masculine society has imposed on them"[33] Paz's words help explain the topos of the *chingada*, the violated Mexican mother, who lurks in Kahlo's paintings and identity.

Kahlo's ambivalent memories of childhood affected her adult work in a different way. Confined, like Carr, within strict behavioral limitations placed on children in her family, Kahlo longed for freedom and choices. In search of escape, Kahlo withdrew at times into an imaginary existence inhabited by a special friend, a girl of her own age. Such invented friends are common in childhood, but Kahlo's was more than a playmate; she filled a specific need for diversion from a difficult time in life. According to Kahlo's adult diary, the imaginary friend made her appearance about the time Frida contracted polio at age six. Restricted by an atrophied, painful right leg and a nine-month convalescence, Frida no doubt contrived the carefree, abler friend to help her cope with this first of many long illnesses. Years later, the grownup Frida described her imaginary companion as laughing, agile, a dancer—

a freer, happier version of herself. And she cited the memory of that fictive friend as the source for her double self-portrait *The Two Fridas* (see fig. 50), painted at another low point in her life, when the artist needed to conjure a more serene self.

Kahlo's connection to childhood was also reinforced by her extensive collection of dolls and dollhouse furnishings. Raquel Tibol recalls the role these toys had in her life: "Frida invented a life-style in which toys had a place: dolls asleep in lacquered boxes and skeletons hanging from ceilings, walls, and furniture." Some biographers see Kahlo's interest in dolls as a sublimation of her desire to be a mother; certainly they were highly visible in her home. On shelves and in a glass case the dolls are displayed today at Casa Azul; beside her bed, as seen in old photographs, they lay tucked into their own tiny doll bed.[34]

Bodies, Muses and Mediators: Reclaiming the Child Within

Childhood forms the first matrix for the future artist. Out of their varied beginnings, Kahlo, O'Keeffe, and Carr each retained elements of a child-self that was later incorporated into her grown-up mythology. For each, the unforgotten child within mediated important adult relationships.

Although Kahlo remained ambivalent about any identification with the surrealists, it is clear from her own words and paintings—especially after she met André Breton—that she adopted some of their ideas, especially with regard to questions of women and creativity. Male surrealists tended to think of women as muses, as men's mediator with nature and the unconscious, or as *femme-enfants*. This woman-child, as Whitney Chadwick has said, "fired the Surrealist imagination [but] plagued attempts by women artists to achieve artistic maturity."[35] In this sense, woman was not a subject but a projection of male dreams of femininity. Breton's *Nadja* (in his eponymous novel, which Kahlo read) is such a femme-enfant: she is a visionary, a way for him to access his own unconscious.

The female body became one of the chief elements of surrealist discourse, particularly in the poetry and painting of the 1920s. It is also one of the elements most discussed by recent feminist critics, who have argued instead for an art based on women's own bodily experiences. Some of the female surrealists, such as Kay Sage and—I suggest—Frida Kahlo, struggled against this male-dominant language of the female body to assert themselves as creative subjects. They worked to develop a corporeal imagery rooted in their own experiences.[36]

That Kahlo was seen as a femme-enfant by her husband and, at times, by herself, is clear from their actions and words. Indeed, there are indications that she conspired in her own infantilization. For one thing, she enjoyed the vast difference in their ages and physical stature. Given her small size and her youth, it is unsurprising that Kahlo and Rivera both used nicknames that were diminutives in referring to her. This was reinforced by an actual physical quirk. Several times, physicians told Kahlo that her reproductive organs were developmentally "infantile":

her ovaries were "the organs of a small girl in a grown woman," perhaps the overriding factor in her inability to bear children.[37]

But in other important ways Kahlo resisted and overturned the femme-enfant image. While still a girl she had assumed the role of caregiver to her father, accompanying him as he photographed; when he suffered epileptic seizures, it was Frida who helped him and guarded his equipment in the street. She also became a caregiver and mothering figure for Rivera, who tended to overwork and overeat at the risk of his health. Eventually, both she and he painted Rivera as a child in the care of an adult Frida. One suspects that both enjoyed the humor and ironies implicit in such a role reversal.

Until she met the formidable Alfred Stieglitz, Georgia O'Keeffe seemed secure in her maturity and independence, both as a woman and an artist. Though perhaps neither he nor she was aware of the term *femme-enfant*, there is evidence that at times he regarded her as such. Writing to O'Keeffe in Texas in 1918 where she was recovering from an illness, Stieglitz sounded like a mentor and a suitor in the same breath: "Of course I am wondering what you have been painting—what it looks like—what you have been full of—The Great Child pouring out some more of her Woman self on paper—purely—truly unspoiled."[38] An admirer of women and a collector of protégé(e)s, Stieglitz seemed to relish having both in the person of O'Keeffe.

Not long after writing that letter, Stieglitz began to construct a similar image of O'Keeffe for public consumption after she moved to New York. Pure, intuitive, sexually liberated, "the Great Child" became the quintessential American version of the femme-enfant. Distrustful of what he called "that damned French influence," Stieglitz never allied his invention with the surrealist muse, nature-mediator, and usher to the unconscious. But O'Keeffe came close to serving all those purposes for Stieglitz. Especially in the early years of their relationship, and particularly in his monumental collective photographic portrait of her, Stieglitz explored the many aspects of O'Keeffe. But always he recorded his perception and his arrangement of her body—an O'Keeffe of his making, not hers. She later wondered who the person in the photographs was. The portrait was generated out of Stieglitz's eye (and the camera's surrogate eye, its lens); missing is any sense of an image rooted in O'Keeffe's own physical experience.

Mostly patient and compliant in this exhaustive project, O'Keeffe was too new and (one suspects) too grateful to object seriously. And just as likely, incapable of framing or expressing an objection to what was clearly Stieglitz's loving tribute. So she accepted his encouragement and support and the publicity attendant upon his sensational collective portrait. Only when the body in the portrait was linked by critics to a rampant sexuality in her painting did O'Keeffe begin to feel manipulated. And even then, her frustration was directed (at least publicly) only to the critics. If she felt exploited or patronized by Stieglitz's photographs, she never said so openly.

Yet she eventually began to chafe under the nurture Stieglitz provided. That she sometimes felt infantilized within their relationship came through eighteen years later in her lament, "It often sounds as if I was born and taught to walk by [Stieglitz]— and never thought of painting till he worked on me."[39] By this time O'Keeffe had taken charge of her reputation and wanted it known that she had been an artist before she ever met Stieglitz.

Emily Carr infantilized herself deliberately; she consciously reclaimed and recast a childhood version of herself in her writing. In many of her reminiscences Carr expressed a longing for the "little self that is always learning things without knowing that it is doing so."[40] Writing through that remembered child-self, she could portray herself as innocent, honest, and direct, qualities she often set in opposition to the adult hypocrisy she felt around her.

Carr also signaled in those writings the future artist within, keenly sentient and aware. A charming example is her story in the autobiographical *A Little Town and a Little Girl* of a family ramble on foot through Victoria's various neighborhoods, each described through the child's olfactory sense: "delicious" wild roses near the James Bay Bridge, pungent mudflats at low tide, the "foreign" smells of Chinatown, the fresh woodiness of the sawmill, the sour affront of the tannery.[41] In Carr's writings are preserved both her childhood frustrations and her remembered delight in sensory experience. As an adult she remained a poor speller (like O'Keeffe), a liability masked by the childlike writing style she affected. Carr's self-imposed literary "rules" were: "Get to the point as directly as you can; never use a big word if a little one will do." These guidelines applied equally, she said, to her painting. When Carr abandoned the first person for the third in *The Book of Small*, it may have been a distancing device for the writer; "Small" could say what Carr could not always voice directly, particularly her deep, continuing resentment of her father.[42]

Late in life Carr used the Small persona for connection instead of distance. Through Small she reached out for intimacy with a male friend and literary mentor, Ira Dilworth, voicing through her child-self the cranky, spontaneous nature she seldom conveyed directly. In their letters it becomes clear that Dilworth helped heal the childhood betrayal Carr felt at the hands of her father. Their shared love of writing led to a collection of poetry they called "Sanctuary," lovingly bound by Carr in a cloth-covered portfolio tied with string and designated for Dilworth upon her death. These poems, by many famous writers, most often dwelt on the consolations of nature—the woods, the silent wilderness, and the meditative spaces of the natural world. In a note enclosed with the portfolio, Carr expressed thanks for the joy and comfort these poems had afforded her.[43] Dilworth shepherded much of Carr's own writing through the publication process, both before and after her death. He became her trusted friend, confidant, and soulmate—perhaps the first male to break through her sometimes misanthropic exterior to rediscover the exuberant spirit of the child Emily.

As adults, Carr, O'Keeffe, and Kahlo worked to claim their own lives, moving beyond the authority of families whose structure and support both impelled and impeded their emergence as artists. They expended much energy on healing their childhood wounds and learned firsthand about the risks of intimate engagement. What they gave and what they withheld from relationships, what they made known in their painting and what they kept secret—these things testify to the ultimate, unsung heroics of human creativity: that artists create the reality they need in order to discover themselves.

The places Carr, O'Keeffe, and Kahlo chose to live and work were important to their self-mythologizing. Each labored, over many years, to create highly idiosyncratic living and working spaces, places that in time become repositories of their energies. Virginia Woolf understood how places became part of creativity; in *A Room of One's Own* she wrote, "Women have sat indoors for all these millions of years, so that by this time the very walls are permeated by their creative force, which has, indeed, so overcharged the capacity of bricks and mortar that it must needs harness itself to pens and brushes and business and politics." More simply, in their *Theory of Literature*, Austin Warren and René Wellek assert that "a man's house is an extension of himself. Describe it and you have described him."[1]

Georgia O'Keeffe claimed to disagree. She wrote that "where and how I have lived is unimportant. It is what I have done with where I have been that should be of interest."[2] Yet she herself spoke and wrote about her living spaces on many other occasions, and clearly understood the relation between her painting and her rooms. In that spirit, I transgress knowingly through her own inconsistency to explore something of the role O'Keeffe's domestic spaces played in the development of her mythology of self.

O'Keeffe's thinking about living spaces, about what constituted a "home," began early. The boxy, eccentric O'Keeffe farmhouse at Sun Prairie had been built by Georgia's father, who tried to impose some distinction (in the style of the day) through ungainly Victorian architectural details (fig. 131). Simpler and more functional was the sturdy barn, a hundred feet long and painted the red prevalent among outbuildings in the Midwest. Redolent with the smell of sweet hay, the Sun Prairie barn lodged as a warm memory in O'Keeffe's mind: "The barn is a very healthy part of me," she said later, "It is something that I know. . . . It is my childhood."[3] Throughout her adult life, the artist painted many barns in many different locations.

The barn's vastness offered one kind of childhood space; another was O'Keeffe's dollhouse. Unlike Kahlo's, O'Keeffe's focus on dolls, their clothes, and their entertainments was

131
Unknown photographer, O'Keeffe family farmhouse, Sun Prairie, Wisconsin. State Historical Society of Wisconsin, WHi(N48)30166.

confined to her childhood. Though she owned large dolls and made paper dolls, O'Keeffe remembered spending most of her time with a family of small china-faced, movable-limbed dolls, for whom she sewed clothes and constructed a dollhouse. It was easily portable—just two interlocking thin boards that created a house of four rooms. On summer days she carried the house outdoors and set it up within an elaborate miniature garden that she landscaped and tended. O'Keeffe called these doll activities "the principal amusement that I remember from my childhood."[4]

As she grew up, O'Keeffe's concern with arranging and decorating rooms made itself felt in every house and studio she inhabited. Like her collapsible dollhouse—or perhaps more like a tent—O'Keeffe carried her idea of an ideal workspace with her from place to place. It would undergo certain modifications over the years, but some features remained constant.

My concern here is chiefly with the availability and character of her studios as they allowed her the solitude in which to work. For years O'Keeffe's living space was also her working space. As an art teacher she had access to school studios, but she required privacy for her own work. When she had to, O'Keeffe would clear a space in her bedroom and spread materials out on the floor. Her meticulous work habits— she cleaned and stored her materials with great care—were probably reinforced by the necessity to live and work in the same place. Even when she had ample studio space, the fastidious work habits continued.

When O'Keeffe contemplated giving up teaching in 1918 for a try at full-time artmaking in New York, she was persuaded to do so in part by the offer of a studio in Manhattan. Stieglitz's niece Elizabeth, who was not occupying her Fifty-ninth Street studio, wrote to O'Keeffe urging her to come East and use it. One of the studio's two sparely furnished rooms was already occupied by Stieglitz's photographic equipment; the other, into which O'Keeffe moved, contained a bed, two windows, and a skylight. Bright and cheerful, with an orange floor and yellow walls, this multipurpose top-floor space served as O'Keeffe's first New York studio; it was also the site of informal exhibitions of both artists' work for a while.

Subsequent rooms took on different and distinctive characters, as O'Keeffe began to express her individuality in the decoration of her workspace. As early as 1922 she remarked, "I prefer to live in a room as bare as possible."[5] She strove to maintain this simplicity wherever she settled. Some of O'Keeffe's ideas about domestic space may have been encouraged by Claude Bragdon, an architect-mystic she knew in the 1920s. To Bragdon, the essence of a house was simplicity, coherence, and individuality, exactly the qualities O'Keeffe sought in her homes.

In later studios, O'Keeffe would mute the walls, usually to a soft, neutral gray. She repainted the rooms in the Shelton Hotel, where she and Stieglitz spent ten winters starting in 1925, to create a soothing environment. From the twenty-eighth floor (and later the thirtieth), the large windows of their apartments overlooked great expanses of the city and admitted an abundance of light. Furniture was covered in

off-white to set against pale gray walls, a look O'Keeffe replicated in her New Mexico homes in future years. In rooms such as these, distractions were minimized, focus on O'Keeffe's paintings encouraged. And thanks to its large windows, her skyscraper residence afforded her expansive views and an approximation of the sense of space she had first loved in Texas.

In her Texas years O'Keeffe conceived an abiding love for solitude and open space, though she experienced little of either during her initial stays at Lake George, where the large Stieglitz clan spent summers. There the nearly constant presence of family members could not be neutralized by the lush, green countryside, with its high surround of hills. From Lake George, where would-be onlookers were plentiful, she wrote in 1923, "I can never show what I am working on without being stopped—Whether it is liked or disliked I am affected in the same way—sort of paralyzed."[6] Years later her need for private working space persisted. In a late interview she explained, "I can never bear to have people around me when I'm working, or to let anybody see what I'm doing or say anything about it until it's finished. Stieglitz never could understand that."[7]

Wherever they were, the gregarious Stieglitz thrived on a constant audience for his talk. As O'Keeffe put it, "He loved having people around the house all the time, and I'd have to take three weeks off to do a painting. And that's no way to be a painter."[8] She struggled to make an art that was as individual and personal as she was, while somehow accommodating the tangle of relationships she had entered at her marriage—a knot with Stieglitz at the center.

Still, if Stieglitz needed a perpetual surround of people, he was also sensitive to certain of O'Keeffe's needs. As early as 1925 he had recognized that she craved expansive space, writing to Waldo Frank, "She dreams of the plains—of real spaces."[9] If she couldn't experience "real spaces" in the landscape around Lake George, O'Keeffe could at least have a dedicated workspace there. Gradually she took over and converted a small outbuilding, some distance away from the main house, into her studio. The Shanty became her refuge, a place for undisturbed painting. The rural flavor of life at Lake George brought back O'Keeffe's childhood close to the earth, and she began to garden assiduously; for the rest of her life she grew much of her own food, linking human creativity with the earth's fecundity.

In the spring of 1926 she spoke to the National Women's Party in Washington about the need for women to become independent. Even as the words came out of her mouth, O'Keeffe had to be aware of the difficulty of accomplishing that. Struggle though she might to focus on her own work, the needs of others often intervened. Like the women in her audience, her need for self-fulfillment often took a back seat to myriad other obligations.

In 1940 O'Keeffe bought her first piece of real estate: Rancho de los Burros, a house lying on seven acres at Ghost Ranch. Five years later she purchased another New Mexico adobe—a ruined house overlooking the Chama River Valley from the

village of Abiquiu. It took several years for Maria Chabot, her close friend and associate during those years, to remodel the property. O'Keeffe took great pleasure in these homes, located less than twenty miles apart, each of which contained a studio. At Abiquiu a crumbling stable became her studio, bedroom, and bath, appropriate in light of her fond memory of childhood farm buildings.

The houses at Ghost Ranch and Abiquiu both became expressions of O'Keeffe's sensibilities: spare, tactile, sculptural, with a relation between outside and inside that speak at once of her need for privacy and her openness to the natural world. In later years, O'Keeffe kept an essential bareness in her homes, developing a curious mix of the elegant and the idiosyncratic. In the old adobe rooms light-bulbs were suspended from the ceiling on unadorned wires; sometimes the lights were left starkly bare, sometimes they were covered with Noguchi-designed Japanese paper shades. Pale slipcovers pushed ordinary upholstered furniture into the largely white environment, which further highlighted O'Keeffe's singular pieces—an Eames chair, a Saarinen table, a Calder mobile—each carefully chosen and placed.

Considerable effort went into making rooms that seemed effortless. Agnes Martin said of O'Keeffe's homes, "Georgia was crazy about decorating. She would decorate and redecorate the Abiquiu house." Paintings were often given pride of place. "I used to stay in a room with a Marin painting," remembered Martin, "and all the colors in the room—the bedspread and pillows—were chosen to match the colors in the Marin." [10] Other paintings on the walls were often small oils by Arthur Dove (an artist whose work O'Keeffe claimed could stay up for longer periods than most) and examples of her own work.

The house at Ghost Ranch is an embracing U-shape (like Kahlo's Casa Azul in Coyoacan), while the Abiquiu adobe contains two distinct patios. O'Keeffe's favorite was the internal one, which she described as "a square box; you see the sky over you, the ground beneath. . . . There's a plot of sage, and the only other thing in the patio is a well with a large round top. It's wonderful at night—with the stars framed by the walls." [11] It was also wonderful in the daytime, when the patio's black door receded into the shadow of the thick adobe. O'Keeffe always said that the door was her reason for wanting the house, and she painted it many times, both in black and in imagined reds and greens (fig. 132). The patio well, plunging down into the earth, connected surface and depth in O'Keeffe's New Mexico world. As if in recognition of its sacred axis mundi role, O'Keeffe placed a changing array of objects—rocks, bones, and later the elemental sculptures of her assistant Juan Hamilton—on the round wooden well cover. The patio, like the rest of the house, was a pristine, spare place where the careful ordering of life became almost an art.

O'Keeffe and many Americans of her generation found such living concepts expounded in Okakura Kakuzo's *The Book of Tea* (1900), an edition of which remained in O'Keeffe's library until her death. In this small book and in his subsequent *The Ideals of the East* (1903) Okakura, a close associate of Ernest Fenollosa's,

expounded a unified concept of art and life, an Eastern blending of nature and art into harmonious daily living. From Okakura we learn that small acts, perfectly performed, are a vital feature of the Zen tradition: "A Special contribution of Zen to Eastern thought was its recognition of the mundane as of equal importance with the spiritual. It held that in the great relation of things there was no distinction of small or great, an atom possessing equal possibilities with the universe."[12]

O'Keeffe became conversant with Zen through her reading and friends, particularly the philosopher Alan Watts. She incorporated something of a Zen spirit into her surroundings and became the sole arbiter of an aesthetically attuned household, in which exquisite care was extended to gardening, cooking, preserving food, and arranging objects. Visible even now in the Abiquiu house is O'Keeffe's awakened engagement with the living of everyday life. A jar in her pantry retains the label "good tea," in O'Keeffe's own hand. It is an immediate reminder of another of Okakura's comments, likening tea to art: "Tea is a work of art and needs a

132
Georgia O'Keeffe, *In the Patio VIII*, 1950, oil on canvas, 66 x 50.8 cm. Georgia O'Keeffe Museum, Santa Fe, New Mexico.

master to bring out its noblest qualities. We have good and bad tea, as we have good and bad paintings—generally the latter." To her friend William Howard Schubart, O'Keeffe began a letter, "Do you drink tea—Tea can be a real experience you know."[13]

Food and its careful preparation were also important to O'Keeffe. She appreciated good cooks, either as employees or as friends, and she enjoyed attending to the stove herself at times. She ate carefully, avoiding sugar and favoring good meats, home-baked breads, and fresh salads. At Abiquiu, with its large irrigated garden, much of the fresh produce for her table was homegrown. After the harvest, kitchen canning preserved some of the garden's bounty during the long months when little fresh produce was available. When she first moved in, what she couldn't grow had to be brought from stores in Santa Fe, an hour's drive away. Usually the produce arrived wilted and unappealing. When electricity was brought to the village, the artist had a large refrigerator and freezer installed. Meals might be simple, but everything was exquisitely prepared.

The spareness of O'Keeffe's apartments and houses had a distinct Asian feel. Acquainted early with Asian aesthetics through Arthur Wesley Dow and Fenollosa, she had painted emptiness—the vacuum—in a number of her works. In her two versions of *Music—Pink and Blue* (1918; private collection and Whitney Museum of American Art, New York) the void is the essential form, that which invites entry and participation. The Daoists spoke of the reality of a room as existing within the vacant space enclosed by walls, not in the walls or roof itself. Such pronouncements underscored O'Keeffe's own inclinations, perhaps even to the extent of influencing her "roofless room" at Abiquiu, an utterly simple space reminiscent of the so-called straw-hut aesthetic of the classic Japanese tearoom. The enclosure is nearly empty except for the occasional presence of a single art object (again, in keeping with the Japanese tearoom aesthetic), her circular cast sculpture *Abstraction* (1945).[14] Such spaces are sculptural or architectural embodiments of what Alan Watts would identify as the central meaning of Zen thought: "What is form that is emptiness, what is emptiness that is form."[15]

Such similarities to Asian aesthetics might be noted silently during a visit to the Abiquiu house, but comments were usually not welcome; O'Keeffe was as prickly about acknowledging sources in her home as in her paintings, and she dissembled more than once about both. When a friend likened her house to a monastery he had seen in Kyoto, O'Keeffe brusquely dismissed the comparison, saying, "This is entirely my own, there is nothing Japanese about it." And, "I've never wanted to make it look Spanish or Indian or anything like that. I wanted it to be my house."[16] In spite of her denial, both O'Keeffe's Abiquiu house and some of the paintings she made there do retain a Japanese flavor. *In the Patio VIII* (fig. 132) employs the strong diagonals of Japanese art, as well as the light-dark patterning reminiscent of *Notan*.

In one of her New Mexico houses O'Keeffe stationed a weathered wood boddhisatva in a niche. At the Abiquiu house a stone Buddha, gift of Asian art curator Henry Clifford, was prominently displayed. And she mounted a stylized sculptured hand in the wall of her Abiquiu bedroom; this symbol, familiar from Indian religion, makes the gesture of *abhaya mudra*—"have no fear." Perhaps O'Keeffe acquired this sculpture on her travels, but she may well have known the symbol years earlier through the work of colleagues. In Marsden Hartley's 1912–1913 abstract painting *Musical Theme (Oriental Symphony)* (Rose Art Museum, Brandeis University, Waltham, Mass.) multiple raised hands convey this message, accompanied by a meditating figure of Buddha.[17] Hartley was in close touch with Stieglitz during those years, and O'Keeffe came to know his work well.

Did O'Keeffe install the abhaya mudra hand in her room as an antidote to fear? She admitted to many fears: during an early summer spent in New Mexico she wrote to Henry McBride from Alcalde: "It galls me that I haven't the courage to sleep out there in the hills alone—but I haven't."[18] During the 1910s she had written Stieglitz of her fear of snakes while on a hike in Virginia. Later she suppressed that fear, coming to regard snakes as friends. Still, one suspects she preferred them dead: in her Abiquiu house she kept a fine coiled snake skeleton (reportedly ordered from a scientific supply house) in a glass niche set into an adobe banco.

In her last two decades, working with studio assistants to complete her late paintings, O'Keeffe struggled against a final fear: a twilight of inconsequence. As long as she kept working she could keep that terror at bay. Looking back on her life, O'Keeffe expressed pride in her ability to overcome fear. In her eightieth year she told an interviewer, "I'm frightened all the time. Scared to death. But I've never let it stop me. Never!"[19] Whether in modulating physical risks or forcing professional ones, fear never became the enemy in O'Keeffe's life; instead it served her as an energizing fuel.

The business part of O'Keeffe's life was conducted out of the Abiquiu house, where one end of the studio was given over to an office. Ghost Ranch, on the other hand, was less accessible. Visitors had to travel over corrugated roads, and for a long time there was no telephone—factors which especially endeared the ranch to O'Keeffe. There she withdrew to contemplate the sky from the roof (reached by a ladder), to walk the dry hills, and to receive the occasional invited guest. One of these was the poet Thomas Merton, with whom she was photographed (fig. 133), who understood her need for private spaces. As if directed to O'Keeffe, he

133
Unknown photographer, Georgia O'Keeffe and Thomas Merton, c. 1960s. Photo courtesy Dorothy Perron.

wrote in *New Seeds of Contemplation*, "There should be at least one room, or some corner, where no one will find you and disturb you or notice you. You should be able to untether yourself from the world and set yourself free, loosing all the fine strings and strands of tension that bind you, by sight, by sound, by thought, to the presence of other men." [20]

If Georgia O'Keeffe succeeded—at least most of the time—in acquiring a room of her own Emily Carr did not. Her room, that is, a conventional studio, eluded her for long periods. But she adapted existing spaces into workable studio areas.

When Carr returned in the 1890s from study at the California School of Design, neighbors began to ask whether she would consider teaching art to their children. She agreed and began giving lessons in the family house. Soon, though, her sisters complained about the mess and the incompatibility of their quiet home religious meetings with the children's noisy energies. Emily retreated from the house to the barn, where she set up a studio for lessons and for her own work. A carpenter and the family handyman helped her install a skylight, window, and stove in the barn loft, along with an outside staircase for the children. Below, the cow, chickens, mice, and a kitten dwelled, while a peacock made daytime visits to the studio roof, and Carr's big dog stretched out on the floor. Animals and artist found it a highly satisfactory space.

In the barn studio Carr's working hours were her own, uninterrupted by sisters and unwanted human visitors: "When I worked at night under a big coal-oil lamp suspended from the rafter under an immense reflector, made by myself out of split coal-oil cans, it was nice to hear the cow's contented chew, chew, chew below." In her autobiography, the barn studio was the standard by which Carr judged all future working spaces: "No studio has ever been so dear to me as that old loft, smelling of hay and apples, new sawed wood." [21] Her barn memories were like those of O'Keeffe's Sun Prairie years; for both, barns were places of health, contentment, intimacy with nature and living things. They provided emotional ballast in lives that were growing increasingly complex.

Carr's classes in the barn studio were offered as a way of supporting herself and saving money for more travel and art study. Like O'Keeffe, she surprised herself with the unexpected pleasure she got from teaching. "I did not want to teach," recalled Carr. "I was afraid of pupils, but I did teach and soon I got fond of the children and liked the work." [22] What she wanted most, though, was to further her education in art, and for that, Carr believed she had to leave Canada. In Europe she reentered classrooms and studios not as a teacher but as a student. Rented rooms and, increasingly, the outdoors became her working space for the next eleven years.

But she missed having a workspace of her own. As soon as she could, upon her return from France in November 1911, Carr set up a studio in Vancouver. On its walls she hung an exhibition of her own French work. Critics, her own family, and the public did not know what to make of the new fauvist paintings, and

she could interest few students. Lacking sales as well, she decided that making a living as an artist in Vancouver was impossible.

She returned to the family home in Victoria, where her parents' property had been divided into city lots. On the one she had inherited, a part of the former cow pasture, Carr decided to build an apartment house that would contain rooms and a studio for herself. Rent from the other apartments, combined with the occasional sale of a painting, would sustain her, she reasoned. "Hill House," as she called the new structure on Simcoe Street, was ready for occupancy in the fall of 1913. Soon after she moved in, Carr staged an open-house exhibition in the new studio, to which she invited friends. As O'Keeffe and Stieglitz would discover a few years later in New York, studio space could serve nicely for small exhibits when necessary. Carr recalled that a "great many people" visited her studio show and that Dr. C. F. Newcombe, who had recently begun collecting her native-inspired work, purchased eight or nine paintings from the exhibit.[23]

Before she moved her paintings to storage in the basement of the new apartment house, Carr showed nine of them—both from France and from northern British Columbia—at a 1913 Island Arts and Crafts exhibition in Victoria. The city's taste, in matters aesthetic as well as social, was as conservative as that of Canyon, Texas, when confronted by O'Keeffe's work. Both communities cherished stability and the status quo. In Victoria, art exhibits were known for their mild, muted landscapes, often of Beacon Hill Park, located near Hill House. Local reviewers of the Island Arts and Crafts exhibition praised the "decorative" quality of Carr's totem paintings, but nobody was prepared for her high-keyed interpretations of the French landscape, in blinding greens, blues, yellows, and reds. The reviewer for the Victoria *Colonist* described the work as "unlike anything that has ever been in Victoria before" and hoped that "this attack of neo or post impressionism" would not wreak permanent damage on Carr's use of color.[24]

There is sharp acerbity in this negative hometown criticism, where artist-amateurs sneered openly at Carr's innovative canvases. Carr, who never learned to accept critical opinion with equanimity, was offended. She was always prone to overstate her isolation and the ridicule her work received, but it is clear from published reports that there was widespread negative reaction to her work in 1913. Even, or perhaps especially, her fellow members of the Island Arts and Crafts Society voiced their disapproval. Carr claimed that they were "angered into fierce denouncement," ridiculing her "striving for bigness, depth." In her disappointment at the reception given her work, Carr lashed out at her critics, giving the impression that she was odd or, worse, a bit mad. Locals made fun of her, even though some recognized that her work was "way, way ahead of her time as far as this part of the country went. . . . The general attitude was that she was pretty queer and her work was queerer."[25]

Given the artistic climate and Carr's recalcitrant attitude, it is unsurprising that she withdrew her work from public scrutiny. Not for ten years would she enter

her paintings in a group show. But it was not just her sense of public rejection that prevented her from exhibiting. In her new occupation as a landlady, she simply didn't have the time. Looking back, she recalled, "I never painted now—had neither time nor wanting. For about fifteen years I did not paint."[26] This was a gross overstatement, for Carr did manage to paint and draw periodically during those years. But her experiences were far from what she had envisioned.

Artistic compromises, as well as personal ones, plagued the artist during her years at 646 Simcoe Street. We have seen the discomfort she felt with making "Indian" pottery." But pottery making also contributed to her reputation as an eccentric. She found a workable, if unusual way to haul the quantities of heavy clay she required: along the streets of Victoria she pushed a baby buggy filled with the clay, atop which rode her monkey Woo. Onlookers, noticing only the monkey, chalked it up to the growing oddity of the artist.

As a landlady Carr hoped at first to maintain a genteel balance between painting and managing Hill House. She advertised for tenants, and the enterprise began promisingly. But the disruption of World War I sabotaged those plans: in 1914 living costs rose, rents fell, and Carr found that she had to become "owner, agent, landlady and janitor."[27] To supplement her income she began to raise rabbits, hens, and dogs; in a large adjacent garden she grew fruit and vegetables, both for her own table and to sell. These activities absorbed an enormous amount of time, and she found it more and more difficult to make time to paint.

Though she had painted diligently in the fall of 1913, Carr was unable to get away for a trip north to her beloved coastal villages the following summer. Instead, she built a small cottage on the coastal outskirts of the city, possibly for use as a summer studio. But again, she found little time to use it. At home on Simcoe Street the upstairs portion of the house, containing a studio and living quarters, was Emily's. The studio was long and narrow, with a north-facing skylight, a stone fireplace (later replaced by a more efficient stove), and five windows hung with simple white curtains. Seating was afforded by a sofa near the fireplace, supplemented when needed by chairs Carr could lower from the ceiling on pulleys. In an alcove stood a massive oak table where she kept her rug frame and supplies, and a cage of birds or chipmunks. Beneath the skylight two homemade easels were surrounded by charcoal and paint tubes; nearby, another sofa was often occupied by her dogs. Carr's paintings crowded the walls, hanging edge to edge on virtually every vertical surface. The studio provided exhibition space as well as storage for the works that would not fit in the attic or basement.

When rents could not meet the expenses of running the house, Carr tried various alternatives. In 1916, for example, she took a break from running Hill House for a job in San Francisco painting decorations for a new ballroom at the St. Francis Hotel. Not exactly what she had dreamed of doing, but it kept alive a slender connection to her art.

Back at the apartment house she looked for other ways to raise her income. She started a dog kennel, a most successful enterprise. She also took up rugmaking, using wool yarn and fabric scraps and employing traditional designs. In 1917 she turned the entire second floor into a women's apartment. Now the tenants ate at her large work table and used the remainder of the studio for a sitting room. Carr moved herself upstairs to an attic bedroom, then outdoors to a backyard tent in the summers of 1917 and 1918.

Even when the studio was not bristling with tenants Carr seldom had the sustained privacy she needed to paint. Though she grew tolerant of painting in the presence of people she knew, like O'Keeffe she was profoundly uncomfortable painting around strangers. People would walk in unannounced, wanting to see a room, to borrow a tool, to complain about something. At such moments Carr was mortified: "I was caught there at my easel; I felt exposed and embarrassed as if I had been discovered in my bathtub!"[28] She would quickly toss a dust cover over the easel.

Carr recorded all these trials much later in her book *The House of All Sorts* (1944), a funny, acerbic account of the people and events at 646 Simcoe Street. As much as anything, she resented the way the apartment house defined her: as a failed artist. The tenants became the target of her resentment at not being able to paint regularly; she blamed them for her creative hiatus and feared (as she had when despair overcame her in England and in France) that she would never exercise her real calling. Of those dreary years she would later recall feeling only "a dead lump . . . in my heart where my work had been." Hill House, conceived to free her from financial worry, became instead a kind of prison for Carr. With obvious anger and self-pity, she bemoaned her state: "The tenant always had this advantage—he could pick up and go. I could not. Fate had nailed me down hard. . . . No, I was not nailed. I was *screwed* into the House of All Sorts, twist by twist. . . . Each twist had demanded—'Forget you ever wanted to be an artist. Nobody wanted your art. Buckle down to being a landlady.'"[29]

Truly, Carr's tenants were of "all sorts." Some—newlyweds, children, spouses mistreated by their mates—found a friendly ally in Carr, but others she considered a perpetual annoyance. Carr craved her own privacy but was apparently unable to grant the same to her tenants. She always applied something of a double standard in her attitude and her apartment house. Years later, when she was trying to sell the Simcoe Street property, she resented the intrusiveness of prospective buyers, who (she felt) poked their noses into her business: "I resent being a show for strangers, exposing the meanness of my home, and I shiver when they peer and discuss the personality in my studio, my mode of painting and living. 'And she keeps a monkey!'. . . Then there is a bellow, 'Look at the chairs hanging from the ceiling!' What business of theirs where I keep my chairs? I'd strap them round my waist so that they'd naturally sit me whenever I bent, if I *wanted* to."[30]

When she was freed at last of the constricting apartment house, Carr looked around for quarters where she could work easily, with art and animals happily accommodated. Her thoughts reverted to the comfortable spaces of her past: "I want a place I can be free in, where I can splash and sling, hammer and sing, without plaster tumbling. I think I want a warm barn. I want space and independence with people not too near and not too far."[31]

She did not find a suitable barn but settled instead into a small cottage on Beckley Street. There, as always, her studio would be the center of everything, the place where the pulse of the house beat. But it took some time before she felt that it had become hers. Shortly after she moved in, Carr spoke of the settling process: "There is just one room I don't *know* yet, which my spirit is not at home in, and that is the studio. It is not a studio yet. I have written, sewed, cooked, slept, eaten, gardened, but so far my spirit has not *painted* there, nor have my pictures hung on the walls, nor have I seen myself at an easel painting. . . . Rooms take on habits. I will have to teach that environment. It may repulse me and I shall have to woo it."[32]

Over the next four years she did manage to woo, teach, and win that studio, as she had her former ones. As the place warmed to her, she savored the pleasures and the isolation of living alone, a condition she described as "nice and not nice." Safely away from the din of the apartment house, she mused romantically (and unrealistically) on togetherness: "Big community Indian houses must have been very jolly, each family with its own fire—public privacy. One apple on a tree is lonesome, a crop is jolly; they must encourage each other no end." Carr had once painted a lively communal house, *Indian House Interior with Totems* (see fig. 88). But her own repeated experience of chafing under the annoyance of close-packed souls made human tangles impossible to tolerate. Like O'Keeffe, she needed periods of frequent and sustained solitude. Even so, experience did not dampen Carr's nostalgic longings for a kind of utopian community she thought she had glimpsed in the native villages. She wrote her friend Nan Cheney in 1941 that going over her old Indian sketches had made her "homesick" for the villages.[33] Soon, perhaps in answer to that nostalgia, she returned to Indian themes in her work.

In the Beckley Street studio between 1936 and 1940, Carr's artistic reputation grew even as her health declined. Several heart attacks slowed her considerably. At the outbreak of World War II, Canadian life again was plunged into upheaval, unlike the situation in the United States, which did not enter the war for two more years. Carr's landlady decided to sell the Beckley Street cottage, and it was clear that the artist was too ill to live alone any longer. She arranged to move into a flat in St. Andrew's Street, in a schoolhouse building her sister Alice had owned and operated for many years. Alice, her only surviving sister, had long since retired from teaching but continued to live in half of the old building and now needed a tenant. Emily announced to her sister that she was moving in, but privately felt some reservations: "It is a sober business this uprooting, this abandoning of a piece of

space that has enclosed your own peculiarities for a while. . . . Now I am going home to end my life a few yards from where I started it. How shall I paint and how write in the new environment, or are my work days done?"[34]

Emily renovated part of the building for her own use, converting the former schoolroom into a studio, building storage racks for her paintings, and creating an aviary and fenced area for her birds and dogs (fig. 134). Alice complained that the place was no longer hers but grudgingly accepted Emily and the changes she had made. As it turned out, Emily's work days were not done. She discovered at long last that in a world where others mostly make the rules, home is a place of autonomy and power. And she came to terms, finally, with the domestic side of herself. In her landlady days, art and household chores had pulled Carr in opposite directions; now she found that they could complement one another: to a museum director friend she wrote that "to cook and to be domestic . . . seems to bolster up art and the pretty side of life and make it all fit together [to] make life so much fuller."[35]

Frida Kahlo's homes provided stability in a life wracked with upheavals. Hers was the history of of a person who was born and died under the same roof, in a house her parents built in 1904, three years before her birth. The Casa Azul—brilliant blue with accents of red and green—stands in the leafy Mexico City suburb of Coyoacan. Symbolically, the expansive, sheltering arms of the Casa Azul welcomed Kahlo into the world at birth and repeatedly after her voyages into the larger world. Her ashes rest there today.

The arms (or wings) of the Casa Azul also encompass the contradictions in Kahlo's ancestry and in her life, bringing all into a balance. Her painting *My Grand-*

134
Unknown photographer, Emily Carr's studio at 218 St. Andrews Street, Victoria, c. 1945. British Columbia Archives D03843.

parents, My Parents and I (fig. 135) situates the child Frida within the interior court-yard, planted with flowers and a fruit tree and looking like a miniature Mexican Eden. The nude Frida, child of nature, stands similarly planted within this narrative of her identity. Behind her, hovering above the house are portraits of her parents, painted from their 1898 wedding photograph; above them on the left are her maternal Mexican grandparents, symbolically positioned above the land, while her paternal European grandparents float over the ocean on the right. Frida's father Guillermo is positioned exactly where land and water come together, emblematic of his immigrant status. In paintings of her grown-up self Frida would take up his position straddling land and water, a placement that served multiple symbolic purposes, not least of which was to convey her close identification with her father. In *My Grandparents, My Parents and I*, Kahlo demonstrates family ties or bloodlines in the literal connection of red ribbon between the generations. In its embrace of Frida, the Casa Azul anchors three generations to a place on the earth. Seen through the child Frida's eyes, it is the center of the earth, and she its singular possessor.

At the time she painted this work, domestic stability was far from her grasp. A few years earlier Kahlo and Rivera had moved into twin houses designed by their friend Juan O'Gorman in the San Angel district of Mexico City; the houses were the architectural embodiment of their wish for simultaneous closeness and separation. Planned to maximize creativity for each of them, the houses contained studios connected by an aerial walkway. But the arrangement was soon sabotaged by the couple's regular demons, ill health and infidelity. Rivera's affair with Frida's younger sister Cristina devastated Kahlo, who fled from San Angel to an apartment on Avenida Insurgentes. Reconciling after a time, the couple returned to the double house, where Kahlo spent six months recovering from a miscarriage and foot surgery late in 1935. In 1936 Kahlo underwent a third operation on her right foot; in addition, she suffered spinal pain, nervousness, exhaustion, and anorexia. In this troubled year, *My Grandparents, My Parents and I* was her chief artistic accomplishment; against a backdrop of physical and emotional anguish, it becomes Kahlo's nostalgic wish for a restored, undamaged self.

Kahlo, who read Freudian literature with enthusiasm, perhaps knew of the many metaphors of house as self. The idea that dreams transform internal sensations into symbolic pictures extends back to ancient Greece; in the mid-nineteenth century R. A. Scherner worked out the idea of the house as a symbol of the body in dreams—a metaphor which Freud later enlarged and embellished.[36] The low, earth-hugging house in Coyoacan, with its many window and door orifices, certainly lends itself to such images.

The Casa Azul stood as an island of refuge for Kahlo in the downturns of her life. When she and Rivera divorced in 1939, she returned there temporarily, then moved there permanently after her father's death in 1941. While she still could, Kahlo loved to work alongside her cook in the sunny kitchen, as joyous and folklorically

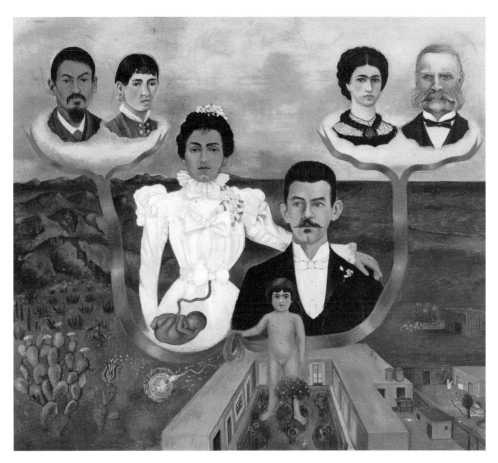

135

Frida Kahlo, *My Grandparents, My Parents and I*,
1936, oil and tempera on metal panel, 30.8 x 34.6 cm.
The Museum of Modern Art, New York, Gift of
Allan Roos, M.D., and Mathieu Roos. Photo © 2000
The Museum of Modern Art.

opulent as O'Keeffe's was spare. Where O'Keeffe set plain metal cabinets into adobe walls to make them unobtrusive, Kahlo arranged clay pots, dishes, and sculptured objects on freestanding shelves painted brilliant yellow. Bright tiles enlivened the stove and sink, while the names "Frida" and "Diego" were inset in the tiles on the wall. Guests remembered the aromas of roasting meats, pots of slow-simmering beans, and fresh-squeezed fruits. Nothing was hidden; all was revealed in baroque exuberance.

Rivera and Kahlo were very aware that they were on exhibit at Casa Azul. Friends recall lively meals, bawdy laughter, the enthusiastic chatter of Kahlo's painting classes in the garden, the sounds of parrots, monkeys, and Itzcuintli dogs. Who but Frida Kahlo, with her vibrant, extravagant personal appearance, could have stood up to such a powerful visual environment as Casa Azul? The downstairs, particularly, testifies to the abundance, amplitude, even excess of Kahlo's life. In their richness and largesse, those rooms stand as an antidote to the deadening pressures imposed on the artist by pain. The zestful lower rooms capture the carpe diem mentality she often manifested.

Upstairs, the mood was more somber, with memento mori aspects, the obverse of the joyous kitchen below. Miniature skeletons (calaveras) and several of Kahlo's plaster corsets, made grotesquely festive by the symbols and designs she painted on them, convey the intimate dance of pain and art in Kahlo's life. In the bedrooms upstairs, Frida slept, or tried to, in a bed that had an overhead mirror. Later she used the mirror to limn her own demise.

Eventually, as Kahlo's health worsened, the house became the invalid's whole world. Within its walls, she performed the daily ritualistic acts of survival: dressing, adorning herself, painting. What helped her survive were collections of the things she loved: a wall of votive paintings along the stairway, her china and cloth dolls, a few cabinets of books, her jewelry, clothes, hair ornaments.

As her world shrank, Kahlo kept her imagination turned to global politics: she was working on a portrait of Stalin when she died, while the walls of her nearby bedroom featured large photographs of Engels, Marx, Lenin, and Mao that lend severity to the space. In contrast, intimacy is the theme suggested by several of her late works in which, her technique coarsened by ill-health and dependency on painkillers, she clusters her intimates about her (fig. 136). Their visits, especially Rivera's noisy comings and goings, enlivened a life drained of its former exuberance. In another upstairs room, a painted banner announces, "The room of Maria Felix, Diego Rivera, Frida Kahlo, Elenita and Teresita"—her friends and lovers of both sexes, habitués all of Casa Azul.

Visitors to Coyoacan, Abiquiu, and Victoria can enter homes once occupied by Kahlo, O'Keeffe, and Carr. Each has been preserved with careful attention, and each projects something of the artist's self and lifelong attitudes about home, privacy, and creative space. Casa Azul, with its high walls, blind streetside fenestration,

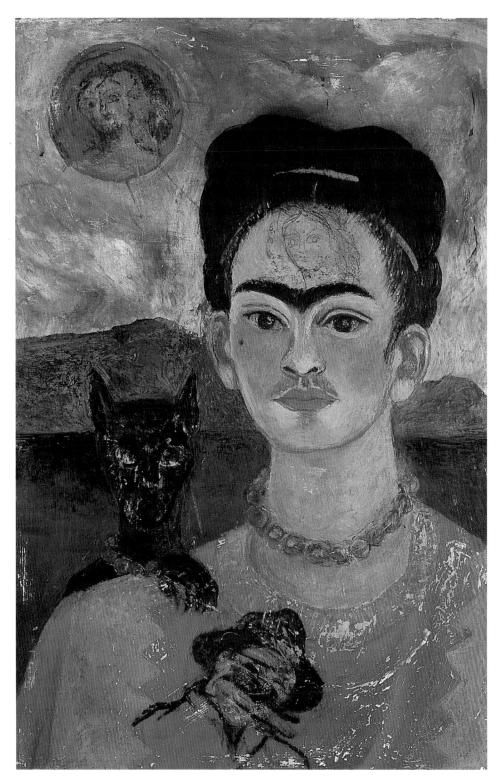

136
Frida Kahlo, *Self-Portrait with a Portrait of Diego
on the Breast and Maria Between the Eyebrows*, 1953–54,
oil on masonite, 61 x 41 cm. Private collection.
Photo courtesy Salomon Grimberg.

and indigo facade is assertively hermetic from the outside; inside, the interior rooms exude a kind of unguarded intimacy. There is a sense of openness that is suitable to Coyoacan's mild climate and to the artist's inclination to reveal herself there: her bold appearance, her personal relationships, her leftist politics, her artistic tastes, even her physical sufferings. The house's local building materials, including stone, tile, mosaic, and shell insets, speak of a deep attachment to Mexico, as do its collections of ancient and modern Mexican fine and folk art. The attachment to pageant and spectacle, for example, are revealed in Day of the Dead artifacts and in the oversize papier-maché Judas figures Kahlo and Rivera collected. One wonders how O'Keeffe, visiting Kahlo on her first visit to Mexico in 1951, reacted to the vivid eccentricities of Casa Azul.

Sedate and decorous by comparison is the Richard Carr home in Victoria, its exterior restored much as it looked in photographs from the last half of the nineteenth century. Since the original furnishings were sold long ago, its contents today have been assembled from other Victoria residences of similar vintage and class and cannot truly convey the place in which Carr declared herself an artist. Emily Carr's own houses, including the nearby House of All Sorts on Simcoe Street, and the St. Andrews Street school which became her last home and studio, are privately owned and have changed since her years of occupancy. O'Keeffe's house at Ghost Ranch, long her summer residence, is similarly unavailable for public viewing, but her Abiquiu home, now a National Historic Landmark, remains much as she left it and can be visited by appointment.

In her essay "Modern Fiction" (1919), Virginia Woolf described the simultaneous difficulty and necessity of investigating the spiritual aspects of consciousness: "Life is a luminous halo, a semi-transparent envelope surrounding us from the beginning of consciousness to the end. Is it not the task of the novelist to convey this varying, this unknown and uncircumscribed spirit, whatever aberration or complexity it may convey?"[1] What is required of the novelist can equally be asked of the artist searching for openings into the deepest recesses of the self—to speak the ineffable, to paint the invisible. Georgia O'Keeffe, Emily Carr, and Frida Kahlo, however differently they construed their own realities, all probed for meanings within this spiritual envelope. They formed their individual mythologies, which were deeply entwined with their conceptions of the spiritual, by contemplation of the universe at large as well as of some of its smallest parts. Evidence of their quests resides in their paintings and in their words, adding a dimension of complexity and depth to their work.

Georgia O'Keeffe's spiritual core must be sought within paintings whose clarity, seamless surfaces, and precise focus mask ethereal intentions. I have written elsewhere about spiritual elements in O'Keeffe's paintings, a discussion that is too broad in its entirety for this chapter.[2] But we have already encountered some of the ingredients of O'Keeffe's spirituality in this book; it is bound up with nature and sensitivity to Asian metaphysics. Light, color, limitless space: formal elements for most artists, these took on spiritual functions in O'Keeffe's compositions. At its most basic level, O'Keeffe's spirituality is tied to her intuitive self, to her ability to translate sensation into abstract form. In abstraction, O'Keeffe expressed moods and nuanced feeling not commonly apparent in representational painting.

One important aspect of O'Keeffe's spirituality is that it lay outside organized religion. Brought up within a strong Christian tradition and educated partly in Catholic school, she learned something about the power of icons even as she retreated from formal practice. What O'Keeffe gradually rejected was the structure of organized religion that intervened between her and a direct personal experience of the spiritual. Her increasing reliance on nature's spiritual energies as stimulus for her own creativity collided directly with the hostility of Catholic doctrine to unmediated encounters with the divine. And she considered the twentieth-century scientific-mechanistic worldview equally useless for explorations of the spiritual. She had to find another way to explore her own personal responses to the natural world, responses that she could pursue in both representational and abstract work.

O'Keeffe learned to read nature in part by reading her own mind. She decided early that she would need to summon all her inner intelligence to gain access

to nature's hidden, inner intelligences. In this endeavor she was encouraged by her study of Wassily Kandinsky's pithy *Concerning the Spiritual in Art*, a volume she read twice before 1916. The Russian artist and theorist urged his readers to harken to their own inner sound and to submit to what he called "inner necessity." More specifically, he asserted that finely tuned inner emotion consists of vibration, which also shapes the work of art. That work vibrates in turn, setting the soul of the beholder into vibration.

Looking at the visible manifestations of vibration they embody, many of O'Keeffe's most abstract works from 1915 onward argue forcibly that she was using this model of artistic production. In several of her large charcoal abstractions made in 1915, pulsing, wavelike lines suggest that O'Keeffe was trying out Kandinsky's notion that purely pictorial images could derive from inner vibration, especially in works such as *Special No. 9* (Menil Collection, Houston) and *Drawing XIII* (Metropolitan Museum of Art). She did not say so publicly. What she did reveal was both more prosaic and more characteristic of her: she claimed that the former work represented her experience of a headache. "Well, I had the headache, why not do something with it?"[3] Pulsing energy, given visible form in wavelike lines, thus circles intimately with the inner sources of O'Keeffe's creativity, whether experienced as exquisite sensitivity to vibration or to pain.

The history of the body's vulnerability has been described in literary, political, philosophical, medical, and religious terms; and suffering has received visual attention throughout art history in certain familiar subjects: the Crucifixion, combat, disease's ravages, the spectre of death. In Frida Kahlo's highly personal and secular images, for example, the artist endowed her pain with visual form, usually by representing her own suffering body. O'Keeffe's nature did not allow her such intimate expressions of personal agony. Her breakthrough in *Special No. 9* was to invent an abstract visual language for the inexpressibility of pain, and to defy pain's ability to destroy the language of the sufferer. Virginia Woolf would recognize the same wordless dilemma for pain sufferers: "English, which can express the thoughts of Hamlet and the tragedy of Lear has no words for the shiver or the headache. . . . The merest schoolgirl when she falls in love has Shakespeare or Keats to speak her mind for her, but let a sufferer try to describe a pain in his head to a doctor and language at once runs dry."[4]

Blessed for the most part with good health in the 1910s, O'Keeffe seldom focused on the visual expression of pain; more often she turned to nature to express emotional states. In her early years as a painter she learned the power of the single, iconic image. Whether it was a flower, a shell, a burst of light, or a skyscraper, she taught herself to endow that image with a drama and a singularity far beyond its usual associations. For O'Keeffe, art became a private language between two speakers, sometimes between her paintings and Stieglitz's photographs, more often between herself and her viewer.

O'Keeffe was more concerned with the objects she herself transformed into icons, but occasionally she tested the power and paintability of more universal symbols. The cross, as seen in Chapter 2, resonated in her work with meanings old and new when placed in the context of Southwestern nature. An even more complex icon—because of its figural and gendered form—was the Virgin Mary, whose nature and status have evolved over centuries. When she encountered Mary's image in the Southwest, O'Keeffe had to paint it, just as she had to paint the church at Ranchos de Taos.

Wooden Virgin (fig. 137) was painted in 1929, O'Keeffe's first summer in the Southwest. It was probably based on a *bulto*, a carved and painted Hispanic devotional image, that came from Mabel Dodge Luhan's extensive collection in Taos. O'Keeffe painted the statuette as if it were a doll, its face a painted mask. A great many carved or painted madonnas in the Western hemisphere represent the Virgin of Guadalupe,

137
Georgia O'Keeffe, *Wooden Virgin*, 1929, oil on canvas,
58.4 x 25.4 cm. Private collection.

a favorite intercessor among people of color in the Americas. Her images are ubiquitous, and many visiting artists have interpreted them as part of their cataloging of regional imagery. Marsden Hartley, for example, painted a fairly straightforward rendering of Guadalupe (1918–19; Metropolitan Museum of Art) that included her full-body mandorla, rayed like the sun. He also painted a Virgin within a grouping of bultos in his *Santos, New Mexico* (c. 1918–20; Weisman Art Museum, University of Minnesota).

O'Keeffe's *Wooden Virgin*, whether a reference to Guadalupe or (as appears likely) painted from the same figure Hartley had used in Luhan's collection ten years earlier, departs dramatically from his and other treatments of the wooden bultos. O'Keeffe has framed her Virgin by a partial mandorla—but not of gilded wood; it is created out of a cloud. It is as if this Virgin's divinity derives from nature; she has been emptied of historical context, refilled with nature. She is another example (like Carr's D'Sonoqua) of a twentieth-century artist naturalizing the cultural—what Roland Barthes designated as the role of modern myth.

The Virgin's cloud-halo allows her to visibly stand apart from, and yet belong to, the infinite. But when one gazes longer at the halo, an alternative way of seeing emerges: the white halo can be read as negative space, at either side of which the blue shapes now suggest drapery, such as often frames saints in Hispanic *retablos*. Spatial depth becomes disconcertingly ambiguous around a figure painted with convincing plasticity. In this most somber painting, O'Keeffe makes a playful trompe l'oeil statement.

More significant in O'Keeffe's rendering of her cloud-shrouded Virgin, however, is its clue to her spiritual identification with the forms and forces of nature. As O'Keeffe's friend Vernon Hunter wrote, her "regard for nature seems virtually pantheistic. She . . . loves the sky, the wind, the solitary places and what grows therein, as she might love a person."[5] Nature and spirituality merge in O'Keeffe's modest painting of a bulto. Her Virgin is part religious icon, part woman-in-nature—an appropriate crossover image for the artist. Long estranged from formal religion, she later adopted for herself an almost nunlike garb, reminiscent of the Virgin's draped garments. The artist Dorothy Brett saw her friend O'Keeffe's dress as reflecting a persona at once iconic and passionately outside convention. She called O'Keeffe "a strange madonna, with a fiery intensity for life, which we are not taught belongs to a madonna."[6] And artist Peggy Bacon, who drew O'Keeffe's caricature, said she was "conspicuous as a nun."[7] There is a highly romantic, even *faux naïf* element in such aspects of O'Keeffe. *Wooden Virgin* expresses the artist's belief not in her own innocence but in the innocence of the "other" found in Native American or Hispanic contexts. Some of the same sentiments emerge from Carr's and Kahlo's encounters with native art and people.

In images with an indigenous cultural and religious context, such as the Virgin of Guadalupe or the kachinas she painted, O'Keeffe could remain, paradoxically, at once intimate and detached. She could use them as subjects to test the ways

The Spiritual Core

nature and spirit converge in the Southwest. But they meant more: on a personal level, the Virgin, for example, embodied certain character traits, as well as belonging to the artist's own religious upbringing. The Virgin's quietude and long-suffering (though hardly a feminist model for the increasingly independent O'Keeffe) might have appealed to O'Keeffe in 1929. Her visit to New Mexico that year must be seen, at least in part, as a retreat from her growing discomfort at Stieglitz's attentions to Dorothy Norman.[8] O'Keeffe's *Wooden Virgin* contains something of the stolidity, self-containment, and dignity she needed that year, but may reflect as well an emotional numbness and mute loss. Clearly, the artist felt herself at a personal cross-roads, an idea that appeared in her choice and rendering of early Southwest subjects.

In the West, O'Keeffe's reverence for nature increased. Attracted to Native American concepts, she began to blur notions of the sacred and the profane— distinctions made meaningless by her growing belief that the divine is immanent within everything. This is perhaps O'Keeffe's greatest lesson from Native American culture: her holy places became, like theirs, mountains, bodies of water, majestic trees, and recesses within the earth. Sky and sun exercised her visual as well as her spiritual capacities until she ultimately approached all nature with reverence. Just as the sanctification of landscape is a fundamental function of mythology, one function of an artist can be to mythologize the divinity inherent in nature. In this sense all landscapes are potentially sacred.

Another symbol of O'Keeffe's deep attachment to nature in the Southwest is her vast collection of pebbles, stones, and rocks. They are objects of ancient age and unknown origin, polished by water, weather, and time. O'Keeffe called them her "treasures." She searched for them in the hills and riverbeds, filched them from amused friends, caressed them, pocketed them, brought them home. She exhibited them on windowsills and low platforms in her outdoor courtyards. Like altars (which in Catholic tradition were sacred because they contained relics: the bones of a saint and a block of stone) these lapidary groupings presided, with quiet sentience, over the spare spaces O'Keeffe frequented. In typically understated fashion, she down-played their role in her surroundings; to a friend she wrote, "I'm glad I'm satisfied with a lot of space and colored earth and a few bones and rocks."[9]

O'Keeffe's stones are on one hand solid, material, ordinary objects. But there is evidence that they meant much more to the artist; and they belong in a con-sideration of spirituality in O'Keeffe's art. *Saxa loquuntur*—the rocks speak—as Freud declared, and as archaeologists have always known. The Greek command *gnothi seauton*—know thyself, Socrates' guiding principle—was inscribed in stone at the site of the Delphic oracle. And the Rosetta Stone, with which Jean-François Champollion deciphered the meaning of Egyptian hieroglyphs in 1821, likewise points metaphorically to the value of "reading" images in stone.

Stones and rocks appear early in O'Keeffe's work, and remain persistently, as bearers of diverse meanings. Perhaps the earliest appearance is in two of her charcoal

drawings from 1915, a period of fertile experimentation. *Special No. 1* (1915: National Gallery of Art, Washington, D.C.) and *Special No. 2* (fig. 138) both feature what appears to be a shiny dark stone floating atop a column of spurting liquid. These mysterious drawings have been variously interpreted as expressions of Art Nouveau design, phallic-uterine symbols, or eye forms. Stieglitz supported and encouraged sensationalized interpretations of their sexual content.[10]

But there is another, subtler interpretation that accords with other artistic concerns that were much discussed at the time. O'Keeffe's ovoid forms in *Special No. 2* also read as emblems of creativity, symbols of self-fertilization and the birth of artistic form. In this sense they are self-referential, but they present an idea which was also near to Stieglitz's heart: the originality and wholeness of artistic expression. Not long after he saw these images, Stieglitz, in fact, mounted a lengthy campaign to prove that O'Keeffe was an original, self-fertilizing artist. Such ideas were already in the air: Brancusi, whose very first exhibition was held at 291 early in 1914, was already exploring ideas of creativity in egg-shaped stones and bronzes.[11]

By the time she drew her first charcoal specials, O'Keeffe may well have been acquainted with Kuo Hsi's essay on landscape, part of her assigned reading in Arthur Dow's classes. The Chinese painter wrote that "stones are the bones of heaven and earth." Had she looked into other ancient traditions, O'Keeffe would have

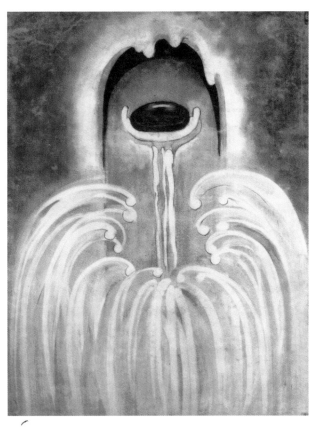

138
Georgia O'Keeffe, *Special No. 2 [No. 2 — Special]*,
1915, charcoal on laid paper, 60.3 x 46.4 cm.
National Gallery of Art, Washington, D.C., the Alfred
Stieglitz Collection, Gift of the Georgia O'Keeffe
Foundation, 1992.89.4 (DR).

The Spiritual Core

learned that among the Maya and Inca, stone was the source of life and fertility, a concept referred to as *petra genetrix* in other cultures.[12]

The *lapis philosophorum*—the mysterious philosopher's stone in the alchemical tradition—was symbolic of transformation, healing, and arcane knowledge. Generally described as a common-looking gray (or sometimes red) stone, the philosopher's stone moved in time from the material to the spiritual realm, becoming (in the later spiritual alchemical tradition) the key to self-knowledge, "whereby the forms of things and the hidden springs of Nature become known intuitively."[13]

Did O'Keeffe know anything about alchemy when she drew *Special No. 1* and *Special No. 2*? That she may have done appears in their references to intuitive knowledge and "hidden springs," both ideas in accordance with O'Keeffe's thinking and imagery in 1915. They recall, as well, ideas that were well known to her colleagues, especially Stieglitz, whose interest in alchemy has been widely acknowledged.[14] Also established is O'Keeffe's exploration during those years of the possibility that art could be a healing agent. The purpose of this discussion is not to argue that O'Keeffe was an alchemist; whether she knew much about the hermetic tradition is ultimately beside the point. More important is whether her catalogue of elemental forms—sometimes abstract, sometimes representational—draws from the pool of archetypal imagery and concerns discussed by Jung and others (and manifested historically in alchemy as well as in many other spiritual traditions). O'Keeffe, as has long been known, read and absorbed works by Jung, including his foreword to an ancient Chinese mystical text she favored late in her life, *Secret of the Golden Flower*, which he described as an alchemical work as well as a Daoist study of Chinese yoga.

The idea of self-fertilization, of the artist as autonomous creator, is latent in the image of the egg as well as the stone. The potential of new life and creativity has long been invested in the idea of the egg, whether cosmic or animal. O'Keeffe employed the image in the 1920s in a still-life that seems more than a study in pictorial function. In *Three Eggs in a Pink Dish* (fig. 139) she nestles the eggs, tellingly, within a footed pink compote, which also appears in a contemporaneous work called *Pink Dish and Green Leaves* (1928, private collection). Both are strange and some-

139
Georgia O'Keeffe, *Three Eggs in a Pink Dish*, c. 1928, oil on canvas, 30.5 x 80.6 cm. Museum of Fine Arts, Museum of New Mexico, Gift of the Estate of Georgia O'Keeffe, 87.449.2.

what eerie paintings, with the dish given central focus, like a ritual chalice or a grail. In *Three Eggs in a Pink Dish*, the compote-chalice-grail is placed upon a pale draped fabric ground, which further isolates and sets it apart from ordinary reality. Perhaps O'Keeffe is poking fun at the artmaking process itself, in the delicious oxymoron she has created between the egg's banality and the austere apartness she has given it in its rarefied studio setting.

As visual objects, O'Keeffe probably enjoyed the eggs' pleasing, smooth shapes, which echo the ovoid forms of the pears and avocados she had painted earlier in the decade. (Their round hardness also anticipates the smooth river rocks she collected later.) Eggs are also emblems of purity—white, whole, sealed—hermetic shapes, self-contained and concealing their contents. They are at once mysterious and commonplace. They lie there unchanging (unlike flower blooms) and keep their secrets. They allude to reproduction, and obliquely to sexual process, but the connection has been purified. Only in the shiny red lip of the dish, seen from above in *Three Eggs in a Pink Dish*, do we glimpse a suggestion of voluptuous flesh. Perhaps O'Keeffe is mocking the Freudian critics who had given her work such disturbing sexual interpretations in previous years. Or perhaps these are the paintings Arthur Dove referred to in letters, enigmatically, as O'Keeffe's "Altar Pieces." They certainly fit his comment that while some viewers saw in them a preoccupation with sex, to Dove they were "quite as pure painting as any spiritual experience, if not identical." [15]

Again, spirituality and creativity seem linked in O'Keeffe's mind. Thinking back to *Special No. 1* and *Special No. 2*, made thirteen years earlier, we see in *Three Eggs in a Pink Dish* a motif similarly linked to new beginnings and latent creativity. The egg has become the source of creation. In this sense, I believe O'Keeffe is revisiting ideas of self-fertilization and artistic potency, communicated in a visual pun. Finally, her enigmatic painting may also refer to Stieglitz's quasi-mystical belief in the life-enhancing power of art. In his *Our America* (1919), Waldo Frank called Stieglitz's gallery 291 "a religious fact . . . an altar where talk was often loud, heads never bared, but where no lie and no compromise could live. A little altar at which life was worshipped above the noise of a dead city." [16] Is *Three Eggs in a Pink Dish* a symbolic portrait of 291 itself?

The artistic and spiritual latency of eggs and polished rocks continued to engage O'Keeffe for many years. In 1929 she painted several enigmatic works based on her first summer's visit to New Mexico. By their titles they seem to refer to experiences as much as to visual perceptions. *At the Rodeo, New Mexico* (private collection) is a kaleidoscopic image variously described as a pun on the camera lens, a stylized flower, and a reference to a silver conch form of Native American design. Another work from the same summer, *After a Walk Back of Mabel's* (fig. 140), is equally puzzling. The pink central shaft, wrapped in an irregular black form, seems to suggest the hardness of rock, with accents of the same red, white, and blue that

140
Georgia O'Keeffe, *After a Walk Back of Mabel's*, 1929,
oil on canvas, 101.6 x 76.2 cm.
Collection of Lee E. Dirks, Santa Fe, New Mexico.

O'Keeffe was using at that time to signal the American character of her work. She was later photographed against this painting with her head (itself wrapped in a dark fabric band) almost exactly filling the central pink shaft (fig. 141). Dressed in her severe black and white, O'Keeffe seems surrounded by an eerie halation. She is framed, like her wooden Virgin (painted the same summer) in a nimbuslike device that reads, again, as an iconographic attribute.

Rocks appeared in O'Keeffe's work either visually or metaphorically for decades. Even when absent from her canvases, their smooth perfection and their lapidary timelessness often seemed present metaphorically. Writing of her work in the 1930s, critic Lewis Mumford saw "canvases that are as simple as a polished pebble and as finely wrought, out to the very edges of the picture frame, as the most honest piece of Flemish craftsmanship." [17] Sometimes O'Keeffe abandoned metaphor, returning directly to rocks as subjects. She placed them in visually pleasing combinations, playing with scale and relational form.

Decades later she was still thinking about rocks and chose a black stone shaped in an irregular triangle to paint. In a small series she rendered it against vari-

141
Peter Juley, Georgia O'Keeffe in front of her painting
After a Walk Back of Mabel's, n.d., photograph.
Juley Collection, Smithsonian Institution, Washington,
D.C., PPJ2030.

The Spiritual Core

ous backdrops, including sky and clouds. But she also renewed the powerful union of red and black in *Black Rock with Red* (fig. 142). She brought these water-polished rocks home from a river trip and wrote of them in her book *Georgia O'Keeffe* (1976), accompanied by a paean to their suggestive presence: "The black rocks from the road to the Glen Canyon dam seem to have become a symbol to me—of the wideness and wonder of the sky and the world. They have lain there for a long time with the sun and wind and the blowing sand making them into something that is precious to the eye and hand—to find with excitement, to treasure and love."[18]

The subject of *Black Rock with Red* has the substantiality of a large rock, even a boulder, but was probably of modest size, like most of the hundreds of rocks O'Keeffe kept near her in New Mexico. Typically they were small enough to hold in the palm of her hand. Photographs of her rocks pick up their lustrous sheen, recording an instance in which O'Keeffe's recurrent, idiosyncratic attention to photography may have suggested to her how to paint such rocks. The stone in *Black Rock with Red* has been positioned atop a base, probably a tree stump or trunk section, modified by O'Keeffe into a shape resembling a fragment of a fluted marble

142
Georgia O'Keeffe, *Black Rock with Red*, 1971, oil on
canvas, 76.5 x 66 cm. Georgia O'Keeffe Museum,
Santa Fe, New Mexico, Gift of the Burnett Foundation
and the Georgia O'Keeffe Foundation.

architectural column. Its austere monumentality is thus further enhanced. This paint-
ing and a few others from the same series pleased O'Keeffe, who said she that
in them she had gotten what she tried for. Shining darkly, they predict the free-form
ceramic pots she began making soon afterward with her new assistant, Juan Hamil-
ton. Like the rocks, these pots seem to belong to nature, old and laden with mystery.

So securely grounded was O'Keeffe's world—natural and constructed—in
New Mexico, that she remarked to a close friend, "My world is a rock."[19] Not
like a rock, but a rock itself, the most direct and solid of metaphors. We have seen the
many roles rocks came to serve for her: as a surrogate heart in Chapter 2; as repos-
itories of creative energies; as emblems of the mysterious and sacred; as weights hold-
ing her to geological time and the slow processes of nature; as treasures without
intrinsic value; and as symbols for "the wideness and wonder of the sky and world."
They endured, embracing one of her favorite contradictions: the subtle, the complex,
and the immaterial all dwelling within apparent materiality.

For O'Keeffe, painting and spirituality served parallel functions: art and
metaphysics both helped her to probe the endless universe and to attempt to fathom
its source. To do that, she had to reject the religious traditions of her youth as
narrow, limiting, tied to conventions that imposed human mastery on the natural
experience encompassing all life forms. Conventional religion threatened to
interfere with her direct—we might say gnostic—perceptions of nature, unmediated.
O'Keeffe's metaphysics were complex; to nature's hidden, inner intelligences
she brought her own exquisitely tuned understandings. More than once O'Keeffe
acknowledged the romanticism noted in her work; in the end she emerges as a
quintessential romantic. Writer Friedrich von Schlegel described the romantic view of
nature in words that anticipate O'Keeffe's conviction—seldom voiced, often
painted—that the infinite reveals itself in nature: "Only he can be an artist who has a
religion of his own, an original view of the infinite."

Emily Carr too looked deeply into the spiritual implications of creativity. She too
turned to nature for spiritual ballast early and late in her life. And she took as one of
her links to nature the spiritual pathways of native peoples. Carr's admiration for
indigenous groups was based, admittedly, on limited experience, but she unabashedly
called on her imagination to supplement her own scanty knowledge. Examples
of her invocation of native spirituality in paintings have been discussed in previous
chapters. In her book *Klee Wyck*, Carr posited native peoples as sources of magic
and knowledge of the natural and supernatural—a knowledge she thought had been
renounced by whites in modern secular society. Late in life Carr's spirituality wove
together elements of native mysticism with a highly personal brand of Christianity.

Before then, however, Carr experienced a significant encounter with another
form of spirituality that would affect her aesthetic sense as well. There is much evi-
dence that two events—her introduction to the painter Lawren Harris and, through

him, to esoteric spiritualism—were responsible for reawakening Carr's artistic production in 1928, after a fifteen-year hiatus from painting. During her first visit to Toronto in 1927, she was struck by the work of Harris, the leader of the Group of Seven painters. She adopted Harris as something of a mentor (though she was the older by fourteen years). When she returned to British Columbia, the two began an intimate correspondence that was frequent until 1934, sporadic thereafter.

From the early 1920s Harris participated actively in the modern philosophical-religious association known as Theosophy.[20] Like a number of other creative individuals during the first half of the twentieth century, including W. B. Yeats and the pioneer abstractionists Wassily Kandinsky, Piet Mondrian, and Frantisek Kupka, Harris glimpsed in Theosophy a vision of order underlying the cosmos. Significantly for this discussion, it was through the teachings of Theosophy that these artists found new ways of pursuing their own creativity and interacting with others. For many outsiders, Theosophy has always appeared to be an occult, eccentric religious sect, but to its adherents its messages offered the promise of inner peace attained through an antimaterialistic worldview and by keeping one's emotions in constant equilibrium.

The Theosophical Society was founded by Helena P. Blavatsky and a small group of associates; their aim was to free humankind from material dependency through positive spiritual inquiry, but without dogma. Established in New York in 1875, the society later moved its headquarters to India, whence many of their mystical concepts had originated. The society's goals have been enumerated in these general terms:

1. To form a nucleus for the Universal Brotherhood of Humanity.
2. To encourage the study of Comparative Religion, Philosophy, and Science.
3. To investigate the unexplained laws of Nature and the powers latent in man.

Theosophists introduced the sacred texts of the East to many artists and intellectuals of the West. Particularly in the years of disillusionment surrounding World War I, Theosophy seemed to challenge the pervasive materialism of Western culture, offering an alternative of spiritual fulfillment. From Buddhist and Vedic thought came the central notion that all existence is interdependent. A path to nirvana or enlightenment (envisioned by Blavatsky as a ray of pure white light) also arose from Buddhist and Brahmanist thought, as did the karmic conception of cumulative growth through reincarnation.

For Harris, Theosophy held special promise for Canadian artists. Beginning in the 1920s Harris identified and painted certain Canadian landscapes that he believed demonstrated the unity of all things and could elevate the spirituality of their beholders. Essentially a romantic view, this notion focuses on the artist's role in capturing the daemon of a place. The evolution of the human spirit, in other words, could be stimulated by geography, by what Harris called the "informing spirit" of the land itself. Canadian artists, he came to believe, could draw on the "clear,

replenishing, virgin north" for release from materiality into a "rhythm of light, a swift ecstasy, a blessed severity."[21]

Thus Harris urged Canadian artists, including Emily Carr, to focus on both microcosm and macrocosm: they needed to fix on their own unique environment, throwing off foreign influence to achieve, paradoxically, "an art more spacious, of a greater living quiet, perhaps of a more certain conviction of eternal values" than (for example) that made by artists within the teeming populations of the United States. This is one of three forceful messages Harris conveyed to Carr. Another was that the wilderness experience was the path to the artist's successful union with place. Harris himself had often journeyed into the northern wilderness—beyond Lake Ontario in the 1920s, later to the Rockies and the deep isolation of the Arctic. The most important thing, he urged Carr, was to "saturate ourselves in our place, the trees, skies, earth and rock, and let our art grow out of these."[22]

These were messages Carr was fully prepared to hear. Although she had traveled into the northern rainforests as a young artist, by 1928 she was distressed by a life of landlady drudgery, of years without measurable artistic achievement or spiritual enrichment. Inspired by Harris and his high-minded Theosophical principles, she listened avidly to his discussions of a philosophy that seemed to offer a return to art and nature-based spirituality. In the late 1920s Carr transformed her study of nature: departing from her former position of observing nature's outward forms, she now looked deeply within nature to grasp what Harris called its "indwelling spirit." As she learned to synthesize the qualities of her experience in nature, she enshrined the wilderness experience in a deeply romantic internal sanctuary. Her most direct artistic approach to Theosophy is her oil *Nirvana* (fig. 143), exhibited with the Group of Seven in Toronto in April 1930. Here, in one of a series of formalized, disciplined works from this period, Carr has invested Indian totem poles with a dark silence that matches the severely stylized foliage forms that surround them. Native art, she suggests, partakes of the same universal oneness, the fusion of art and religion, that Theosophy gathered from Eastern religious traditions.

Still another of Harris's Theosophical artistic principles was the notion, borrowed from Buddhist cosmology by Blavatsky, that vibration was both a generative and a visible aspect of all shapes in the visible and invisible worlds. We have already encountered O'Keeffe's interest in vibration fifteen years previous to this. In the early 1930s (especially after Carr saw Charles Burchfield's paintings in New York, but also following her introduction to Theosophical concepts) Carr's work begins to pulsate increasingly with the force of vibration. In works such as *[Untitled; Forest Interior, Black and Grey]* (see fig. 94) there is a tremulous new energy. In this example of the oil-on-paper sketches that rejuvenate her work from 1932 onward, Carr demonstrates the freedom and energy she now saw in nature itself: "Everything is alive. The air is alive. The silence is full of sound. The green is full of color. Light and Dark chase each other." So strong was Carr's passion for nature in these

years that it demanded representation, even as—because of that intensity—it threatened to defeat, or at least expose, the limits of representation. Carr could identify with Vincent van Gogh's great sweeps of movement and his blazing energies for artmaking, though she claimed that she arrived at her "unity of movement" independent of him.[23]

Carr's artistic passions hovered for a long time at a remarkably high pitch: her delight in vibration, sound, and movement in nature remained throughout the years, though they assumed other forms and intensities in later work. In her work what remained of this passion was her sustained interest in formal unity, achieved through paint application, color harmonies, and a rhythmic continuity that lifted sea, forest, and horizon into great arcing movements. Motion became an equivalent for spiritual energy and for the pervasive life force. By endowing nature's forms with those struggles, she gave visible proof of her belief in the oneness of art and religion.

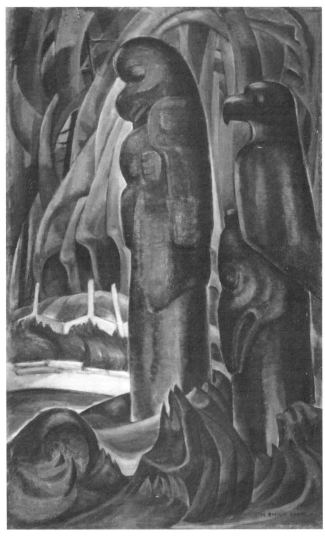

143
Emily Carr, *Nirvana*, 1929–30, oil on canvas,
108.8 x 69.4 cm. Private collection.
Photo courtesy Art Gallery of Ontario.

Harris's paintings tended to be severely geometric and crystalline in their purity, but his was not the only example she studied. With the help of Burchfield's and van Gogh's paintings, she created her own highly animated version of Harris's parallel representation: the portrayal of material reality that conveys a suggestion of a higher spiritual plane. Here was an idea that also preoccupied O'Keeffe; both had taken it in part from Kandinsky. As Ruth Appelhof points out, Carr may have known Kandinsky's writings as early as 1910 or 1911; certainly she encountered them through Harris, and she saw Kandinsky's work for herself during her 1930 trip to New York.[24] Kandinsky had adopted from Theosophy the idea of a "spiritual atmosphere" filled with color, movement, thought, and feelings. Taking what she needed from these artists, Carr painted personal responses to nature's inner workings, creating a powerful example of art that transcends the material.

Carr's flirtation with Theosophy was intense but relatively brief. On the recommendation of Harris, she read some of Madame Blavatsky's writings and struggled with P. D. Ouspensky's *Tertium Organum* (1911; English trans. 1922) an esoteric treatise advocating cosmic consciousness. During her visit to New York, Carr visited Katherine Dreier, another Theosophist close to the spiritualist-architect Claude Bragdon (who had translated Ouspensky and was also a friend of O'Keeffe and Stieglitz). Along with Marcel Duchamp and Man Ray, Dreier had founded the Société Anonyme, an organization dedicated to promoting modern art. Carr, who liked to play the outsider, overacted the part of the Canadian provincial in Dreier's presence: as if she had never seen a modern painting, Carr asked the formidable Theosophist about an abstract work in her apartment, Dreier's own well-known portrait of Duchamp. "Please, Miss Dreier, why is that carrot struck through the eye?" she asked, with dissembling naïveté.[25] Carr seemed consciously to be associating advanced art with esoteric theory, a linkage that intimidated her.

Harris, the sole Canadian member of the Société Anonyme, helped initially to assuage Carr's discomfort with Theosophy and abstract art. In letters to her, Harris dwelled at length on creativity as spiritual endeavor, and his advice to her contains the clearest exposition of his Theosophical principles. For a time, she accepted certain of them.

One of Harris's chief artistic motifs during the early 1930s was the mountain, a vital symbolic element to Kandinsky and Theosophists in general, who held that mountains (especially the Himalayas and, to a lesser extent, the Rockies) were prime sources of spiritual knowledge. Earthbound yet aspiring to the infinite, mountains preoccupied Harris in his effort to represent the connections between realms of earthly knowledge and higher planes. Like Kandinsky, Harris believed that the spiritual potency of a mountain could be conveyed in austere geometries. The spiritual triangle, whose equivalent in nature was the mountain, figured prominently in many of Harris's paintings of the thirties.

In an earlier discussion I looked at Carr's personal identification with some of nature's forms, including the female mountain. But in 1933, at the height of her involvement with esoteric philosophy, Carr saw mountains as more exalted forms. That May she traveled north from Vancouver to the mountainous country beyond. From there she wrote of "mountains towering—snow mountains, blue mountains, green mountains, brown mountains, tree-covered, barren rock, cruel mountains with awful waterfalls and chasms and avalanches, tender mountains all shining, spiritual peaks way up among the clouds."[26] It is a description at once reminiscent of the aesthetics of the sublime and indicative of Carr's receptivity to the spiritual in nature. No doubt predisposed by Harris, Carr was temporarily overwhelmed by the scale, power, and spiritual potency of mountains. But her infatuation was brief; she would never, like Harris, make the mountain an enduring spiritual motif in her painting.

Through Harris, Carr achieved a greater understanding of the role of abstraction in conveying the spiritual. Writing to her following his trip to Europe in 1930, he had expressed reservations: "I have seen almost no abstract things that have that deep resonance that stirs and answers and satisfies the soul." Even so, he held out hope that profundity, which he defined as "the interplay in unity of the resonance of mother earth and the spirit of eternity," might be achieved by the fusion of nature and abstraction. Over the next several years Harris struggled to achieve this in his own work. He abstracted from mountain forms, reducing them to lines of energy and color-light auras similar to those described by Theosophists as "thought forms."[27] Harris's *Mount Lefroy* (fig. 144) exemplifies this period of his intense spiritual symbolism derived from nature.

Within a few years Harris became committed to abstraction as the chief pathway of the spiritual quest. In 1936 he wrote to Carr encouraging her to experiment with the technique. Knowing of her insistence on investing her work with feeling, Harris argued, "Feeling can be as deep, as human, or spiritual or resonant in an abstraction as in representational work. . . . Abstract the essence, the essential from nature, give it new form and intensity."[28]

Knowing of Carr's deep affinity for nature, Harris never tried to divert her from it and onto his own lifelong path of esoteric spiritual growth through art. Certainly she followed him for a period, and in their intense correspondence between 1928 and 1934 he responded to her questions and explained complex philosophical ideas to her. But at least as important in that correspondence was the plain, human encouragement he gave her. When Carr wrote to him of feeling old and discouraged in her work, he replied,

Then you say "you guess you're through"—what nonsense. You're just beginning a deeper search into the fundamental life in trees and forest and nature in her deepest, most secret moods and meanings. . . . Now, again and again—no one in Canada or anywhere

else is doing what you are doing. That is, your contribution is unique and will remain so, I feel. For goodness sake, do keep on despite any temporary discouragement or anything else. Age has nothing to do with it—though maturity of idea and conviction has—and you have both.

And she did keep on, finding ways to spend part of most summers working outdoors in the great forests of British Columbia. A few years later Carr reported to Harris that she had "bought a hideous but darling old caravan trailer, am now independent of cabins for sketching trips" (fig. 145). Harris's hearty reply, recorded Carr, was "Swell! Swell!"[29]

Whatever artistic advice Harris had given her, Carr, in her late fifties, was unlikely to radically or permanently alter her visual language. Rather, Carr's continuing sensitivity to spiritual nuance, absorbed from a variety of sources and incorporated, especially during her middle years, into her search for the wellsprings of her own creativity led to changes in her art. To understand the ways in which spirituality, creativity, and modernism intertwined in Carr's life and work demands a closer consideration of her metaphysical preoccupations (with and beyond Theosophy) alongside her developing artistic practices.

Nineteen twenty-eight marked the beginning of a particularly pivotal period in Carr's formal development. She had just been east for the West Coast Exhibition, where she had seen the idealized forms, suppression of detail, directional light

144
Lawren Harris, *Mount Lefroy*, 1930, oil on canvas,
133.5 x 153.3 cm. McMichael Canadian Art Collection,
Kleinberg, Ontario, purchase 1975.7.

shafts, and austere geometric underpinnings of Harris's recent work. From those paintings and the confident example of the eastern painters, Carr had begun to explore new ways of rendering space and volume. In June she embarked on an extensive trip north to the Nass and Skeena Rivers and the Queen Charlotte Islands, visiting villages she had first seen years earlier, and returning with a clutch of sketches heralding a new sculptural simplification in her work. These she intended to develop in the studio the following winter.

Before she could do so, Carr spent an important three weeks in the early fall with Mark Tobey, a dynamic young modernist painter and teacher who was then resident in Seattle. They had first met earlier in the 1920s, when Tobey and several other young painters began to visit Victoria. Several times these painters stayed with Carr in her House of All Sorts, where Tobey encouraged her to paint more, tend less to her household duties.

Now he asked Carr to convene a group of Victoria students for a master class to be given in Carr's studio. She herself enrolled, as did Victoria artist Ina D. D. Uhthoff. During the course of three weeks, recalled Uhthoff, "art changed its face in Victoria," as "abstractionism took the place of realism under the guidance of Mark Tobey."[30] An overstatement, undoubtedly, in general terms, but Tobey's presence did affect both Uhthoff and Carr. Tobey had recently returned from France, afire with enthusiasm for the far-from-new cubism of Picasso and Braque. And as usual with him, he pressed his students to adopt his current artistic passions. His own

145
Unknown photographer, Emily Carr (*left*), with friends and the "Elephant," her caravan trailer, at Esquimalt Lagoon, May 1934. British Columbia Archives B09610.

adaptation of cubism stressed volumetric analysis of form encompassing the pressures of lights and darks against one another.

Perhaps for the immediate benefit of his Victoria students, Tobey painted a complex, jumbled oil called *Emily Carr's Studio* (fig. 146). In it Tobey orchestrated a study in analytical cubism using elements of Carr's fireplace, mantel, and studio accessories. His canvas demonstrates a degree of fracturing and reassembling of forms that Carr would never attempt. Nonetheless, she gamely explored aspects of Tobey's volumetric analysis, compressing space and faceting foliage forms into something akin to cubism. Ultimately, Carr's flirtation with cubism resulted in fresh ways of creating or consolidating masses, not of dismembering them, as Tobey had, although that tendency, and perhaps his influence, appear in *[Untitled; Eye in the Forest]* (see fig. 56). Rather, she took from cubism new structural potential for augmenting movement and energy in her canvases. Those residual effects are apparent in her *Indian Church* and *Wood Interior* (both discussed earlier), painted within a year or so after Tobey's visit.

146
Mark Tobey, *Emily Carr's Studio*, 1928, oil on canvas,
75.6 x 62.9 cm. Current location unknown.
Photo courtesy Seattle Art Museum.

The Spiritual Core

Even as she experimented, Carr did not yield readily or completely to Tobey's imprecations. It was difficult for her, his elder by nineteen years, to accept Tobey's heavy-handed direction. As Tobey later recalled, Carr clung at first to the support of older styles, and only after prolonged struggle came to him one day and said "You win." Reservations aside, she felt at first overwhelmingly positive about Tobey's instruction; shortly after the 1928 course she wrote to Eric Brown, "I think [Tobey] is one of the best teachers I know of. . . . I felt I got a tremendous lot of help from his criticisms. He was very keen on my summer's work and his crits, I feel, will be very useful in the working out of many problems connected with my summer's work which I hope to do this winter." [31]

What Tobey found especially interesting about Carr and her work was her use of native art, which he also admired and collected. Both heartily disliked cities. And the two shared certain temperamental traits: the red-haired American was initially shy, like Carr, but similarly stubborn and volatile underneath. Finally, Tobey encountered Carr at a time when spiritual concerns infused her thinking. A convert to Baha'i since 1918, Tobey talked with Carr about the spiritual unity of humanity.

Carr considered Tobey's studio criticism valuable enough to seek it several more times. In 1930 she invited him back to Victoria for another critique. He failed to come, and irritated Carr by keeping the five dollars she had sent him for travel. Instead, he sent her a letter advising her to "pep my work up and get off the monotone, even exaggerate light and shade, to watch rhythmic relations and reversals of detail, to make my canvases two thirds half-tone, one third black and white." Put off by Tobey's brusque manner, and probably as well by his cavalier treatment of her, Carr decided, "He is clever, but his work has no soul." And Tobey's advice to her "sounds good but it's rather painting to recipe, isn't it? I know I am in a monotone. My forests are too monotonous. I must pep them up with higher contrasts. But what is it all without soul? It's dead." [32]

Tobey and Harris provided the bulk of Carr's exposure to modernism in the 1920s, but theirs were not the only ideas she encountered. She also read and marked texts by various writers on modern art. In Carr's library is a copy of Ralph Pearson's *How to See Modern Pictures*, in which she annotated passages on weight and density in natural forms, probably transferring that knowledge to her own study of mountains. More technical and specific is Jay Hambidge's *Dynamic Symmetry in Composition*, which remained in her library until her death. The Canadian-born Hambidge proposed certain principles of natural design based on the symmetry of growth in nature, particularly in plant forms. On the flyleaf Carr wrote: "Dynamic = pertaining to bodies in motion opposed to static." [33] It was a simple but fundamental idea that informed her work in many ways.

Still another volume in Carr's small library on modern art was Edward Alden Jewell's *Modern Art: Americans*, published in 1930. In this book O'Keeffe's 1923 pastel *Two Lilies* appeared as plate 1, a reminder of O'Keeffe's growing stature as an

American painter. From her trip to New York that year Carr brought back and heavily annotated Katherine Dreier's *Western Art and the New Era* (1930). Such texts broadened Carr's exposure to modernist theory and practice at a time when little of it was available in Canada.

Certainly the subsequent freedom and fluidity in Carr's own work owe something to these texts. Through them she advanced her understanding of abstraction. A month before her pivotal visit to New York (and her encounter with the work of Dove and O'Keeffe), Carr had spoken to a frankly conservative audience about modern painting. Addressing the Victoria branch of the Women's Canadian Club, she insisted that the beauty in modern art lay in building a "structural, unified, beautiful whole—an enveloped idea—a spiritual unity." Fresh seeing required felt experience in nature, forgetting the individual objects, and abandoning visual accuracy for its own sake. The result, which might lead as far as abstraction, was art in which "only the spiritual remains."[34]

If complete abstraction was ultimately too hermetic, too lacking in human content for Carr to adopt, she nonetheless came to appreciate Harris's own abstractions—sometimes machinelike in their precision—as an amalgamation of the abstract and the spiritual. And she came to terms with her decision: "I was not ready for abstraction. I clung to earth and her dear shapes, her density, her herbage, her juice. I wanted her volume, and I wanted to hear her throb. I was tremendously interested in Lawren Harris's abstraction ideas, but I was not yet willing to accept them for myself."[35]

Carr's disengagement from the esoteric began as early as 1933, a process that reveals her variable states of mind. Traveling across Canada by train in the fall, Carr mused in her journal (in words that have a Theosophical ring) about the terrain—whether she had experienced it in some past incarnation or would in a future one. A few days later, visiting the Chicago World's Fair, she reported—only half in jest—that she had listened to a "first-rate talk by a Mormon on their beliefs. He was so convincing and sincere I nearly turned Mormon."[36]

Soon after that, upon reaching Toronto, she immersed herself in philosophical discussions with Harris, the writer and artist Fred and Bess Housser, and other friends: "We discussed theosophy. They are all theosophists. I know there is something in this teaching for me, something in their attitude towards God, something that opens up a way for the artist to find himself an approach. We discussed prayer and Christ and God." But something troubled her, perhaps a deep discontent with their proselytizing manner. She continued: "I didn't sleep well and woke at 5 o'clock the next morning with a black awfulness upon me. It seemed as if they had torn at the roots of my being, as if they were trying to rob me of everything—no God, no Christ, no prayer."

The "black awfulness" was clearly Carr's apprehension at the loss of old values, the rushing eradication of her familiar childhood Christianity. She expressed

The Spiritual Core

her despair to Harris, who the next day arranged another chat during which, as Carr reported, the "black passed over. Yes, there is something there for me and my work. They do not banish God but make him bigger. They do not seek him as an outsider but within their very selves. Prayer is communion with that divinity. They escape into a bigger realm and lose themselves in the divine whole. To make God personal is to make him little, finite not infinite. I want the big God."[37]

The "big God" was exactly what Carr had been searching for in nature. If Theosophy could provide communion between the grand divine in nature and in herself, along with inner harmony and inspiration for her work—then she felt a place for herself within that larger reality.

Still, once back in Victoria, doubt returned. Her reservations about Theosophy probably lay mainly in her self-concept as a loner, a nonjoiner. More than a loss of her childhood beliefs, she felt a threatened loss of self. The vastness of Canadian landscape posed no threat to Carr, but the metaphysical landscape of Theosophy troubled her more and more: it was oceanic in scope, amorphous in shape. There was nothing to hold onto. Worse, she began to feel that Theosophy was "cold and remote and mysterious." She had already tried to use the concept of nirvana in a painting as a bridge between cultures. But even painting the subject and naming it had failed to pin it down. In a state of nirvana, personality, desire, and temporal existence are virtually annihilated. These things, as well as her sense of connection to the physical world around her, she could never abandon. Once she realized this impossibility, all was over. Only three months after their deep, searching conversations in Toronto, she wrote Harris of her inability to accept Theosophy. To her journal she confided, "I think he will be very disappointed in me and feel I have retrograded way back, fallen to earth level, dormant, stodgy as a sitting hen. I think he will hardly understand my attitude for I have been trying these three years to see a way through theosophy. Now I turn my back on it all and go back sixty years to where I started, but it is good to feel a real God, not the distant, mechanical, theosophical one. I am wonderfully happy and peaceful."[38]

Carr's break with Theosophy was difficult, but the end was made sharper—perhaps cleaner—by a scandal that erupted around Harris. In June 1934, Harris left his wife Trixie for Bess Housser, who separated at the same time from her husband Fred. Both the Harrises and the Houssers were active Theosophists, and the subsequent divorces and the remarriage of Harris and Bess Housser seemed vaguely connected to mid-life crises, to loose morals, and to hypocrisy. At least this is the way Carr viewed the matter. The "bust up," as she referred to it, left her even further alienated from Theosophy, as well as bereft of an important friendship with Lawren Harris. Trixie Harris had never threatened the closeness Carr enjoyed with Lawren; but Bess was an artist herself and a woman of strong opinions— competition for the artistic rapport Carr had shared with Lawren. Angry and disillusioned, Carr determined to separate herself from the East and from Harris and

Housser's once-welcome collegiality and helpful criticism of her work. "For years," she told her journal, "I have been 'pillared' and 'pillowed' on the criticisms and ideals of the East. Now they are torn away and I stand *alone* on my own perfectly good feet. Now I take my own soul as my critic." [39]

For many years Carr's fundamentally conservative nature prevented her reconciliation with Harris, who continued to write her and eventually moved to Vancouver in 1940 after a period of quasi-exile in the United States. Canadians, whether in Toronto or British Columbia, were less tolerant of marital scandals in the 1930s than in O'Keeffe's more cosmopolitan New York or Kahlo's Mexico City. Emily Carr's attitudes were those of her social milieu. Committed to personal freedom in her painting and willing—even eager—to be thought an outsider in her art, she had difficulty discarding Victorian morals. She cut the Harrises and Theosophy from her life with the same sharp knife.

But there were other spiritual avenues to be investigated. Even before her break with Theosophy, Carr—ever searching for a spiritual compass—tilted toward multiple poles. In the early 1930s she tried out "Unity," an antimaterialistic alternative to Christianity, "Applied Psychology," "New Cycle Philosophy," and lectures by such itinerant religious lecturers as Harry Gaze, Christina Killen, and Walter Newell Weston. About the time she rejected Theosophy she grew interested in a traveling preacher named Raja Singh, whose variant of Christianity seemed to offer a deepened experience of God and nature. His roots in India suggested links to Eastern mysticism, but in more accessible terms than those of Theosophy. Carr attended all his lectures, invited him to dinner, and for a time made him the substitute for Harris's religious tutelage in her life. After Singh's departure and a dwindling correspondence, Carr seemed to settle on a personal version of her childhood Christianity. Through art, she continued to believe, her soul could be elevated to oneness with the universe.

Carr's late-life religion was a mixture of many of the ideas she had tried out: a largeness of vision, a personal union with the divine. If by 1940 she could take a longer view of her religious odyssey, she had still not fully resolved its contradictions. On 6 March she wrote, "I do not call myself religious. I do not picture after-life in detail." [40] By the end of the year she had reconsidered somewhat: "To church-goers I am an outsider, but I *am* religious [Carr's emphasis] and I always have been. . . . Alone, I crept into many strange churches of different denominations, in San Francisco, in London, in Indian villages way up north, and was comforted by the solemnity." From this vantage point, Carr did not even mention Theosophy or her spiritual meanderings along the religious margins during much of the 1930s. Her selective memory had discarded what was painful in her search, internalized other aspects so deeply that they now seemed to have been part of her from the beginning. What she had learned through her own struggle was that her God did not reside in any religious edifice. "God got so stuffy squeezed into a church. Only out in the open was there room for him." And finally, she acknowledged the expansiveness of her

hard-won spirituality, a religion as intimate as a whispered prayer in the forest, as vast as the limitless space of the outdoors: "In the open He had no form; He just was, and filled all the universe."[41]

At heart, it is clear that Carr and O'Keeffe embraced personal spiritualities that were nature-based, whatever other traditions might overlay or underpin them. What alienated these two initially from the formal religion of their youth appears to be what they considered its inadequate, or even adversarial, position with regard to nature; at the very least their youthful Christianity interfered with their need for a direct, unmediated perception of nature. Eventually both made their ways to a spirituality that was at once intimate and grand, embodying a dynamic creative principle and patterns of interrelationship that were of infinite interest to them as visual artists. Making art became an activity akin to exercising their spirituality, as when Carr wrote of trying in her painting "to get that joyous worshipping into the woods and mountains." With Whitman she could conclude,

> *Nature's green robe, the shining sky*
> *The winds that through the tree-tops sigh*
> *All speak a bounteous God.*[42]

Frida Kahlo's self-portraits often contain obsessive references to objects or animals with which she associated herself. Her complex allegorical schemes contain manycultural layers. Often she invoked images of physical suffering borrowed from Mexican Catholicism: intense, detailed, bloody, highly graphic. As a vehicle of suffering, her body makes narcissistic allusion to the Passion of Christ and to her own blood struggle to make art. Indeed, as Laura Mulvey and Peter Wollen point out, there are crossover details: "the wounds of the scourging and the crucifixion, the knotted cord, the ring of thorns, the simultaneous shining of sun and moon during the tenebrae."[43]

Kahlo's collection of Mexican tin *ex-voto* paintings, thank offerings for deliverance from disasters, provided other elements that she used in her own paintings: the detailed rendering of whatever accident befell the victim, the saint who produced the miracle, and a written inscription recounting the whole story on the lower portion. In Kahlo's paintings she occasionally invoked a new, inventive hagiography, as in *Marxism Will Give Health to the Sick* (1954; Museo Frida Kahlo, Mexico City). There she canonized Marx himself for curing her, and shows herself discarding her crutches. So obsessively did Kahlo paint some of the objects and animals in her self-portraits that she sometimes took on the attributes of a bizarre saint herself.

But the visible grafting of both Christian iconography and communism onto Kahlo's paintings remained sporadic and only superficially politicized. Her true subjects remained her body and her deeper interest in mythic connections. Those she explored in searching ways, at once more subtle and more poignant.

Alchemical imagery gave her access to arcane knowledge and occult spirituality. There are many references in Kahlo's painting and writing that support this conclusion: her color symbolism, her frequent use of dualities (underpinned by dialectical properties within pre-Cortésian art and culture), and her specific readings of Paracelsus and the portrait of him included among her galaxy of heroes in the painting *Moses* (see fig. 5). Beyond this, her odd juxtapositions of objects she rendered as discrete pictorial facts lend her paintings the hermetic quality of rebuses, the picture-riddles associated with alchemy. Most particularly, in her frequent references to transformation, we see the central tenets of alchemy at work.[44] Leonardo, already noted as a source for Kahlo's study of the self in nature, was also a student of alchemy.

Sarah Lowe points out that in one of Kahlo's favorite youthful readings, Marcel Schwob's *Imaginary Lives*, Paolo Uccello is described as an alchemist.[45] In Schwob's text the Renaissance painter throws forms into a crucible, then mixes and melts them into a new substance containing all ideal forms. Kahlo's mysterious painting *Without Hope* (fig. 147) embodies the role of art in the radical transmutation of forms. In this painting, as usual, Kahlo mingles her own experience with the larger metaphor of creativity, blends the present with the past. As she wrote in her diary, "There is always something new. Always tied to ancient existence."[46] In *Without Hope* her invalid's easel over the bed supports a giant funnel (an old alchemical symbol familiar from Hieronymus Bosch's *The Garden of Earthly Delights*)

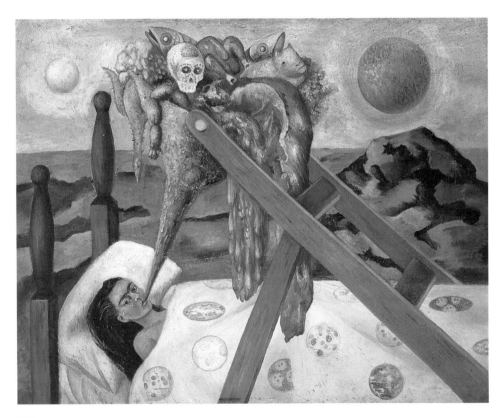

147
Frida Kahlo, *Without Hope*, 1945, oil on canvas
mounted on masonite, 27.9 x 36.2 cm. Collection of
Museo Dolores Olmedo Patiño, Mexico City.
Photo by Rafael Doniz.

The Spiritual Core

filled with a mound of slaughtered meat, fish, and poultry, atop which rests a skull inscribed with Frida's name. On the bedsheet, cellular forms divide and proliferate. Together, these symbols illustrate Paracelsus's claim that "Man is compacted of all bodies and created things." And Kahlo referred in her diary to such unions: "Opposites unite. . . . We all would like to be the sum total. . . . We are . . . universes and cell universes."[47] Still more alchemical indicators appear in *Without Hope:* above, a twin sun and moon, emblems of both alchemical and Aztec duality, burn simultaneously in the sky, as they do in many paintings by Kahlo.

In *Without Hope*, Kahlo, recovering from yet another illness, is bedridden, depressed. She imbibes everything modern medicine and ancient mysticism can offer her for wholeness. But despite medicine's best efforts, Kahlo ultimately despairs at her prospects for renewed creativity. "Not the least hope remains to me," she wrote on the back of the canvas, adding, enigmatically, "Everything moves in tune with what the belly encloses."[48] In these words lies a clue to still another layer of alchemical meaning within the painting. Paracelsus had written of woman as the compendium of all nature: "Woman is like the earth and all the elements and in this sense she may be considered a matrix . . . so the members of woman, all her qualities, and her whole nature exist for the sake of her matrix, her womb."[49] Kahlo's painting may thus be read as an oxymoron of womanhood: though she contains all the elements, she is nonetheless reduced to the contents of her womb. This paradox of repletion and barrenness forms a darker reality in the painting; the whole scene is set against the barren expanse of the *pedregal*, itself fissured like the scarred terrain of Kahlo's own body. Her tears are for her hopeless, childless, state.

A few months before she painted *Without Hope*, Kahlo completed *Flower of Life*, another painting about the natural counterparts of creativity. These sexually charged flowers occupied her twice: first in 1938, then with more detail in 1944. In the second version (fig. 148), alchemical imagery is unmistakably present in the zigzag of lightning and glowing sun. References to sexual organs are blatant: the female's appear in a tubular vessel-shape whose "arms," if lifted, would mimic the configuration of ovaries and fallopian tubes leading into the human womb; the male is represented as a phallic stamen bursting with light-energy, perhaps symbolizing the moment of conception. This painting is a more graphic extension into plant imagery of similar reproductive paths Kahlo had painted demurely, with portraits linked by red ribbons, in her multigenerational *My Grandparents, My Parents, and I* (see fig. 135). Yet even in that painting she had alluded to human fertility and conception in the pollination of cactus flowers. Xochitl, Kahlo's flower of life, was celebrated for centuries in Aztec poetry and song, a visible reminder of the widespread anthropomorphizing tendency in Aztec culture.

Many past cultures understood the sexuality of plants and incorporated such ideas into their agriculture and mythology. In Mesopotamia and India, plants were often classified as male or female, and in Sanskrit terminology (with which

Kahlo's diary demonstrates some acquaintance) vegetable species were compared to human genital organs. Certain herbs, like the male satyricon, were prescribed to cure impotence. In a contemporary Mexican survival, modern Oaxacans observed the Fiesta de los Rabanos, during which market stalls were hung with large radishes, carved into lifelike figures of men, with sexual features exaggerated. Kahlo probably knew much more esoteric plant lore as well: Diego Rivera painted anthropomorphic radishes and knowingly incorporated a plant from alchemical tradition, the mandrake (mandragora), a root said to exist in both male and female forms with corresponding shapes.[50] Such examples expand the modern context for old ideas about the primordial world of vegetation, within which lives the animal world, dependent upon it. As the historian of religion Mircea Eliade has written,

When we talk of the "sexualization" of the vegetable world it is necessary to be clear as to the precise meaning of the term. It is not a question of the actual phenomenon of the fertilization of plants but of a qualitative "morphological" classification, which is the culmination and expression of an experience of mystical sympathy with the world . . . embracing sexuality, fecundity, death and rebirth.[51]

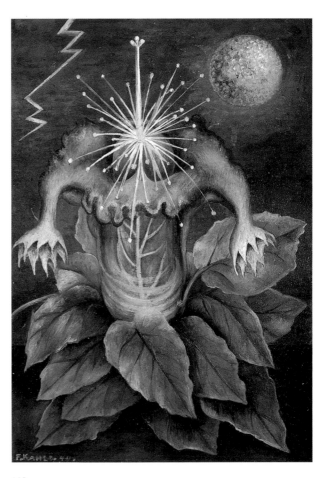

148
Frida Kahlo, *Flower of Life*, 1944, oil on masonite,
29.2 x 22.9 cm. Collection of Museo Dolores Olmedo
Patiño, Mexico City. Photo by Rafael Doniz.

The Spiritual Core

We know that Kahlo was knowledgeable about alchemy because of the frequency with which she painted specific metaphors of transformation and mutation. She encountered such thinking through many avenues of reading and contact with individuals. Nor was she alone in her interest: many late nineteenth- and twentieth-century artists and writers employed alchemical imagery in their work. Poets like Charles Baudelaire, Arthur Rimbaud, and Guillaume Apollinaire explored the arcane, while Marcel Duchamp, Max Ernst, Jackson Pollock, Robert Rauschenberg, and Anselm Kiefer are perhaps the best known of twentieth-century artists to incorporate alchemical symbols and ideas into their work. Kahlo would have known some of these efforts.

Most direct, however, was Kahlo's friendship with André Breton, who saw a kinship between surrealism and Renaissance alchemy. Like Breton she relished the symbolic crossovers alchemy afforded between art and life. Breton himself was vitally interested in the occult aspects of surrealism; and we recall that Kahlo, though she resisted the appellation of surrealist, repeatedly called herself an occultist, "la gran occultadora."

In the late twentieth century, it is the symbolism rather than the substance of alchemy that interested artists. If its goals were once the philosopher's stone and the elixir of life, the transformative processes behind alchemical experiments have been, to many later thinkers, analogues of a much larger idea: that humanity can collaborate in the work of nature. Eliade examined the ideas in this way, as one of history's avenues to cosmic and eschatological renewal. And Carl Jung wrote extensively on alchemy, exploring the way in which its symbols appear in modern dreams and fantasies. Jung believed that heretical movements from gnosticism to alchemy took up certain archetypal elements ignored by Christianity. In this important alternative tradition, according to Jung, alchemists long ago constructed a kind of textbook of the collective unconscious, within which the individual's entire biological and psychological development are present in symbols.[52] In Kahlo's *Without Hope* she makes precisely this kind of symbolic reference to her personal ontogeny.

In addition to Kahlo, many twentieth-century women artists—particularly those associated with surrealist circles—have responded to the appeal of the alchemical tradition, as Whitney Chadwick has shown.[53] The link between female creativity and hermetic traditions seemed based in part on a desire to recover access to secret lore and coded symbols from ancient sources that were later buried in Western patriarchal systems. On one level, the use of a language of secret symbols encouraged solidarity among women artists of hermetic inclinations. Agnes Pelton, Leonor Fini, Remedios Varo, Dorothea Tanning, and Leonora Carrington all demonstrated interest in alchemy. With Kahlo, they found validation for their own creativity in fertile nature and in its symbolic female personages.

Appearing frequently in the work of these women is the idea that growth and reproduction are manifestations of a life force inherent in all created things. Kahlo

encountered these ideas from two sources: Paracelsus and shamanic concepts in Mesoamerican religion. These sources shared significant elements, notably their identification of earth, air, fire, and water as the basic elements, a notion dating back to the Greek philosopher Empedocles and passed along in the work of Aristotle. The same elements appear in ancient Nahuatl culture, which associated them with the cosmic forces that erupt violently from the four corners of the universe.[54]

Alchemy and ancient Mexican culture both held that all forms of creativity are linked, and existing forms are subject to change into others. From the essential life force flowed the power of matter to grow, to resist disease, to heal, and to reproduce itself; all of these abilities were vital to Kahlo, in part because her body manifested constant physical difficulties. Paracelsus called the life force *Archaeus*, but it strongly resembles the old alchemical term *prima materia* and *Qi* in Chinese cosmogony. In Sanskrit (Vedic philosophy) and in Aztec thought, the life force was manifest in both the juice of plants and in blood. This is another point at which Kahlo's images of anthropomorphized plant life, of growth, and of reproduction converge with alchemical, Aztec, and Eastern sources. Her art is a complex blending of sources and symbols, which both invites and resists full explication.[55] In the end, Kahlo's interest in such esoteric ideas must be seen both personally and metaphorically: alchemy, like art, imitates creation.

In an informal way, Kahlo understood that alchemical symbolism and thinking helped her to reveal the complex nature of her self. Perhaps part of its appeal was as a tool to distinguish the stuff of her life as separate from the "I." Both Jung and Paracelsus believed in the importance of *separatio*—a step in the gold-making process for medieval alchemists, later a useful psychological metaphor for modern students of the mind. Paracelsus thought of separatio as the primary activity in creation, both of the world and in every human creative act. Jung thought of it as the necessary differentiation of parts of the psyche in order to understand them individually.[56]

Spiritual issues became identity issues for Kahlo, Carr and O'Keeffe. Coming to terms with the uncontrollable forces of nature, life, and death, they celebrated the life force while burdened with the awareness that they would die. In their thoughts and (I have argued) in their paintings each probed for consciousness—a kind of expanded knowledge centered in the self but enhancing all other relationships: with time past and future, and with all the objects they chose to paint.

The Spiritual Core

6 Sexuality, Androgyny, and Personal Appearance

Part of the human urge to find order in chaos makes us seek patterns—sometimes hidden—in nature, music, or numbers. We sort and separate things to make sense of them. Such themes of separation and unity appear together intertwined from ancient cultures to modern psychoanalytic thought.[1] From such widespread sources springs the endless fascination in Western culture with questions of sexual differentiation. Literature and art abound with mythic examples, the most compelling of which often involve the hermaphrodite and the androgyne. Although those two words originally meant the same thing, today they have different, often confused, meanings. A hermaphrodite is an individual who contains the reproductive organs of both sexes, an anomalous physical condition. Androgyny, however, has come to mean less a set of physical characteristics than a range of behaviors in which sexual characteristics are not rigidly assigned. This idea has a venerable lineage. When Samuel Taylor Coleridge wrote, "The truth is, a great mind must be androgynous," he was saying that the mind must be expansive, ample enough to embrace the whole of experience. Other thinkers and writers including Virginia Woolf and D. H. Lawrence have agreed. And modern visual artists, from Brancusi to Picasso, Chagall, and Breton have invoked androgyny's nuanced forms.[2]

The androgyne as romantic and mythical fantasy has been taken up in a kind of "psycho-mythology" by several generations of artists, philosophers, theologians, and analysts.[3] Although many creative individuals over the centuries have made no secret of their androgyny, the concept has been widely distrusted in European thought. Spiritual, mythic, and archetypal androgyny might be tolerated, but the physical—the sexual—has generally met with disapproval. In particular, androgynous behavior was repugnant to notions of rigid sexual polarization cherished in the Victorian era.

Frida Kahlo, Georgia O'Keeffe, and Emily Carr were born into a world of strong gender dichotomies. In societies wedded to conventional definitions of "masculine" and "feminine" (whose roots lay deep in the Judeo-Christian past), the free interplay of such traits was viewed as dangerous. Commonly accepted was the view that, as linguistic theorist Deborah Cameron has written, "sex differentiation must be rigidly upheld by whatever means are available, for men can be men only if women are unambiguously women."[4]

In the arts, the rare designation of genius was still reserved almost exclusively for men. As Edmond de Goncourt asserted, "There are no women of genius, and . . . if they manifest it, it is by some trick of nature, in the sense that they *are men*." In other words, if a woman's work was too accomplished, her output must

be defined as abnormal. To critics who could not otherwise account for it, Emily Carr's power as an artist was sometimes construed as a gender aberration.[5] Women's art, once distinguished from the "lesser" artistic output of most women, could thus be ignored; despite occasional anomalies, the whole body of women's artistic production was rarely reexamined or reevaluated. With a few exceptions, this attitude defined the artistic world into the early twentieth century. Creativity and mastery of materials were inherently male; a concern with surfaces and the nuanced use of materials were gendered as female.

Androgynous activity, whether in artmaking or other human pursuits, suggested uncomfortable encroachments by women across the line supposedly separating male talent from female. More, breaking down rigid gender stereotypes threatened social convention by suggesting a full range of experience open to both men and women. Women who chose careers as professional artists transgressed gender expectations. So did women whose appearance or social behavior defied sexual norms. Ambiguous female sexuality was viewed by the Victorians with disapproval because of its inherently subversive nature, its defiance of expectations that a woman should be, as Carolyn G. Heilbrun suggested, "tender, genteel, intuitive rather than rational, passive, unaggressive, readily given to submission . . . a nourisher."[6]

Frida Kahlo was rarely any of those things. With Diego Rivera she could be tender, and she was certainly intuitive, but only as it suited her self-conception, not as a result of social imposition. That self-conception grew out of her encounters with a multitude of sources. Vitally important in midlife was Kahlo's study of psychoanalytic theory, which challenged her to attend to her private and psychological concerns as well as to social and political issues. At times the two intersected, as in her study of cross-cultural mythologies.[7]

There are many instances in which she used dualities—from Aztec and other traditions—as metaphors for her own interest in cross-gendered experience. Besides merging her own face with Rivera's in two 1944 anniversary portraits (see fig. 109), Kahlo painted a number of other double faces. Combined faces—fleshed and skeletal, male and female—were a frequent feature of pre-Columbian imagery, and they survived into more recent Mexican folk representations such as the Christian trinity shown with a triple face. Found in various cultures from the Olmec to Classic Teotihuacan, the divided face is regarded by scholars as a manifestation of the dualism at the heart of Mesoamerican thought. Often in the twin-faced pre-Columbian masks the visages contain three eyes, the central one shared by both.[8]

About 1946 Kahlo designed a ceramic brooch mounted on silver as a gift for a friend (now in a private collection). From the clay a conjoined face, half male, half female emerges. It is the face of an androgyne. For Kahlo, whose relationships with both men and women defied conventional sexual mores, the androgynous held strong appeal.

Sexuality, Androgyny, Appearance

Before I explore other personal aspects of Kahlo's androgynous self, it is important to note the complex background of her interest in symbolic dualities. In the crowded Aztec pantheon, local gods and goddesses were closest to the people. But there existed a succession of paired divinities above this group, some borrowed from earlier cultures to reconcile discordant elements of historical religion. At Tenochtitlan, the duality of the Aztec was best expressed in the great temple, at whose summit stood two sanctuaries: that of Tlaloc, the ancient rain god, and that of Huitzilopochtli, the fire god. Kahlo's paintings and diary record these dual sanctuaries or pyramids.[9] The Aztecs also recognized a supreme dual god, who was both male and female. This was a vast and shadowy being, perhaps the ethereal form who looms behind Mexico (the Earth) in Kahlo's *The Love Embrace of the Universe* (see fig. 39). This universal deity in Kahlo's painting is clearly dual: half light, half dark, of undetermined sex, spanning the realms of sun and moon. For Kahlo, the dual divinity hovered over all earthly life.

Another emblem that was important in Kahlo's concept of conjoined gender opposites is the yin-yang symbol, which she frequently used in her diary and paintings. It signals her longstanding interest in Eastern thought (which she shared with O'Keeffe), as well as in magic, esotericism, and sexuality.[10] This well-known Chinese mandala, representing the twin cosmological principles, is depicted as an S-curve which divides black and white halves of a circle, each containing a spot of the opposite color. Yin and yang have long been symbolic of light and dark, life and death, heaven and earth. But of all its bipolar references, the yin-yang symbol refers most visibly to male and female. When she painted it in her diary with the Sanskrit word *Sadja* (a variation of *Sadha*, heaven and earth, or *Sahaja*, the interpenetrating unity of lovers), her reference was immediately apparent.[11]

With multiple historical prototypes in mind, and in deliberate defiance of modern convention, Kahlo stretched gender boundaries. A male friend commented on her ability to embody both masculine and feminine traits: "She was a kind of ephebe, boyish and emphatically feminine at the same time." As a young woman she occasionally adopted men's clothes, as in a well-known family photograph for which she donned a man's suit. In later years (as when she painted herself in an oversize man's suit with cropped hair), she occasionally crossed-dressed for emotional effect. More often her dress was extremely feminine: long Tehuana dresses, abundant jewelry, makeup, and flower- or ribbon-adorned hair. Still, she simultaneously cultivated sexual ambiguity. Clad in her feminine garb, she would accent her facial hair in paintings of the late 1940s, and regularly groomed her "moustache" and single eyebrow with a small comb. And she told an interviewer, "Of the opposite sex, I have the moustache and in general the face."[12]

Kahlo and Rivera explored the range of masculinity and femininity in each other. Kahlo appreciated certain "feminine" traits in Rivera and he certain "masculine" traits in her. She commented on his androgynous appearance:

His childish, narrow, and round shoulders turn into feminine arms with no angles, finally coming to marvelous, small, finely drafted hands. . . . About his chest, I will say that if he had disembarked on the island governed by Sappho, he would not have been executed by her warriors. The sensitivity of his breasts would have made him acceptable. His peculiar and strange virility makes him also desirable in the territories of empresses eager for masculine love.[13]

The ease with which Kahlo and Rivera spoke of their sexually ambiguous physical traits reveals the flexibility of their notions of gender. Their verbal and visual images became a kind of dialogue between them and their intimates (fig. 149), similar to the private artistic language between O'Keeffe and Stieglitz in their early years. Artistic couples who share intimate creative lives often speak to each other through images, and sometimes in the pairing of such images we can see renegotiated

149
Frida Kahlo and Lucienne Bloch, *Exquisite Corpse*
(Diego), c. 1932, pencil on paper, 21.5 x 13.5 cm.
Private collection.

Sexuality, Androgyny, Appearance

relationships to work, to specific motifs, and to each other. Some couples are able to question stereotypes of gender and creativity and even attempt to embrace categorized images. Kahlo and Rivera, as Frida seems to suggest in their fused images, at moments approached a kind of creative hermaphroditism. With Stieglitz and O'Keeffe, the artistic dialogue was intimate, though fueled by a dynamic of strong differences.

The expanding range of Kahlo's gender explorations led to visual portrayals of her own dual eroticism. For Kahlo, who had relationships with both men and women, bisexuality was an open secret. Her relationships with women take visual form in such paintings as *Two Nudes in the Forest* (1939; Collection of Mary-Anne Martin), reportedly a gift to her intimate friend Dolores del Rio. Her emotions held hostage by an unfaithful husband, Kahlo found solace in extramarital affairs from the 1930s on. Although Rivera objected strenuously to her liaisons with other men, he tolerated or even encouraged her affairs with women, perhaps to distract her attention from his own philandering. He spoke openly of his wife's protean desire, and she seems to have made no effort to conceal her homoerotic excursions from him. In fact, she exaggerated them. In a sense, Kahlo's bisexual affairs offered her a release and an assertion of her flexible sexual identity. Her bisexuality also reinforced her disinclination to a single definition of self; within her layering of several personal identities she laid claim simultaneously to the multiple cultural meanings surrounding each sex. All was part of the artist's widening, inclusive search for identity.

Personal appearance can also reveal certain aspects of the identity formation of Kahlo, O'Keeffe, and Carr. Clothing is a kind of language, a transmitter of cultural codes, of sexual and psychological messages. What we wear is at once personal and social: our clothes signify class, social status, and, in most cases, gender specificity. In the apparel we put on, we reveal as much as we cover. Virginia Woolf's *Orlando* endorsed the power of clothing to be more than body covering: "There is much to support the view that it is clothes that wear us and not we them; . . . they mold our hearts, our brains, our tongues to their liking." [14]

Kahlo's attention-getting way of dressing, the messages latent within her hair, and her cross-dressing direct attention to simultaneous impulses, both personal and cultural. She wore clothes as vehicles for design forms originating in native cultures and to champion the folk aesthetic she wanted to encourage in Mexico. Nowhere is this more visible than in her frequent adoption of the Tehuana costume. The women from the peninsula of Tehuantepec represented a strong, decisive brand of Mexican womanhood for Frida Kahlo. As Mexican costume experts Donald and Dorothy Cordry have noted, "The special dignity and excellent carriage of the Tehuana may be attributed partly to the fact that she never carries burdens on her back—only on her head, be it water jar, wooden tray, basket or gourd." [15]

The Tehuana costume itself evolved over time into a highly distinctive look. The headdress, or *huipil grande*, is the most characteristic and memorable Tehuana

150

Frida Kahlo, *Self-Portrait as a Tehuana (Diego on My Mind)*, 1943, oil on masonite, 76 x 61 cm. Jacques and Natasha Gelman Collection, Mexico City.

garment. According to legend, the lacy headcover was derived from a woman's petticoat found in a shipwreck by Tehuantepec natives, who chose to wear it on their heads. It actually derived from a huipil (blouse) worn over the head with vestigial sleeves hanging down in front and back. Kahlo wears the huipil grande in photographs and in self-portraits painted in 1940, 1943 (fig. 150), and 1948. By the 1940s, wrote the Cordrys, such garments were kept by certain families for ceremonial wear, especially at weddings. In Kahlo's self-portraits the huipil grande frames the face in intricate, pleated lace, a highly romantic invocation of cultural, if not personal, innocence.

Kahlo's self-conscious choice of folk or indigenous clothing signals her resistance to what she saw as the elitist tendencies of expensive designers in capitalist society. She was undoubtedly amused when Parisian haute couture took up her Mexican dress; Schiaparelli designed a "robe Madame Rivera" during her 1939 visit to France. Kahlo resisted Paris fashion (which she could not have afforded in any case), and wrote her intimate friend Nickolas Muray that "I don't have to buy dresses or stuff like that because being a 'tehuana' I don't even wear pants, nor stockings either." [16] Always she took pleasure in shocking people, perhaps particularly in Paris, center of style and home of those she labeled the "big cacas" of surrealism.

Kahlo's clothing carried more than social messages; in some of her paintings it became a surrogate for herself. Because clothing is so closely identified with the body of the wearer, in a painting such as Kahlo's *My Dress Hangs There* (fig. 151), it is a natural signifier of the artist herself, a stand-in for her presence. By contrasting that dress, a Tehuana costume, with the crowded and collaged elements of what she regarded as a decadent capitalist society (Manhattan looms in the background), she comments on her own sense of alienation and estrangement from American values. Clothes become her political response to the age.

The empty-clothing motif in *My Dress Hangs There* speaks to more personal cultural complexities as well. The Tehuana dress contrasts starkly with another woman's image, that of Mae West, who appears at the left in a flamboyant portrait. Kahlo was fascinated with the American movie star, particularly as she appeared in her risqué film of that year, *I'm No Angel*. West, whose use of the sexual double entendre troubled censors in the 1930s, was notorious for such remarks as, "It's better to be looked over than overlooked" and "Between two evils, I always picked the one I never tried before." West's neon sexuality dominated the screen whenever she appeared, and capitalized heavily on two qualities to which Kahlo also aspired: hyperfemininity (as manifested by both in their dress) and an epicene quality which borders on female impersonation. West exaggerated her self-presentation to the point of exposing the artificialities latent within gender, both feminine and masculine. Even now, she remains (like Kahlo) appealing to homosexuals as well as to feminists and those who study what it means to be female or male. [17]

Kahlo, who shared West's ribald humor, likewise made playful sexual jokes and incorporated theatricality, travesty, and impersonation into her style of personal

presentation. Self-conscious artifice, a spirit of extravagance, even self-parody, belong to both Kahlo and West; both courted notoriety through outrageous behavior. But with Kahlo we struggle to decide where tragedy and irony diverge, where corrupted innocence separates itself from witty hedonism. Kahlo's style struggles with content: her campy sensibility shows up in a love of artifice that sees absurdities everywhere and threatens to render even nature unnatural.

Kahlo used clothing to point out cultural difference and gender uncertainties against a backdrop of popular culture. Yet she also used it in more personal ways. In *Memory* (see fig. 11), the emptiness of her clothes—containing only her arms—seems to connote private loss instead of cultural alienation. One arm remains in her schoolgirl outfit at the left, the other in her Tehuana costume at the right. Both reach for the central Frida, who stands literally un-armed, or dis-armed. Kahlo's iconography resides in the representative power of the clothing: the two dresses are her past and her recent present, hanging stiffly like discarded selves. On the body of the central figure of Frida—eerily like a paper doll—European-style dress of the kind she wore when she was separated from her faithless husband signals the artist's estrangement from Rivera and from her cherished Mexican identities.

151
Frida Kahlo, *My Dress Hangs There*, 1933, oil and collage on masonite, 45.8 x 48.3 cm. Private collection.
Photo courtesy Mary-Anne Martin/Fine Art, New York.

Sexuality, Androgyny, Appearance

For Kahlo, adopting the clothing of the European American "other" was a conscious gesture, a kind of cultural transvestitism. With shorn hair and ripped-out heart, she and her clothes communicate a profound sense of loss, an empty, heartless state she equated with *gringolandia*, the spiritually impoverished domain north of Mexico's borders. Small details complete the painted messages: in *My Dress Hangs There*, the garment hangs suspended from a blue hanger among symbols of America's "elevated" achievements, sports, movie industry, and modern plumbing. In *Memory* the intensity and personal pain reside in the blood-red vein-ribbons, which converge in the hole where Frida's heart used to be. What lingers, remarkably, in this painting about loss, perhaps even denial, is Kahlo's ironic assertion of self. It is another incremental step in her move toward a mythology and iconography based on her own experience and psychology.

There are related personal and artistic ironies resident in the experience of Kahlo and O'Keeffe, both of whom asserted (at times) their experience as women while making occasional public forays in male attire.[18] In this sense cross-dressing, a kind of masquerade, can be seen as a deliberate break with convention and a destabilization of categories of feminine and masculine. This view is present in both Kahlo's and O'Keeffe's cases.

O'Keeffe's interest in a more liberated dress for women was intensified in 1915 by her reading of Charlotte Perkins Gilman's year-long missive in her feminist periodical *The Forerunner*. Gilman advocated comfortable, safe clothes that bore some relevance to a woman's daily activities. Corsets and makeup, clear signals of a woman's desire to attract men, were unnecessary artifice. Further, Gilman decried maidenly modesty—blushes and downcast eyes in the presence of a man. Instead, she suggested that her reader meet men "clear-eyed and indifferent, as if she was a boy, or he was a woman." Such ideas were radical in 1915, but O'Keeffe was receptive to them. While teaching in Amarillo, she had already begun dressing in man-tailored suits and oxfords and wearing her hair cut short. In Texas she also wore a narrow-brimmed hat remembered by one of her students as "a man's type felt hat."[19] This hat—or a similar one in dark straw, pulled down well over her brow—contributes to her androgynous appearance in some of Stieglitz's photographs.

In the years to come O'Keeffe's dress became increasingly simplified—she dressed mostly in black and white—and her approach to men more direct. At Lake George and in New Mexico, O'Keeffe adopted trousers as comfortable outdoor attire—garb shockingly unlike conventional women's dress. Later photographs show her in simple dresses or suits, with an occasional foray into something as informal as a red sundress and tennis shoes donned for a rafting trip on the Colorado in 1961. She wrapped herself Indian-like in white blankets for several portraits by Todd Webb, and she chose other distinctive looks on special occasions. Severe in the extreme were her costumes—as they clearly were intended to be—donned for visitors to New Mexico, for travel, for public appearances, and for photographic sessions.[20]

O'Keeffe could be vain and obsessive about her appearance. She posed her expressive hands for the camera whenever possible, and, as Roxana Robinson reports, allowed guests to "catch" her late in life with her still-luxuriant hair loose, then quickly pinned it up as if for the sake of propriety.[21]

When photographer Fritz Kaeser and his wife, Milly, visited her at Ghost Ranch in 1968, O'Keeffe wore what appears to be a dark kimono (she had visited Japan in 1959 and 1960) wrapped over a white V-neck blouse (fig. 152), producing a neckline effect very similar to some of those in the Stieglitz portraits of nearly a half century earlier. Her once-velvety throat was no longer smooth in 1968, but it still held erect her proud, weathered head.

To her distinctive turn-outs, O'Keeffe always added her own touches. In the Kaeser photograph she has fastened the kimono with a Navajo silver concho belt. Two additional accessories enhanced the severity of black and white that day: white gloves over her hands, and a severe white headwrap made from a man's handkerchief, worn smooth over her brow with flowing folds in back. More than a little, it calls up a resemblance to a nun's habit, or accrues to her legend as a pilgrim in nature.

Before leaving the Kaeser photograph, let us pause over a tiny detail that slices through the seamless austerity the portrait otherwise projects: barely visible beside the proper right-hand collar of her kimono, is a simple straight pin. In a photographic scenario calculated to iconize, this homely object unwittingly works to demystify, to sabotage O'Keeffe's cool detachment as legendary artist. Like those familiar, ever-present pins our grandmothers wore on their aprons and housedresses, O'Keeffe's pin is a reminder of her domesticity: here was a woman who sewed, who darned—a practical woman, careful with resources, ready to pin together whatever might come apart in the course of a day. Although those qualities were also appropriate to a quintessentially American legend, they signal a connection of another kind: to craft traditions and to "women's work," affinities that have perpetually dogged women artists in their pursuit of professionalism. O'Keeffe would not have wanted her domestic skills linked too visibly to her artistic talents, either in a photograph or in a paragraph such as this one. Yet it was she, presumably, who picked up the pin and fixed it to her garment.

Whatever else O'Keeffe's severe dress conveyed of artistic persona and gender identification, it owed a basic debt to the painter's desire to be free and comfortable while observing a personal aesthetic of her own devising. Art and personal appearance were closely tied together in O'Keeffe's mind from the early days. As her teacher Arthur Dow had taught her, O'Keeffe passed along to her Texas students that art is important in everyday life. "I wanted them to learn the principle," she recalled, "that when you buy a pair of shoes or place a window in the front of a house or address a letter or comb your hair, consider it carefully, so that it looks well."[22]

Unlike O'Keeffe and Kahlo, Emily Carr did not cross gender lines in her dress. She affected neither men's suits nor boyish haircuts. For the most part, at least

in the early years, she dressed the way her sisters and peers did. Photographs show her conventionally attired; in one she is at a garden tea party in 1899 with her hair piled high and wearing "a large full-skirted white frock of soft material that billows as she walks and is held at the waist by a bright sash."[23]

As time went on Carr gave up whatever youthful concern for fashion she might have had. When she went north to native villages, she donned a self-devised uniform to foil the fierce swarms of mosquitoes: heavy canvas pants, two pairs of gloves (how could she manage a brush?), and over her head a cloth sack inset with a glass pane to enable her to see. This was an unconventional uniform for serious work in adverse conditions. At home, as biographer Paula Blanchard writes,

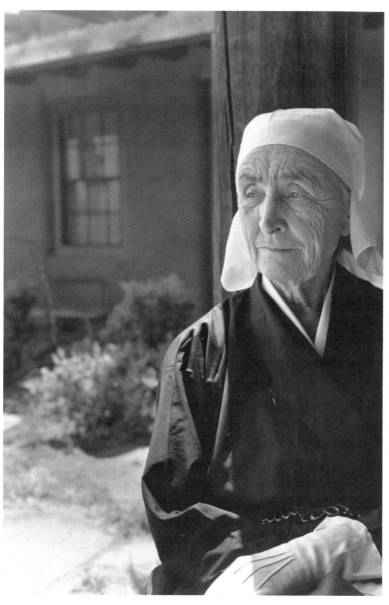

152
Fritz Kaeser, *Georgia O'Keeffe #12*, 1968, silver gelatin print. Snite Museum of Art, University of Notre Dame, South Bend, Indiana, Gift of Milly Kaeser.

In her person, as in her house, [Carr] cared nothing for appearances, only thrift and com-
fort. She always dressed conservatively on special occasions, in black with gloves, hat
and cameo brooch. But her everyday clothes were homemade smocks, and for outdoors a
shapeless wool coat and felt hat. On her feet she wore sturdy laced shoes, or (for
walking the dogs) a pair of old boots, cut down to size. Beginning probably in the early
1920s, she always wore a hairnet with a velvet band around the forehead, under
which she tucked her greying hair. It was not unattractive but it was, to say the least,
distinctive. Nobody knows why she wore it, but one suspects her hair became thin,
possibly after her surgery in 1923.[24]

Dress helped O'Keeffe and Kahlo project a distinctive persona; by appearing and
painting in a manner that resembled no other, each achieved the singularity
she sought all her life. Carr shrank from such a culturally and personally foreign idea.
To be noticed for her work and not for her appearance—this was Carr's aim.
Unlike O'Keeffe or Kahlo, she never made an aesthetic or political statement in what
she wore. Carr never moved within or tried to look like a member of the artistic
avant-garde. She did nothing to suggest she was other than a middle-aged, plump
Anglo-Canadian woman. The dowdy clothes she wore caused her some ambiva-
lent feelings: on the one hand, like emblems of pride, the shapeless, voluminous
dresses she made announced her disdain for fashion and all things extravagant. They
also declared her hors de combat in the gender charades: she would engage in
no coquettish angling for male attention. And her loyal women friends, she reasoned,
would not care what she wore.

 In their attitudes about personal appearance, gender, and sexuality, Carr,
O'Keeffe, and Kahlo revealed unique aspects of their creative selves. In common with
the rest of humanity, they had to choose which aspects of the self to emphasize.
Unlike most of us, theirs were creatively varied and alternative approaches. What is
particularly fascinating about these three creative women is their willingness to try
on, to modify, and sometimes to fantasize on the foundational aspects of their private
selves, weaving the resultant pleasure and pain into the fabric of their consciousness.

Part Three A Public Career

Nothing is got for nothing, and self-appropriation involves the immense anxieties of indebtedness, for what strong maker desires the realization that he has failed to create himself?

– Harold Bloom
The Anxiety of Influence

During their journeys in search of personal and artistic identities, Carr, O'Keeffe, and Kahlo each framed and reframed a narrative of how they had become the people and artists they were. Public and private versions of that self-mythology did not always agree. Though on one hand intensely personal, self-mythology reaches beyond the self to express an image that reflects the deepest issues shaping every human life. Whether written, dreamed, or painted, myth gives body to the veiled, timeless factors always present in individual lives. How much of the myth to reveal? As these artists became more successful, each had to make choices about which version of the self to project, which to protect.

Like O'Keeffe, Carr wanted both to be known and not to be known. The two shared the practice of withholding aspects of themselves from others and separating, when convenient, the public artist from the private person. At one point, when an article entitled "Emily Carr and Her Art" appeared in a local Victoria publication, Carr fretted about the attention its writer had given to her personal life and circumstances. The reporter, Elizabeth Ruggles, acknowledged Carr's need or privacy, quoting such comments as "What does it matter if I keep monkeys, or am fat or thin, or stand on my head. What's that to do with art?" Still, Carr was incensed at the intrusive quality she found in the article. To her friend Nan Cheney she exploded in a letter following its publication: "I think that write up was *filthy* never again. I loathe those reporters like revolutions. I said you may write about the pictures & I'm willing to tell you anything about them but personalities I *will not* have & she said of course I understand and having *forced* herself into my house 'snooped,' following me rudely from room to room."[1] Carr's antipathy to outsiders prying into her personal life was markedly similar to O'Keeffe's, though the latter usually spoke in a milder tone.

If we take Carr at her word when she objected to publicity, how can we reconcile that attitude with her revealing published journals, as well as her five pub-

lished volumes of stories and reminiscences? From 1942 on her writings appeared regularly, and for some years Carr the author far outstripped the painter in fame. Her writing turned her name into a household word in Canada and extended her reputation well beyond death. Most of Carr's books remain in print today and are widely admired among Canadian readers.

Carr's efforts to take up writing began while she was still a landlady, as one of her many gambits to earn extra money. In 1924 she enrolled in a correspondence course in short-story writing from the Palmer Institute of Authorship in Los Angeles. As she drafted early stories, she sought criticism from many friends, including Lawren Harris, who liked what she sent him and urged her to write a book about her experiences with native peoples. She wrote more such accounts, then moved on to animal stories and to tales about her childhood. In Victoria she joined a short-story writing course in 1934 and won the top prize for student writing. But when she began to send her stories to such publications as *Maclean's*, the *Saturday Evening Post*, and *Atlantic Monthly*, she received more rejection slips than acceptances. Adverse criticism, whether for her painting or writing, Carr always received with peppery disdain. She refused to write what editors seemed to want: "Blood and thunder, sex and crime, crooks, divorce, edgy things that keep them on the *qui vive* wondering which way the cat is going to jump and hoping it's the *risqué* way. I can't write that stuff. I don't want to learn. I won't. So I guess my little homely tales of creatures and things will sit in my box forever. I want the money dreadfully but I don't want dirt money."[2]

In 1937 Carr had a heart attack, prompting more serious focus on her writing. During the long weeks of enforced bed rest, writing helped her overcome depression; she wrote more and more, ushering in the period of her greatest literary productivity, 1937 to 1941. In those years she completed the drafts for most of her later manuscripts. When published they stood on their own merits as literary achievements, though today her writing is considered a lesser art than her painting. Together, the two expressions produced a kind of synergy: the more accessible stories and personal sketches provided a bridge to some of the more esoteric and universalizing symbolism in Carr's painting.

Carr retrospectively edited her autobiographical reflections with great care to serve the mythology she developed for herself as artist and woman. By writing her own biography, Carr could control the dissemination of information, recasting her life in later years with heightened drama, directness, and a clarity the original events probably did not possess. To the extent possible, she wanted to name her own defining experiences, to have the world view her through her own eyes. With that in mind, she intended her journals for publication; they were written, she said, "to jot me down in, unvarnished me, old at fifty-eight."[3]

With care she crafted the telling of how she became who she was, adjusting the narrative as she saw fit. Still, despite editing, Carr's writings did indeed expose

aspects of a private self—crotchety, doubting, tired. Clearly she wanted to convey her humanity to her readers; the journals blend the musings of her artistic self with expressions of her frequent anger, frustration, and provinciality. More, she used writing to maintain an emotional equilibrium: "Writing is a splendid sorter of your good and bad feelings, better even than paint." But she chafed when well-intentioned editors tried to tidy up her writing: "I have not the least doubt [my story 'Wild Flowers'] is rough, unlettered, unpolished, but I *know* my flowers live. . . . I know my mechanics are poor. . . . I suppose only if one says something ultra-honest, ultra-true, some deep realizing of life, can it make the grade, ride over the top, having surmounted mechanics."[4] Carr was right to preserve the vivid eccentricities of her writing style, as most later editors recognized.

That said, in purely factual terms it is necessary to recognize some misconceptions Carr herself perpetrated through her writing. Almost from the beginning, the autobiographical Emily Carr has been charged with excessive concealment, distorting the truth, falsifying her age, and failing to acknowledge personal help with her backwoods travels or the development of her art. Carr's self-mythologizing (like Kahlo's), included frequent understatements of her age and portrayals of herself as more alone and audacious on her travels north than she really was. She claimed, for example, that she was only twelve rather than fifteen when her mother died; that she was approaching sixteen instead of nearing twenty when she petitioned her guardian to study art in California; and that her first visit to the village of Ucluelet occurred when she was a "girl of fifteen in pigtails," when she was actually twenty-six. She also tended to overstate her separation from the world as an outcast, a village oddity, a maligned artist.

For some Carr scholars, such misrepresentations have been more than disingenuous; they find her inaccuracies at times tinged with malice and spleen. Others excuse her vagueness or misstatements with the argument that although her writing, as she told Ira Dilworth, was "all sort of Biographical," it ought not be held to standards of precise accuracy.[5]

My point here is that all lives and all autobiographies have inconsistencies and fictive passages; personal perspectives (however inaccurate) bare their own inner verities. Precision and authenticity are two different things. Carr's favorite author, after all, was Walt Whitman, whose autobiographical poetry cannot stand as accurate autobiography. Literary concerns usually tinted Carr's tellings of the past: as biographer Maria Tippett explains, "Where [Carr] found gaps in her memory, fictitious characters and incidents were invented to bridge the holes."[6]

As for the harshness of Carr's written recollections, readers must remember that the anger present in her original journals, before they were tidied up for publication, was based on many perceived injustices and slights in her life. Her father grumbled that she should have been a boy; her sisters rarely encouraged her art; and critics often ignored or were slow to recognize her gifts.[7] She spent years strug-

gling as an overworked landlady, and her life was devoid of direct sexual expression. A romantic, Carr's life held considerable passion, though much of it found no sympathetic human recipient; instead her intensity was diverted into her art.

Carr's writing allowed her to vent her anger, to whine when she felt like it—in general, it provided a needed emotional outlet. Friends like Lawren Harris, Ira Dilworth, Nan Cheney, and Humphrey Toms kept up a lively correspondence with her; Cheney and Toms in particular were close friends during the years Carr's health began to fail and she was less able to travel and visit. Letters filled the gaps between face-to-face contacts, and she could be as direct and feisty there as in conversation: "Feel like firing off to someone," she wrote Nan Cheney, "so will spill over onto you." [8]

What Carr's late-life writing also allowed her, belatedly, was to reconsider and restore balance to some of the early events of her life. For example, *The Book of Small*, though published in her seventy-first year, records stories of her early childhood. Those incidents, often about her father, occurred before the "brutal telling," that is, at a time when "Small" viewed Richard Carr as honorable, upright, and estimable. Writing as that child, Emily could recast her father in a favorable light: "If I have made people respect and honour father through the *Book of Small*," she realized, she might have "in some way atoned for all my years of bitterness." But she confessed an opposite truth, revealing the depth of her hurt and the reason, as an adult, she could never completely overcome her revulsion for her father. In a late letter to Ira Dilworth, Carr explained in an urgent rush of words, "I couldn't forgive Father I just couldn't for spoiling all the loveliness of life with that bestial brutalness of explanation telling me with horror instead of gently explaining the glorious beauty of reproduction the holiness and joy of it." [9]

It was vitally necessary for Emily Carr, like everyone else, to maintain certain fictions in her life. But because she wrote prolifically and intimately of her inner feelings, her inconsistencies surface more visibly than in most lives. At the same time one senses that she manipulated memory and imagination in shaping the materials of her past to serve the present.

When she complained, "How completely alone I've had to face the world, no boosters, no artist's backing, no relatives interested," we hear, sotto voce, her pride in overcoming indifference. When she referred to herself as "an isolated little old woman on the edge of nowhere," Carr's self-imposed alienation was becoming a vital component of her artistic will. To realize a unique artistic identity, she needed to feel different from others. Always suspicious of praise, she longed for acceptance even as she pretended indifference to critical notice. When in the fall of 1939 Wolfgang Paalen visited her (he had, incidentally, praised Kahlo's work in Paris earlier the same year), Carr wrote of her amazement: "To my surprise Mr. Paalen was very enthusiastic about my work. I felt like a hayseed but he found something in it." [10]

For Emily Carr, the final years brought the satisfaction of knowing whence certain directions in her work arose and how they developed. What had seemed frag-

mented efforts in earlier decades began to cohere. She liked the idea that her work proceeded along a more-or-less continuous trajectory: she had rarely dated her paintings and always resented attempts by others to separate her work into "periods." Resisting such artificial constructs, she preferred always to cast her images of self in nature's terms: "I've done an immense amount of work. In looking back I can see the puckerings of preparation for ideas that burst later and bore fruit, little brown acorns that cracked their shells and made little scrub thickets full of twists, and a few that made some fairly good oaks."[11]

In Carr's mind her life and work were cumulative: their full effect emerged only in the aggregate. In that spirit she titled her published journals *Hundreds and Thousands*, after the tiny English candies she had loved as a child—candies so minute they had to be eaten by the mouthful to be savored. Carr enjoyed thinking of her life as being like those candies: "Too insignificant to have been considered individually, but like Hundreds and Thousands lapped up and sticking to our moist tongues, the little scraps and nothingnesses of my life have made a definite pattern."[12]

One final thing to be gleaned from Carr's writing is its intimate relation to her painting; together they generated a kind of energy that moved both enterprises forward. She insisted that "trying to find equivalents for things in words helps me find equivalents in painting. That is the reason for this journal."[13]

O'Keeffe's writing and painting did not serve each other in such a clear way. They seldom fed each other—at least not consciously. Painting was always her preferred form of expression, the one in which she felt most confident and articulate: "I paint because color is a significant language to me." As a young woman O'Keeffe had developed a keen appreciation for poetry, but when she tried to write rhymed verse she failed. What she discovered, it seems, was that she could never be as precise with words as with visual language: "The meaning of a word—to me—is not as exact as the meaning of a color. Colors and shapes make a more definite statement than words."[14]

Because she insisted on precision in every aspect of her creative life, O'Keeffe never considered herself much of a writer. Still, there is much to be learned from her letters. In the late 1930s O'Keeffe looked back some twenty years at letters she had written while in Texas, a period when she made great discoveries about nature, abstraction, and herself. She recalled her "excitement over the out doors and just being alive—. . . it was like an urge to speak."[15] Reading those letters now, one hears in them the excitement of discovery. They overflow with sensation, and with the feeling that she was being forever changed by the experience of Texas. In disclosing that impact, O'Keeffe conveyed more than she knew.

In another sense—especially as a visual artist—O'Keeffe was right to be suspicious of words and to trust her visual vocabulary instead. Words and language are powerful shapers of the known world. And when used as a linear medium arranged chronologically, language tends to incorporate organizing principles such as causality or historical process. This linearity can convey a false order to the

experience of life. O'Keeffe's letters managed to avoid such traps. She thought and wrote in spontaneous, nonlinear fashion. Her holographic layouts in letters are themselves visually arresting, punctuated by long dashes separating phrases and paragraphs, layered like landscapes in varied shapes (fig. 153).

A probable early influence on O'Keeffe's letter writing was critic Arthur Jerome Eddy's *Cubists and Post-Impressionism* (1914), which O'Keeffe studied during the 1910s.[16] Eddy argued that conventional punctuation was "too slow" for modern writing; instead, he suggested the dash as the free vehicle of a terse, substantive style on an unorthodox page. As if in response to Eddy, O'Keeffe made visual compositions of her words, on pages that complement her paintings. Both forms of expression—writing and painting—demonstrate the modernist's breakdown of artificial barriers of language and form.

On the pages of her letters, for example, O'Keeffe would often end a line abruptly, halfway across, then pick it up at another point below, as if to deliberately disrupt time and causality. Sometimes she dropped a thought, then returned to it later in a sentence of new shape. Her visual ambit, both in letters and in her return

153

First page of an undated letter from Georgia O'Keeffe to Spud Johnson. Harry Ransom Humanities Research Center, University of Texas, Austin.

The Public Self

to painted motifs years after she first put them down, allows us to see vital connections present throughout her work. The patterns traced in her letters—loop processes, interactions, spiraling out and back from core experiences—remind us of the many circular forms in O'Keeffe's paintings. But they also serve as a kind of metaphorical key to her creativity: for an artist who often painted things for which she had no words, process overcame subject. Her words became an expansive Whitmanic response to the grandeur of nature itself, as expressed in his "Song of the Rolling Earth":

> *Were you thinking that those were words, those upright lines? those curves,*
> *angles, dots?*
> *No, those are not the words, the substantial words are in the ground and sea,*
> *They are in the air, they are in you.*[17]

Aside from her expressive letters, O'Keeffe's writings were spare and infrequent. Even, or especially, after she became famous, she seldom communicated with the public in written words. Arthur Dove wrote as late as 1937 that he "hardly knew that she could read and write." Dove was wrong: write she could—and read—continuing to absorb some of the best of her century's literary images to confirm her own visual perceptions. Ernest Hemingway had written in 1927 of a stretch of long white hills in his story "Hills Like White Elephants." That image, as re-expressed by George Orwell in *Homage to Catalonia* in 1938, became "The hills opposite us were grey and wrinkled like the skins of elephants." Surely those widely read authors shaped O'Keeffe's recognition of gray hills near her own Black Place, painted several times and described by the painter as looking "like a mile of elephants." Except for such rare comments, O'Keeffe mostly resisted "explaining" her work in words or risking discernible sources of influence. "The meaning is there on the canvas," she insisted at age eighty. "If you don't get it, that's too bad. I have nothing more to say than what I painted."[18]

 Frida Kahlo's writing, like O'Keeffe's and Carr's, rings with spontaneity and life, with an urgency to convey to her reader as vivid and intense a record of her feelings as she could. In earlier chapters I considered aspects of the visual and verbal interplay contained in Kahlo's diary, kept during the last ten years of her life. Here I shall examine her letters as expressions of her own reality and—even more fundamentally—of her projection of a self into the world.

 Often that self was an afflicted one. Long periods of medically enforced rest and recuperation gave Kahlo ample time for reflection. She relied on the company of friends and family to entertain and cheer her, though they reported that she often provided most of the mirth. When visitors were scarce, painting and writing were her outlets; in both she spared no energy, glossed over no pain.

 As a young woman Kahlo wrote love letters to Alejandro Gómez Arias, both before and after the harrowing accident they experienced together. Those letters were

pleas for his attention and reveal Kahlo's profoundly human fears. Sometimes these fears centered on what she was missing during her periods of invalidism. About a year after the accident she wrote to Gómez Arias of its cataclysmic effects on her life:

A short while ago, maybe a few days ago, I was a girl walking in a world of colors, of clear and tangible shapes. Everything was mysterious and something was hiding; guessing its nature was a game for me. If you knew how terrible it is to attain knowledge all of a sudden—like lightning elucidating the earth! Now I live on a painful planet, transparent as ice. It's as if I had learned everything at the same time, in a matter of seconds. My girlfriends and my companions slowly became women. I grew old in a few instants and now everything is dull and flat.[19]

Kahlo's words convey her disillusionment with a life suddenly grown colorless and cold. In other letters she complained of loneliness, boredom, and the unending round of ineffectual treatments she underwent. At times she wrote in graphic detail, inventing language and metaphors to communicate the reality of her physical pain to people not themselves in pain. Her tone grew insistent, as if desperate for validation of her tortured existence. To the absent Gómez Arias she conveyed her downward-spiraling emotions in the face of agonizing medical attempts to put her broken body back together:

How I wish I could explain to you, minute by minute, my suffering. Since you left, I've gotten worse and I cannot for a moment either console myself or forget you. Friday they put the plaster cast on me, and since then it's been a real martyrdom *that is not comparable to anything else. I feel suffocated, my lungs and my whole back hurt terribly; I can't even touch my leg. I can hardly walk, let alone sleep. Imagine, they hung me by just my head for two and a half hours, and then I stood on my tiptoes for more than one hour while [the cast] was dried with hot air; but when I got home, it was still completely wet.*[20]

Kahlo's poignant letters continued in later years, as she pursued medical treatment in both Mexico and the United States. Travels prompted epistles to those at home, and an increasing range of friends both north and south of the border received her lively communiqués. Her forthright manner of writing extended Kahlo's face-to-face directness through the mails.

To Georgia O'Keeffe she expressed warmth and sympathy on the written page. Perhaps in response to hearing of O'Keeffe's breakdown and subsequent hospitalization, Kahlo phoned her in New York early in 1933. Kahlo and Rivera were then living in Detroit, where Rivera was completing a mural commission and Kahlo herself was doing some painting. Following up her phone call, Kahlo wrote O'Keeffe (who was still in the hospital) on 1 March. She had intended to write earlier, and explained

her hesitancy: "Every day since I called you and many times before, months ago I wanted to write you a letter. I wrote many, but every one seemed more stupid and empty and I tor[e] them up. I can't write in English all I would like to tell, especially to you." Kahlo went on to express her sadness and concern at O'Keeffe's illness, but despaired that "I still don't know what is the matter with you." If O'Keeffe were unable to answer, Kahlo hoped that Stieglitz would send a brief note to allay her worry.

Then Kahlo (whose own recent history had included a Detroit miscarriage and her mother's death) injected a winsome remark, a reference to shared understandings of the difficulties in both lives: "I would like to tell you every thing that happened to me since the last time we saw each other, but most of them are sad and you mustn't know sad things now." Then, as if recognizing her own tone of self-pity, Kahlo quickly added, "After all I shouldn't complain because I have been happy in many ways." She closed with an expression of admiration and affection, perhaps a key to Kahlo's later offhand statements that she had once flirted with O'Keeffe: "I thought of you a lot and never forget your wonderful hands and the color of your eyes. I will see you soon. . . . I like you very much Georgia."[21]

Clearly Kahlo hoped for a deeper friendship, or perhaps more, with O'Keeffe, when she and Diego went to New York a few weeks later. From there, she wrote to a friend on 11 April (by which time O'Keeffe had gone to Bermuda to convalesce) that because of O'Keeffe's illness there had been no lovemaking between them that time. A boastful exaggeration of their closeness? Knowing Kahlo's predilection for sexual hyperbole, this seems likely. The record of the women's subsequent contact is frustratingly slim, though their husbands soon became engaged as allies in a celebrated battle involving politics, art, and big money in New York. In May 1933 Diego Rivera wrote Stieglitz to thank him for his support against the opposition of the Rockefeller family to Rivera's leftist Radio City frescoes, a commission that Nelson Rockefeller had canceled abruptly.[22]

The next confirmed record of the O'Keeffe-Kahlo contact was through their mutual friend Rose Covarrubias, who took O'Keeffe to visit Kahlo (confined to her bed in Coyoacan after a year-long hospitalization) twice during O'Keeffe's 1951 visit to Mexico. It is an interesting reversal of roles from their 1933 contact, when it was O'Keeffe who was ill, Kahlo the solicitous visitor. Sadly, no record of the visits in Mexico City has survived.

In the writings of each artist appear autobiographical reflections, though vastly different in quantity, form, and intent. Kahlo's were highly personal, often diaristic, rich in metaphorical considerations of self and others. So visual were her images that she could scarcely refrain from drawing on the pages of her letters or diary. As psychiatrist Salomon Grimberg suggested, such incessant drawing reveals her as "an artist who, like a child, thought mostly in images." Like O'Keeffe, Kahlo downplayed her verbal abilities; she opened her "Portrait of Diego," written for his 1949

retrospective at the Palacio Nacional de Bellas Artes in Mexico City, by saying, "I warn you that I will paint this portrait of Diego with colors that I am not familiar with: words. That is why it will be poor."[23]

O'Keeffe's writings, as we have seen, were visually as well as verbally interesting, though she seldom illustrated them, except occasionally to identify a particular work to a correspondent like Anita Pollitzer. O'Keeffe wrote to keep in contact with people she cared about, to express to intimates her feelings about the places and events of her life and, in later years, to conduct some of the business of a successful artist's career. Though she may have wished occasionally to clear the air of inaccuracies and distortions about her life and work, she usually refrained from doing so. She certainly did not have to write to publicize herself; others—first Stieglitz, then a host of critics, and finally a range of biographers—did that for her. Her autobiographical reflections were confined to an occasional brief catalogue statement and to the terse interweaving of work and words in her 1976 book, entitled simply *Georgia O'Keeffe*.

One of the great secrets O'Keeffe kept was her ambition, her desire for success. Pretending to disdain publicity contributed to her persona of committed idealist, one for whom the creative drive far outweighed material gain or personal fame. The evidence suggests otherwise. True, she spoke in idealistic terms, once advising Sherwood Anderson, "Whether you succeed or not is irrelevant—There is no such thing—Making your unknown known is the important thing." But for O'Keeffe, there clearly was such a thing as success, and she worked hard to achieve it. About the same time as her letter to Anderson, she wrote to Henry McBride of her own aspirations: "I don't like to be second or third or fourth—I like being first— if Im noticed at all—thats why I get on with Stieglitz—with him I feel first."[24] To remain first, not submerged beneath her husband's identity, she chose to keep her own name after her marriage the next year.

O'Keeffe's quest for a singular identity in art and in life intensified with the following years. Although she noisily lamented the speculations of critics about her personality, her sex life, and her choices of subjects, she was forced to find ways to accommodate her ambition with her need for privacy. More than Carr, O'Keeffe was subjected to reams of discussion about every aspect of her life. As early as 1921 she spoke out on the invasive quality of the Freudian-inspired criticism—most of it positive—directed at her work. She described the "shiver and . . . queer feeling of being invaded . . . when I read things about myself."[25]

Soon, however, O'Keeffe grew resigned to the necessity of publicity. In 1922, just a year after she had wept over what she felt was intrusive press scrutiny of her work, she adopted a much more pragmatic attitude toward public exposure. To a former classmate she wrote: "I dont like publicity—it embarrasses me—but as most people buy pictures more through their ears than their eyes—one must be written about and talked about or the people who buy through their ears think your work

is no good—and wont buy and one must sell to live—so one must be written about and talked about whether one likes it or not—it always seems they say such stupid things." [26]

Stupid or not, the speculations of critics brought O'Keeffe renown and sales. By 1927 the art critic C. J. Bulliet was writing of her as "the best-known woman painter in America," producing "the best work, perhaps, of any American, male or female in the pure abstract." [27] Bulliet's remarks appeared in his widely popular *Apples and Madonnas*, a book we know Emily Carr read. She must have been deeply impressed at the stature O'Keeffe had attained at a time when success seemed a distant dream to the Canadian.

O'Keeffe would soon see how publicity could be manipulated. On at least one occasion, her desire for public attention led her to acquiesce in the dissemination of false information about her work. In 1928 a famous hoax (perpetrated, it was later revealed, by Stieglitz) put forth the fiction that six of O'Keeffe's paintings of calla lilies had been sold to a European collector for the astonishing sum of $25,000. No such sale took place, but when O'Keeffe was asked in an interview whether the figure was accurate, she replied, "Oh, yes, that's true." The interviewer concluded, after hearing more from the artist about her exhibitions and prices, that O'Keeffe "was out to win." [28] The game she was already winning, orchestrated by Stieglitz, was that of placing skillful publicity designed to elevate her prices and reputation. O'Keeffe's duplicitous confirmation of the sale may have troubled her conscience, for she left for Maine soon after being interviewed.

Regardless of the excitement the bogus sale generated, O'Keeffe knew she had to look beyond a single coup, whether real or invented. She told one of her interviewers, "Success doesn't come with painting one picture. It results from taking a certain definite line of action and staying with it." She had a larger, long-range reputation to build, and she bent her efforts to it. Soon her ambitions became known, at least to art-world insiders. Katherine Dreier, active in New York art circles, informed Emily Carr, "Georgia O'Keeffe wants to be the greatest painter," adding (perhaps as a palliative to Carr) "Everyone can't be that, but all can contribute." [29]

The desire to be first, to "win" at the art game, drove O'Keeffe to exhibit frequently, so as to keep her name before the public. It also fueled her efforts toward innovation and change. At a point when she had achieved unprecedented successes, including the first solo show of a woman's work mounted at the Museum of Modern Art, she paused to describe her career almost as if it were a horse race: "I have always been willing to bet on myself you know—and been willing to stand on what I am and can do even when the world isn't much with me—Alfred was always a little timid about my changes in my work—I always had to be willing to stand alone—I dont even mind if I dont win—but for some unaccountable reason I expect to win." [30]

Tellingly, although she was willing to bet on her own success, O'Keeffe's ambition did not extend so far as to turn her into one of those painters who document

every scrap of artistic output. Privately, O'Keeffe kept a record of her work, and she signed and dated some of it with marks that indicated the painting's relative significance to her. But those records never embodied the historical consciousness or served as a publicly autobiographical record in the manner of, say, Picasso, who came to view himself as an archetype of the creative being: "Why do you think I date everything I do?" he once asked, then answered his own question: "Because it's not sufficient to know an artist's works—it is necessary to know when he did them, why, how, under what circumstances. . . . Someday there will undoubtedly be a science—it may be called the science of man—which will seek to learn about man in general through the study of creative man. . . . That's why I put a date on everything I do."[31] Such hubris was never matched by O'Keeffe, Carr, or Kahlo; indeed, it is rare for any artist.

If one placed Picasso at the extreme of a continuum of artistic self-consciousness, O'Keeffe might appear somewhere in the center, Kahlo and Carr closer to the opposite end. Still, Frida Kahlo shared a few aspirations with O'Keeffe. Both wanted to be "originals," free of entangling theory and of foreign "isms." Yet it was Kahlo's appropriation by surrealism—at once foreign and deeply enmeshed with psychological theory—that brought her breakthrough as a successful painter. And like

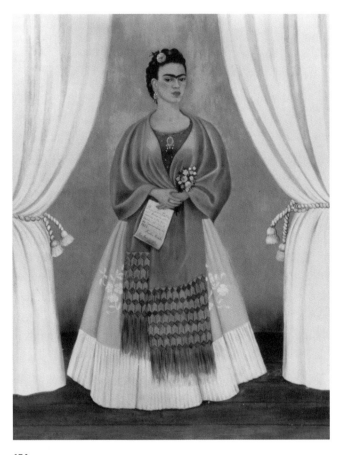

154
Frida Kahlo, *Self-Portrait Dedicated to Leon Trotsky*, 1937, oil on masonite, 76.2 x 61 cm. National Museum of Women in the Arts, Washington, D.C.

The Public Self

O'Keeffe, she manipulated her reputation to promote a self-image; in Kahlo's case it was as a candid, pure, and self-fertilized painter. Though her art was indeed inventive, it was not recondite. It depended on a certain accessibility of image: she relied on her strong intuition for vernacular metaphors to connect with a wide range of viewers. They came to know, even if they could not decipher every meaning, that Kahlo's symbolism was autobiographical, stemming from a vision based in her experiences and environment.

Kahlo made sure that she was not the one to label her work surrealist. That she left to others. André Breton found an impulse to fantasy in much of her work, such as a self-portrait painted for Leon Trotsky (fig. 154). Of this painting Breton wrote, "She has painted herself dressed in a robe of wings gilded with butterflies." Biographer Hayden Herrera argues further that Kahlo's close friend Miguel Covarrubias would not have classed her as a surrealist in the catalogue of the exhibition "Twenty Centuries of Mexican Art" if Kahlo had objected.[32] When it served her ambitions, Kahlo accepted the labels bestowed on her. As the vogue for surrealism waned in Mexico, she and Rivera turned to other designations. He called her fantasy paintings "occult realism" and her self-portraits "monumental realism" in a 1943 article. By returning her to a "realist" category, Rivera regrafted Kahlo to her political roots; realism has always been the preferred style of Marxism and of Mexican painting in general (fig. 155).

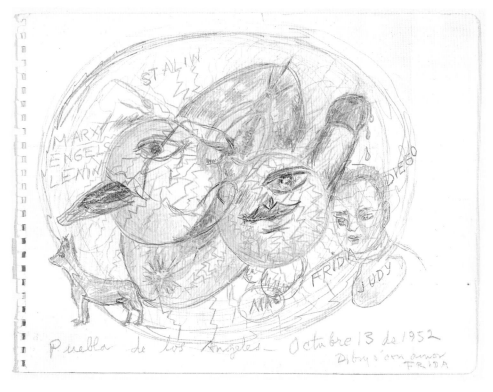

155
Frida Kahlo, *Puebla de los Angeles*, 1952, colored
pencil on paper, 22 x 29 cm. Private collection,
Panama, Republic of Panama. Photo by Javier Hinojosa.

Kahlo desired fervently to be financially independent and to earn her own living. When the actor Edward G. Robinson bought four of her paintings in 1938 for two hundred dollars each, Kahlo was overjoyed, envisioning a life of greater autonomy: "This way I am going to be able to be free, I'll be able to travel and do what I want without asking Diego for money."[33]

Despite growing fame, Kahlo—ever the faux-naïf—clung to a kind of ironic primitivist public identity. Even those close to her often did not know what to make of her ambitions: after Kahlo's death her friend Annette Nancarrow told Herrera that Frida dressed in men's clothing and cut off her hair to promote her identity as a serious, career-minded artist, unshackled from Diego. On the other hand, Kahlo wrote this coy self-introduction in a 1947 exhibition catalogue of self-portraits by Mexican painters: "I haven't painted much, and that without the least desire for glory or ambition, with the determination to give myself pleasure and to be able to earn my living with my work."[34]

Making a reputation in Canada took quite a different kind of effort. In the early days of Emily Carr's career the magisterial, solemn, and monumentally calm canvases of the Group of Seven dominated Canadian painting, presenting a seemingly insurmountable canon for the landscape painters—both male and female—who followed them. Because she chose to work primarily with landscape, Carr labored to find a vision of her own making. What released her from the Group's overriding definition of Canadian landscape was her discovery of how to make it her own: she introduced rhythmic movement as a vital, overriding element; she extended space and light beyond the knowable here and now; she gave her line spontaneity and exuberance; she peered into the intimate space of the forest interior, in a manner that somewhat parallels O'Keeffe's close renderings of the hearts of flowers.

Maria Tippett's *By a Lady: Celebrating Three Centuries of Art by Canadian Women* brings together a remarkable collection of accomplished work, documenting the slowly changing fortunes of women artists in Canada. Tippett argues that in the early decades of the twentieth century, artists like Emily Carr were neglected, despite their talent and professionalism. These women had studied abroad, adopted sophisticated modernist styles, and made innovative subject choices. Tippett concludes, "Their misfortune was due to the popularity of landscape painting, to the continued assumption that a woman's place was in the home, and to the mediocrity that characterized so many women's exhibitions."[35]

Subject matter was indeed a sticking point: into the 1920s Carr's compositions often contained figures, and were particularly identified with native imagery of totem poles and villages. At that time and well beyond, the uninhabited landscape as a bearer of meaning appealed to many more of Canada's critics and collectors. Even into the 1930s Canadian painters resisted the social issues and themes that preoccupied artists south of their border and in Europe. When some critics asked why, others defended the traditional landscape orientation of the Canadian artist. Insisted one,

"From Paul Kane to the Group of Seven," Canadian painters "contributed their finest works when they turned their backs on civilization in preference for the wilderness."[36]

So Carr was caught in a double bind. She followed Lawren Harris's suggestion to eliminate Indian subjects and focus more consistently on "pure" landscape. Was it good advice? The answer is yes and no. In her highly personalized interpretations of the forest interior, Carr found structure in the midst of chaos and imposed order on a Western landscape many male artists had considered unpaintable. Single-handedly, she countered the prevailing wisdom, as Harris would recognize: "The Pacific coast landscape in all its forms and moods is made for modern expression in paint. . . . Emily Carr was the first artist to discover this."[37]

When she invented an early, singular alternative to the entrenched landscape vision of the Group of Seven, Carr became, in a sense, a Western Group of One. Her closeness to the forest, to animals, and to native culture made Carr something of a shamanic figure in Canada; she was widely mythologized as an interpreter who drew native lore, art, and culture into an expanding definition of Canadian identity. That reputation, established in an era when native culture was being politically neutralized by the benign imposition of white economic and educational institutions, would not survive unchallenged in later years. Nor would her unique use of the language of landscape; even this, long regarded as her most abiding contribution to Canadian painting, has been seen by some critics as a limitation in Carr's work.

Carr, O'Keeffe, and Kahlo all benefited from the assistance of men who were influential in the art world. More than women, men contributed to their varying degrees of success. Of course, more men were in positions that allowed them to advance artists' careers in those days. Few women were museum directors, critics, curators, art dealers, or even colleagues, and they had narrower spheres of influence. Despite these limitations, it is noteworthy that it was other women who first tried to bring the talents of Carr and O'Keeffe to public notice.

Sophie Pemberton (1869–1959) was Victoria's first woman artist to study in Europe, setting an important precedent for Carr. Following time in both England and France, Pemberton returned to British Columbia. In 1921 she praised Carr's painting to Harold Mortimer Lamb, a Vancouver photographer, mining engineer, and arts patron. Lamb visited Carr's studio, where he saw her paintings of Indian villages and totems and wrote an enthusiastic letter about them to Eric Brown, director of Canada's National Gallery. Although he commended Carr's work as "fine in colour and broad and vigorous in treatment" as well as ethnographically important, nothing came of Lamb's first letter, perhaps because Carr could supply only poor snapshots of her work.[38] Possibly for the same reason, Lamb's planned article on Carr for the English art journal *International Studio* was never completed—an event which might have changed decades of her life. Lamb, however, remained interested in Carr's work, visiting her studio from time to time, where he photographed her with her painting *Sunshine and Tumult* in the background (fig. 156).

Two other men took up Carr's cause. Next—or perhaps first, depending on the telling—to champion Carr's work was Marius Barbeau, an ethnologist at the Victoria Memorial Museum, who encouraged Carr and other women artists to record the vanishing totem poles and houses of the West Coast. Accounts of Barbeau's meetings with Carr have been questioned; years later he said he had first heard of her visits to Skeena villages from a native interpreter in 1915 and that he met Carr in 1916. Barbeau definitely visited her in 1926, observed her making pottery, and bought two paintings of Tsimshian subjects from her. By that time, he recalled, Carr complained of the rejection of her work in both Victoria and Vancouver; "She had already given up any hope of ever gaining success," according to Barbeau.[39]

Her despair was premature, for Barbeau's visit initiated a major change in Carr's career. That year he and Eric Brown began to plan their pathbreaking "Exhibition of Canadian West Coast Art, Native and Modern," to be mounted late in 1927 at the National Gallery in Ottawa, with additional venues in Toronto and Montreal. At Carr's Victoria studio Barbeau made some preliminary choices; final selec-

156
Harold Mortimer Lamb, Emily Carr with her
painting *Sunshine and Tumult* in the background,
c. 1935, oil on paper, 87.9 x 57.7 cm. British
Columbia Archives, D06009.

The Public Self

tions, including rugs and pottery as well as twenty-six paintings, were made by Brown on a visit in September 1927. The exhibition had as its stated rationale integrating "for the first time the art work of the Canadian West Coast tribes with that of our more sophisticated artists in an endeavour to analyse their relationship to one another." [40] Merely being identified as one of the West Coast's "more sophisticated artists" accomplished wonders for Carr's morale at a low point in her life.

Barbeau's and Brown's efforts brought Carr's work to the notice of many in the East. Subsequently Barbeau helped to make Carr's work known in central Canada, while Brown saw to it that Carr's painting (along with that of many other women) was included in national and international exhibitions. Carr especially credited Brown (along with Lawren Harris) for helping her escape her landlady prison and return to artistic production. In 1934 Carr told Brown, "I always have and always will feel gratefully towards you personally, for hauling me out of the slough of despair and setting me to work again." That same year two other Canadians, painters both, tried to promote Carr's work in the United States. Jack Shadbolt and John Macdonald wrote her from New York urging her to have photographs made of her paintings for circulation among dealers. The idea of a show in New York did not appeal to her at all in 1934. In a truculent tone she told her journal, "I refused. It is not practical and I do not want that thing, publicity. I want work. I do not think for an instant they would want my stuff anyhow and oh, the worry and trouble! No thanks." [41]

Carr's vitriol often stood between her and a wider audience. And she knew it. With studio visitors and interviewers she was often abrupt. Even with the growing number of younger painters (such as Shadbolt and Macdonald) who came to admire and pay homage, she often showed her canvases grudgingly and defensively. Maria Tippett attributes Carr's aloofness to her own insecurities: the painter felt ignorant about the history of art, its techniques, its jargon; she lacked the unbridled enthusiasm of the younger painters. [42] This reasoning seems irreconcilable with Carr's long professional training and, as seen in Chapter 3, her investigation of some of the most advanced texts of her day. One can only conclude that Carr's extreme sensitivity to criticism and the resentment she harbored against unkind critics sometimes poisoned her relationships with admirers or collectors. Clearly she thwarted some of the possible avenues for her own success.

Nonetheless, her reputation grew, and many critics responded positively. When the "Century of Canadian Art" exhibition opened at London's Tate Gallery in 1938, Carr's four paintings received special praise. The influential critic Eric Newton, who had visited her in Victoria, wrote of those works, "If the word 'genius' (a word to be jealously guarded by the critic and used only on very special occasions) can be applied to any Canadian artist it can be applied to [Carr]." [43]

The most sustained appreciation of Carr's painting was that of Lawren Harris (fig. 157). Despite its periodic disruption Harris's artistic relationship with Carr

was of singular importance in the development of her painting, though he claimed no special credit. As early as 1931 he helped her to see the developments in her own work, moving her from "Indian" subjects to an exploration of nature's spaces and subsequently to what he called "a deeper penetration into the life of nature." Harris knew that Carr's forest interiors were the places where her values were made manifest, where universal experiences were interiorized. Building on those kernels of truth, he gave Carr the repeated assurances necessary to maintain confidence in herself. She wrote in 1944 that Harris's "work and example did more to influence my outlook upon Art than any school or any master. . . . He did not seek to persuade others to climb his ladder. He steadied their own, while they got foot-hold."[44]

Carr had to be thinking of the contrast between Harris's nonintrusive support and Mark Tobey's unapologetic imposition of his own artistic viewpoint. After Carr's death Tobey went so far as to claim credit for transforming her, a beleaguered landlady, from artsy amateur to powerful painter: "It simply is not possible that a woman living her circumscribed life, could have developed as she did, to conceive the great swirling canvases, the wonderful tree forms, unless there had been someone to

157
Unknown photographer, Lawren Harris at the Vancouver Art Gallery about 1945. At the left is Emily Carr's painting *Silhouette No. 2*, c. 1930–31. British Columbia Archives I-51570.

The Public Self

indicate the way for her: I was that someone." With characteristic immodesty, Tobey concluded, "There would have been no Emily Carr if it hadn't been for me."[45]

Still one more benefactor in Carr's life, most important in her literary efforts and arguably her closest friend, was Ira Dilworth. In her last years, Carr found in Dilworth the trusted male figure she had so long lacked; in addition, he acted as her literary mentor, adviser, and executor. Entrusted with Carr's literary reputation, he made heroic efforts to transcribe her handwritten pages, to publicize her work, to find appropriate publishers, and to safeguard her highly idiosyncratic style. Dilworth understood that Carr's prickly odd-woman-out stance masked a deep need for acceptance by the Canadian public, and he laid the groundwork for her warm embrace by generations of readers.

It is telling that the reputations of O'Keeffe, Carr, and Kahlo now surpass those of their male mentors. In the case of O'Keeffe, that outstripping was occasioned in part by the age difference: Stieglitz was some twenty-three years older than his wife. Long after his energies declined, O'Keeffe's career continued; beginning in the 1930s she retrieved control of her career from him.

Though O'Keeffe was testy, even resentful about ceding any degree of originality to artistic predecessors, she mentioned her teachers: John Vanderpoel ("one of the few real teachers I have known"), F. Luis Mora, William Merritt Chase, Kenyon Cox, and Arthur Dow, to whom she gave the broadest compliment: "By that time I had a technique for handling oil and water color easily; Dow gave me something to do with it." Nonetheless, she regretted that both the past and the present had mandated teaching and criticism from a male viewpoint:

I have had to go to men as sources in my painting, because the past has left us so small an inheritance of women's painting that has widened life. And I would hear men saying, "She is pretty good for a woman; she paints like a man." That upset me. Before I put brush to canvas, I question "Is this mine? Is it all intrinsically of myself? Is it influenced by some idea or some photograph of an idea which I have acquired from some man?" . . . I am trying with all my skill to do painting that is all of a woman, as well as all of me.[46]

Eventually O'Keeffe found ways to bring women into her professional life; she entrusted her livelihood to two powerful dealers who guided her from 1950 well into the 1970s. These were Edith Gregor Halpert of the Downtown Gallery (1950–63) and Doris Bry, who took over as O'Keeffe's agent from 1963 until 1977. Thereafter, as her eyesight and energies failed, O'Keeffe allowed another man to assume great power in her life: Juan Hamilton, who began as her assistant and eventually controlled most aspects of her life. Even after her death, Hamilton has continued to exert extraordinary influence over O'Keeffe's legacy and reputation.

Kahlo's trajectory was different. Though she was also some twenty years younger than her husband, she did not outlive him to invent a life of her own. Instead,

she remained in Rivera's shadow, her energies compromised by her physical problems. Rivera's energies, on the other hand, were legendary; capable of prodigious output, he snagged an international reputation early and held on to it despite political and stylistic vicissitudes. Mexico's most famous artist in his day, Rivera used the power of that entrenched position and the force of his personality to generate more fame, controversy, and influence. Some of that renown he used to promote his wife's artistic efforts; without him it is unlikely that Kahlo's work would have been much noticed outside Mexico City. There, however, late-life tributes helped to solidify her identity and artistic contribution as separate from her husband's. Women helped: Lola Alvarez Bravo's Galeria Arte Contemporaneo gave Kahlo an important retrospective in April 1953, over which the painter presided from a sickbed brought to the gallery. Kahlo's aspirations as a painter were different from her husband's. Unlike his work, Kahlo saw hers as highly personal, not political: "It is not revolutionary. Why should I have any illusions that it is combative? I can't."[47]

Retrospectively, Rivera's art seems now to belong to past decades, a vital part of Mexico's struggle to shape a modern identity. That intimate association is both its strength and its chief limitation: as large as Mexico in scope, it remains tied to the nation's struggles and its revolutionary history. Even his murals of larger revolutionary struggle and the machine age are tied to particular decades. Paradoxically, Kahlo's paintings, especially her self-portraits, begin as the most personal statements imaginable yet somehow transcend the idiosyncratic to present the face of woman, untethered to place and time. This transcendence is part of what has lifted Kahlo's stature as artist and popular icon to an unprecedented level for a Mexican figure, male or female.[48]

Every public figure sometimes operates behind screens put up to mark divisions between public and private life, setting apart what may be known from what must remain unseen. Art is one of the mirrors at the place where outside and inside meet. So are masks, which function in meaningful ways in art and ritual, including the art of Carr, O'Keeffe, and Kahlo.

As a ritual agent of transformation, the mask is much older than classical Greek culture, but it was the Greeks who first spelled out the importance of masks for Western culture. In classical drama the actors wore a mask called a *persona* because the voice—*sona*—sounded through it. The mask presented the actor in altered form, with disguised and enhanced sound transmission. The mask was thus an agent of transformation from inside to outside, a process which parallels the ability of myth to reveal the inner workings of culture in terms of its outward manifestations. "The seat of the soul is there," wrote Novalis in *Sacred Songs* (1799), "where the outer and inner worlds meet."

The mask is thus poised on a threshold, a liminal zone where incoming sensations encounter the human imagination. Through the mask, the inner self—

individually and freighted with collective consciousness—sounds through. It speaks the ineffable, touches pulses of life beyond the knowable, revealing the unknowable. The mask has also provided rich formal possibilities for artists past and present; in the twentieth century they are prominent in the work of Paul Klee, Pablo Picasso, the Mexican muralists (including Rivera), and Rufino Tamayo. Picasso's biographer Patrick O'Brian reports, in a fascinating connection, that when Rivera went to Europe in 1907 he took with him an ancient Tlatilco sculpture, a head whose three eyes and two mouths enabled it to be seen simultaneously in full face and profile. Rivera reportedly showed this object to Picasso, whose many subsequent versions of the dual or simultaneous face testify once more to the staggering implications of a wide range of indigenous art within his work.[49]

In Mesoamerican ritual and mythic thought the mask played an essential metaphoric role. It opens understanding to the Mesoamerican view of a pervasive unity. As Maya scholar Alberto Ruz Lhuillier writes, the mask is "one of the most widespread elements of Mesoamerican culture, . . . found in all chronological horizons, from the Olmec to the Aztec, and in all geographic areas." Scholars disagree on the precise lineage of Mesoamerican mask traditions, but that ancient forms survive in later Mexican art is beyond doubt. Octavio Paz brought the mask metaphor up to date in Mexican culture: "While we are alive we cannot escape from masks or names. We are inseparable from our fictions—our features. We are condemned to invent a mask for ourselves and afterward to discover that the mask is our true face."[50]

After he returned from Paris, Rivera often employed masks in his attempts to render modern Mexican consciousness. More than Paz, Rivera politicized the motif in his insistence that Mexico's native culture was contained behind the "mask" of a decadent, Europeanized class system. In Rivera's mind, the mask thus expressed a revolutionary view of reality, and could be used (like much of his iconography) to unite the indigenous with modern, political Mexico.[51]

Frida Kahlo's art, supported by traditions old and new, used masks in ways both personal and cultural. Because Kahlo felt herself heir to ancient Mexican traditions, and because she explored her own identity along many avenues, she took up and tried on the mask as metaphor in many of her paintings. For her, the mask alluded to Mexico's indigenous past, as well as suggesting the spiritual mystery inherent in artmaking itself. About the same time she included the stone death mask in *My Nurse and I* (see fig. 38), she painted two versions of *Girl with Death Mask* (fig. 158).

In the painting reproduced here, there are two masks. Near the girl's feet stands a *tigre* mask, modern survivor of the pre-Columbian jaguar, symbol of the earth, rain, and fertility. Through the mask, the jaguar symbolizes connections between humanity and the spirit world, in the eternal cycle of death and rebirth.[52] The second mask is worn by the girl herself, a papier-maché death mask; in her hand she holds a yellow flower, a marigold. The skull and flower also allude to death, specifically the Mexican Day of the Dead observances, but there is an additional layer

of personal meaning that Kahlo intended for this image. Dolores del Rio, a friend of Kahlo and Rivera's, was the painting's first owner. According to the authors of the Kahlo catalogue raisonné, the artist told del Rio that she painted *Girl with Death Mask* to work through her sorrow at the loss of a pregnancy, terminated by abortion around 1935. Post-procedure analysis showed that the fetus had been female, so Kahlo painted a commemorative "birthday" portrait three years after the abortion took place. The unborn child, about three years of age and wearing a festive party dress, wears the mask Death has given her.[53]

Pressing on in search of what Yeats called the "living face behind the mask," Kahlo's work contains other telling examples of the mask as mediator of identity. Sometimes she used it to hide an inner self in a modern world that required the alienated individual to put on a false face in order to survive. Seven years after *Girl with Death Mask*, the artist covered her own adult face with a mask. *The Mask* (fig. 159) is a tragicomic caricature of the female face, clownlike in its visage of

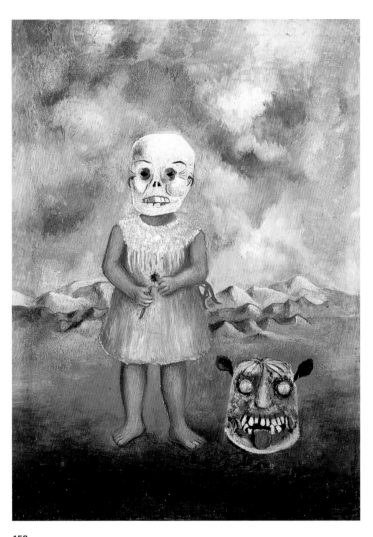

158
Frida Kahlo, *Girl with Death Mask*, 1938, oil on metal, 19.8 x 14.7 cm. Collection of Nagoya City Art Museum, Japan. Photo courtesy Christie's.

The Public Self

orange surrounded by garish purple hair. Trompe l'oeil eyeholes pierce the mask, allow-
ing the artist—whose face hides behind it—to look out and weep through it.
The year she painted this, when Rivera was again unfaithful to her, Kahlo's tears convey
her misery, but it is visibly the mask that weeps, not she.

Onto the already complex visual dynamic of the self-portrait, Kahlo here grafts
another dimension. The manicured hand supporting the mask and the dark
braid of hair above it argue that the sitter is Frida, yet her face, the essential identifying
element, is missing. What does that absence suggest? Does the mask signal that
everything has shifted into a metaphorical zone? Consider a possible scenario: Rivera's
infidelities had caused Kahlo, metaphorically, to "lose face." That loss is made
visible—literal—by the mask, which stands in for her lost visage. The artist is lost in
another sense as well: *dis-placed* from her husband's affections, she is unsure where
she stands. And so is the viewer. Where, exactly, is the "real" Frida at this moment? In
front of the painting, where viewer (and Frida the painter) stand? In the fictive

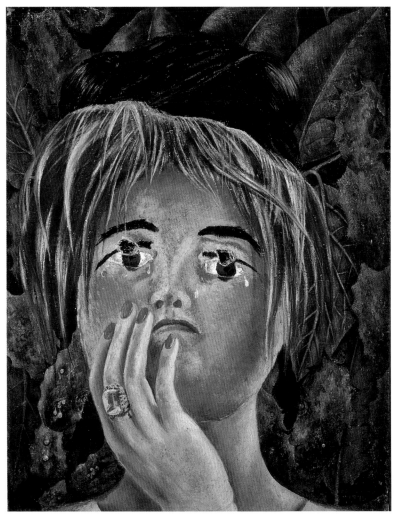

159
Frida Kahlo, *The Mask*, 1945, oil on masonite,
40.1 x 30 cm. Collection of Museo Dolores Olmedo
Patiño, Mexico City. Photo by Rafael Doniz.

three-dimensional zone behind the painted mask? The mask metaphorizes and literal-izes that spatial uncertainty as well. And if representations, such as Kahlo's own self-portraits, are meant to be "read" and thus rendered transparent, putting a mask over her face might hide her all-too-transparent pain.

Kahlo was a woman whose identity—the self she presented to the world—was fused to that of her husband. Their marital troubles loosened that bond periodically, and her continual physical difficulties likewise damaged her sense of wholeness. What *The Mask* reveals, finally, is how badly Kahlo's own identity faltered when Rivera's attention and affection were diverted elsewhere. The woman who told her diary, "I love Diego more than myself," and who lamented her loneliness on its pages, clearly feared abandonment and resisted separation.[54]

Masks allowed Kahlo both to be and not to be herself. They intervened between a vulnerable self-image and the impassive face she wore in her self-portraits. Behind a mask, she could turn the world of appearances back on itself. A year later, she painted a bleak *Paisaje* (Landscape, fig. 160), where a mask, perhaps the stone death mask worn in *My Nurse*, lies discarded at the lower left. At first this landscape seems to be one of Kahlo's rare excursions into unpeopled terrain. But if we study the deeply fissured surface, it becomes clear that—in a year when Kahlo was plagued by painful back surgery—she was once more invoking the earthly and the fleshly together: this scarred landscape surely mimics the wounded terrain of her own body. Like a cicatrix thickening around a wound, the earth's skin gapes around an unhealed cavity within it. Gradually, the

160

Frida Kahlo, *Paisaje*, c. 1946–47,
oil on canvas, 50.8 x 68.6 cm. Museo Frida Kahlo,
Mexico City.

cavity assumes the shape of a human form, or perhaps a skeleton, La Huesera, lying within a shallow excavation.

Paisaje is the shadowy obverse of Kahlo's painting *Roots* (see fig. 105) of a few years earlier. In *Roots* she and the Mexican earth lived in and for each other, symbiotically. The stuff of body and land was virtually interchangeable; she was at ease in *Roots* with the body-land dialectic of inside and outside. Here in *Paisaje*, it is as if Kahlo, the figure who reclined on the earth, has been ravaged and left for dead in a fissured, desiccated landscape that functions as a signifier of the body, flayed and turned inside out. Nearby, the discarded stone funerary mask alludes to another casualty—Kahlo's nurse, the Mexican earth itself. In a dark reference to the artist's shamanistic role, the mask bridges the gap between nature and spirit, moving between worlds.

The year before her death Kahlo returned to the theme of the mask, this time in a work she titled *La Risa* (The Laugh, 1953; private collection, Mexico). On this mask Kahlo painted Olmec features frozen into a toothsome expression halfway between a smile and a grimace. Once again, the mask is a vehicle for her own mental state: that year brought both torment and triumph. Confined to a bed the frail painter presided over the gala opening of her solo show at the Galeria de Arte Contemporaneo; a few months later her gangrenous right leg was amputated. The smile on the mask is at once brave and sardonic; Kahlo "faced" a future of continued decline. At times suicidal, she consumed alcohol and pain killers in ever larger doses, fighting to maintain control over a body that was deteriorating like the decaying fruit she painted in late still lifes. At first glance *La Risa* is a mask of heroic impassivity; studied more closely it both reveals and conceals the face of Kahlo's suffering.

Her paintings of masks illustrate a significant paradox: Kahlo, who seemed to possess such a defiantly individual and original personality, was play acting much of the time. Her art nearly always possesses a sense of the theatrical; her paintings presume an audience susceptible to dramatic effects, sometimes to shock. Even Kahlo's clothes are costumes. Her long, full skirts were donned both for expressive effect and to camouflage her withered, later amputated leg.

Like a mask, Kahlo's sardonic personality disguised her fear of death, abandonment, and physical disintegration. History's famous painters of multiple self-portraits—Rembrandt, for example—spent years studying their faces in all their changes and moods. Kahlo's self-portraits, on the other hand, resist change; she paints the same frozen mask for decades, as if to certify that she is still in possession of a threatened self. To paint change was to acknowledge decline, something she chose not to do in her self-portrait heads. Yes, tears fall, accessories change, but the face is constant. Her traumas and joys were reserved for her full-figure paintings, where physical pain had a basis in bodily reality—abortions, surgeries, the arrow-embedded surrogate body of her pet deer.

Still, Kahlo's self-portrait heads are much more than expressionless masks. Their sheer numbers and the pivotal moments at which they appear describe a passionate, obsessive intensity of execution. Speaking through these self-portrait masks, Kahlo asks critical questions about life and art: Who am I at this moment? How can I find myself again? To those, one could add a larger question: In a world where meaning is in jeopardy, how can self-portraits, carefully signed and dated, create meaning and confirm reality?

Interviewers pressed Georgia O'Keeffe to explain why she seldom signed her paintings. Once she responded with a query of her own: "Would you sign your face?" It was a blunt answer, designed to derail further questions. But instead of getting anyone off track, O'Keeffe's retort only confirms how intensely personal her paintings really are. She felt no need to sign most of her work because to her it was as unique and singular as her face; the skin of her paintings was akin to her own skin. And both were linked with the face's surrogate, the mask. Though their pristine surfaces may conceal the labor of their execution, they reveal O'Keeffe's chosen persona. Collectively, they present the composed visage she showed to the world, a face destined to become, like many of her canvases, an artistic icon. As iconic stand-ins for the artist herself, such paintings function, in many cases, as thinly disguised self-portraits.

In Chapter 2 I argued that some of O'Keeffe's paintings of skulls, such as those in *My Autumn* and *Ram's Head with Hollyhock* (see figs. 118 and 119), served as expressive episodes in the history of her consciousness. They reflect conceptions of the self in nature, subtly infused with the painter's experiences and feelings. As is often the case in O'Keeffe's work, her masklike forms appear to be summoned from places beneath the surface of thought, subject to moods, events, and private musings. As Jung remarked, "We know that the mask of the unconscious is not rigid—it reflects the face we turn towards it."[55]

Masks in art were known to O'Keeffe from her early years in New York, for it was in late 1914, when she was studying at Columbia Teachers College, that Stieglitz showed African masks and sculptures at 291. O'Keeffe and Stieglitz knew the role such masks had played in inspiring Picasso and Braque to cubist formal experimentation. She painted one as part of a still life in 1924, *Mask with Golden Apple* (private collection). Paired with the glowing orb of the apple, the mask sets up a rich dialogue of concavities and convexities, of textures and skins. Preserved there are O'Keeffe's romantic sympathies with organic life, what Thomas Mann in *The Magic Mountain* called "the touchingly lustful embrace of what is destined to decay."[56]

With O'Keeffe there is also a haunting reminder of masks in her paintings of animal pelvis bones. Mounted on fences and walls at Ghost Ranch, the twin holes in the bones resemble eye holes in ghostly masks. O'Keeffe may have been aware that cultures as ancient as the Olmecs in the Americas had made masks of animal pelvis bones—hauntingly familiar, yet oddly strange (fig. 161). Two African

masks remained objects of interest for O'Keeffe, displayed prominently on the walls of her Abiquiu house in later years. There too, in an outdoor *zaguan*, or passageway, O'Keeffe embedded a tiny mask or head into the adobe wall. Probably a souvenir from her Mexican travels, it still casts a wary eye on those who pass through O'Keeffe's domain.

Masks occur as great forest denizens within Emily Carr's primal landscapes, as I discussed in Chapter 2. Like vestiges of ancient beings, they populate her timbered tracts, making sanctuaries of ordinary spaces and hinting at the interiority hidden within Carr herself. The brooding faces Carr copied from carved totem poles speak of her respect for the religious traditions of Canada's First Peoples. The writer K. P. Stich observes another way in which Carr's twin self-concepts as writer and painter developed with relation to masks: "One self is concentrated into Small. The other self expands ultimately into the woods, the sea and the mountains; in other words it grows into the vast wilderness she sees personified in the carved figure of D'Sonoqua. . . . Small is, I think, essentially Carr's mask as a writer; D'Sonoqua is the maternal mask behind which she grows as a painter."[57]

It suited Carr to withdraw behind visual or verbal constructs to mask a self she alternately protected and presented. The presence of masks and the element of masking in the work and lives of Carr, O'Keeffe, and Kahlo provide an intriguing approach to intersections of their private and public selves. Does looking at masks in the work of the three painters reward the careful observer with an understanding of the metaphorical dimensions of their work? No, but it argues for the existence of that element in compelling ways.

How successful were these artists in presenting themselves to the world? How closely do their reputations coincide with their own conceptions of self? And how can we account for their unprecedented success as cultural heroes of the twentieth century? O'Keeffe's artistic personality—part her own making, part critical invention—contributed to the appeal of her painting, turning familiar, memorable images into popular ones as well. In them lies a curious combination of distance and imagined intimacy, with the subject and with the painter. Ostensibly straightforward, they seem to hold few secrets; only long, slow looking suggests the artist's private, internal search. Frequently viewers have said that they feel summoned to participate with O'Keeffe in a momentary experience of awe. For some, she stimulates their own generative sensations in the face of nature.

O'Keeffe made paintings that are reductive in the extreme, with the paradoxical result that they are somehow

161
Ancient Olmec mask made from a pelvic bone.

personal and romantic in the opposite extreme. Their arcane beauties changed over time. She moved from identification with her own experiences, seen in the early sensation-derived work, to paintings that identify with the whole of being.

And yet her art has never encouraged anonymity. Partly because of the criticism accorded it, O'Keeffe's work became the art of "a great personality," mythologized in somewhat the same manner Picasso's was. And similarly, critics have come to recognize in both those artists that the well of inventiveness was not inexhaustible. Both Picasso and O'Keeffe were immensely protean: both absorbed, used, and expanded everything that came their way. Picasso's eclecticism was more overt, O'Keeffe's so richly and complexly melded that it is difficult to separate out sources and influences.

If O'Keeffe's paintings move from private sensation to larger realms of perception, Frida Kahlo's move in the opposite direction—from the outside in. So intimate, piercing, and individual that they defy conceptual enlargement, one can scarcely imagine them transposed (as they have been) into a universal rhetorical key. Kahlo found the pain of her own life unendingly interesting; the viewer finds it impossible to participate fully with her in her continuing crisis of subjectivity. Like a laboratory experiment in which unstable chemical compounds move from one form to another and back again, Kahlo fed history, myth, and symbol into the experience trapped within a single body, only to disgorge it onto canvas, a process she portrayed in *Without Hope* (see fig. 147). Though here—as in many of Kahlo's works—it is difficult to determine her precise meaning, she managed to convey perfect clarity in ambiguity. Ultimately, her body became the seen or unseen premise beneath each act of painting—simultaneously a site of painful reality and a site of exile from ordinary reality.

Emily Carr's art, on the other hand, was a process of slow, searching ascent, marked by long interruptions, sealed-off corridors, and remembered resentments. For many years she searched for a private language, a voice with which to explain her experience with nature. After she found it, she worked that voice in registers that spiraled upward and out from the whispered intimacies of the forest enclosure to full-throated crescendos. What surprises viewers in the end is how literal, in effect, her reverence for nature became: heaven, she insists, pulses in the sky's ceaseless rhythms, while earth's best prospects for holiness reside in the urgent growth of all living things. Carr's art tried to contain those energies, to fix them momentarily on surfaces from which they seem always ready to rise. Though her paintings began as original narration of her own experience, she learned to give shape as much to what she imagined as to what she saw. Those images have taken generations of viewers on journeys of discovery into Carr's creative imagination and into their own.

The lives of painters can fascinate us because if all art is in some measure autobiographical, their paintings provide not maps but glimpses of the terrain through which their journeys can be tracked. Needing female heroes in the arts, viewers

have constructed a mythic stature for O'Keeffe, Carr, and Kahlo, drawn as much from the raw material of their lives as from their artistic achievements. They stand at the crossroads of art and personal celebrity, the objects of almost obsessive mass-media attention. Public deification has taken place, and with it impossible demands on reputations and achievements. In death, released from many other restrictions, they have become, nearly, prisoners of their own inflated symbolism. When, as John O'Brian reminds us, the Vancouver School of Art became the Emily Carr College (later Institute) of Art and Design, legitimate questions were raised by students who thought the name sounded like a "girls' finishing school" and by a feminist artist who felt that such gestures merely released the government from giving any further serious consideration to the feminine "other" in art.[58]

Carr's legacy, strongest in British Columbia, looms over the broader reaches of Canada as well. Canadian painters struggle with it: for decades artists like Jack Shadbolt and David Alexander have called Carr a vital link to romantic landscape traditions as well as an obstacle they must overcome in finding their own expressions.[59] So it is with O'Keeffe's legacy in the United States. And Kahlo—what a great iconic burden she has been asked to carry! Theological icon, kitsch idol, emblem of what is both accessible and forbidden, she appears almost infinitely adaptable, expansive and profitable, a mirror for the commercial projections of others.

The risk for all these artists' reputations is that they are being frozen into commodities and captive icons. There is a disadvantage in enshrining these painters prematurely: making a deceased artist into a dominant cultural figure confers honor while simultaneously circumscribing her possible influence. It presses us to fix her in ideological systems, artistic lineages, and institutional frameworks that may prematurely quiet a still-evolving voice.

Chronology

Georgia O'Keeffe **Frida Kahlo**

1887

born in Sun Prairie, Wisconsin, 15 November 15,
daughter of Francis Calyxtus O'Keeffe and
Ida Totto O'Keeffe; spends early childhood on
family's prosperous dairy farm

1902

O'Keeffe family moves to Williamsburg, Virginia

1903

enrolls at Chatham Episcopal Institute (later
Chatham Hall), Chatham, Virginia; meets first
female mentor, instructor Elizabeth May Willis

1904

leaves England, spends two weeks in Toronto, eight weeks in Cariboo; returns to Victoria in October

1905

publishes political cartoons in *The Week*, local Victoria paper

1906

moves to Vancouver, again teaches children's art classes

1907

travels with sister Alice to Sitka, Alaska, and the Yukon; decides to document Indian totem poles in village settings

1908

travels to Alert Bay and Campbell River, B.C.

1909

becomes founding member of newly incorporated British Columbia Society of Artists; travels to mainland villages at Lillooet, Hope, and Yale

1910

travels with sister Alice to France for further art training; studies at Académie Colarossi; becomes ill and convalesces for a month in Sweden; back in France, studies privately with John Duncan Fergusson, Harry Gibb, and Frances Hodgkins

1911

October, exhibits two works (Nos. 245, 246) in Salon d'Automne, Paris; returns to Victoria in November

1912

January: opens studio in Vancouver and holds a studio show of her new work in March; summer, six-week trip north to visit Kwakiutl villages in Alert Bay area, Tsimshian villages in Upper Skeena River area and Haida settlements in Queen Charlotte Islands, British Columbia, from which many sketches, drawings, and paintings result

Georgia O'Keeffe　　　　　　　**Frida Kahlo**

1905

graduates from Chatham Episcopal Institute

1906

stricken with typhoid, first of many long
convalescences during her life

1907

enrolls at Art Students League, New York;
studies with F. Luis Mora, Kenyon Cox, William
Merritt Chase; sees exhibitions by Rodin
and Matisse at Alfred Stieglitz's Little Galleries of
the Photo-Secession (called 291 for its Fifth
Avenue address)

1907

born 6 July in Coyoacan, a suburb of Mexico
City; christened Magdalena Carmen Frieda
Kahlo y Calderon; parents are Matilde Calderon
y Gonzalez, a mestiza, and Guillermo Kahlo,
photographer, a German Jew of Austro-Hungar-
ian descent

1908

attends Art Students League summer school at
Lake George, New York

1908–10

works as commercial artist in Chicago drawing
lace and advertising logos; returns to live with
her family in Charlottesville, Virginia

1910

Mexican Revolution begins; in sympathy with
revolutionary aims, Kahlo often cites this as her
birth year

1911

works as substitute teacher at Chatham Hall, her
first teaching experience

1912

studies with Alon Bement at University of
Virginia summer school; begins teaching art for
two years in Amarillo, Texas, public schools

1913

hires a hall in Vancouver and exhibits nearly two hundred examples of her native subject work; petitions provincial government unsuccessfully to purchase it and to fund further documentation; delivers "Lecture on Totems"; moves back to Victoria and begins building an apartment house on Simcoe Street, the operation of which will occupy much of her time for the next twenty-two years

1916–17

in San Francisco for eight months, during which she paints decorations for St. Francis Hotel ballroom

1917–28

breeds sheep dogs, makes pottery and hooked rugs, paints relatively little

1920s

meets and befriends young artists visiting Victoria from Seattle, among them Mark Tobey

1921

through Sophie Pemberton and Harold Mortimer Lamb, Eric Brown of the National Gallery of Canada is informed of work

Georgia O'Keeffe **Frida Kahlo**

1913–16

summers: teaches art with Alon Bement at
University of Virginia summer school

1914

studies with Arthur Wesley Dow at Teachers
College, Columbia University, sees work
of Braque, Picasso, Marsden Hartley, and John
Marin at 291; joins National Woman's Party

1915

teaches at Columbia College, South Carolina;
makes large charcoal abstractions

1916

teaches in Canyon, Texas; paints her first South-
west landscapes; exhibits in group show at 291

1917

has her first solo exhibition at 291; visits New
York, meeting members of the Stieglitz circle;
Stieglitz photographs her for the first time; in
summer she vacations and paints in Colorado,
traveling via New Mexico

1918

suffers influenza attack, resigns teaching job in
Texas and moves to New York; begins relationship
with Stieglitz as protégée, regular photographic
model, lover

1918–29

O'Keeffe (GOK) and Stieglitz spend summers at
Lake George, winters in New York; GOK paints
still lifes, abstractions, city paintings

1921

Stieglitz exhibits photographs of GOK publicly;
Hartley praises her paintings in sexual terms

1923

undergoes surgery, probably for gall bladder

1924

resumes participation in group shows after absence of ten years; participates in Artists of the Pacific Northwest show in Seattle; thereafter exhibits fairly regularly during remainder of her life; enrolls in correspondence course in short-story writing with Palmer Institute of Authorship, Hollywood, California.

1925

participates in Artists of the Pacific Northwest show in Seattle

1926

visited first by Marius Barbeau, later by Eric Brown, who select Carr's paintings for "Canadian West Coast Art" exhibition in Ottawa

1927

travels to opening of "Canadian West Coast Art" exhibition, meets Lawren Harris and other members of the Group of Seven painters; begins a regular correspondence with Harris

1928

sells three watercolors to National Gallery of Canada; makes two-month trip north to native villages on Vancouver Island's northeast coast, then north along the mainland cost, up the Skeena River to Kitwancool; her book *Klee Wyck* later results from the places, characters, and experiences of this trip; Mark Tobey teaches master class in Victoria studio, paints his *Emily Carr's Studio*

Georgia O'Keeffe

Frida Kahlo

1922

attends National Preparatory School, Mexico City

1923

exhibits a hundred works at Anderson Galleries, New York City; Stieglitz shows 116 new photographs, including many of GOK

1924

GOK and Stieglitz exhibit paintings and photographs simultaneously at Anderson Galleries; GOK begins large floral and leaf paintings; GOK and Stieglitz marry

1925

GOK and Stieglitz move to Shelton Hotel, New York, from which she paints her first skyscrapers; Stieglitz opens Intimate Gallery, where GOK supervises most installations of exhibits, including her own subsequent annual shows

1925

severely injured in streetcar accident, Mexico

1926

paints first oil, *Self-Portrait Wearing a Velvet Dress*

1927

undergoes two surgeries for breast lump; slow recovery

1927

joins Young Communist League, Mexico

1929

again travels north to sketch and paint native villages at Nootka and Friendly Cove in May; publishes her article "Modern and Indian Art of the West Coast"; visits Port Renfrew in August; begins spiritual investigation of Theosophy in correspondence with Harris; exhibits at Women's International Exposition, Detroit

1930

has solo show at Crystal Garden Gallery, Victoria; addresses Women's Canadian Club of Victoria; visits Toronto and New York, where she meets Katherine Dreier and Georgia O'Keeffe, sees the work of Kandinsky, Burchfield, Dove, Roerich; exhibits in "Contemporary Canadian Artists" show sponsored by American Federation of Arts at Corcoran Gallery, Washington, D.C.; makes her last trip north to native villages at Alert Bay and Quatsino Sound; solo show at Seattle Art Museum, with twenty-seven old and new Indian motif paintings, seven landscapes

1931

included in Ontario Society of Arts Annual Exhibition, Toronto; shows with Group of Seven at Art Gallery of Toronto; wins first award in watercolors at 17th Annual Exhibition of Northwest Artists, Seattle; camps and sketches with Edythe Hembroff at Cordova Bay and Goldstream Park; in winter paints portraits

1932

tries to promote a People's Gallery in her Simcoe Street house; begins sketching with gasoline-thinned paint on manila paper, a practice she continues for several years

Georgia O'Keeffe

Frida Kahlo

1929

spends most of the summer painting in Taos, New Mexico, as guest of Mabel Dodge Luhan; learns to drive and purchases a Ford; Stieglitz opens An American Place

1929

marries Diego Rivera, 21 August

1930

exhibits New Mexico subjects at An American Place; revisits New Mexico (and most summers thereafter until she moves there), begins first paintings based on animal bones

1930

Kahlo (FK) and Rivera live in Cuernavaca, where Rivera paints murals at Cortés Palace for American Ambassador Dwight W. Morrow; in November FK and Rivera travel to San Francisco, meet Imogen Cunningham, Dr. Leo Eloesser, Edward Weston; Rivera paints murals at San Francisco Stock Exchange Luncheon Club and California School of Fine Arts

1931

FK, while staying at Stern home in Atherton, California, paints portrait of horticulturist Luther Burbank; then paints wedding portrait, *Frida Kahlo and Diego Rivera*; later exhibits it at 6th Annual Exhibition of the San Francisco Society of Women Artists; FK and Rivera return to Mexico, then sail to New York for Rivera's show at the Museum of Modern Art; Mexican folk art exhibited at Metropolitan Museum of Art, New York; probably meets Georgia O'Keeffe for the first time during this period

1932

travels to Gaspé Peninsula in Canada; accepts commission for mural at women's room, Radio City Music Hall, but technical problems halt the work; suffers nervous breakdown, abandons painting for more than a year

1932

FK and Rivera travel to Detroit where he paints murals at the Detroit Institute of Arts; FK tries to learn to drive; pregnancy of $3^1/_2$ months miscarries; spends 13 days at Henry Ford Hospital, Detroit; in September, learning of her mother's grave illness, travels to Mexico; Matilde Kahlo dies; FK returns to Detroit in October

1933

British Columbia College of Arts formed; shows with the Group of Seven painters in Toronto; purchases old caravan trailer, "The Elephant," for painting and camping; spring and summer sketching trips to British Columbian interior; visits Chicago and Toronto in November, renews contact with Harris

1934

takes short-story writing course at Provincial Normal School, Victoria; another in the fall at Victoria High School

1934–35

takes summer sketching trips in her van

1935

sketches at Albert Head, Metchosin

1936

ends work as a landlady by trading her Simcoe Street apartment house and moving to a smaller house on Beckley Avenue, Victoria; camps near gravel pit, Metchosin; exhibits in Canadian Group of Painters traveling show; sister Lizzie dies; loan exhibition of Van Gogh painting shown at Art Gallery of Toronto, stimulating Canadian critical writing in the direction of formalist concerns

1937

has heart attack and spends time writing during recovery; visited by noted critic Eric Newton; exhibits with Canadian Group of Painters at Art Gallery of Toronto

Georgia O'Keeffe

Frida Kahlo

1933

hospitalized in New York for psychoneurosis, recuperates in Bermuda and Lake George

1933

arrives in New York with Rivera, who is commissioned to paint mural at Rockefeller Center; they remain eight months; paints *My Dress Hangs There*; Rivera's Rockefeller Center commission canceled; FK and Rivera return to Mexico late in the year; move into their new double house with separate living quarters and studios in San Angel; New York Museum of Modern Art mounts exhibition "American Sources of Modern Art," tracing relation of Aztec, Incan, and Mayan art to contemporary art

1934

has retrospective of forty-four paintings at Stieglitz's gallery; Metropolitan Museum of Art buys a painting; GOK returns to New Mexico, where she visits Ghost Ranch

1934

Rivera has affair with Cristina Kahlo; FK takes apartment in Mexico City, cuts her hair; travels to New York with Anita Brenner and Mary Schapiro; makes no paintings this year; has appendix removed, another miscarriage, and the first of many foot surgeries

1935

paints *Self-Portrait with Curly Hair* and *A Few Small Nips*; has affairs with Ignacio Aguirre, Isamu Noguchi; travels to New York; reunites with Rivera at their San Angel home late in the year

1936

FK and Rivera join fundraising effort for Mexicans fighting on side of Loyalists in Spanish Civil War

1937

stays at Ghost Ranch, July–December; travels in the West with Ansel Adams and other friends

1937

Leon Trotsky and Mme. Trotsky arrive in Tampico, become guests of Rivera and FK at Casa Azul

Emily Carr

Chronology

1938
has solo show at Vancouver Art Gallery; also exhibits at University of British Columbia, Victoria; shows with Canadian Group of Painters in Ottawa and Montreal; included in "A Century of Canadian Art" in London; begins to spend more time writing; Ira Dilworth reads her stories, later becomes her editor and literary executor

1939
has second heart attack in March; exhibits paintings at New York World's Fair and at Golden Gate Exposition, San Francisco

1940
has minor heart attack in March, stroke in May; moves to St. Andrews Street, Victoria, next door to sister Alice; stories read on CBC radio

1941
Klee Wyck wins Governor General's award for best book published in Canada that year; Lawren Harris's article "Emily Carr and Her Work" published in *Canadian Forum*; two articles by Ira Dilworth on her work published in *Saturday Night*; University Women's Club of Victoria holds gala celebration of her seventieth birthday

1942
publishes *Book of Small*; exhibits with Canadian Group of Painters in Toronto, Montreal, and Ottawa; Emily Carr Trust founded to oversee her artistic and literary work; makes last outdoor sketching trip; failing health forces more time in hospitals and nursing homes

Georgia O'Keeffe

Frida Kahlo

1938

André Breton and his wife Jacqueline Lamba visit Mexico; Breton, Rivera, and Trotsky publish "Toward an Independent Revolutionary Art" in *Partisan Review*; FK makes her first major sale: four paintings to actor Edward G. Robinson; she exhibits twenty-five paintings at Julien Levy Gallery, New York in November, for which Breton writes catalogue preface; renews acquaintance with O'Keeffe at the opening of this show

1939

honored at New York World's Fair as one of twelve outstanding women of past fifty years; paints in Hawaii, later becomes ill and exhausted

1939

sails to France, January; stays with the Bretons in Paris until hospitalized with a kidney inflammation; exhibits in "Mexique" show at Galerie Renou et Colle, Paris, for which Marcel Duchamp helps with exhibition arrangements; returns to Mexico; FK and Rivera divorce in November

1940

buys house at Ghost Ranch, New Mexico, during six-month visit

1940

included in three exhibitions: International Surrealism Exhibition sponsored by the Galeria de Arte Mexicano, Mexico City; "Contemporary Mexican Painting and Graphic Art," Palace of Fine Art, Golden Gate International Exhibition, San Francisco; "Twenty Centuries of Mexican Art," Museum of Modern Art; FK and Rivera suspected in assassination plot which kills Trotsky; Rivera flees to San Francisco, FK jailed for two days in Mexico; FK and Diego Rivera remarry in San Francisco, 8 December; agree to share household expenses, forgo physical relationship, and move into Casa Azul

1941

included in "Modern Mexican Painters" at Institute of Contemporary Arts, Boston; selected as one of twenty-five founding members of Seminario de Cultura Mexicana, Ministry of Education

1942

participates in two New York exhibitions: "Thirty-One Women" at Peggy Guggenheim's Art of This Century Gallery and the "First Papers of Surrealism" exhibit sponsored by Coordinating Council of French Relief Societies

1944

has large retrospective show at Dominion Gallery, Montreal, from which many paintings are sold; suffers another stroke, but continues to paint and write in bed; publishes *House of All Sorts*

1945

dies 2 March at St. Mary's Priory, Victoria; buried in Ross Bay Cemetery, Victoria; given memorial exhibition at Art Gallery of Toronto; show travels to Ottawa and Montreal; bulk of this work passes eventually to Vancouver Art Gallery

1946

memoir *Growing Pains* published, with foreword by Ira Dilworth

1947

work included in Canadian Women Artists exhibition at Riverside Museum, New York

1949–50

Emily Carr Memorial Exhibition, University of Washington

Georgia O'Keeffe

Frida Kahlo

1943

has full-scale retrospective at Art Institute of Chicago; begins series based on animal pelvis bones

1943

appointed painting professor at La Esmeralda, Education Ministry's School of Painting, Mexico; students paint murals at neighborhood *pulqueria* (bar); "The Latin American Collection of the Museum of Modern Art" exhibition shown at Art Gallery of Toronto

1944

exhibits pelvis and cottonwood tree subjects in her annual exhibition at Stieglitz's gallery An American Place

1944

begins a diary, continues it until her death; paints *The Broken Column*, two versions of *Diego and Frida, 1929–1944*

1945

acquires ruined adobe house in Abiquiu; with friend Maria Chabot undertakes a three-year restoration project, after which the house is occupied as O'Keeffe's winter home and studio

1945

awarded 25,000 peso prize for *Moses* at the national exhibition at the Palace of Fine Arts, Mexico City

1946

given retrospective at Museum of Modern Art, New York, the first solo show there of a woman's work; begins patio series at Abiquiu, continues it until 1960; Alfred Stieglitz dies in New York, 13 July

1946

travels to New York for bone graft operation in which a metal rod is implanted in her spine and four vertebrae are fused with bone extracted from her pelvis; paints *The Little Deer* and *Tree of Hope, Hold Firm*; begins an affair with Josep Bartoli, a Spanish refugee artist

1949

After three years of settling Stieglitz's estate and painting little, moves permanently to New Mexico and into her renovated adobe house at Abiquiu; closes An American Place gallery; Edith Halpert's Downtown Gallery becomes her new dealer (until 1963)

1949

paints *Diego and I*; and *The Love Embrace of the Universe: the Earth (Mexico), Diego, Me, and Senor Xolótl*. Rivera given fifty-year retrospective of five hundred works at Palacio Nacional de Bellas Artes, Mexico City

1950

undergoes further spinal surgery; hospitalized for nearly a year in English Hospital, Mexico City

1953

Two books by published: *Pause* (her memoir of fifteen months in a Suffolk sanatorium); and *The Heart of a Peacock* (bird and Indian sketches)

1955

"An Address" (transcript of her 1930 talk at the Crystal Gardens) published

Georgia O'Keeffe

Frida Kahlo

1951

visits Mexico, including Yucatán, Oaxaca, and Guadalajara; visits Frida Kahlo twice in Mexico City

1952

exhibits twenty-four pastels (made 1915–45) at Downtown Gallery

1953

makes first trip to Europe (France and Spain)

1953

has first solo show in Mexico at Galeria Arte Contemporaneo; gangrenous right leg partially amputated

1954

visits Spain for three months

1954

dies in Mexico City, 13 April; cause of death listed as "pulmonary embolism": some suspect suicide

1955

Rivera gives Casa Azul, including its art collection and furnishings, to the people of Mexico to perpetuate FK's memory

1956

makes three-month trip to Peru, paints Andean and coastal subjects

1957

makes return visit to Oaxaca

1958

Casa Azul opens as museum, an effort spearheaded by Mexican poet Carlos Pellicer

1959

travels around the world for 3½ months (India, Japan, Hong Kong, Taiwan, Southeast Asia, Pakistan, the Middle East, Rome); begins painting aerial views of rivers

1960

has fourth retrospective exhibition, at Worcester (Mass.) Art Museum; takes six-week trip to Asia and the Pacific

1961

makes seven-day raft trip on Colorado River

1962

artifacts and more than a hundred paintings
(most pre-1913) purchased for Provincial
Archives, Victoria

1966

*Hundreds and Thousands: The Journals of Emily
Carr* published

1972

Fresh Seeing: Two Addresses by Emily Carr
published

Georgia O'Keeffe

Frida Kahlo

1962

elected to American Academy of Arts and Letters

1963

travels to Greece, Egypt, and the Middle East

1964

opening of Anahuacalli, the museum planned by Rivera and Kahlo to house his collection of Aztec and Mayan art

1966

has retrospective at Amon Carter Museum, Fort Worth, Texas; travels to England and Austria

1968

hires Doris Bry as agent, replacing Downtown Gallery

1969

makes second raft trip on Colorado River

1970

Whitney Museum of American Art, New York, holds major GOK retrospective

1971

vision fails, leaving only peripheral sight

1972

makes last unassisted painting in oil

1973

meets and hires Juan Hamilton as assistant; makes hand-built clay pots

1974

visits Morocco, writes text for *Some Memories of Drawings*

1975

paints watercolors and assisted oils

1976

travels to Antigua, publishes *Georgia O'Keeffe*

1979
First full-length studies of Carr published

Georgia O'Keeffe

1978

exhibition "Georgia O'Keeffe: A Portrait by Alfred Stieglitz" opens at Metropolitan Museum of Art

1979

travels to Costa Rica and Guatemala

1982

travels to Hawaii; exhibits large abstract sculpture at San Francisco Museum of Modern Art

1983

visits Ansel Adams in California three times; also visits Costa Rica

1986

dies in Santa Fe, New Mexico, 6 March

1987

Major retrospective of GOK's work opens at National Gallery of Art, Washington, D.C., with catalogue of her art and letters

1989

Georgia O'Keeffe Foundation established

1995

Georgia O'Keeffe Museum established, Santa Fe

1997

Georgia O'Keeffe Museum opens; exhibition "Georgia O'Keeffe: A Portrait by Alfred Stieglitz" again shown at Metropolitan Museum of Art

1999

O'Keeffe catalogue raisonné published

Frida Kahlo

1977

national exhibition of Kahlo's work at Palacio de Bellas Artes, Mexico City

1978

traveling exhibition of FK's work in United States, organized by the Museum of Contemporary Art, Chicago

1982

exhibition "Frida Kahlo/Tina Modotti" organized by the Whitechapel Art Gallery, London; it travels to Berlin, Hamburg, Hanover, Stockholm, New York, Monterrey, Saltillo/Coahuila, and Mexico City; sets off renewed interest in FK and encourages many further publications and exhibitions

1996

exhibition "Frida Kahlo, Diego Rivera and Mexican Modernism from the Gelman Collection" opens at San Francisco Museum of Modern Art

1997

works from the Collection of the Museo Dolores Olmedo Patiño travel to Helsinki, Barcelona, Oslo, and Copenhagen

Notes

Introduction

1 Emily Carr, letter to Ira Dilworth, c. 1942, quoted in Doris Shadbolt, *The Art of Emily Carr* (Vancouver: Douglas and McIntyre, 1979), 40; Harris, quoted in David Alexander and John O'Brian, *Gasoline, Oil and Paper: The 1930s Oil-on-Paper Paintings of Emily Carr* (Saskatoon: Mendel Art Gallery, 1995), 32.

2 Emily Carr, journal entry for 8 February 1940, *Hundreds and Thousands: The Journals of Emily Carr* (Toronto: Clarke, Irwin, 1966), 315 (hereafter cited as *HT*).

3 Stendahl, quoted in Simone de Beauvoir, *The Second Sex* (1949; New York: Vintage, 1953), 149. There are parallels here with what Alois Riegl has called the "absolute will to Art" and Wilhelm Worringer has discussed in terms of the reproduction of nature in essentialized form. Otto Rank (whose *Art and Artist* is cited elsewhere) continued that discussion, as has Ann Truitt in her *Daybook: The Journal of an Artist* (New York: Penguin, 1982), 23 ff.

1

Nationality, Region, and the Cultural Landscape

1 Peter Schjeldahl, pers. comm., 28 February, 2000.

2 Diego Rivera, quoted in Hayden Herrera, "Beauty to his Beast," in Whitney Chadwick and Isabelle de Courtivron, eds., *Significant Others: Creativity and Intimate Partnership* (London: Thames and Hudson, 1993), 133.

3 Modern scholars disagree on the character of Aztec civilization. Some hold that the Aztecs practiced a kind of tribal democracy (which Kahlo and Rivera preferred to identify as communism), while others see them variously as a totalitarian society, piratical freebooters, or a supremely humanistic people. Probably some of each element existed in the culture. See, for example, Benjamin Keen, *The Aztec Image in Western Thought* (New Brunswick, N.J.: Rutgers University Press, 1971), 3 ff.

4 Fuentes, introduction to Sarah M. Lowe, ed., *The Diary of Frida Kahlo: An Intimate Self-Portrait* (New York: Abrams, 1995), 8.

5 Esther Pasztory, *Aztec Art* (New York: Abrams, 1983), 89.

6 For more on the Whitman-Aztec connection, see Peter T. Markman and Roberta H. Markman, *Masks of the Spirit: Image and Metaphor in Mesoamerica* (Berkeley: University of California Press, 1989), 150.

7 Kahlo's familiarity with Aztec culture and language is demonstrated in her inscription of Nahuatl words in her diary. See Lowe, ed., *Diary of Frida Kahlo*, diary pages 49, 117.

8 Octavio Paz, "Art and Identity: Hispanics in the United States," in *Hispanic Art in the United States*, Exhibition catalogue (New York: Abbeville and Houston Museum of Fine Arts, 1987), 25–26. Still another notable Latin American mother goddess of interest here is Pachamama, the Andean earth-mother deity, who has often been connected to the Virgin Mary, particularly through a well-known eighteenth-century Peruvian painting *The Virgin of the Cerro Postosi*, in which Mary's hands and head seem to arise from within the mountain.

9 Kahlo, letter to Alejandro Gómez Arias, 20 October 1925, in Martha Zamora, comp., *The Letters of Frida Kahlo: Cartas Apasionadas* (San Francisco: Chronicle, 1995), 21–22 (hereafter cited as *Letters*).

10 This is just one of many versions of La Llorona, whose story has evolved in multiple ways and who is still used throughout Latin America and the southwestern United States as a warning to disobedient or wandering children. The parallel of her story with that of Lilith, the feared rebel-woman of Hebrew tradition, has been widely noted. For more on La Llorona see Marta Weigle, *Spiders and Spinsters: Women and Mythology* (Albuquerque: University of New Mexico Press, 1982), 255–56; Clarissa Pinkola Estes, *Women Who Run with the Wolves* (New York: Ballantine, 1992), 301 ff.; and Tey Diana Rebolledo, *Women Singing in the Snow: A Cultural Analysis of Chicana Literature* (Tucson: University of Arizona Press, 1995), 76–81.

11 Kahlo, letter to Alejandro Gómez Arias, 13 October 1925, reprinted in Zamora, comp., *Letters*, 20. In a letter to Dr. Leo Eloesser, 26 May 1932, Kahlo confides her fear that La Pelona might take her away during her current precarious pregnancy, and accompanies that remark with a drawing of a skull and crossbones. See Zamora, comp., *Letters*, 48. In world myth and folklore the archetypal creature La Pelona has other names: Baba Yaga, Hel, Berchta; to the ancient Greeks she was a collective entity known as the Graeae. See Estes, *Women Who Run with the Wolves*, 136.

12 For more on Malinche, including the frequent discussion of her by modern Chicana writers, see Rebolledo, *Women Singing*, 62–63; and Ana Castillo, *Massacre of the Dreamers: Essays on Xicanisma* (New York: Penguin, 1995).

13 Charlotte McGowan, "The Philosophical Dualism of the Aztecs," *Katunob* (December 1977), 42; Frida Kahlo, "Portrait of Diego" [1949], reprinted in Zamora, *Letters*, 150; Kahlo, "Moses" [1945 speech], reprinted in Zamora, *Letters*, 122. For concurring views on the merger of Cihuacóatl into La Llorona, see also Donald A. MacKenzie, *Myths of Pre-Columbian America* (London: Gresham, n.d.), 231; and Octavio Paz, *The Labyrinth of Solitude*, trans. Lysander Kemp (New York: Grove, 1961), 75. In other contexts the syncretic image of La Llorona shares aspects with Mocihuaquetzque (women who died in childbirth), and with Coatlicue, who in modern myth sometimes also roamed the crossroads. In folklore La Llorona and La Malinche have sometimes merged into a doubly negative figure, as in Rudolfo Anaya's *The Legend of La Llorona* (Berkeley: Tonatiuh-Quinto Sol, 1984). See also Rebolledo, *Women Singing*, 62–81.

In the complex linkage among these chthonic divinities, note that Tonantzin was the goddess on whose sacred hill the peasant Juan Diego saw a vision of the Virgin Mary, who thenceforth was revered in Latin America as Guadalupe, patron of indigenous peoples. A whole cluster of goddesses related to maternity existed in the Valley

of Mexico, all expressing the multiple Terrible Mother aspects of lavish fecundity and horrifying death. As earth mothers, they embody the duality of earth as both womb and tomb of life. See Patricia Harrington, "Mother of Death, Mother of Rebirth: The Mexican Virgin of Guadalupe," *Journal of the American Academy of Religion* 56, no. 1 (Spring 1988), 25–50.

The monumental stone Coatlicue was discovered in 1790, after which it was much studied and celebrated both in Mexico and abroad. Leon y Gama published an analysis of it in 1792, and Baron Alexander von Humboldt made it famous by including it in a large album called *Vue des cordillères et monuments des peuples indigènes de l'Amérique*, published in Paris in 1810.

14 Miguel Léon-Portilla, *Aztec Thought and Culture: A Study of the Ancient Nahuatl Mind*, trans. Jack Emory Davis (Norman: University of Oklahoma Press, 1963), 53.

15 George C. Vaillant, *Aztecs of Mexico: Origin, Rise and Fall of the Aztec Nation* (1944; rev. ed. Baltimore: Penguin, 1962), 170.

16 The German Americanist Edward Seler wrote of these ancient rites. See Weigle, *Spiders and Spinsters*, 67. Coatlicue, as Vegetation Goddess, was also invoked to keep the exuberant jungle at bay, a possible alternative meaning here. See Buffie Johnson, *Lady of the Beasts* (San Francisco: Harper Collins, 1988), 163. Kahlo's decapitated self appears in a study for her *Remembrance of an Open Wound* (1938; destroyed), reproduced in Hayden Herrera, *Frida Kahlo: The Paintings* (New York: Harper Collins, 1991), 115.

17 See Raquel Tibol, *Frida Kahlo: An Open Life*, trans. Elinor Randall [1983] (Albuquerque: University of New Mexico Press, 1993), 72. My thanks to Dr. Jill Furst for the information about Chalchiutlicue's role.

18 Kahlo, "Moses," in Zamora, comp., *Letters*, 121.

19 See Zamora, comp., *Letters*, 30.

20 Kahlo drew herself with netted hair on other occasions—twice, for example, during her hospitalization following a miscarriage in Detroit in July 1932. In those drawings, reproduced in Herrera, *Kahlo: The Paintings*, pp. 72 and 77, the

nets also suggest despair and mourning. For more on Matlachiuatl, especially as a variant of La Llorona, see Betty Leddy, "La Llorona Again," *Western Folklore* 9 (1950), 363–65.

21 Kahlo's letter refers to her 1926 self-portrait and is reprinted in Zamora, comp., *Letters*, 37; the Nefertiti reference is quoted in Hayden Herrera, *Frida: A Biography of Frida Kahlo* (New York: Harper and Row, 1983), 482 (hereafter cited as *Frida*); "Neferisis" is in Lowe, ed., *Diary of Frida Kahlo*, 220–21.

22 See Hayden Herrera, *Kahlo: The Paintings*, 112.

23 See, for example, Mary Garrard, *Artemisia Gentileschi* (Princeton: Princeton University Press, 1989), 271.

24 Merlin Stone, *When God Was a Woman* (New York: Dial, 1976), 219. Kahlo was not alone among women artists in her interest in Isis. Whitney Chadwick suggests that Leonora Carrington and Remedios Varo, both Europeans who settled in Mexico in 1942, also included references to Isis in their paintings. Chadwick, *Women Artists and the Surrealist Movement* (Boston: Little, Brown, 1985), 214–15.

25 E. A. Wallis Budge, *Gods of the Egyptians*, 2 vols. (New York: Dover, 1969), 1:519, 2:90.

26 Fray Bernardino de Sahagún, *Florentine Codex: General History of the Things of New Spain*, trans. Charles E. Dibble and Arthur J. O. Anderson, 13 vols. (Santa Fe: School of American Research and University of Utah, 1961), 11:55–56.

27 For more on *What the Water Gave Me*, see Herrera, *Kahlo: The Paintings*, 125–28; and Sarah M. Lowe, *Frida Kahlo* (New York: Universe, 1991), 91–93.

28 Kahlo, quoted in Herrera, *Frida*, 199.

29 See Lowe, ed. *Diary of Frida Kahlo*, 36, 67. A photograph of the letter box appears in a Erika Billeter, ed. *The Blue House: The World of Frida Kahlo* (Houston and Seattle: Museum of Fine Arts and University of Washington Press, 1993), 43.

30 Townsend, quoted in Markman and Markman, *Masks of the Spirit*, 139.

31 Graham McInnes, quoted in Gerta Moray, "Northwest Coast Native Culture and the Early Indian Paintings of Emily Carr, 1899–1913," Ph.D. diss., University of Toronto 1993, 37.

32 Paula Blanchard, *The Life of Emily Carr* (Seattle: University of Washington Press, 1987), 21.

33 Carr, *Growing Pains,* in *The Emily Carr Omnibus* 1946 (1946; Vancouver: Douglas and McIntyre, 1993), 312.

34 Laura Mulvey and Peter Wollen, "Frida Kahlo and Tina Modotti," in Mulvey, *Visual and Other Pleasures* (Bloomington: Indiana University Press, 1989), 96.

35 MacDonald, quoted in Roald Nasgaard, *The Mystic North: Symbolist Landscape Painting in Northern Europe and North America 1890–1940* (Toronto: Art Gallery of Ontario and University of Toronto Press, 1984), 3. The Scandinavian exhibition, which opened in January in Buffalo and subsequently traveled to Boston and Chicago, was considerably more conservative than the Armory Show, which also traveled to Boston and Chicago. Among the artists represented in the Scandinavian show were Anders Zorn, Edvard Munch, and a few modernists, whose innovations seem to have been ignored by the visiting Canadians. Contemporary critics remarked on the greater complexity of Armory Show innovation as compared with the Scandinavian work.

36 The original members of the Group were Lawren Harris, J. E. H. MacDonald, A. Y. Jackson, Arthur Lismer, Frederick Varley, Franklin Carmichael, and Frank Johnston. Later, following Johnston's withdrawal, three more members were added: A. J. Casson of Toronto, Edwin Holgate of Montreal, and Lionel LeMoine FitzGerald of Winnepeg. Lawren Harris remained the Group's guiding spirit, and it was he who befriended and encouraged Emily Carr. His influence and Carr's relationship with the Group will be discussed later. On the Group of Seven, see Dennis Reid, *The Group of Seven* (Ottawa: National Gallery of Canada, 1970); Peter Mellen, *The Group of Seven* (1970; Toronto: McClelland and Stewart, 1981); Charles C. Hill, *The Group of Seven: Art for a Nation* (Ottawa: National Gallery of Canada, 1995); and Megan Bice, "Time, Place and People," in Megan Bice and Sharyn Udall,

The Informing Spirit: Art of the American South-west and West Coast Canada, 1925–1945 (Kleinburg, Ont: McMichael Canadian Art Collection and Taylor Museum, Colorado Springs, 1994), 47–94.

37 Catalogue, quoted in Bice, "Time, Place, and People," 47; Frederick B. Housser, *A Canadian Art Movement: The Story of the Group of Seven* (Toronto, 1926), 24. From the beginning the Group's exhibitions at the Art Gallery of Toronto (now the Art Gallery of Ontario) were accompanied by catalogues containing statements of their beliefs. In words strikingly similar to those used by Alfred Stieglitz and his circle to describe their goals, the Group declared in 1922, "Artistic expression is a spirit, not a method, a pursuit, not a settled goal, an instinct, not a body of rules" (Foreword, *Group of Seven Exhibition of Paintings* [Toronto: Art Gallery of Toronto, 1922]). Specifically, the symbolist notion that the Group credo centered around a spirit or idea (rather than firm aesthetic rules) is reminiscent of Stieglitz's question concerning his innovative gallery called 291, "What Is '291'?" The answers, published in the July 1914 issue of *Camera Work,*, included responses from his own circle. Arthur Dove, for example, called 291 "what the observer sees in it—an idea to the 7th power." Critic Charles Caffin declared, "To me '291' represents an Idea. . . . The Soul of the Idea has been the liberty of spiritual growth." Future members of the Group of Seven, though not yet ready to form their own official circle, might well have seen these issues of *Camera Work.*

38 Emily Carr, notebook, 1913, quoted in Bice, "Time, Place and People," 52; Carr, *Growing Pains,* 427; Carr, *Sunlight in the Shadows* (Toronto: Oxford University Press, 1984), n.p. This volume is a publication of Carr's April 1913 notebook. Carr was not alone in the idea of recording totem poles. Theodore Richardson, a Minneapolis artist whom she met in Sitka in 1907, had been systematically documenting the villages of the Alaskan natives since 1884. Part of that time he had worked under contract to the Smithsonian Institution and

had become successful selling his work in New York. Richardson saw Carr's watercolors and encouraged her in her documentary efforts.

39 James Clifford, *The Predicament of Culture: Twentieth-Century Ethnography, Literature, and Art* (Cambridge: Harvard University Press, 1988), 4. Attitudes toward native culture and land claims in British Columbia were long tinged with colonialism. For an account of the ways the narratives of early missionaries, anthropologists, and ethnologists contributed to public attitudes about native peoples, see Moray, "Northwest Coast Native Culture," 109–55. One of Carr's critics is Marcia Crosby, a Canadian art historian of native descent, whose objections to Carr's "Indian paintings" focus on their representations of totem poles and native villages. Crosby argued that Carr's works were "predicated on the concept of a dead or dying people," as questionable a notion at the turn of the century as it is now ("Construction of the Imaginary Indian," in *Vancouver Anthology: The Institutional Politics of Art*, ed. Stan Douglas [Vancouver: Talonbooks, 1991]). Heated critical debate has since surrounded Carr's "Indian paintings," often portraying them as fantasies of colonialist fulfillment. More recently, Gerta Moray has followed the controversy, studying Carr's own conflict between documentation and desire in her "Northwest Coast Native Culture and the Early Indian Paintings of Emily Carr."

40 Carr, *Growing Pains*, 431.

41 Carr, *An Address* (1930; Toronto: Oxford University Press, 1955), 11.

42 The closest and most enduring of those friendships was with Sophie Frank of North Vancouver. Carr also kept in touch with William and Clara Russ at Skidegate, Mrs. Douse at Kitwancool, and George Hunt at Fort Rupert.

43 Claude Lévi-Strauss, *The Way of the Masks* (1975; Seattle: University of Washington Press, 1982), 59. Kwakiutl is the traditional spelling of this group's name, though it should be noted that Kwakwaka'wakw is today's preferred spelling among First Nations people, more accurately reflecting the pronunciation.

44 Carr, "D'Sonoqua," in *Emily Carr Omnibus*, 40–41. Curtis photographed Kwakiutl subjects in 1910 and 1912 and shot a Kwakiutl motion picture in 1914. His photographs became part of volume 10 of his monumental twenty-volume study *The North American Indian, Being a Series of Volumes Picturing and Describing the Indians of the United States and Alaska* [(1910–1916; rpt. New York: Johnson Reprint, 1970). Carr probably heard of Curtis's work among the Kwakiutl from one of several contacts she had in the region. Carr's attention to the work of ethnologists working in the Pacific Northwest is further underscored by her page of Indian designs copied from Franz Boas and now housed at the British Columbia Provincial Archives, Victoria, PDP05647.

45 Carr, "D'Sonoqua," 44; Lévi-Strauss, *Way of the Masks*, 100. There is a Kwakiutl family legend which connects D'Sonoqua with the Sistheutl (Sisiutl). See Aldona Jonaitis, ed., *Chiefly Feasts: The Enduring Kwakiutl Potlatch* (New York: American Museum of Natural History, 1991), 90.

46 For Barbeau, see Weigle, *Spiders and Spinsters*, 257; Lévi-Strauss, *Way of the Masks*, 107. Such belief in the "vertical" (North-South) relationships of Native American cultures was also shared by anthropologist Franz Boas and, later, anthropologist and artist Wolfgang Paalen and Miguel Covarrubias.

47 Carr, "Klee Wyck," in *Emily Carr Omnibus*, 102.

48 Carr, "D'Sonoqua," 42.

49 John Newlove, "Resources, Certain Earths," quoted in Margaret Atwood, *Survival: A Thematic Guide to Canadian Literature* (Toronto: Anansi, 1972), 103–04. Among First Nations people, the preferred spelling of Nootka is *Nuu-chah-nulth*. The reference to a hummingbird worn in the wild woman's hair provides still another point of comparison with Kahlo and Aztec religion, as discussed above. Carr is not alone among twentieth-century European American artists in finding D'Sonoqua a compelling image. A D'Sonoqua mask was exhibited at the Museum of Modern Art in 1941 where, argues

W. Jackson Rushing, an artist such as Adolph Gottlieb could have seen it and subsequently borrowed the image. Rushing, "Ritual and Myth: Native American Culture and Abstract Expressionism," in Maurice Tuchman, ed., *The Spiritual in Art: Abstract Painting 1890–1985* (New York: Los Angeles County Museum of Art and Abbeville Press, 1985), 281.

50 Roland Barthes, *Mythologies* (New York: Hill and Wang, 1972), 142.

51 Frye, quoted in Atwood, *Survival*, 17.

52 Ibid., 200; Atwood, *Survival*, 32.

53 Carr, *Growing Pains*, 439.

54 Ibid., 104, 283–84.

55 Emily Carr, *HT*, 287.

56 Ian Angus, "Crossing the Border," *Massachusetts Review* 31, no. 1–2 (Spring–Summer 1990), 40–41; Carr, *HT*, 61.

57 Gaston Bachelard, *The Poetics of Space* (New York: Orion, 1964), 183ff.; Emily Carr, *Growing Pains*, 437.

58 Carr, *An Address*, 3. On memory aids, see, for example, Doris Shadbolt, *The Art of Emily Carr* (Vancouver: Douglas and McIntyre, 1979), 72–74.

59 Carr, *HT*, 5. O'Keeffe too spoke of her own "paintings of so many things that may be unpaintable — and still that can not be so." For O'Keeffe, the unpaintable subjects were not so much landscape as "the feeling that a person gives me that I can not say in words [which] comes in colors and shapes" (O'Keeffe, letter to Jean Toomer, 8 February 1934, quoted in Jack Cowart, Juan Hamilton, and Sarah Greenough, *Georgia O'Keeffe: Art and Letters* [Washington: National Gallery of Art, 1987] no. 69, p. 218 [hereafter cited as *Art and Letters*]).

60 O'Keeffe to Henry McBride, summer 1929, reprinted in *Art and Letters*, no. 44, p. 189.

61 Carr, *An Address*, 10; Carr, *HT*, 5.

62 Carr, *HT*, 83.

63 Ibid., 301, 96.

64 O'Keeffe, quoted in Blanche Matthias, "Stieglitz Showing Seven Americans," *Chicago Evening Post Magazine of the Art World*, 2 March 1926, 16; Georgia O'Keeffe, letter to James Johnson Sweeney, 11 June 1945, in *Art and Letters* no. 90, pp. 240–41; Stieglitz, quoted in Charles Eldredge, *Georgia O'Keeffe* (New York: Abrams, 1991), 14.

65 Frances O'Brien, "Americans We Like: Georgia O'Keeffe," *Nation* (October 1927), 361–62.

66 The Lamb-Stieglitz correspondence at the Beinecke Library, Yale University, begins in 1911. Lamb's photograph *Portrait Group* appeared in *Camera Work* 39 (1912). By 1914 Lamb was sufficiently close to 291 to be asked to contribute to the "What Is 291" issue of *Camera Work* (see note 37, above). Stieglitz would have been aware of and perhaps seen catalogues of Canadian painting shows before 1920 — quite likely the important Group of Seven exhibition which toured the United States in 1920–21, with venues including Boston, Rochester, Buffalo, and other major cities. For more on the later reception of Canadian painting in the United States, see Christine Boyanoski, *Permeable Border: Art of Canada and the United States 1920–1940* (Toronto: Art Gallery of Ontario, 1989), 5–14; and the List of Exhibitions in Hill, *Group of Seven*, 338–41. On the purchase of *The Eggplant*, see Boyanoski, *Permeable Border*, 16. This painting is now in the collection of the Art Gallery of Ontario, Toronto.

67 We do not know whether O'Keeffe saw Carr's work in the Exhibition of Paintings by Contemporary Canadian Artists at the Grand Central Galleries in New York in June 1930, three months after the two artists met. O'Keeffe left New York that month for New Mexico, but she would have had another opportunity to see Carr's work in the Exhibition of Paintings by Contemporary Canadian Artists in March 1932 at the International Art Center of the Nicholas Roerich Museum, New York.

68 Sarah Whitaker Peters, *Becoming O'Keeffe: The Early Years* (New York: Abbeville, 1991), 70–71.

69 Michael Gold, quoted in Helen Delpar, *The Enormous Vogue of Things Mexican: Cultural Relations Between the United States and Mexico, 1920–1935* (Tuscaloosa: University of Alabama Press, 1992), 24. Gold wrote a play, *Fiesta*, about

Mexican life and revisionist politics; first produced by the Provincetown Players, it opened in New York in 1929, but closed after only thirty-nine performances. Gold, an active member of the Communist Party of the United States, remained visible in the art world, working for such left-wing publications as *New Masses*.

70 Delpar, *Enormous Vogue of Things Mexican*, 12.

71 Rivera, quoted in the *New York Times*, 19 July 1931, 21. Rivera's misgivings were based largely on his ambivalence toward the North American industrial environment. As a communist, he feared the tyranny of the machine over the worker, but at the same time he spoke of the beauty and potential economic benefits of modern machinery. Humanity, he argued, must retain control over machines: "Machinery does not destroy, it creates, provided always that the controlling hand is strong enough to dominate it" (manuscript dated 3 August 1930, quoted in Laurance P. Hurlburt, *The Mexican Muralists in the United States* [Albuquerque: University of New Mexico Press, 1989], 157).

Sarah Peters has argued convincingly that Rousseau's static, frontal forms were an influence on O'Keeffe in the 1920s, perhaps by way of Wassily Kandinsky, the critic Herbert Seligmann, and Stieglitz himself (*Becoming O'Keeffe*, 101–2).

72 Announcement of the Modern Gallery, 7 October 1915, reproduced in William Innes Homer, *Alfred Stieglitz and the American Avant-Garde* (Boston: New York Graphic Society, 1977), 195.

73 Unnamed critic, writing in the *New York Evening Post*, 7 October 1916, quoted in Marius De Zayas, "How, When and Why Modern Art Came to New York," ed. Francis Naumann, *Arts* (April 1980), 119–20. Most critics, though aware of the effects of tribal art on advanced contemporary work (such as African and Iberian sculpture's influence on Picasso, Braque and Max Weber) were not well enough acquainted with the ancient art of the Americas to measure its influence on an advanced painter like Rivera, who had already developed a lively interest in pre-Cortésian art and who would eventually (with Kahlo) accumulate a vast collection of Aztec and Mayan art. By entering the collections of modern artists like Rivera, tribal or "primitive" work was aesthetically "redeemed" by them (as Thomas McEvilley discusses throughout his *Art and Otherness* [Kingston, N.Y.: McPherson, 1992]) and installed into the developing aesthetic of twentieth-century modernism.

74 For more on Pach's role, see Margarita Nieto, "Mexican Art and Los Angeles, 1920–1940," in Paul J. Karlstrom, ed., *On the Edge of America: California Modernist Art, 1900–1950* (Berkeley: University of California Press, 1996), 121–35.

75 Wolfgang Paalen, "Totem Art," *DYN* 4–5 (December 1943), 17.

76 Seligmann, quoted in Charles Eldredge, *Georgia O'Keeffe: American and Modern* (New Haven: Yale University Press and InterCultura, 1993), 180.

77 Georgia O'Keeffe, *Georgia O'Keeffe* (New York: Viking, 1976), opposite plate 58 (hereafter cited as *Georgia O'Keeffe*). I have written of O'Keeffe's veiled mystical content in "Beholding the Epiphanies: Mysticism and the Art of Georgia O'Keeffe," in my *Contested Terrain* (Albuquerque: University of New Mexico Press, 1996).

78 Peters, *Becoming O'Keeffe*, 297.

79 For more information on kachinas, see Bertha P. Dutton, *American Indians of the Southwest* (Albuquerque: University of New Mexico Press, 1983), 246–47; and Dorothy K. Washburn, ed., *Hopi Kachina—Spirit of Life* (Seattle: University of Washington Press and California Academy of Sciences, 1980).

80 Walt Whitman, "A Clear Midnight," in *Walt Whitman: The Complete Poems*, ed. Francis Murphy (New York: Penguin, 1975), 497. O'Keeffe's interest in kachinas was perhaps restimulated by the important "Indian Art of the United States" exhibition curated by René d'Harnoncourt at the Museum of Modern Art in 1941, where Native American art received both cultural contextualization and aesthetic appreciation, a project paralleling O'Keeffe's own efforts to understand such material.

81 O'Keeffe, letter to William Howard Schubart, 23 December 1950, in *Art and Letters*, no. 106, p. 257.

82 O'Keeffe, letter to Henry McBride from Alcalde, New Mexico, July 1931, in *Art and Letters*, no. 56, pp. 202–3. An example of O'Keeffe's black rectangle paintings is her *Black Spot No. 2* (1919; collection Loretta and Robert K. Lifton).

83 The crossroads were not always apparent; O'Keeffe painted one less decisively in *Black Cross with Red Sky* (1929; Collection of Mr. and Mrs. Gerald Peters). My thanks to Maury Calvert for drawing my attention to the crossroads in *Black Cross with Stars and Blue* (1929; private collection).

84 O'Keeffe, *Georgia O'Keeffe*, opposite plate 63.

85 Ibid.

86 Lawren Harris, letter to Emily Carr, spring 1929, Provincial Archives of British Columbia.

87 Blanchard, *Life of Emily Carr*, 190.

88 Whitman, "From Paumanok Starting I Fly Like a Bird," in Murphy, ed., *Complete Poems*, 309; Whitman, quoted in Frederick B. Housser, "Walt Whitman and North American Idealism," *Canadian Theosophist* 11, nos. 4 and 5 (June–July 1930), 137.

89 Carr, *HT*, 47. Carr wrote to a friend: "When I want to realize growth and immortality more I go back to Walt Whitman. *Everything* seemed to take such a hand in the ever-lasting on-going with him—eternal overflowing and spilling of things into the universe and nothing lost" (letter to Ruth Humphrey, April 1938, quoted in Shadbolt, *Art of Emily Carr*, frontispiece). For the extent of Whitman's effect on painters see, for example, Geoffrey M. Sill and Roberta K. Tarbell, eds., *Walt Whitman and the Visual Arts* (New Brunswick, N.J.: Rutgers University Press, 1992). Ann Davis traces his influence on painters in *The Logic of Ecstasy: Canadian Mystical Painting, 1920–1940* (Toronto: University of Toronto Press, 1992), 42–94.

90 Carr, *HT*, 48.

91 Whitman, "I Sing the Body Electric," in Murphy, ed., *Complete Poems*, 131.

92 Whitman, "Starting from Paumanok," in Murphy, ed., *Complete Poems*, 50; Carr, *HT*, 54.

93 Carr, *Growing Pains*, 471. Carr owned several copies of Whitman's *Leaves of Grass*, three of which are now preserved at the British Columbia Archives and Records Service. Flora Burns, a close friend, recalls that Carr always kept Whitman's writings nearby. See *Dear Nan: Letters of Emily Carr, Nan Cheney and Humphrey Toms*, ed. Doreen Walker (Vancouver: University of British Columbia Press, 1990), n. 1, p. 17.

94 Whitman, "Starting from Paumanok," 50; Wanda M. Corn, "Postscript," in Sill and Tarbell, eds., *Whitman and the Visual Arts*, 169.

95 Kahlo, "Portrait of Diego," quoted in Herrera, *Frida*, 362.

96 Anita Brenner, *Idols Behind Altars* (New York: Payson and Clarke, 1929), 32.

97 Whitman, "Starting From Paumanok" and "I Sing the Body Electric," in *Complete Poems*, 50, 131.

98 Markman and Markman, *Masks of the Spirit*, 150.

99 William Carlos Williams, "Whitman and the Art of Poetry," *Poetry Journal* 8 (November 1917), 27–36; Matthew Baigell, "American Landscape Painting and National Identity: The Stieglitz Circle and Emerson," *Art Criticism* 4 (1987), 30.

100 O'Keeffe, quoted in Barbara Haskell, *Arthur Dove* (Greenwich, Conn.: New York Graphic Society, 1974), 118.

101 A recent exhibition demonstrating the connections between Mexico and the United States is featured in James Oles, *South of the Border: Mexico in the American Imagination, 1914–1947* (Washington: Yale University Art Gallery and Smithsonian Institution Press, 1993).

102 Copland, quoted in Delpar, *The Enormous Vogue of Things Mexican*, 90. For its premiere Chavez's production was retitled *H.P. (Horsepower)*. As in Frida Kahlo's painting of the same year, *Self-Portrait on the Border Line Between Mexico and the United States and Mexico* (fig. 3), Chavez (with Rivera's sets) represents the North by means of machines and materialism: gasoline pumps, bathtubs, and a stock ticker; while the the symbols of the South were vegetal and folkloric, with mermaids playing guitars. See Lois Palken Rudnick,

Utopian Vistas: The Mabel Dodge Luhan House and the American Counterculture (Albuquerque: University of New Mexico Press, 1996), 154–56.

103 See Lawrence, "Whitman," in *Studies in Classic American Literature* (1923; New York: Doubleday, 1953), 174–91; Lawrence, letter to Gilbert Seldes, 1922 or 1923, quoted in Eliot Fay, *Lorenzo in Search of the Sun: D. H. Lawrence in Italy, Mexico and the American Southwest* (New York: Bookman, 1953), 46.

104 Kahlo, letter to Isabel Campos, 16 November 1933, in Zamora, comp. *Letters*, 50.

105 Lawrence, quoted in Keen, *The Aztec Image in Western Thought*, 555; Kahlo, "Portrait of Diego," in Zamora, comp. *Letters*, 153.

106 Kahlo, quoted in Malka Drucker, *Frida Kahlo: Torment and Triumph in her Life and Art* (New York: Bantam, 1991), 97.

107 Kahlo, letter to Dr. Leo Eloesser, 18 July 1941, in Zamora, comp. *Letters*, 111.

108 Paz, *The Labyrinth of Solitude*, 111.

109 Lawrence, "The Woman Who Rode Away" (1925; New York: Secker, 1928).

110 O'Keeffe, statement from exhibition catalogue, An American Place, 1944, quoted in O'Keeffe, *Georgia O'Keeffe*, opposite plate 74. In 1916–17 O'Keeffe had been reading the works of Wassily Kandinsky and seemed to be testing his statements on color, some of which anticipate Lawrence's views of blue. As Kandinsky wrote: "Blue . . . draws away from the spectator. . . . The power of profound meaning is found in blue. . . . When it sinks almost to black, it echoes a grief that is hardly human" (*Concerning the Spiritual in Art*, trans. M. T. H. Sadler [1914; rpt. New York: Dover, 1977], 38).

111 D. H. Lawrence, *St. Mawr* and *The Man Who Died* (1925; New York: Vintage, 1953) 102; O'Keeffe, letter to William Einstein, 19 July 1938, in *Art and Letters*, no. 76, 224–26.

112 Lawrence, *St. Mawr*, 140.

113 Emily Carr, 4 April 1934, *HT*, 106–7.

114 Waldo Frank, *Our America* (New York, 1919), 96; Rosenfeld, quoted in Peters, *Becoming O'Keeffe*, 134; William Carlos Williams, *A Recognizable Image: William Carlos Williams on Art and Artists* (New York: New Directions, 1978), 68.

115 Writing from Switzerland to Stieglitz in August 1928, Lawrence asked how O'Keeffe liked the book. In another letter the following month Lawrence asks Stieglitz to convey his thanks to O'Keeffe for her letter, presumably a note acknowledging *Lady Chatterley*. See Stieglitz *Correspondence*, Series 1, D. H. Lawrence file, letters of 5 July, 15 August, and 12 September 1928, Beinecke Rare Book and Manuscript Library, Yale University. For Carr's interest see Ruth Appelhof, "Emily Carr, Canadian Modernist," in *The Expressionist Landscape*, exhibition catalogue (Birmingham, Ala.: Birmingham Museum of Art, 1988), 73.

2

The Natural Self

1 Nietzsche, for example, argued that "the healing balm of myth" must accompany the reception of modern science. Nietzsche, *The Birth of Tragedy*, trans. Walter Kaufmann (1872; New York: Vintage, 1967), 110–11.

2 Examples of the wide-ranging literature include Eric Neumann's *The Great Mother* (New York: Pantheon, 1955); Simone de Beauvoir's *The Second Sex* (1949; New York: Vintage, 1953); Paul Shepard's *Man in the Landscape: A Historic View of the Esthetics of Nature* (College Station: Texas A & M University Press, 1967); and Carolyn Merchant's *The Death of Nature: Women, Ecology and the Scientific Revolution* (San Francisco: Harper and Row, 1980).

3 Margaret Atwood, *Survival: A Thematic Guide to Canadian Literature* (Toronto: Anansi, 1972), 200.

4 Maurice Merleau-Ponty, *Phenomenology of Perception*, trans. Colin Smith (London: Routledge and Kegan Paul, 1962), 206.

5 Paul Shepard, *Man in the Landscape*, 100. When such assertions have impinged on religion, as in G. Rachel Levy's likening of mountain profiles rising beyond ancient temple altars to openings whose corporeal equivalent is the vulva, modern readers have often resisted.

6 Norman O. Brown, *Love's Body* (New York: Random House, 1966), 265.

7 Whitney Chadwick, *Women Artists and the Surrealist Movement* (Boston: Little, Brown, 1985), 74; see also 141ff.

8 Cardoza y Aragon, quoted in Hayden Herrera, "Beauty to His Beast," in Whitney Chadwick and Isabelle de Courtivron, eds., *Significant Others: Creativity and Intimate Partnership* (London: Thames and Hudson, 1993), 135.

9 Alice Paalen, "L'Ixtaccihuatl" *DYN*, nos. 1–3 (April–May 1942), 44 (my translation).

10 Rivera, "Frida Kahlo y el arte Mexicano," quoted in Raquel Tibol, *Frida Kahlo: An Open Life*, trans. Elinor Randall (1983; Albuquerque: University of New Mexico Press, 1993), 124–25.

11 Quoted in Carolyn Merchant, *Death of Nature*, 18.

12 Kahlo, letter to Alejandro Gómez Arias, 18 August 1924, in Zamora, comp., *The Letters of Frida Kahlo: Cartas Apasionadas* (San Francisco: Chronicle, 1995), 11.

13 Gustave Flaubert, *Salammbô*, trans. A. J. Krailsheimer (London: Penguin, 1977), 56.

14 Sigmund Freud, *Moses and Monotheism*, in *Complete Psychological Works*, ed. and trans. James Strachey (London: Hogarth, 1953–74), 23:117–18.

15 Leonardo da Vinci, quoted in Shepard, *Man in the Landscape*, 111.

16 Kahlo, "birth announcement," in Zamora, comp., *Letters*, 24. Kahlo had not yet dropped the German spelling of her first name. Campos and Gómez Arias were her closest youthful friends. The authors of the Kahlo catalogue raisonné argue that the two small calligraphed "o's" in Leonardo's name (detailed like the male and female signs for yin and yang) convert "Le Narde" into "Leonardo." Le Narde, as Salomon Grimberg points out, is the pistil, the female part of a blossom. He also sees symbols for river and sea goddesses in the accompanying drawing of a turtle with fish scales. Altogether, conclude the catalogue authors, the birth announcement reads as a hymn to female sexuality. See Helga Prignitz-Poda, Salomon Grimberg, and Andrea Kettenmann, *Frida Kahlo: Das Gesamtwerk* (Frankfurt am Main: Verlag Neue Kritik, 1988), cat. 235.

17 See Sarah M. Lowe, ed., *The Diary of Frida Kahlo: An Intimate Self-Portrait* (New York: Abrams, 1995), 230. We think here of Leonardo's assertion "ogni dipintore dipinge se": every painter paints himself. Still another link between Kahlo and Leonardo occurs in her painting *The Wounded Table* (1940; now lost), a composition organized like Leonardo's *Last Supper* (c. 1495–98; Santa Maria delle Grazia, Milan) and similarly dealing with betrayal—in Kahlo's case, Rivera's, through his infidelities.

18 Kahlo, "Moses," in Zamora, comp., *Letters*, 123.

19 Kahlo, diary entry, quoted in Lowe, ed., *Diary of Frida Kahlo*, 20–21.

20 This story, from a lost Aztec myth, was said to have been compiled by missionaries in 1543, translated into French by André Thevet and into English by John Bierhorst. It is reprinted in Marta Weigle, *Spiders and Spinsters: Women and Mythology* (Albuquerque: University of New Mexico Press, 1982), 67–68.

21 This is a subject to which I shall return in Chapter 3. Laura Mulvey and Peter Wollen, for example, have argued persuasively for Kahlo's "explicit use of the imagery of the Passion: the wounds of the scourging and the crucifixion, the knotted cord, the ring of thorns, the simultaneous shining of sun and moon during the tenebrae" ("Frida Kahlo and Tina Modotti," in Mulvey, *Visual and Other Pleasures* [Bloomington: Indiana University Press, 1989], 102).

22 *Codice Matritense de la Real Academia*, vol. 8, fol. 172v., quoted in Miguel León-Portilla, *Aztec Thought and Culture: A Study of the Ancient Nahuatl Mind*, trans. Jack Emory Davis (Norman: University of Oklahoma Press, 1963), 168.

23 León-Portilla, quoted in Frank Waters, *Mexico Mystique* (Chicago: Swallow Press, 1975), 121.

24 *Codice Matritense*, vol. 8, fol. 118v. . Contemporary Latina author Gloria Anzaldua adopts a similar idea about her own creativity: "When I write . . . it feels like I'm creating my own face, my own heart—a Nahuatl concept. My soul makes itself through the creative act" ("The Path of the

Red and Black Ink," in *The Graywolf Annual Five: Multi-Cultural Literacy*, ed. Rick Simonson and Scott Walker [St. Paul: Graywolf Press, 1988], 38).

25 In addition to the Nahua reference in the Farill portrait, Kahlo's heart-shaped palette probably alludes to a second source as well. She was well acquainted with the alchemical writings of Paracelsus, whose portrait she would include in *Moses*, her idiosyncratic pantheon of heroes painted a few years later. It was Paracelsus who wrote that the art of medicine is rooted in the heart, an image perfectly congruent with that of the Aztecs. In the following chapters I shall explore the far-reaching influence of alchemy in Kahlo's work. See Jolande Jacobi, ed., *Paracelsus: Selected Writings* (New York: Pantheon, 1951), 146.

26 Kahlo, diary entry, quoted in Hayden Herrera, *Frida Kahlo: The Paintings* (New York: Harper Collins, 1991), 201.

27 Laurette Séjourné, *Burning Water: Thought and Religion in Ancient Mexico* (Berkeley: Shambhala, 1976), 105.

28 Lowe, ed., *Diary of Frida Kahlo*, 147; Anita Brenner, *Idols Behind Altars* (New York: Payson and Clarke, 1929), 14.

29 Fragment from a poem by Elias Nandino, quoted in Herrera, *Kahlo: The Paintings*, 135.

30 Lewis Mumford, "The Art Galleries: Autobiographies in Paint," *New Yorker*, 18 January 1936, 48.

31 O'Keeffe to Dorothy Brett, April 1930, Yale Collection of American Literature, Beinecke Rare Book and Manuscript Library, Yale University (henceforth YCAL).

32 O'Keeffe to Carl Zigrosser, April 1944; O'Keeffe to Ettie and Carrie Stettheimer, 10 June 1944; both in Jack Cowart, Juan Hamilton, and Sarah Greenough, *Georgia O'Keeffe: Art and Letters* (Washington: National Gallery of Art, 1987), 236, 239.

33 O'Keeffe, quoted in Laurie Lisle, *Portrait of an Artist: A Biography of Georgia O'Keeffe* (New York: Seaview Books, 1980), 261. O'Keeffe's previous references to hearts (painted several times in the 1920s and 1930s) were the complex forms of blown-up bleeding-heart blossoms, curiously

delicate antipodes of the stone-hard 1944 painting. In another context, the eighteenth-century naturalist J. B. Robinet wrote of primordial stones that imitate and predict the later development of the body's organs; among these are Lithocardites, or heart stones, which he illustrated as early drafts of hearts that would someday beat. See Gaston Bachelard, *The Poetics of Space* (New York: Orion, 1964), 113–14.

34 Carr, journal entry for 9 March 1934, *HT*, 101. This is a notably Whitmanesque passage, reminiscent of the poet's return, as he wrote in "Song of Myself" to "the naked source—life of us all— to the breast of the great silent savage all-acceptive Mother."

35 Carr, journal entry for 6 October 1932, *HT*, 64.

36 Carr, journal entry for 31 December 1940, *HT*, 329–30.

37 Carr, journal entry for 9 June 1936, *HT*, 241–42; and 9 October 1933, *HT*, 65.

38 Carr, journal entry for 28 November 1935, *HT*, 207.

39 O'Keeffe, *Georgia O'Keeffe*, opposite plate 76.

40 Brown, *Love's Body*, 246; Carr, journal entries for 16 September 1933 and 14 August 1936, *HT*, 61, 256.

41 Carr, journal entries for 14 October 1933 and 12 and 17 June 1936, *HT*, 66, 242–43. Worth noting here is the manner in which Carr's forests seem to open up in the 1930s and abolish certain claustrophobic constraints, a change due in great measure to her adoption of a new medium, oil on paper.

42 Carr, journal entry for 10 November 1927, *HT*, 4.

43 Carr, journal entry for 25 September 1938, *HT* 309.

44 Carr, journal entry for 23 February 1936, *HT*, 224.

45 For other examples of Carr's eye-forms in the sky, see plates 143, 148, 162, 163 and 164 in Doris Shadbolt, *The Art of Emily Carr* (Vancouver: Douglas and McIntyre, 1979). For a prominent eye-form in foliage, see *Untitled* (c. 1933–34; Vancouver Art Gallery), reproduced in Robin Laurence, *Beloved Land: The World of Emily Carr* (Vancouver and Seattle: Douglas and McIntyre and University of Washington Press, 1996), 76.

46 For extensive material and illustrations of such eye imagery, see, for example, Marija Gimbutas, *The Language of the Goddess* (San Francisco: Harper Collins, 1989), esp. chap. 6.

47 Shadbolt, *Art of Emily Carr*, 78; Sarah Whitaker Peters, *Becoming O'Keeffe: The Early Years* (New York: Abbeville, 1991), 47.

48 For examples of such paintings, see plates 21, 32, and 47 in Herrera, *Frida*.

49 William Wordsworth, "Lines Composed a Few Miles Above Tintern Abbey . . ." (1798), in *Writers of the Western World*, ed. Addison Hibbard (Boston: Houghton-Mifflin, 1954), 654–55. Great symbolic eyes appear as well in the work of Paul Klee, who alluded in such works as *With the Eagle* (1918; Kunstmuseum, Bern) to a romantically tinged purity of artistic vision.

50 In later paintings like *Hills—Lavender, Ghost Ranch, New Mexico II* (1935; private collection), she would revisit the eye-shape, finding it in the openings within pale brown hills.

51 Whitman, "Kosmos," in Murphy, ed., *Complete Poems*, 413. On Courbet see, for example, Michael Fried, *Courbet's Realism* (Chicago: University of Chicago Press, 1990), chaps. 8 and 9; and Simon Schama, *Landscape and Memory* (New York: Vintage, 1995), 373. For Degas's late bodyscapes, see Richard Kendall, *Degas: Beyond Impressionism* (London: National Gallery, 1996), cats. 97 and 98. A fascinating predecessor to Degas's gendered landscapes appeared in the French popular press in an essay called "Un Dimanche d'été," by a writer identified only as "Y." Writing about the hordes of Parisians descending on the countryside for a Sunday outing, the writer notes, "These people came to handle the hillsides as if they were breasts, to look up the skirts of the forests, and to disarrange the river's costume" (*La Vie parisienne*, 3 July 1875, 375–76, quoted in T. J. Clark, "The Environs of Paris," in *The Painting of Modern Life: Paris in the Art of Manet and His Followers* [Princeton: Princeton University Press, 1984], 149).

52 Lachaise, quoted in Barbara Rose, ed., *Readings in American Art Since 1900* (New York: Praeger, 1968), 181.

53 A forceful argument for such connections was begun by Elizabeth Duvert, "With Stone, Star, and Earth: The Presence of the Archaic in the Landscape Visions of Georgia O'Keeffe, Nancy Holt, and Michelle Stuart," in Vera Norwood and Janice Monk, eds., *The Desert Is No Lady: Southwestern Landscapes in Women's Writing and Art* (New Haven: Yale University Press, 1987), 197–222.

54 O'Keeffe to Pollitzer, 30 October 1916, YCAL; Willard Huntington Wright, *The Creative Will* (New York, John Lane, 1916), 11.

55 Charles Eldredge, afterword, *Canyon Suite: Early Watercolors by Georgia O'Keeffe* (Santa Fe: Gerald Peters Gallery and the Kemper Collection, 1994), 70.

56 Examples include *Special No. 16* (1918; charcoal, National Gallery of Art, Washington, D.C.); *Series I, No. 4* (1918; o/c, Städtische Galerie im Lenbachhaus, Munich); and *Series I, No. 1* (1918; o/c, Amon Carter Museum).

57 Wright, *Creative Will*, 15.

58 O'Keeffe to Cady Wells, early 1940s, in Cowart, Hamilton, and Greenough, *O'Keeffe: Art and Letters*, no. 93, p. 243.

59 O'Keeffe, 1978 comment quoted in Peters, *Becoming O'Keeffe*, 147; O'Keeffe, *Georgia O'Keeffe*, opposite plate 85.

60 Yeats, quoted in Vera John-Steiner, *Notebooks of the Mind: Explorations of Thinking* (Albuquerque: University of New Mexico Press, 1985), 13. O'Keeffe's 1915 charcoal drawing *Special No. 2* (fig. 138) suggests a visual expression of Yeats's principle.

61 For more on the concept of whiteness, see my chapter "Beholding the Epiphanies: Mysticism and the Art of Georgia O'Keeffe," in Udall, *Contested Terrain: Myth and Meanings in Southwest Art* (Albuquerque: University of New Mexico Press, 1996), 83–110.

62 From the extensive literature on the tree in world mythology, see, for example, E. O. James, *The Tree of Life: An Archaeological Study* (Leiden: E. J. Brill, 1966), chaps. 1 and 2; Ralph Metzner, *The Well of Remembrance: Rediscovering the Earth Wisdom Myths of Northern Europe* (Boston: Shamb-

hala, 1994), esp. 194–200; and Barbara G. Walker, *The Woman's Dictionary of Symbols and Sacred Objects* (San Francisco: Harper and Row, 1988).

63 Otto Rank, *Art and Artist: Creative Urge and Personality Development* (New York: Tudor, 1932), 184.

64 Quoted in Alfredo Lopez Austin, *The Human Body and Ideology: Concepts of the Ancient Nahuas*, trans. Thelma Ortiz de Montellano and Bernard Ortiz de Montellano (Salt Lake City: University of Utah Press, 1988), 346–47.

65 Humbert de Superville, *Essai sur les signes inconditionnels dans l'art* (Leiden, 1827–32).

66 Samuel Taylor Coleridge, "Christabel," in *Writers of the Western World*, p. 673, l.49–50.

67 John Ruskin, *Modern Painters*, ed. David Barrie (1843; New York: Knopf, 1987), 363–68.

68 Georgia O'Keeffe, *Georgia O'Keeffe*, n.p.

69 W. A. Lambeth, *Trees and How to Know Them: A Manual with Analytical and Dichotomous Keys of the Principal Forest Trees of the South* (Atlanta: B.F. Johnson, 1913). On the front endpaper the artist wrote "Georgia O'Keeffe/University of Virginia—1913." My thanks to Sarah Burt for this information.

70 Barbara Buhler Lynes, *O'Keeffe, Stieglitz and the Critics, 1916–1929* (Ann Arbor: UMI Research Press, 1989), 19; Stieglitz to Anne Brigman, 24 December 1919, YCAL; Georgia O'Keeffe to Blanche Matthias, March 1926, in Cowart, Hamilton, and Greenough, *O'Keeffe: Art and Letters*, no. 36, p. 183.

71 Dasburg, quoted in Sheldon Reich, *Andrew Dasburg: His Life and Art* (Lewisburg, Pa.: Bucknell University Press, 1989), 23.

72 Peters, *Becoming O'Keeffe*, 88–90; O'Keeffe, quoted in Marsden Hartley, *Adventures in the Arts* (1921; rpt. New York: Hacker, 1972), 116.

73 Stieglitz's understanding of the expressive potential of nature's forms was at least equal to O'Keeffe's; he had in fact entitled a photograph from the same period *Dancing Trees* (1922; Museum of Fine Arts, Boston).

74 Arthur Wesley Dow, *Composition: A Series of Exercises in Art Structure for the Use of Students and Teachers* (1899; New York: Doubleday, 1938), 50. See, for example, the account of Dow's efforts

to paint the Grand Canyon of Arizona, a struggle recounted in Frederick C. Moffatt, *Arthur Wesley Dow* (Washington: National Collection of Fine Arts, 1977), 117–21.

75 Dow, *Composition*, 23.

76 Ernest Fenollosa, "The Nature of Fine Art," *Lotos* 9 (1896), 759–60; Fenollosa, quoted in Ezra Pound, *Instigations* (New York: Boni and Liveright, 1920), 377.

77 Ernest F. Fenollosa, *Epochs of Chinese and Japanese Art* (London: William Heinemann, 1912), 10.

78 Kuo Hsi, quoted in Fenollosa, *Epochs*, 17; Fenollosa, *Epochs*, 11. For the Chinese painter's complete text, see Kuo Hsi, *An Essay on Landscape Painting*, trans. Shio Sakanishi (London: John Murray, n.d.).

79 See, for example, F. S. C. Northrop, *The Meeting of East and West* (New York: Macmillan, 1953), 163–64; and Charles Eldredge, *Georgia O'Keeffe: American and Modern* (New Haven: Yale University Press and InterCultura, 1993), n. 23, p. 214.

80 Fenollosa, quoted in Marianne W. Martin, "Some American Contributions to Early Twentieth-Century Abstraction," *Arts* (June 1980), 158. O'Keeffe, pleased with her own departure from the artist's customary viewpoint, described the tree in letters to two friends as "standing on its head" (letters to Mabel Dodge Luhan, August 1929, and Rebecca Strand, 24 August 1929, in Cowart, Hamilton, and Greenough, *O'Keeffe: Art and Letters*, nos. 47 and 48, pp. 192, 193. There is also a Stieglitz photograph from 1924, *Dying Chestnut Trees—Lake George*, which features a large branch cropped and photographed from below, entering the frame at an angle similar to that in O'Keeffe's *The Lawrence Tree*. The Stieglitz photograph is reproduced in Waldo Frank et al., eds., *America and Alfred Stieglitz: A Collective Portrait* (New York: Doubleday, 1934), pl. 32B.

81 D. H. Lawrence, *St. Mawr* (1925; New York: Vintage, 1953), 145–46; O'Keeffe, *Georgia O'Keeffe*, opposite plate 57. The title *The Lawrence Tree* was not used until later. When the painting was originally exhibited in 1930 at An American Place, it

was under the title *Pine Tree with Stars at Bretts, N.M.* The British painter Dorothy Brett had come to New Mexico with the Lawrences in 1924; unlike them, she stayed permanently, becoming a friend of O'Keeffe's as well.

82 Fenollosa, *Epochs*, 41. My thanks to Barbara Ogg for this reference.

83 Lawrence, *St. Mawr*, 103.

84 O'Keeffe to Ettie Stettheimer, 24 August 1929, in Cowart, Hamilton, and Greenough, *O'Keeffe: Art and Letters*, no. 49, p. 195.

85 O'Keeffe, *Georgia O'Keeffe*, opposite plate 64.

86 Rebecca Strand to Alfred Stieglitz, 14 May 1929, YCAL; Dorothy Brett, letter to Alfred Stieglitz, 9 October 1930, YCAL.

87 O'Keeffe to Russell Vernon Hunter, 30 October 1948, in Cowart, Hamilton, and Greenough, *O'Keeffe: Art and Letters*, no. 98, p. 249.

88 O'Keeffe to William Howard Schubart, 26 October 1950, in Cowart, Hamilton, and Greenough, *O'Keeffe: Art and Letters*, no. 105, pp. 255–56.

89 O'Keeffe, quoted in Pollitzer, *A Woman on Paper* (New York: Simon and Schuster, 1988), 259, 260.

90 O'Keeffe, quoted in Doris Bry and Nicholas Calloway, eds., *Georgia O'Keeffe in the West* (New York: Knopf, 1989), n.p.

91 Carr, quoted in Paula Blanchard, *The Life of Emily Carr* (Seattle: University of Washington Press, 1987), 251.

92 If Carr had access to Arthur Jerome Eddy's book *Cubists and Post-Impressionism* (Chicago: McClurg, 1914), as we know O'Keeffe did, she would have seen there Eddy's discussion of *Sei Do*, which he calls a "strictly enforced law of Japanese painting. . . . Should [the artist's] subject be a tree he is urged when painting it to *feel* the *strength* which shoots through the branches and sustains the limbs" (148).

93 Carr, journal entry for 12 February 1934, *HT*, 96; Carr to Nan Cheney, 20 March 1932, Nan Cheney Papers, quoted in Shadbolt, *Art of Emily Carr*, 180; and Carr, journal entry for 13 December 1940, *HT*, 326.

94 Carr, journal entry for 23 November 1930, *HT*, 22.

95 Shadbolt, *Art of Emily Carr*, 110; Carr, journal entry for 18 January 1931, *HT*, 25.

96 See Edythe Hembroff-Schleicher, *M.E.: A Portrayal of Emily Carr* (Toronto: Clarke, Irwin, 1969).

97 Carr, journal entry for 5 April 1934, *HT*, 107.

98 Carr, journal entry for 18 January 1931, *HT*, 25; O'Keeffe, letter to Dorothy Brett, mid-February 1932, quoted in Cowart, Hamilton, and Greenough, *O'Keeffe: Art and Letters*, 206. Even more on point than Gauguin's statement, given O'Keeffe's stated interest in dream, memory and essences, is Edgar Degas's advice: "It is all very well to draw what you see; it is much better to draw what you see only in memory. There is a transformation during which the imagination works in conjunction with the memory. You put down only what made an impression on you, that is to say the essential" ("Shop-Talk," in Elizabeth Gilmore Holt, ed., *A Documentary History of Art*, vol. 3 [Garden City, N.Y.: Doubleday, 1966], 401).

99 Carr, journal entry for 17 January 1936, *HT*, 216l Ruth S. Appelhof, "Emily Carr, Canadian Modernist," in Appelhof, Barbara Haskell, and Jeffrey R. Hayes, *The Expressionist Landscape: North American Modernist Painting, 1920–1947* (Birmingham, Ala.: Birmingham Museum of Art, 1988), 69.

100 Carr, letter to Eric Brown, 4 March 1937, quoted in David Alexander and John O'Brian, *Gasoline, Oil and Paper: The 1930s Oil-on-Paper Paintings of Emily Carr* (Saskatoon: Mendel Art Gallery, 1995), 29.

101 Carr, journal entries for 6 April and 16 1934, *HT*, 108, 132.

102 O'Keeffe to Anita Pollitzer, October 1915, quoted in Elizabeth Hutton Turner, "I Can't Sing so I Paint," in *Two Lives*, ed. Alexandra Arrowsmith and Thomas West (New York: Callaway Editions and the Phillips Collection, 1992), 80.

103 Carr, journal entry for 2 February 1940, *HT*, 314.

104 Carr, journal entry for 17 June 1931, *HT*, 29.

105 Kahlo, letter to Alejandro Gómez Arias, quoted in Tibol, *Frida Kahlo*, 67–68.

106 Léon-Portilla, *Aztec Thought and Culture*, 8; Kahlo, letter to Eduardo Morillo Safa, 11 October 1946, quoted in Herrera, *Frida*, 352.

107 Jacobi, ed., *Paracelsus*, 99.

108 For more on these metaphorical images see Barbara Brodman, *Mexican Cult of Death in Myth and Literature* (Gainesville: University of Florida Press, 1976).

109 Andres Henestrosa, quoted in Herrera, *Frida*, 485n356.

110 Carr, journal entries for 12 November 1932 and 2 February 1940, *HT*, 31, 314.

111 Carr, journal entry for 28 November 1935, *HT*, 207.

112 Kahlo, "Moses," 1945 speech, reprinted in Zamora, comp., *Letters*, 120–24.

113 Kahlo, letter to Rivera, 8 December 1939, quoted in Tibol, *Frida Kahlo*, 70.

114 In Mexican colonial art the crucified Christ is sometimes shown wearing both a crown and a necklace of thorns.

115 Several scholars have studied the presence and meaning of apples in O'Keeffe's and Stieglitz's work See, for example, Sarah E. Greenough, "From the American Earth: Alfred Stieglitz's Photographs of Apples, *Art Journal* 41 (Spring 1981), 49; Eldredge, *Georgia O'Keeffe: American and Modern*, esp. 180–87; and Peters, *Becoming O'Keeffe*, 274.

116 Herrera, *Frida*, 397. Kahlo called one of her still lifes *Naturaleza Viva* (live nature) instead of the usual Spanish term for still life, *naturaleza muerta*. And she made references in them to politics and to Mesoamerican lore. A rabbitlike creature painted on the face of the moon in *Naturaleza Viva* (1952; private collection, Monterrey, Mexico) may well be a reference to the Aztec *pulque* god, an association also painted by Rivera. Pulque, other liquor, and drugs were the frequent companions of Kahlo's pain-filled last years. She knew her end was approaching and thought often of death and the beyond. As she increasingly sought escape through alcohol and drugs, the reference to Aztec mind-altering practices comes as no surprise in Kahlo's still lifes. As the Markmans remind us, "The Aztecs considered psychotropic plants sacred and magical, serving shamans, and even ordinary people, as a bridge to the world beyond. Providing the ability to enable man to communicate with the gods and thereby to increase his power of inner sight, such hallucinogens were important enough to be associated with the gods. Xochipilli, for example, was not only the god of flowers and spring, dance and rapture but patron deity of sacred hallucinogenic plants and the 'flowery dream' they induced." (Peter T. Markman and Roberta H. Markman, *Masks of the Spirit: Image and Metaphor in Mesoamerica* [Berkeley: University of California Press, 1989], 104).

117 Georgia O'Keeffe, "About Myself," *Georgia O'Keeffe: Exhibition of Oils and Pastels* (New York: An American Place, 1939), n.p.

118 Emily Carr, "The Cow Yard," in *The Book of Small*, in *The Emily Carr Omnibus* (Seattle: University of Washington Press, 1993), 98; Carr, "Drawing and Insubordination," in *Growing Pains*, in *Emily Carr Omnibus*, 307.

119 Carr, letter to Mrs. Daly, 17 January 1945, in Doreen Walker, ed., *Dear Nan: Letters of Emily Carr, Nan Cheney and Humphrey Toms* (Vancouver: University of British Columbia Press, 1990), 416.

120 Whitman, "Song of Myself," quoted in Carr, "Bobtails," *The House of All Sorts*, in *Emily Carr Omnibus*, 261.

121 Carr, quoted in Blanchard, *Life of Emily Carr*, 156. Carr's biographer Maria Tippett records that she acquired Woo in 1921 in trade for a bobtail puppy plus thirty-five dollars (*Emily Carr: A Biography* (1979; Toronto: Stoddart, 1994), 120.

122 Carr, "Indian Bird Carving" and "Sitka's Ravens," *The Heart of a Peacock*, in *Emily Carr Omnibus*, 525, 523.

123 Carr, "Indian Bird Carving," 525; Carr, journal entry for 5 February 1931, *HT*, 27.

124 See Shadbolt, "Introduction," *Emily Carr Omnibus*, 3–14.

125 Carr, journal entry for 7 March 1945, *HT*, 332.

126 Kahlo scholar Salomon Grimberg argues that Kahlo was religious as a child and her adult renunciation of Catholicism may have been more a gesture of solidarity with Rivera and communism rather than the result of a complete change

of heart. Grimberg sees in Kahlo's *My Birth* (1932; private collection) and *Self-Portrait with Bonito* (1941; private collection) invocations of the Virgin, the latter identified with Kahlo's own image of herself (auction brochure, Wolf's Fine Arts Auctioneers, 1991). For Kahlo's designation of Marin, see Kahlo to Clifford and Jean Wight, 12 April 1932, quoted in Antonio Saborit, "Frida Kahlo: Tres cartas ineditas," *El Nacional Lectura*, 122 (27 July 1991), 3.

127 Two of Courbet's other paintings, widely acknowledged to represent erotic situations between women, are *Young Women on the Banks of the Seine* (1857; Petit Palace, Paris) and *The Sleepers* (1866; Petit Palace, Paris), also known as *Indolence and Sensuality*. The latter painting, of reclining female nudes, predicts in subject if not manner Kahlo's *Two Nudes in a Forest* (1939; Collection of Mary-Ann Martin). Earlier in the year Kahlo had visited Paris, where she could well have seen Courbet's *The Sleepers* at the Musée du Petit Palais.

128 For a discussion of this sculpture and the history of the metaphor, see H. W. Janson, *Apes and Ape Lore in the Middle Ages and the Renaissance* (London: Warburg Institute, 1952), chap. 10.

129 Fludd, quoted in Janson, *Apes and Ape Lore*, 305. The print, according to Janson(p. 322 n. 60), was probably made by Matthaeus Merian. Both this image and the very similar one illustrated in Chapter 1 are based on Apuleius's description of Isis. Janson argues, through a multitude of examples, that the ape is the quintessential emblem of the arts, particularly of painting and sculpture. See especially chapter 10.

130 Laura Mulvey and Peter Wollen have argued for Kahlo's use of emblems from the Passion in "Frida Kahlo and Tina Modotti," 102.

131 Kahlo, "Moses," 123.

132 Esther Pasztory, *Aztec Art* (New York: Abrams, 1983), 89.

133 Herrera, *Kahlo: The Paintings*, 190; Salomon Grimberg, *The Little Deer* (Oxford, Ohio: Miami University Press, 1997); Sor Juana Iñes de la Cruz, "Verses Expressing the Feelings of a Lover," quoted in Herrera, *Frida*, 358.

134 Walt Whitman, "Song of the Universal," in Murphy, ed., *Complete Poems*, 256.

135 O'Keeffe, *Georgia O'Keeffe*, opposite plate 58; Rivera, quoted in Tibol, *Frida Kahlo*, 171–72.

136 O'Keeffe, *Georgia O'Keeffe*, opposite plate 58.

137 Georgia O'Keeffe, letter to Dorothy Brett, fall 1929, quoted in Robinson, *Georgia O'Keeffe: A Life* (New York: Harper Collins, 1989), 344.

138 Lawrence, *St. Mawr*, 152.

139 Mumford, "The Art Galleries," 48. Mumford was not the first to see an autobiographical element in O'Keeffe's work; the critic Helen Appleton Read argued for a similar interpretation in the early 1920s.

140 For more on horns and antlers as attributes of the Great Goddess, see Buffie Johnson, *Lady of the Beasts* (San Francisco: Harper Collins, 1988), parts 6 and 11. For the skull as female metaphor, see D. O. Cameron, *Symbols of Birth and Death in the Neolithic Era* (London: Kenyon-Deane, 1981), 4.

141 Marsden Hartley, "Georgia O'Keeffe: A Second Outline in Portraiture" (1936), reprinted in Gail R. Scott, ed., *On Art by Marsden Hartley* (New York: Horizon, 1982), 107; Mumford, "Autobiographies," 48.

142 R. Vernon Hunter, "A Note on Georgia O'Keeffe," *Contemporary Arts of the South and Southwest* 1 (November–December 1932), 7.

143 William Cullen Bryant, *Poetical Works* (New York: Appleton , 1897), 37–38. Catlin's view is contained in his *Letters and Notes on the Manners, Customs, and Conditions of the North American Indians*, vol. 2 (Minneapolis: University of Minnesota Press, 1965), 256.

144 O'Keeffe, quoted in Robinson, *O'Keeffe: A Life*, 460.

145 Valéry, quoted in Bachelard, *Poetics of Space*, 105–6; Doris Bry, "O'Keeffe Country," in Bry and Calloway, eds., *O'Keeffe in the West*, n.p.

146 O'Keeffe, *Georgia O'Keeffe*, opposite plate 52.

147 For Kahlo's house see *Lola Alvarez Bravo: The Frida Kahlo Photographs*, exhibition catalogue (Dallas: Society of Friends of Mexican Culture, 1991), pls. 2, 3 and 5. On Aztec burial customs, see Markman and Markman, *Masks of the Spirit*, 45–46.

148 Kahlo, quoted in Herrera, *Frida*, 17. *La Calavera Catrina* is only one of the names for Lady Death, Skeleton Woman, La Huesera, Dama del Muerte, the Greek Graeae, Berchta, and the Lady in White, all of whom are associated with archetypal life-death-life in nature. La Calavera Catrina appears, in close imitation of Posada's, in Rivera's fresco *Dream of a Sunday Afternoon in the Alameda* (1947; painted for the Hotel del Prado, now in the Jardin de la Solidaridad, Mexico City). To the Aztecs death represented chaos and darkness; yet, as Esther Pasztory notes, "it was also necessary, for without it life could not continue" (Pasztory, *Aztec Art*, 220).

149 Carr, journal entries for 28 and 29 January 1936, *HT*, 219–20.

150 Carr, journal entry for 28 November 1935, *HT*, 207.

151 Bluemner, quoted in Herbert J. Seligmann, "291: A Vision Through Photography," in Waldo Frank et al., eds., *America and Alfred Stieglitz* (New York: Literary Guild, 1934), 120.

152 Albert Camus, preface to "The Wrong Side and the Right Side" (1958), in Camus, *Lyrical and Critical Essays*, ed. Philip Thody, trans. Ellen Conroy Kennedy (New York: Knopf, 1969), 17.

3

Portrait of the Artist as a Young Woman

1 Otto Rank, *Art and Artist: Creative Urge and Personality Development* (New York: Tudor, 1932), 383.

2 Carr, journal entry for 13 December 1937, *HT*, 296.

3 Emily Carr, *Growing Pains*, in *The Emily Carr Omnibus* (Seattle: University of Washington Press, 1993), 302, 301.

4 Carr, *Growing Pains*, 316. Carr's discomfort with the nude body was not unique in her era; when O'Keeffe attended the Art Institute of Chicago, she was extremely embarrassed at having to draw from a nude model. See Roxana Robinson, *Georgia O'Keeffe: A Life* (New York: Harper Collins, 1989), 51–52.

5 For a discussion of this episode and its varying interpretations, see Maria Tippett, *Emily Carr: A Biography* (1979; rpt. Toronto: Stoddart, 1994),

13–14; and Paula Blanchard, *The Life of Emily Carr* (Seattle: University of Washington Press, 1987), 53.

6 Carr, journal entry for 18 January 1936, *HT*, 217; Carr, *Growing Pains*, 300.

7 Carr, letter to Nan Cheney, 13 March 1941, reprinted in *Dear Nan: Letters of Emily Carr, Nan Cheney and Humphrey Toms*, ed. Doreen Walker (Vancouver: University of British Columbia Press, 1990), 307.

8 Carr, journal entry for 5 October 1934, *HT*, 151.

9 Eleanor Munro, *Originals: American Women Artists* (New York: Simon and Schuster, 1979), 33.

10 O'Keeffe, quoted in Robinson, *O'Keeffe: A Life*, 18.

11 Georgia O'Keeffe, WNET television documentary, *Georgia O'KeeVe: Portrait of an Artist*, by Perry Miller Adato, 1977.

12 From an unpublished O'Keeffe biography by Anita Pollitzer, quoted in Robinson, *O'Keeffe: A Life*, 46; O'Keeffe to Paul Strand, 23 July 1917, quoted in Sarah Whitaker Peters, *Becoming O'Keeffe: The Early Years* (New York: Abbeville, 1991), 186. In a broader sense, it is only fair to acknowledge that artists (whether male or female) who believe art to be rooted in principle-based decisions and difficult choices have often felt similarly. Degas, for example, resisted painting based on an impartial acceptance of sense experience; he argued that "Art is sacrifice, it consists of renunciations."

13 Carr, journal entry for 9 February 1936, *HT*, 223.

14 O'Keeffe, quoted in Mary Lynn Kotz, "A Day with Georgia O'Keeffe," *ARTnews* 76, no. 10 (December 1977), 44.

15 O'Keeffe to Paul Strand, 23 July 1917, quoted in Peters, *Becoming O'Keeffe*, 186; Jean Toomer, quoted in Cowart, Hamilton, and Greenough, *Art and Letters*, p. 285, n. 68.

16 Carr, journal entry for 16 February 1939, *HT*, 224.

17 Mary Cassatt, quoted in Nancy Hale, *Mary Cassatt* (New York: Doubleday, 1975), 150.

18 Martha Zamora, however, disputes this view, saying, "Contrary to widespread belief, Frida was not obsessed by frustrated maternity, although it

was an idea she encouraged." Instead, argues Zamora, Kahlo deliberately aborted several pregnancies because of the risk to her own health, the fear of transmitting epilepsy (her father's illness) or syphilis (suspected but never confirmed in Kahlo herself) to it, and Rivera's reluctance to father another child. (*Frida Kahlo: The Brush of Anguish*, trans. Marilyn Sode Smith [San Francisco: Chronicle, 1990], 91).

19 Kahlo, quoted in Raquel Tibol, *Frida Kahlo: An Open Life*, trans. Elinor Randall (1983; Albuquerque: University of New Mexico Press, 1993), 50.

20 Carr, quoted in Blanchard, *Life of Emily Carr*, 127.

21 Carr, journal entry for 28 November 1937, *HT*, 295.

22 Gerta Moray, "Northwest Coast Native Culture and the Early Indian Paintings of Emily Carr, 1899–1913," Ph.D. diss., University of Toronto, 1993, 383. She bases the claim of the adoption proposal on a 1989 interview with Carol Pearson. See also Carol Pearson, *Emily Carr as I Knew Her* (Toronto: Clarke, Irwin, 1954), 39–48.

23 Carr, journal entries for 26 April 1936 and 9 September 1933, *HT*, 235.

24 O'Keeffe to Katharine Kuh, 1962, quoted in Calvin Tomkins, "The Rose in the Eye Looked Pretty Fine," *New Yorker*, 4 March 1974, 42.

25 Kahlo, quoted in Herrera, *Frida*, 87.

26 Herrera, *Frida*, 32.

27 O'Keeffe, quoted in Laurie Lisle, *Portrait of an Artist: A Biography of Georgia O'Keeffe* (New York: Seaview Books, 1980), 8.

28 O'Keeffe, quoted in Robinson, *O'Keeffe: A Life*, 43.

29 Kahlo, quoted in Herrera, *Frida*, 12.

30 Salomon Grimberg, auction brochure for Kahlo's *Self-Portrait with Bonito* (Cleveland: Wolf's Auctioneers, 1991).

31 From the painted inscription to *Portrait of My Father* (1951; Museo Frida Kahlo, Mexico City).

32 Margaret Atwood, *Survival: A Thematic Guide to Canadian Literature* (Toronto: Anansi, 1972), 131.

33 Octavio Paz, "Art and Identity: Hispanics in the United States," in *Hispanic Art in the United States: Thirty Contemporary Painters and Sculptors* (Houston: Museum of Fine Arts and Abbeville

Press, 1987), 25–26; Paz, *The Labyrinth of Solitude: Life and Thought in Mexico*, trans. Lysander Kemp (1950; New York: Grove, 1961), 197–98.

34 Tibol, *Kahlo: An Open Life*, 11. Occasionally Kahlo painted her dolls: as early as 1927 she placed them with symbols of literature and poetry in *Portrait of Miguel N. Lira* (1927; Instituto Tlaxcalteca de Cultura, Tlaxcala). There was also a chubby nude infant doll seated beside her on a woven rush bed in *Me and My Doll* (1937; Gelman Collection, Mexico City). A miniature bride doll, acquired by Kahlo in a Paris flea market, peers over a cut watermelon amid a still life collection of fruits: *The Bride Who Became Frightened When She Saw Life Opened* (1943; Gelman Collection). At times, Kahlo painted children and adults as if they were dolls: *The Deceased Dimas* (1937; Olmedo Collection, Mexico City) lies, doll-like in the costume of dead Mexican children; elsewhere, Diego is cradled like an overstuffed doll in Frida's arms in *The Love Embrace of the Universe* (fig. 39). Kahlo herself becomes a doll-child, with ill-proportioned head and body, in *My Nurse and I* (fig. 38). Although children, especially those of her sister Cristina, were frequent visitors to Casa Azul, Kahlo seemed to prefer painting dolls to painting real children. Maybe living children squirmed too much, or perhaps seeing them was too painful a reminder of Kahlo's own childless marriage.

35 Whitney Chadwick, *Women Artists and the Surrealist Movement* (Boston: Little, Brown, 1985), 74.

36 For some women artists, this involved reviving or reclaiming female creation myths as models for their activities as artists. Joyce Mansour, for example, drew on her own Anglo-Egyptian background to incorporate Egyptian goddess imagery—Hathor, Isis, the White Goddess—as emblems and agents of female creativity. Mansour's first collection of poetry, *Cris*, was published in Paris in 1953. Kahlo, of course, had been using Egyptian mythology for years previously, and had long identified with such figures as Isis,

Nefertiti (or Neferisis), as discussed in Chapter 1. Clearly Kahlo's paintings, perhaps especially her encyclopedic *Moses* (1945), anticipated such work as Mansour's on female creativity. Mansour even wrote of the conflation of female biology and creativity in lines strongly reminiscent of Kahlo:

The nail planted in my celestial cheek
The horns that grow behind my ears
My bleeding wounds that never heal
My blood that becomes water that dissolves that
　embalms. (Cris [Paris: Pierre Seghers, 1953])

37 Both of Frida's older full sisters had similar (apparently underdeveloped) ovaries (Herrera, *Frida*, n. 147, p. 463).

38 Stieglitz to O'Keeffe, 31 March 1918, quoted in Pollitzer, *A Woman on Paper* (New York: Simon and Schuster, 1988), 159. Stieglitz later adopted a similar attitude and terminology for Dorothy Norman, an adoring younger woman whom he also photographed extensively.

39 O'Keeffe to Carl Zigrosser, April 1944, reprinted in Cowart, Hamilton, and Greenough, *Art and Letters*, no. 86, p. 236.

40 Carr, *Growing Pains*, 423.

41 Emily Carr, "Visiting Matrons," in *A Little Town and a Little Girl*, in *Emily Carr Omnibus*, 151–52.

42 Carr, *Growing Pains*, 460–61; see Doris Shadbolt, "Introduction," *Emily Carr Omnibus*, 6.

43 This portfolio was kept by Dilworth's daughter after his death and is housed with the Parnall Collection at the Provincial Archives of British Columbia, Victoria. Add.Ms. 2763, Box 5.

4

Private Spaces

1 Virginia Woolf, *A Room of One's Own* (New York: Harcourt Brace Jovanovich, 1961), 91; Austin Warren and René Wellek, *Theory of Literature* (New York: Harcourt, Brace, 1970), 221.

2 Introductory statement in Georgia O'Keeffe, *Georgia O'Keeffe* (New York: Viking, 1976), n.p.

3 O'Keeffe, quoted in Roxana Robinson, *Georgia O'Keeffe: A Life* (New York: HarperCollins, 1989), 19.

4 O'Keeffe, *Georgia O'Keeffe*, n.p.

5 O'Keeffe, quoted in Laurie Lisle, *Portrait of an Artist: A Biography of Georgia O'Keeffe* (New York: Seaview Books, 1980), 108.

6 O'Keeffe to Sherwood Anderson, September 1923(?), reprinted in Jack Cowart, Juan Hamilton, and Sarah Greenough, *Georgia O'Keeffe: Art and Letters* (Washington, D.C.: National Gallery of Art, 1987) no. 29, pp. 173–75.

7 O'Keeffe, quoted in Calvin Tomkins, "The Rose in the Eye Looked Pretty Fine," *New Yorker*, 4 March 1974, 47.

8 O'Keeffe, quoted in Robinson, *O'Keeffe: A Life*, 316.

9 Stieglitz, letter to Waldo Frank, 25 August 1925, YCAL.

10 Martin, quoted in Benita Eisler, "Life Lines," *New Yorker*, 15 January 1993, 73.

11 O'Keeffe, quoted in Katharine Kuh, "Georgia O'Keeffe," in *The Artist's Voice: Talks with Seventeen Artists* (New York: Harper and Row, 1960), 190.

12 Okakura Kakuzo, *The Book of Tea* (1900; rpt. Tokyo: Charles E. Tuttle, 1956), 51–52. O'Keeffe probably first heard of this book through Arthur Wesley Dow, who lauded it in his *Composition*, from which O'Keeffe borrowed many ideas for her teaching and her own work.

13 O'Keeffe to William Howard Schubart, April–July 1950, in Cowart, Hamilton, and Greenough, *Art and Letters*, no. 101, p. 252.

14 For more on the aesthetic form and meaning associated with the orthodox tearoom, see Okakura's *Book of Tea*, 53–73.

15 Alan Watts, *In My Own Way: An Autobiography, 1915–1965* (New York: Vintage, 1973), 421.

16 David McIntosh, quoted in Robinson, *O'Keeffe: A Life*, 474.

17 In the collection of the Rose Art Museum, Brandeis University, Waltham, Massachusetts; gift of Samuel Lustgarten.

18 O'Keeffe to Henry McBride, July 1931, YCAL.

19 O'Keeffe, quoted in Mary Lynn Kotz, "A Day with Georgia O'Keeffe," *ARTnews* 76, no. 10 (December 1977), 42.

20 Thomas Merton, *New Seeds of Contemplation* (New York: New Directions, 1961).

21 Carr, *Growing Pains*, in *The Emily Carr Omnibus* (Seattle: University of Washington Press, 1993), 343.

22 Ibid., 342.

23 Newcombe was a semi-retired physician, as well as a botanist and ethnologist, who was instrumental in helping the Provincial Museum acquire Indian totem poles and artifacts. He first visited Carr's studio in Vancouver in December 1912 to assess the possible anthropological value of her work for the museum. Newcombe reported that the work was not accurate enough in its rendering of scale and color, nor could its detail match that of photographs. Nonetheless, he recommended her to paint the decorative wall panels in the new museum, similar to those at museums in New York. Probably he was thinking of the Brooklyn Museum and the Museum of Natural History, whose collection of Northwest-Coast materials Georgia O'Keeffe had admired. When she sought design materials for her students in Canyon, Texas, in the fall of 1916, O'Keeffe thought of those Indian motifs; to her friend Anita Pollitzer she wrote, "Anita—don't you want to go up to the Museum of Natural History and see if there is any way of getting photographs of any of that Alaskan stuff[?]" (O'Keeffe, letter to Anita Pollitzer, October 3, 1916, YCAL). It is coincidental though not surprising, given their respective attitudes toward modern design, that both O'Keeffe and Carr admired Northwest Coast materials.

24 Review quoted in Maria Tippett, *Emily Carr: A Biography* (1979; Toronto: Stoddart, 1994), 117.

25 Mrs. Kate Mather, quoted in Paula Blanchard, *The Life of Emily Carr* (Seattle: University of Washington Press, 1987), 147.

26 Carr, *Growing Pains*, 439.

27 Ibid.

28 Carr, *The House of All Sorts*, in *Emily Carr Omnibus*, 91.

29 Carr, quoted in Blanchard, *Life of Emily Carr*, 142; Carr, *House of All Sorts*, 202.

30 Carr, journal entry for 14 December 1935, *HT*, 211.

31 Carr, journal entry for 18 January 1936, *HT*, 216.

32 Carr, journal entry for 23 February 1936, *HT*, 224–25.

33 Carr, journal entries for 5 and 8 March 1936, *HT*, 227; Carr to Nan Cheney, 30 May 1941, reprinted in *Dear Nan: Letters of Emily Carr, Nan Cheney and Humphrey Toms*, ed. Doreen Walker (Vancouver: University of British Columbia Press, 1990), no. 198, p. 327.

34 Carr, journal entry for 23 February 1940, *HT*, 317.

35 Carr to John Davis Hatch, 2 February 1941, Hatch Papers, Archives of American Art, Smithsonian Institution.

36 Scherner's ideas appear in his *The Life of Dreams* (Berlin, 1861), Freud's in his *Interpretation of Dreams* (Vienna, 1900).

5

The Spiritual Core

1 Virginia Woolf, "Modern Fiction" (1919), in *The Essays of Virginia Woolf*, ed. Andrew McNeillie, vol. 3 (London: Hogarth, 1994), 160.

2 See Udall, "Beholding the Epiphanies: Mysticism and the Art of Georgia O'Keeffe," in *From the Faraway Nearby: Georgia O'Keeffe as Icon*, ed. Christopher Merrill and Ellen Bradbury (Reading, Mass.: Addison-Wesley, 1992), 89–112.

3 O'Keeffe, statement in *Georgia O'Keeffe: Some Memories of Drawings*, ed. Doris Bry (Albuquerque: University of New Mexico Press, 1974), n.p.

4 Virginia Woolf, "On Being Ill," in *Collected Essays*, vol. 4 (New York: Harcourt, 1967), 194. This silencing ability of pain is discussed at length in Elaine Scarry, *The Body in Pain: The Making and Unmaking of the World* (New York: Oxford University Press, 1985), 3–23ff.

5 Vernon Hunter, "A Note on Georgia O'Keeffe," *Contemporary Arts of the South and Southwest* (November–December 1932), 7.

6 Dorothy E. Brett, "Autobiography: My Long and Beautiful Journey," *South Dakota Review* 5, no. 2 (Summer 1967), 53.

7 Bacon, quoted in Laurie Lisle, *Portrait of an Artist: A Biography of Georgia O'Keeffe* (New York: Seaview Books, 1980), 200.

8 These qualities—quietude and long-suffering—were also valued by Emily Carr, whose own spiri-

tuality combined elements of native mysticism with a personal Christianity. Carr wrote in her journal, "I like the Virgin Mary; she was not a blabber" (entry of 16 February 1934, in *HT*, 97).

9 O'Keeffe to Ettie Stettheimer, 1937, YCAL.

10 See Sarah Whitaker Peters, *Becoming O'Keeffe: The Early Years* (New York: Abbeville, 1991), 44–45.

11 Brancusi's 1910 *Sleeping Muse*, owned by Stieglitz, was (as Sarah Whitaker Peters has suggested) a probable inspiration for some of the photographer's camera portraits of O'Keeffe, starting in 1918. (See *Becoming O'Keeffe*, 158–59.) Brancusi explored stone-egg imagery for years, in such works as *The Beginning of the World* (1924), which represented the Cosmogonic Egg of primal wholeness found in many cultures.

12 In the ancient world the belief that stone was an archetypal image representing absolute reality was widespread: see Mircea Eliade, *The Forge and the Crucible* trans. Stephen Corrin (1956; Chicago: University of Chicago Press, 1978), 48.

13 Arthur Edward Waite, *The Secret Tradition in Alchemy* (New York: Samuel Weiser, 1969), 20.

14 Allusions to flames or fire, another feature central to the transforming processes of alchemy, appear in several of O'Keeffe's charcoals from the same period (notably her *Drawing No. 9*, 1915, Menil Collection, Houston).

15 Arthur Dove, letters to Alfred Stieglitz, 4 December 1930 and 27 February 1931, reprinted in Ann Lee Morgan, ed., *Dear Stieglitz, Dear Dove* (Newark: University of Delaware Press, 1988), 201–02 and 205–06.

16 Waldo Frank, *Our America* (New York: Boni and Liveright, 1919), 184.

17 Lewis Mumford, "The Art Galleries: Autobiographies in Paint," *New Yorker* 18 January 1936, 48.

18 Georgia O'Keeffe, *Georgia O'Keeffe* (New York: Viking, 1976), opposite plate 107.

19 O'Keeffe, letter to William Howard Schubart, 28 July 1950, in Jack Cowart, Juan Hamilton, and Sarah Greenough, *Georgia O'Keeffe: Art and Letters* (Washington, D.C.: National Gallery of Art, 1987), p. 253, no. 102.

20 Harris joined the International Theosophical Society around the end of World War I, and in 1923 he became a member of the active Toronto branch. In the journal *The Canadian Theosophist*, Harris began to set forth publicly his ideas on creativity, a practice he would continue in print, in private correspondence, in speeches, and in radio broadcasts for several decades (Lawren Harris, "Revelation of Art in Canada," *The Canadian Theosophist* 7 [July 15, 1926]).

21 Harris, "Revelation of Art in Canada," 87.

22 Harris to Carr, June 1930, quoted in Dennis Reid, *Atma Buddhi Manas: The Later Work of Lawren S. Harris* (Toronto: Art Gallery of Ontario, 1985), 18.

23 Carr, journal entry for September 1935, *HT*, 193; See Carr, journal entry for 4 April 1934, *HT*, 106–07. Van Gogh's art was much discussed in Canada during those years, especially after a large exhibition of his work, organized by the Museum of Modern Art in New York, was shown at the Art Gallery of Toronto in 1936. Carr's oil-on-paper works, begun about 1932, encouraged critics to view her within the sphere of European and American modernism initiated by such pioneers as Van Gogh.

24 Ruth Appelhof, in Appelhof, Barbara Haskell, and Jeffrey R. Hayes, *The Expressionist Landscape: North American Modernist Painting, 1920–1947* (Birmingham, Ala.: Birmingham Museum of Art, 1988) 77.

25 Carr, *Growing Pains*, in *The Emily Carr Omnibus* (Seattle: University of Washington Press, 1993), 451.

26 Carr, journal entry for 7 June 1933, *HT*, 35.

27 Harris, letter to Carr, June 1930, Carr Papers, Provincial Archives of British Columbia, Victoria [hereafter cited as Carr Papers]. The best-known exposition of this concept was *Thought Forms*, by Annie Besant and C. W. Leadbeater. First published in 1901, the 1925 reprint was reviewed in *The Canadian Theosophist* in 1926 only a month before Harris's first published article on Theosophy appeared there.

28 Harris, letter to Carr, May 1936, Carr Papers, MG 30 D215. Harris here expresses an attitude that is remarkably close to that held by Georgia O'Keeffe, whose abstract work was nearly always based on intense experience of nature.

29 Harris to Carr, 20 December 1931, Carr Papers; Carr, *Growing Pains*, 456.

30 Uhthoff, quoted in Maria Tippett, *Emily Carr: A Biography* (1979; rpt. Toronto: Stoddart, 1994), 160.

31 Colin Graham, *Mark Tobey in Victoria* (Victoria: Art Gallery of Greater Victoria, 1976), n.p.; Carr, letter to Eric Brown, fall 1928, quoted in Doris Shadbolt, *The Art of Emily Carr* (Vancouver: Douglas and McIntyre, 1979), 62.

32 Carr, journal entry for 24 November 1930, *HT*, 21.

33 Carr's flyleaf comment in her copy of Jay Hambidge, *Dynamic Symmetry* (1920; New Haven: Yale University Press, 1926), Carr Papers.

34 Carr, quoted in Tippett, *Emily Carr*, 193, and Blanchard, *Life of Emily Carr*, 218.

35 Carr, *Growing Pains*, 457.

36 Carr, journal entry for 4 November 1933, *HT*, 74.

37 Carr, journal entry for 17 November 1933, *HT*, 79.

38 Carr, journal entry for 29 January 1934, *HT*, 94.

39 Carr, journal entry for 5 July 1934, *HT*, 138.

40 Carr, journal entry for 6 March 1940, *HT*, 324.

41 Carr, journal entry for 28 December 1940, *HT*, 329.

42 Carr, journal entry for 6 March 1934, *HT*, 100; Whitman, "The Love That Is Hereafter," in *Walt Whitman: The Complete Poems*, ed. Francis Murphy (New York: Penguin, 1975), 640.

43 Laura Mulvey and Peter Wollen, "Frida Kahlo and Tina Modotti," in Mulvey, *Visual and Other Pleasures* (Bloomington: Indiana University Press, 1989), 102. Close friends such as Ella Wolfe, Virginia Valadez, and Lucienne Bloch have commented that although Kahlo was not a practicing Catholic, she often wanted to "play church" as a child and remained fascinated with the aesthetic content of Christian art as an adult. Bloch asserted that Kahlo's adoption of the votive painting format came as a result of Rivera's suggestion. See Salomon Grimberg, "Frida Kahlo's *Memory*: The Piercing of the Heart by the Arrow of Divine Love," *Woman's Art Journal* 11, no. 2 (Fall–Winter 1990–91), p. 6, n.2.

44 Kahlo's painting of Luther Burbank, discussed in Chapter 2, is a prime example of the paradigm of transformation central to alchemy.

45 Sarah M. Lowe, *Frida Kahlo* (New York: Universe, 1991), 80.

46 Kahlo, diary entry for 9 November 1951, in Sarah Lowe, ed., *The Diary of Frida Kahlo: An Intimate Self-Portrait* (New York: Abrams, 1995), 102.

47 Paracelsus, quoted in Peter Ackroyd, *Blake* (New York: Knopf, 1996), 90; Kahlo, diary pages 87, 88, 91 in Lowe, ed., *Diary of Frida Kahlo*. Kahlo and Rivera shared a vision of the interaction of the cellular and the cosmic. In his ill-fated Radio City mural Rivera included both a telescope and microscope, which he said allowed humankind to see and link the smallest cells with the vastness of space. Still another reference in Kahlo's *Without Hope* may be to what André Breton called "the mysteries of alimentary generation," an arcane allusion to the digestive process within the painting ("Frida Kahlo de Rivera," *Mexique*, exh. cat., Galerie Renou et Colle, Paris, 1939], n.p). On Bosch as an alchemical painter see Laurinda S. Dixon, "Bosch's *Garden of Delights* Triptych: Remnants of a 'Fossil' Science," *Art Bulletin* 63, no. 1 (March 1981), 96–113.

48 One thinks here of the all-consuming state of invalidism Thomas Mann describes in *The Magic Mountain*: "A human being who is first of all an invalid is *all* body; therein lies his inhumanity and his debasement. In most cases he is little better than a carcass" (trans. H. T. Lowe-Porter [New York: Knopf, 1955], 100).

49 Paracelsus, quoted in Merchant, *Death of Nature*, 26–27.

50 In his 1939 painting *Mandragora* (San Diego Museum of Art), Rivera painted a smiling woman holding a skull, while above, prominently situated, appears a mandrake with its long, sinuous root.

51 Eliade, *Forge and the Crucible*, 34.

52 Carl G. Jung, *Psychology and Alchemy* in *The Basic Writings of C. G. Jung*, trans. R. F. C. Hull, intro. Violet S. De Laszlo (Princeton: Princeton University Press, 1990). The unity of mind and

matter emphasized by alchemists thus corresponds both to Jung's study of the developmental process of individuation and to Freud's conception of the unconscious existing within a psychobiological framework. The fundamental assumptions and efforts of alchemists in history span both Eastern and Western traditions, as well as many disciplines within them. There is a sense, for example, in which Marxist thought and dialectical materialism have been likened to classic, transforming dualities of alchemy. Kahlo and Rivera, if they made that connection, would have found such analogies highly engaging.

53 See Whitney Chadwick, *Women Artists and the Surrealist Movement* (Boston: Little, Brown, 1985), esp. chap. 5.

54 As Eduard Seler notes, "These four distinct prehistoric or precosmic ages of the Mexicans, each one oriented toward a different direction of the heavens, are astonishingly related to the four elements, water, earth wind and fire, known to classical antiquity and which even now constitute the way that the civilized peoples of East Asia look upon nature" (quoted in Miguel Leon-Portilla, *Aztec Thought and Culture: A Study of the Ancient Nahuatl Mind*, trans. Jack Emory Davis [Norman: University of Oklahoma Press, 1963], 46).

55 I can but note the obvious points of convergence here. In addition to the Aztec and alchemical sources already cited, more on such correspondences can be found in S. Mahdihassan, "Alchemy, with the Egg as its Symbol," *Janus* 63, nos. 1–3 (1976), 133–53.

56 The way in which the alchemical tradition was maintained and extended in the nineteenth and twentieth centuries forms a complex and illuminating narrative, with a number of key players. Jacob Bohme, for example, revealed notions of mystical duality, whereby the undifferentiated One divides itself into two principles; the single being gives birth to itself (this is a notion dear to both Kahlo and Rivera). A dialectic is thus created in which each principle is defined by the existence and character of the other. The tradition of separatio is thus the separation of the true from

the false, pure from impure, light from darkness, good from evil. In the 1850s three obscure works were published in England and America which characterize alchemy as practiced in the soul, as the art of life. Mary Anne South (later writing as Mrs. Atwood) published in 1850 (re-released in 1918 and again in 1920) a volume of nearly five hundred pages entitled *A Suggestive Inquiry into the Hermetic Mystery*, which recounts the history of alchemical literature from its early focus on transmutation of metals to later theories of "pure ethereality of Nature," of "substances of life and light, immanifestly flowing throughout Nature" (18) The Hermetic Vessel of alchemy, long a well-guarded secret, emerges in this text as humanity itself. "The alchemical process," concludes Atwood, "is thus a secret method of self-knowledge which the soul follows far through its realm of being" (21) For more on Mrs. Atwood and the surviving alchemical tradition, see Waite, *Secret Tradition in Alchemy*.

6

Sexuality, Androgyny, and Personal Appearance

1 Many thinkers have conceived of an original unity, seen frequently in images of a cosmogonic egg. Plato, in a similar manner, thought of humankind as originating in a bisexual being, spherical in form. It was divided, he related in his *Symposium*, when Zeus saw the dual being as a threat and cut it in two. Thereafter the severed halves embraced, yearning for reunification. Many old stories retell this tale, in which separation or dismemberment of a primordial unity precedes a later reunification. In two variations of the theme, Aztec and Christian, violent death invokes rebirth. The alchemical mystical marriage of sun and moon (male and female) stood for a reunification of nature, producing another kind of wholeness.

2 Woolf described the androgynous mind as "resonant . . . porous . . . transmitting emotion without impediment . . . incandescent . . . undivided" (*A Room of One's Own* (New York: Harcourt Brace Jovanovich, 1961), 171. Particularly in the 1930s, images of androgyny, often related to surrealism, appeared in such works as André Mas-

son's *Hourglass Androgyne* and René Magritte's *Dream of the Androgyne*. André Breton spoke of "the necessity for the reconstitution of the primordial Androgyne" (quoted in Robert Knott, "The Myth of the Androgyne" in *Artforum* 14, no. 3 [Nov. 1975], 38). For more on androgyny in art, see *Androgyn: Sehnsucht nach Vollkommenheit*, exh. cat. (Berlin: Neuer Berliner Kunstverein, 1986); and Albert Beguin, "L'Androgyne," *Minotaure* 11 (1938), 10ff.

3 Freud was deeply interested in both androgyny and bisexuality, which he defined in terms of both physical traits and objects of desire. Most neuroses, he argued, originate in the repression of a universal bisexual nature. Departing from Freud, Carl Jung and his followers—especially Mircea Eliade, Joseph Campbell, and Eric Neumann—popularized a kind of androgyne cult. With individual variations, they discussed the primordial bisexual being as both point of separation and desired goal of personal reconciliation.

4 Deborah Cameron, *Feminism and Linguistic Theory* (London: Macmillan, 1985), 155–56.

5 Goncourt, quoted in Tamar Garb, "Gender and Representation," in Francis Frascina et al., *Modernity and Modernism: French Painting in the Nineteenth Century* (New Haven: Yale University Press, 1993), 231. Women artists were collectively dismissed, as Garb further asserts, for their "lack of originality, their conservatism, their imitativeness, their emotional intensity accompanied by intellectual deficiency and the necessarily all-absorbing concerns of maternity." For Carr see Doris Shadbolt, "Introduction," *The Emily Carr Omnibus* (Seattle: University of Washington Press, 1993) 13.

6 Carolyn G. Heilbrun, *Toward a Recognition of Androgyny* (New York: Harper and Row, 1973), xiv.

7 An Aztec metaphor, for example, usefully describes the male-female union in nature. The Aztec sacred spring with its "flowing, fecundating water is masculine," notes Erich Neumann, "but the spring as a whole is a uterine symbol of the childbearing feminine earth" (quoted in Marjorie Garber, *Vice: Bisexuality and the Eroticism of Everyday Life* New York: Simon and Schuster, 1995], 209).

8 Of such faces Ignacio Bernal writes, "Perhaps these were an attempt to illustrate in primitive form the basic principle of all pre-Columbian civilizations in Mexico; the cosmic and creative duality, the masculine and feminine elements joined in a kind of hermaphroditism, the good and evil which have the same source" (*Mexico Before Cortez: Art, History and Legend*. rev. ed. [Garden City, N.Y.: Anchor, 1975], 30–31). Kahlo painted a triple visage among the gods and heroes in *Moses* (see fig. 5).

9 See, for example, modifications of this idea in her *Self-Portrait on the Borderline between Mexico and the United States* (fig. 3) and her representation of the pyramids of the Moon and Sun at Teotihuacan on her diary page 115: undated diary entry (c. 1953), in Sarah Lowe, ed., *The Diary of Frida Kahlo: An Intimate Self-Portrait* (New York: Abrams, 1995), 261.

10 Kahlo and O'Keeffe also shared an interest in the work of Li Po (Li Bo) (701–62), one of the most widely read poets in the world. His thousand extant poems present a yin or female view of the Dao and often describe imaginary journeys to the sun and moon. Kahlo pleaded with correspondents to send her books on Tao and on Chinese culture in general. O'Keeffe's volume of *The Works of Li Po* remained in her library at Abiquiu until her death. As a sometime student of Daoist mysticism, Kahlo may well have come across the following famous passage from the *Daodejing*: "He who knows the male, yet cleaves to what is female,/Becomes like a ravine, receiving all things under heaven. [Thence] the eternal virtue never leaks away./This is returning to the state of infancy." Kahlo, who imagined herself and her husband returning to states of infancy (as in, for example, her paintings *My Birth* (1932; private collection) and *My Nurse and I* [fig. 38]), also styled herself as the mother of Rivera in *The Love Embrace of the Universe*. Rivera apparently acquiesced in such generational play, as when he

painted himself as a child and Kahlo as an adult holding a yin-yang symbol in his mural *Dream of a Sunday Afternoon in the Alameda* (1947–48; painted for the Hotel del Prado, now in the Jardin de la Solidaridad, Mexico City).

11 The Asian cult of *Sahaja* was written about in the 1920s and 1930s by the Ananda Coomaraswamy (1877–1947), the foremost interpreter of Indian culture to the West: "*Sahaja* has nothing to do with the cult of pleasure. It is the doctrine of the Tao, the path of non-pursuit." Coomaraswamy taught that love is a means of initiation into life, with the possibility of union between the finite and infinite comparable to "the self-oblivion of earthly lovers locked in each other's arms where 'each is both'" (quoted in Claude Bragdon, *Delphic Woman* [1925; rpt. New York: Knopf, 1936], 85–87). Kahlo, whose investigation of Eastern philosophy almost certainly led her to Coomaraswamy, repeatedly referred to such concepts in her diary (notably on page 127, where the yin-yang symbol appears in close proximity with the words *Tao, Sadga, Diego*, and *amor*) as well as in her fused portraits of Diego and herself (see Lowe, ed., *Diary of Frida Kahlo*).

12 Jean van Heijenoort, quoted in Herrera, *Frida*, 198; Kahlo, quoted in Amy Fine Collins, "Diary of a Mad Artist," *Vanity Fair*, September 1995, 185.

13 Kahlo, "Portrait of Diego" (1949), reprinted in Martha Zamora, comp., *The Letters of Frida Kahlo: Cartas Apasionadas* (San Francisco: Chronicle, 1995), 143. Hayden Herrera has explored the creative dynamic at work in the Kahlo-Rivera relationship in several contexts, most recently in her chapter in Whitney Chadwick and Isabelle de Courtivron, eds. *Significant Others: Creativity and Intimate Partnership* (London: Thames and Hudson, 1993). Among the studies that have explored patterns of creative exchange between Stieglitz and O'Keeffe is Belinda Rathbone, Roger Shattuck, and Elizabeth Hutton, *Georgia O'Keeffe and Alfred Stieglitz: Two Lives*, exh. cat. (Washington, D.C.: The Phillips Collection and Callaway Editions, 1992).

14 Virginia Woolf, *Orlando* (New York: Harcourt, Brace Jovanovich, 1956), 188.

15 Donald Cordry and Dorothy Cordry, *Mexican Indian Costumes* (Austin: University of Texas Press, 1968), 273.

16 Kahlo, quoted in Herrera, *Frida*, 245.

17 Two recent books on West and American popular culture are Ramona Curry, *Too Much of a Good Thing: Mae West as a Cultural Icon* (Minneapolis: University of Minnesota Press, 1996); and Pamela Robertson, *Guilty Pleasures: Feminist Camp from Mae West to Madonna* (Durham, N.C.: Duke University Press, 1996). Kahlo's appeal for gay artists is exemplified in the work of Nahum B. Zenil, who uses her as a model for aspects of his own personal narrative. See Eduardo de Jesus Douglas, "The Colonial Self: Homosexuality and Mestizaje in the Art of Nahum B. Zenil," *Art Journal* 57, no. 3 (Fall 1998), 14–21.

18 Susan Fillin-Yeh has written about cross-dressing among early twentieth-century artists (including O'Keeffe) as a deliberate challenge to the image of the male dandy lingering from the last century. Fillin-Yeh argues that gender doubling and role reversal reflect liberating experimentation and activism within avant-garde coteries, which were intensely conscious of self and position ("Dandies, Marginality and Modernism: Georgia O'Keeffe, Marcel Duchamp and other Cross-Dressers," *Oxford Art Journal* 18, no. 2 [1995], 33–44). My thanks to Lois Rudnick for this article.

19 See Roxana Robinson, *Georgia O'Keeffe: A Life* (New York: Harper Collins, 1989), 89.

20 See, for example, plates 67 and 94 in Todd Webb, *Georgia O'Keeffe: The Artist's Landscape* (Pasadena, Calif.: Twelvetrees, 1984). Many of O'Keeffe's singular outfits were items that could be bought ready-made, but O'Keeffe was a gifted seamstress. While living in towns distant from clothing stores, she often stitched her own blouses and underwear. She also seems to have sewed for its therapeutic effect; from South Carolina she wrote to her friend Anita Pollitzer of a mundane, obsessive bout of darning: "This morning —I have been darning stockings—one pair— There is just one girl working in the other studio

so I have had practically nothing to do but darn. I darned all the holes and all the spots that looked as if they might ever wear out and then darned some more—all on the same pair of stockings—because I wanted to think" (letter to Anita Pollitzer, 21 February 1916, YCAL). Years later, long after she could afford to hire a dress-maker, O'Keeffe continued to sew for herself and to mend Stieglitz's clothes. Sewing enabled O'Keeffe to escape into solitary thought, to attend to life's concerns in a quiet, focused manner.

21 Robinson, *O'Keeffe: A Life*, 510.

22 O'Keeffe, quoted in Mary Lynn Kotz, "A Day with Georgia O'Keeffe," *ARTnews* 76, no. 10 (December 1977), 43.

23 Mary Elizabeth Colman, "Emily Carr and Her Sisters," quoted in Paula Blanchard, *The Life of Emily Carr* (Seattle: University of Washington Press, 1987), 76.

24 Blanchard, *Life of Emily Carr*, 152–53.

7

The Public Self

1 Carr, letter to Nan Cheney, early 1940, reprinted in Doreen Walker, ed., *Dear Nan: Letters of Emily Carr, Nan Cheney and Humphrey Toms* (Vancouver: University of British Columbia Press, 1990), no. 139, p. 216.

2 Carr, journal entry for 10 December 1934, *HT*, 159–60.

3 Carr, quoted in the publisher's foreword to *HT*, ix.

4 Carr, journal entries for 5 March 1940 and 21 February 1941, *HT*, 322, 331.

5 Carr, quoted in Maria Tippett, *Emily Carr: A Biography* (1979; rpt. Toronto: Stoddart, 1994), 268. In this vein, Timothy Adams argues that "of [Carr's] books, only *Growing Pains* is autobiography, the remainder constituting a literary 'house of all sorts,' a mixture of genres and approaches somewhere between fiction and nonfiction" ("'Painting Above Paint': Telling Li(v)es in Emily Carr's Literary Self-Portraits," *Journal of Canadian Studies* 27, no. 2 [Summer 1992], 38).

6 Tippett, *Emily Carr*, 11.

7 A significant exception to her family's indifference—so rare that it warranted recording

—occurred in 1933, when Emily reported, "I have just had a surprise and a great joy. My sister Alice came to see the sketches and they really moved her. She went over and over them for a full hour, changing them about on the easels, sorting and going back again to particulars. And she repeated several times, 'They're beautiful. No that's not quite it. They're wonderful.' And she kissed me" (undated journal entry for October, 1933, *HT*, 63).

8 Carr, quoted in Walker, ed., *Dear Nan*, x.

9 Carr, letter to Ira Dilworth, n.d. [1942–43], Carr Papers, Provincial Archives of British Columbia, Victoria [hereafter cited as Carr Papers]; Carr, quoted in Tippett, *Emily Carr*, 13.

10 Carr to Eric Brown, 1934, quoted in Doris Shadbolt, *The Art of Emily Carr* (Vancouver: Douglas and McIntyre, 1979), 108; Carr, journal entry for 5 April 1935, *HT*, 176; Carr to John Davis Hatch, September 1939, Hatch Papers, Archives of American Art, Smithsonian Institution, Washington, D.C.

11 Carr, journal entry for 7 February 1940, *HT*, 315.

12 From a notebook found among Carr's papers, now in Carr Papers.

13 Carr, journal entry for 26 November 1930, *HT*, 22.

14 Georgia O'Keeffe, letter to the editor, *MSS* 4 (December 1922), 17–18; Georgia O'Keeffe, *Georgia O'Keeffe* (New York: Viking, 1976), n.p.

15 O'Keeffe to Cady Wells, Spring 1939 (?), reprinted in Jack Cowart, Juan Hamilton, and Sarah Greenough, *Georgia O'Keeffe: Art and Letters* (Washington, D.C.: National Gallery of Art, 1987), no. 77, p. 227.

16 Two copies of the 1914 edition of Eddy's book, one heavily annotated for Stieglitz by Oscar Bluemner, remained in O'Keeffe's Abiquiu library at the time of her death.

17 Walt Whitman, "A Song of the Rolling Earth," in *Walt Whitman: The Complete Poems*, ed. Francis Murphy (New York: Penguin, 1975), 248.

18 Dove, quoted in Cowart, Hamilton, and Greenough, *Art and Letters*, note 73, p. 286; George Orwell, *Homage to Catalonia* (1938; New York:

Harcourt, Brace, Jovanovich, 1952), 25; O'Keeffe, quoted in Edith Evans Asbury, "Silent Desert Still Captivates Georgia O'Keeffe, Nearing Eighty-One," *New York Times*, 2 November 1968, 39.

19 Kahlo to Alejandro Gómez Arias, c. September 1926, in Martha Zamora, comp., *The Letters of Frida Kahlo: Cartas Apasionadas* (San Francisco: Chronicle, 1995). 25.

20 Kahlo to Alejandro Gómez Arias, 31 [*sic*] April 1927, reprinted in Zamora, comp., *Letters*, 29.

21 Kahlo to Georgia O'Keeffe, 1 March 1933, Stieglitz Collection, YCAL.

22 Kahlo to Clifford Wight, 11 April 1933, reprinted in Antonio Saborit, "Frida Kahlo: Tres cartas ineditas," *El Nacional Lectura*, 27 July 1991, 3. Wight, described by Kahlo's and Rivera's biographers as an English sculptor and former member of the Royal Canadian Mounted Police, was Rivera's assistant on mural projects in the United States. He became a close friend of both Kahlo and Rivera's. By the time the mural was destroyed, in February 1934, Stieglitz had changed his tone, calling the affair a "tempest in a teapot" and laying more blame on the artists than the Rockefellers for "killing" art: see Stieglitz, letter to Arthur Dove, 17 February 1934, in Ann Lee Morgan, ed., *Dear Stieglitz, Dear Dove* (Newark: University of Delaware Press, 1988), 296–97. Interestingly, Nelson Rockefeller later erroneously blamed Frida Kahlo for inciting Rivera to "incorporate the most unbelievable subjects [both political and sexual] into the mural." Laurance P. Hurlburt, *The Mexican Muralists in the United States* (Albuquerque: University of New Mexico Press, 1989) 174.

23 Salomon Grimberg, reviews of three Kahlo publications, *Woman's Art Journal* 18, no. 2 (Fall–Winter, 1997–98), 42–44 (Grimberg, a child psychiatrist as well as a Kahlo scholar, is uniquely qualified to make such a statement); Kahlo, "Portrait of Diego," quoted in Zamora, comp. *Letters*, 142.

24 O'Keeffe to Sherwood Anderson, September 1923? and O'Keeffe to Henry McBride, February 1923, in Cowart, Hamilton, and Greenough, *Art and Letters*, no. 29, pp. 173–74, no. 27, p. 171–72.

25 O'Keeffe, 1921 letter to Mitchell Kennerly, cited in Roxana Robinson, *Georgia O'Keeffe: A Life* (New York: Harper Collins, 1989), 241–42. O'Keeffe's attempts to reconcile public and private are recounted at length in Barbara Buhler Lynes, *O'Keeffe, Stieglitz and the Critics, 1916–1929* (Ann Arbor: UMI Research Press, 1989), as well as in Robinson's and Lisle's biographies (Laurie Lisle, *Portrait of an Artist: A Biography of Georgia O'Keeffe* [New York: Seaview Books, 1980)].

26 O'Keeffe to Doris McMurdo, 1 July 1922, in Cowart, Hamilton, and Greenough, *Art and Letters*, no. 25, pp. 169–70.

27 C. J. Bulliet, "The American Scene," in his *Apples and Madonnas: Emotional Expression in Modern Art* (Chicago: Pascal Covici, 1927), 200–201.

28 Lillian Sabine, "Record Price for Living Artist. Canvases of Georgia O'Keeffe Were Kept in Storage for Three Years until Market Was Right for Them," *Brooklyn Sunday Eagle*, 27 May 1928, reprinted in Lynes, *O'Keeffe, Stieglitz and the Critics*, 288–90. Critic Henry McBride reported in January 1927 that Stieglitz had sold a John Marin watercolor for $6,000, a sale McBride claimed "must be a record price for a work by a living man. . . . To establish a record. . . Miss O'Keefe [*sic*] will have to go far beyond Mr. Marin's $6,000, for she works in oils" ("Georgia O'Keefe's Work Shown: Fellow Painters of Little Group Become Fairly Lyrical Over it," *New York Sun*, 15 January 1927, reprinted in Lynes, *O'Keeffe, Stieglitz and the Critics*, 258). It seems highly probable, in retrospect, that Stieglitz deliberately orchestrated the phony sale in 1928 as a direct response to McBride's implied challenge. To achieve maximum publicity for the invented transaction, Stieglitz announced it to the editor of *The Art News* in a letter published on 21 April 1928 (reprinted in Lynes, *O'Keeffe, Stieglitz and the Critics*, 285). For more on the complex (and misleading) publicity surrounding Marin's $6,000 sale, see Elizabeth Hutton Turner, *In the American Grain* (Washington, D.C.: Counterpoint and the Phillips Collection, 1995), 18–22.

29 O'Keeffe, quoted in Lillian Sabine, "Record Price for Living Artist," 288; Dreier, quoted in Carr, *Growing Pains*, in *The Emily Carr Omnibus* (Seattle: University of Washington Press, 1993), 451. Dreier knew O'Keeffe's work well by that time, having included it in the Société Anonyme publication Dreier had co-edited in 1926, *Modern Art*.

30 O'Keeffe to William Howard Schubart, 28 July 1950, in Cowart, Hamilton, and Greenough, *Art and Letters*, no. 102, p. 253. In later years, as reported by such associates as museum director Van Deren Coke, O'Keeffe watched auction results closely, delighting when her prices exceeded those of her colleagues.

31 Picasso, quoted in Mary Mathews Gedo, *Picasso: Art as Autobiography* (Chicago: University of Chicago Press, 1980), 3.

32 André Breton, *Surrealism and Painting*, trans. Simon Watson (London: Taylor MacDonald, 1972), 35; Herrera, *Frida*, 255. The exhibition was held at the Museum of Modern Art in 1940.

33 Kahlo, quoted in Herrera, *Frida*, 226.

34 Nancarrow, quoted in Herrera, *Frida*, n. 285, p. 478; Kahlo, quoted in Raquel Tibol, *Frida Kahlo: An Open Life*, trans. Elinor Randall (1983; Albuquerque: University of New Mexico Press, 1993), 3–4.

35 Maria Tippett, *By a Lady: Celebrating Three Centuries of Art by Canadian Women* (Toronto: Penguin, 1992), 58.

36 Wyn Wood, "Art and the Pre-Cambrian Shield," *Canadian Forum* 26, no. 193 (February 1937), 13–15.

37 Lawren Harris, *Emily Carr: Her Paintings and Sketches* (Toronto: Oxford University Press, 1945).

38 H. Mortimer Lamb to Eric Brown, 24 October 1921, National Gallery of Canada, Ottowa. Before she left to study in England in 1890, Pemberton had taken art classes in Victoria with Carr and another future painter, Theresa Wylde. Pemberton later distinguished herself at the Académie Julian in Paris before returning to British Columbia. There she had considerable success as a painter of *maternité* subjects, working in the genre popularized by Berthe Morisot and Mary Cassatt. Because of the disparity in the subjects Carr and Pemberton chose to paint, as well as differences in their personal lives (Pemberton married and moved in other social circles), she and Carr never resumed their youthful friendship. Carr's long-stagnant career, a cause of her deep resentment, probably prompted jealousy over her former friend's success. When belated recognition came, Carr thanked others, but did not acknowledge Pemberton's early advocacy of her work.

39 Barbeau to Grace Pincoe, 28 August 1945, quoted in Paula Blanchard, *The Life of Emily Carr* (Seattle: University of Washington Press, 1987), 151. Carr biographer Maria Tippett concludes, based on Barbeau's inconsistencies, that he never met Carr before 1926; other Carr scholars, such as Edythe Hembroff-Schleicher (*Emily Carr: The Untold Story* [Saanichton, B.C.: Hancock House, 1978]) and Paula Blanchard, opt for an initial meeting in the mid-1910s, as recalled by Barbeau.

40 Eric Brown, "Introduction," *Exhibition of Canadian West Coast Art, Native and Modern*, exh. cat. (Ottawa: Victoria Memorial Museum and the National Gallery of Canada, 1927), 2.

41 Carr to Eric Brown, 19 October 1934, quoted in Tippett, *By a Lady*, 66; Carr, journal entry for 16 January 1934, *HT*, 91–92.

42 Tippett, *Emily Carr*, 195.

43 Eric Newton, "Canadian Art Through English Eyes," *Canadian Forum* 18 (February 1939), 344–45. When Carr was not rude to collectors, some of them responded well to her work too. In 1937 buyers included Mme. Leopold Stokowski, wife of the conductor and composer, who purchased a small Carr canvas for $75. A few years earlier Stieglitz had tried to interest the Stokowskis, who had spent time in New Mexico, in O'Keeffe's work. See Carr, journal entry for 3 April 1937, *HT*, 285; and Morgan, ed., *Dear Stieglitz, Dear Dove*, 206.

44 Harris to Carr, 20 December 1931, quoted in Charles C. Hill, *The Group of Seven: Art for a Nation* (Ottawa: National Gallery of Canada, 1995), 334; Carr, *Growing Pains*, 452.

45 Tobey, quoted in Blanchard, *Life of Emily Carr*, 193.

46 O'Keeffe, quoted in Katharine Kuh, "Georgia O'Keeffe," in *The Artist's Voice: Talks with Seventeen Artists* (New York: Harper and Row, 1960), 184; O'Keeffe, quoted in Gladys Oaks, "Radical Writer and Woman Artist Clash on Propaganda and Its Uses," *The World*, 16 March 1930, women's sect., 1, 3.

47 Kahlo, quoted in Tibol, *Frida Kahlo*, 50. By 1949 Rivera had covered nearly 4,800 square yards of wall surface in murals.

48 One of many recent examples of her continuing celebrity is an exhibition called "Frida Kahlo: Modern Portraits of a Modern Icon," staged in 1997 at the Fraser Gallery in Washington, D.C. For this show more than two hundred entrants from four countries submitted entries. In her native country a whole generation has claimed Kahlo as a source, as shown in the exhibition catalogue by Blanca Garduno and Jose Antonio Rodriguez, *Pasion por Frida* (Mexico City: Museo Estudio Diego Rivera-INBA, 1992).

49 Patrick O'Brian, *Picasso: A Biography* (1976; rpt. New York: Norton, 1994), 196. I include this anecdote in full awareness of the problematic criticism of "origin stories" in modernist art, criticism generated around the 1984–85 exhibition "'Primitivism' in Twentieth-Century Art: Affinity of the Tribal and the Modern" organized at the Museum of Modern Art. Such criticism challenged whether any essential affinities actually existed, or whether such connections merely reflect the voracious appetite of the West to collect the world. On this, see James Clifford, *The Predicament of Culture: Twentieth-Century Ethnography, Literature and Art* (Cambridge: Harvard University Press, 1988), esp. chap. 9.

50 Alberto Ruz Lhuillier, quoted in Peter T. Markman and Roberta H. Markman, *Masks of the Spirit: Image and Metaphor in Mesoamerica* (Berkeley: University of California Press, 1989), xxi; Octavio Paz, *Posdata* (Mexico City: Siglo XXI, 1970), 11.

51 For more on Rivera's, Tamayo's and their younger Mexican contemporaries' use of masks, see Markman and Markman, *Masks of the Spirit*, 196–205.

52 For a fuller discussion on the survival and meanings of the jaguar-tigre mask, see Markman and Markman, *Masks of the Spirit*, chap. 12.

53 Perhaps in sympathetic response to Kahlo's *Girl with a Death Mask*, Rivera painted *Girl with Mask* (*Niña con máscara*, c. 1930s; location unknown), a small child holding an animal mask, but it contains no death mask.

54 Kahlo, diary entry for 21 March 1954, in Sarah Lowe, ed., *The Diary of Frida Kahlo: An Intimate Self-Portrait* (New York: Abrams, 1995), 278.

55 Carl Jung, "Introduction to the Religious and Psychological Problems of Alchemy," in *The Basic Writings of C. G. Jung*, trans. R. F. C. Hull (Princeton: Princeton University Press, 1990), 473.

56 Thomas Mann, *The Magic Mountain*, trans. H. T. Lowe-Porter (New York: Knopf, 1955), 281.

57 K. P. Stich, "Painters' Words: Personal Narratives of Emily Carr and William Kurelek," *Essays on Canadian Writing* 29 (1984), 160.

58 John O'Brian, "Introduction: Iconic Carr," in David Alexander and John O'Brian, *Gasoline, Oil, and Paper: The 1930s Oil-on-Paper Paintings of Emily Carr* (Saskatoon: Mendel Art Gallery, 1995). 8.

59 Alexander and O'Brian, *Gasoline, Oil and Paper*, 7–14, 33–34.

Index

Index

Index